D1576662

# THE SELJUQS AND THEIR SUCCESSORS

**Edinburgh Studies in Islamic Art**
**Series Editor: Professor Robert Hillenbrand**

edinburghuniversitypress.com/series/esii

# THE SELJUQS AND THEIR SUCCESSORS

## ART, CULTURE AND HISTORY

EDITED BY SHEILA R. CANBY,
DENIZ BEYAZIT AND MARTINA RUGIADI

EDINBURGH
University Press

Edinburgh University Press is one of the leading university presses in the UK. We publish academic books and journals in our selected subject areas across the humanities and social sciences, combining cutting-edge scholarship with high editorial and production values to produce academic works of lasting importance. For more information visit our website: edinburghuniversitypress.com

Edinburgh University Press Ltd
The Tun – Holyrood Road
12 (2f) Jackson's Entry
Edinburgh EH8 8PJ

Typeset in Trump Medieval by
Servis Filmsetting Ltd, Stockport, Cheshire
and printed and bound in Malta by Melita Press

A CIP record for this book is available from the British Library

ISBN 978 1 4744 5034 8 (hardback)
ISBN 978 1 4744 5037 9 (webready PDF)
ISBN 978 1 4744 5036 2 (epub)

# Contents

# Figures

# Tables

# Series Editor's Foreword

'Edinburgh Studies in Islamic Art' is a venture that offers readers easy access to the most up-to-date research across the whole range of Islamic art. Building on the long and distinguished tradition of Edinburgh University Press in publishing books on the Islamic world, it is a forum for studies that, while closely focused, also open wide horizons. Books in the series, for example, concentrate in an accessible way, and in accessible, clear, plain English, on the art of a single century, dynasty or geographical area; on the meaning of works of art; on a given medium in a restricted time frame; or on analyses of key works in their wider contexts. A balance is maintained as far as possible between successive titles, so that various parts of the Islamic world and various media and approaches are represented.

Books in the series are academic monographs of intellectual distinction that mark a significant advance in the field. While they are naturally aimed at an advanced and graduate academic audience, a complementary target readership is the worldwide community of specialists in Islamic art – professionals who work in universities, research institutes, auction houses and museums – as well as that elusive character, the interested general reader.

*Professor Robert Hillenbrand*

# The Contributors

**Viola Allegranzi** received her doctorate from the Universities Sorbonne Nouvelle – Paris III and 'L'Orientale' of Naples (2017). She is currently a postdoctoral research fellow at the Institute of Iranian Studies of the Austrian Academy of Sciences (Vienna).

**Deniz Beyazit** is Associate Curator in the Department of Islamic Art at The Metropolitan Museum of Art.

**Patricia Blessing** is Assistant Professor of Art History at Pomona College.

**Sheila R. Canby** is Curator Emerita in the Department of Islamic Art at The Metropolitan Museum of Art.

**Roberta Giunta** is Associate Professor of Islamic Art and Archaeology and Islamic Epigraphy in the Department of Asian, African and Mediterranean Studies at the University of Naples 'L'Orientale'.

**Margaret S. Graves** is Associate Professor in the Department of Art History at Indiana University, Bloomington.

**Carole Hillenbrand** is a Professorial Fellow at the School of History of the University of St Andrews and Professor Emerita at Edinburgh University.

**Robert Hillenbrand** is a Professorial Fellow at the School of Art History of the University of St Andrews and Professor Emeritus at Edinburgh University.

**Renata Holod** is College for Women Class of 1963 Term Professor Emerita in the Humanities and Curator of the Near East Section in the Penn Museum, University of Pennsylvania.

**Lorenz Korn** is Professor of Islamic Art and Archaeology at the University of Bamberg, Germany.

**Stefan Masarovic** is Stone and Wood Conservator at the Museum of Islamic Art, Doha.

**Leslee Michelsen** serves as Curator of Collections and Exhibitions at the Shangri La Museum of Islamic Art, Culture & Design (Doris Duke Foundation for Islamic Art) in Honolulu, Hawai'i.

**A. C. S. Peacock** is Professor at the School of History at the University of St Andrews.

**Scott Redford** is Nasser D. Khalili Professor of Islamic Art and Archaeology at the School of Oriental and African Studies, University of London.

**Martina Rugiadi** is Associate Curator in the Department of Islamic Art at The Metropolitan Museum of Art.

**George Saliba** is Professor and Director of the Farouk Jabre Center for Arabic and Islamic Science and Philosophy at the American University of Beirut (AUB) and Professor Emeritus of Arabic and Islamic Science at Columbia University.

**Rustam Shukurov** is Professor in the History Faculty of Moscow State University.

**Alessandro Sidoti** is Senior Book Conservator at the National Central Library of Florence.

**Yasser Tabbaa** is Professor in the Faculty of the Arts and Humanities at New York University, Abu Dhabi.

**D. G. Tor** is Associate Professor in the Department of History at The University of Notre Dame.

**Mario Vitalone** is Librarian at the University of Pisa.

# Editors' Note on Transliteration

This volume brings together authors from a large variety of disciplines and scholarly contexts, each with their own conventions of transliteration from the Arabic alphabet into English. In order to preserve their authorial voice, very little effort has been made to impose a unified standard as to the presence of diacritical marks or the transliteration system overall. However, words that have become a part of the English language (such as Sunni, Shi'i, Qur'an and ulema) are rendered without diacritics.

# PART ONE
# INTRODUCTION

# CHAPTER ONE

# Editors' Introduction

*Sheila R. Canby, Deniz Beyazit and Martina Rugiadi*

FROM 9 TO 11 JUNE 2016, The Metropolitan Museum of Art held a scholarly symposium in connection with *Court and Cosmos: The Great Age of the Seljuqs*, a special exhibition held between 27 April and 24 July 2016 that aimed to present the arts of all the Seljuqs and their successor states from Central Asia, Iran, Anatolia, the Jazira and Syria. These Central Asian Turks first interacted with the Iranian world as herders and mercenaries and eventually ruled a wide swathe of Western Asia. Holding sway from the eleventh to the early fourteenth century and in certain parts of the Jazira until the early fifteenth century, the Seljuqs prevailed during a period of exceptional artistic creativity. While the *Court and Cosmos* exhibition included around 270 works of art in all media, as well as architectural fragments, published with commentary in the exhibition catalogue, neither the exhibition nor the catalogue could address questions of architecture, archaeology or specific objects in the depth afforded by a symposium and its publication.

At the 2016 symposium we were fortunate to have an international group of speakers who are leaders in the field of Seljuq history and art history. Their contributions in this volume comprise six chapters: an Introduction to Seljuq History and Art (Carole Hillenbrand and Robert Hillenbrand); Rulers and Cities (Redford); Faith, Religion and Architecture (Korn, Tor, and Tabbaa); Identities: Rulers and Populace (Blessing, Giunta and Allegranzi, and Shukurov); Magic and Cosmos (Peacock and Saliba); and Objects and Material Culture (Graves, Michelsen and Masarovic, and Sidoti and Vitalone). Together these chapters both broaden and deepen our understanding of Seljuq history and art. In some instances, they connect historical individuals with the works of art and architecture, while others help us understand the social context in which certain visual symbols were prevalent. Importantly, they provide concrete evidence of how the art produced during Seljuq times was the foundation of later forms and techniques.

The contexts in which the Seljuqs operated varied markedly. Their original homeland in the Eurasian steppe was populated by Oghuz and other Turkish-speaking groups who largely converted to Islam in the tenth century. In the service of regional armies – such as the Samanids to the south and east of the Aral Sea – the Seljuqs consolidated their reputation for military prowess, such that they were able to defeat the Ghaznavids in the Iranian province of Khurasan and decisively at Dandanaqan in Central Asia in 1040. With these victories, the path was cleared for the Seljuq move into Khurasan and then the main lands of Iran with its many well-established cities, pre-existing administrative structures and long acceptance of Islam. The topography, language and history of eleventh-century Iran contrasted markedly with those of Central Asia, providing many cultural challenges and opportunities for the Seljuqs. While scholars have debated whether it was the favourable economic climate created by the Seljuqs in Iran or the new tastes of their leaders that underlie the burst of artistic activity in twelfth- and thirteenth-century Iran, the variety and creativity of the period is undeniable. Further west – in Anatolia, the Jazira, Syria and Iraq – the Rum Seljuqs, Zangids and other successor states or representatives of the Great Seljuqs encountered distinctly different social contexts. Whereas Islam and Turks had appeared in Anatolia before the Seljuqs, the dominant faith was Christianity, while Greek as well as Armenian were widely spoken. Arabic and Syriac were the languages of Syria, Iraq and the Jazira. While Muslims far outnumbered followers of other faiths in Syria and parts of Iraq, in the Jazira – northern Iraq, eastern Syria and southeastern Turkey – Christianity was practiced by most of the population. Seljuq architecture and art forms reflect the complex histories and societies in these regions, while to a certain extent maintaining the originality of approach found in the Iranian world of the Great Seljuqs.

One collection of chapters cannot answer all the questions of how a dynasty succeeded in conquering a huge expanse of Western Asia without massacring its population and laying waste to its cities, as the Mongols had done in the thirteenth century, followed by Timur in the late fourteenth century. Nonetheless, each chapter of this book lends insight into the identity of the Seljuqs, the nature of the art produced during the reigns of the Seljuq sultans and their successors, and the importance of this dynasty for the artistic and architectural heritage of the present countries of Turkmenistan, Iran, Iraq, Turkey and Syria.

Such a volume is the product of many people. In addition to the authors, we wish to thank our colleagues at Edinburgh University Press, especially Nicola Ramsey and Kirsty Woods, as well as Courtney Stewart at The Metropolitan Museum of Art. Many extraordinary scholars have provided the foundation on which the research of all of the contributors to this volume is based. One of

these, C. E. Bosworth, passed away as the exhibition and symposium were being planned, and we hope this book honors his legacy. The symposium was generously supported by Roshan Cultural Heritage Institute, the Soudavar Memorial Foundation and the American Institute of Iranian Studies. To them we owe a great debt of gratitude.

CHAPTER TWO

# What is Special about Seljuq History?

*Carole Hillenbrand*

## Introduction

THE ARRIVAL OF the nomadic Turks in the Islamic world was a pivotal moment in medieval Iranian and Islamic history. From the 1020s onwards the eastern Islamic world experienced a wave of nomadic Turkish invasions from the Central Asian steppes. The Seljuq state which was then established marked the beginning of a Turkish military and political dominance in the Muslim world which was to last for many centuries (Figure 2.1).[1]

The Muslim Arabs and Persians had become acquainted with one kind of Turkish military presence since the eighth century. Turkish slave soldiers (*mamluks*), much admired for their skills in horsemanship and archery, had long formed part of the armies and bodyguards of caliphs and independent rulers (Figure 2.2). But that Turkish component in Islamic society had entrenched itself slowly and did not burst onto the scene with the sudden intensity, scale and alien character of the Seljuq invasions.

## What kind of nomadic society did the Seljuq Turks bring with them into the sedentarised Eastern Islamic world?

The nomadic Turks (Turcomans) had endured unremittingly hard lives for millennia. Their most striking characteristic was mobility. This was the key to their survival. It was by their mobility that they could attack the enemy, plunder and then depart at great speed. Their mobility was not confined to warriors alone; it entailed the movement of men, women, livestock, tents and baggage wagons. Their military strength lay in their mounted archers, who discharged their arrows at a distance and avoided direct encounters with the enemy (Figure 2.2). Already in the ninth century the Arabic writer al-Jahiz praised the Turkish cavalry, saying: 'The

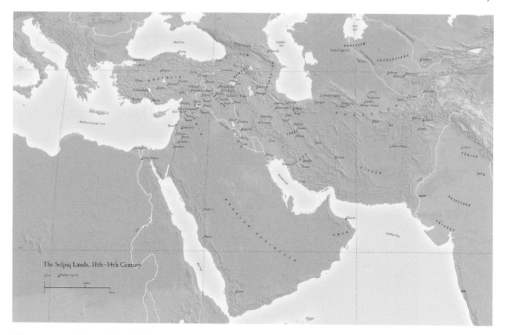

**Figure 2.1** *Map of the Seljuq empire. Source: Courtesy of The Metropolitan Museum of Art,* Court and Cosmos

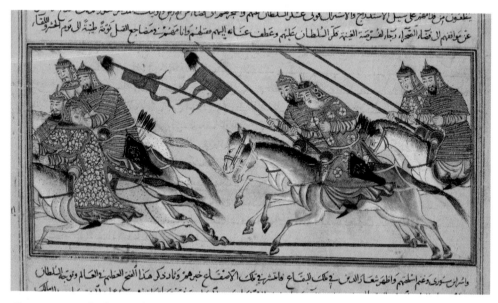

**Figure 2.2** Turkish Cavalry *(detail), folio from the* Jami' al-Tawarikh *of Rashid al-Din. 1314, Iran. The University of Edinburgh, Or.Ms f.129v. Source: © The University of Edinburgh*

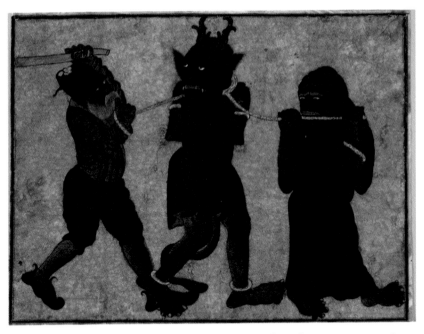

**Figure 2.3** Demon in Chains, *in the style of Siyah Qalam. Circa 1453, Iran or Central Asia. Opaque watercolor and gold on paper. The Cleveland Museum of Art, Purchase from the J. H. Wade Fund 1982.63. Source: Courtesy of The Cleveland Museum of Art*

Turk has two pairs of eyes, one at the front and the other at the back of his head'.[2]

The nomads' dress contrasted forcibly with that of the settled Muslims (Figure 2.3). The Turcomans wore furs, or shapeless sack-like cloth garments. Both sexes wore trousers. The men commonly wore their hair down to their waists and greased it with rancid butter. Indeed, it was rumoured amongst Eastern Christians that the Seljuq army could be smelt three days' distance away. The basis of the nomadic economy was a combination of pastoralism and raiding. The Turcomans' major food supply came from their herds. Their wealth and status were usually assessed by how many horses they owned. The sedentary Muslim populations were disgusted when they saw what the Turcomans ate: wolves, foxes, dogs, mice, rats and snakes. The eleventh-century Arab writer Ibn Hassul says: 'They consume only meat, and do not wish for any substitute, even if it is dripping blood or filthy, and they do not wish for anything else'.[3] Turcoman society was shamanistic, and even after the conversion of their tribal leaders to Sunni Islam the Turcomans retained many of their basic shamanistic practices. Power within the tribe lay with certain families. On the death of a senior male member of the ruling clan, his patrimony would be shared out amongst his male relatives.

## A brief overview of Seljuq history

In the 990s Turcoman groups from Inner Asia moved towards the Muslim frontier near the Aral Sea. The chief of the Oghuz clan, Seljuq, converted to Islam. Some of the Seljuq Oghuz nomadic tribes crossed the river Oxus into Muslim territory in 1025, and the remainder did so ten years later. In 1036–37, under the leadership of two Seljuq brothers, Tughril and Chagri, these nomadic forces conquered eastern Iran. Probably now numbering around 4,000 tents, they were well and truly inside the Muslim world. This was a substantial number of people. Such tents were large, housing extended families and often their animals, too (Figure 2.4).

At that point Chaghri decided to divide forces; he would stay in eastern Iran, while Tughril would move west and keep whatever territory he conquered. In 1043 Tughril seized Isfahan and in 1055 entered Baghdad; he had himself proclaimed 'Sultan of East and West'[4] by the Sunni caliph there and then persuaded the reluctant caliph to allow him to marry his daughter. Tughril was not destined to enjoy supreme power for long. Having definitively taken control of Baghdad, he died in 1063.

The reigns of the next two Seljuq sultans, Alp Arslan and his son Malikshah (Figure 2.5), represent the high point of Seljuq rule in the

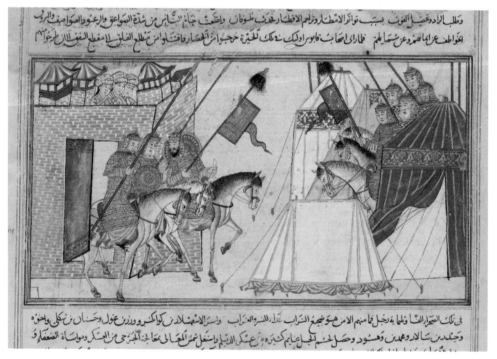

**Figure 2.4** Court Tents *(detail), folio from the* Jami' al-Tawarikh *of Rashid al-Din. 1314, Iran. The University of Edinburgh, Or.Ms f.125v. Source: © The University of Edinburgh*

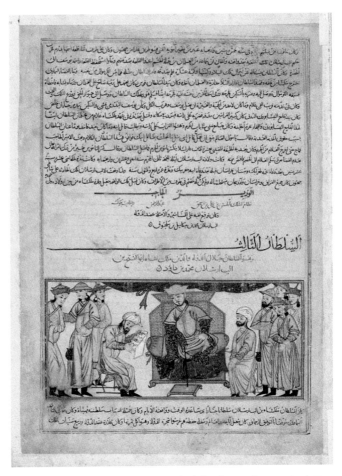

**Figure 2.5** Sultan Malikshah Enthroned, *folio from the* Jami' al-Tawarikh *of Rashid al-Din. 1314, Iran. The University of Edinburgh, Or.Ms f.138r. Source: © The University of Edinburgh*

east. These two sultans were ably supported, and indeed dominated, by the superbly gifted Persian vizier Nizam al-Mulk. Territorially, the Seljuq period saw the first major expansion of the Islamic empire since the seventh-century Arab conquests. Alp Arslan was constantly on the move and created a unified empire that stretched from Syria and Anatolia to Central Asia. In 1071 Alp Arslan moved to confront a huge Byzantine army near Lake Van. He won a famous victory, the Battle of Manzikert;[5] he actually captured the Byzantine emperor and then released him honourably. News of this extraordinary military victory reached Europe, causing unease at the growing Turkish power in Anatolia. Although the Turcomans had roamed across Anatolia as early as the 1030s, Manzikert has been viewed by many historians as the moment when the Turcomans were there to stay (Figure 2.6). Alp Arslan was murdered in 1072 in the east of his empire.

His son Malikshah succeeded him as Seljuq sultan (Figure 2.5). The famous thirteenth-century Arab historian Ibn al-Athir praised his reign, saying: 'His name was mentioned in sermons preached from the borders of China to the limits of Syria and from the extremities of the lands of Islam in the north to the bottom of Yemen'.[6] Malikshah continued to go on military campaigns, but his twenty-year reign represents an important transition in Seljuq history, for he seems to have stayed in one place

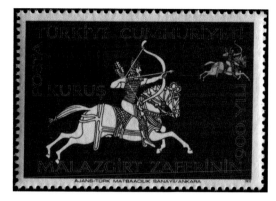

**Figure 2.6** *1971 Manzikert celebratory stamp. Source: Collection of the author*

for certain months of the year. That place was Isfahan, which he made his capital.[7] But it would appear that he did not live in a palace or a citadel. It is probable that he still lived in a tented encampment outside the walls of the city. His vizier Nizam al-Mulk, however, was resident inside the city, conducting government business. Both men were killed within weeks of each other in 1092, and the Seljuq state was never the same again, although the dynasty lasted for another century in Iran.

In the twelfth century, unassimilated Turcomans on the fringes of the Seljuq empire moved from summer to winter pastures, as they had always done. Closer to the centres of Seljuq power in Isfahan and Nishapur the unity of the state was increasingly undermined by fratricidal succession disputes and by the lingering traditional patrimonial division of heritage amongst the ruler's male heirs on his death. Sultan Sanjar stayed in power in eastern Iran, ruling there from 1097 and serving as supreme sultan from 1118 to 1157. But his death ushered in the full decline of the Seljuq state in Iran (Figure 2.7). The last Seljuq sultan, Tughril III, died in 1194.

## The realities of early Turkish rule

The presence of the Turcomans was viewed as a necessary evil by the sedentary Muslim populations. The Seljuq leadership exercised control over them, sometimes precariously. The Seljuqs also came to an understanding with the urban elites; the Seljuqs would provide military support, and the cities would give taxes and the bureaucratic expertise necessary to administer the Seljuq empire. Despite the disruption to agriculture caused by the Turcomans and their tendency to damage cities and monuments, Muslim writers valiantly made the best of the situation, for they saw that these nomads were here to stay.

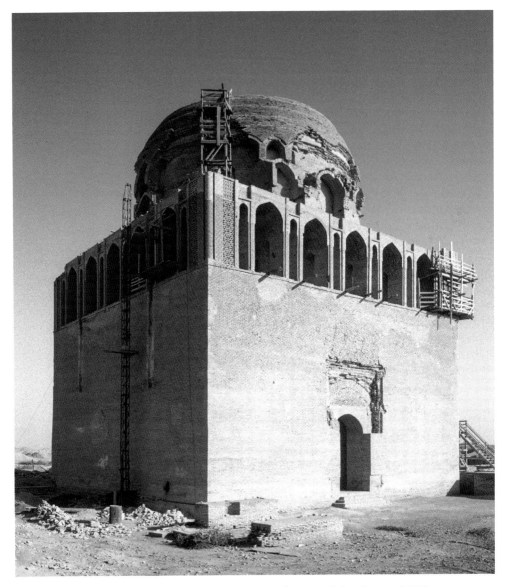

**Figure 2.7** *Mausoleum of Sultan Sanjar. Source: Photograph by Bernard O'Kane*

### Seljuq government

Continuity of governmental practice was achieved in the Seljuq period; Persian elite families passed on their skills from one generation to the next and helped to ensure administrative stability in turbulent times. The chief architect of Seljuq administration was Nizam al-Mulk, probably the most famous of all Persian viziers. During his extraordinarily long period in power (over thirty years), he worked in a travelling court. Wherever the Turkish Seljuq sultan was, Nizam

al-Mulk was there, too. He needed to be there with a restraining hand, teaching him the ways of Perso-Islamic government.[8]

There were, however, new aspects of Seljuq government that came from the shamanistic steppe heritage. The first two Seljuq sultans retained their Turkish totemistic names – Tughril meaning 'falcon' and Alp Arslan meaning 'hero lion'. Thereafter, most (but not all) subsequent Seljuq sultans were known by Muslim names. Even so, the title 'Sultan of East and West' bestowed by the 'Abbasid caliph in Baghdad on the first Seljuq Sultan Tughril in 1055 reflects the nomadic steppe concept of world dominion – a symbol of Turkish sovereignty, extending from where the sun rises to where it sets.

The earliest Seljuq coins show a bow and arrow to denote sovereignty. According to Ibn al-Athir, the Byzantine emperor repaired the mosque in Constantinople in honour of the first Seljuq sultan Tughril, and in the mihrab he placed a bow and arrow.[9]

The Seljuq Turkish institution of *atabeg*, usually denoting a powerful Turkish military commander whose duty it was to supervise the upbringing of young Seljuq princes, also came from steppe tradition. But when it was introduced into the Seljuq government, it had dire consequences. The institution proved to be a serious centrifugal force, working against the centralised government model beloved of Nizam al-Mulk. After 1092 *atabeg*s seized power in their own right, and this contributed to the disintegration of the Seljuq state.

## What of religion?

Traditionally, the Seljuq Turkish elite are presented in the medieval Arabic and Persian sources as pious Sunni Muslims who had converted to Islam before their major invasions began. This portrayal of the Turks, who went on to govern the heartlands of the Islamic world for many centuries, is not surprising. Given the political realities, their Arab and Persian bureaucrats, court chroniclers and poets needed to put on a brave face and help forge an alliance between the military force of the Turks and the long-established prestige of the Sunni Arab and Persian religious classes. No doubt, over time some of the Turkish sultans did indeed grow into the role accorded them by their chroniclers and court poets – namely, that of defenders of Sunni Islam and fighters of *jihad* against infidels and heretics.

As an alien, invading military force, the Seljuq Turkish sultans generally adopted a publicly supportive and deferential stance towards the Sunni caliph in Baghdad, from whom they sought religious credentials. And the caliphs gave them grand robes and honorific titles. Both internally and externally, the Seljuq government took decisive steps against the Isma'ili Shi'ites, who were cursed from the pulpits and forbidden employment. A major religious development was the establishment of a network of Sunni

*madrasa*s by high-ranking Seljuq administrators across the empire. Nizam al-Mulk set the example by funding and supervising at least ten such *madrasa*s or religio-legal colleges; the principal one of these was in Baghdad. Thus, a reliable, well-trained class of Sunni religious scholars could promote orthodox Islam across the empire.

## What of the Seljuq court?

Two traditions blend in the evolution of the Seljuq court ceremonial: the Perso-Islamic heritage and the Turkish tradition of the Central Asian steppes. It is hard to assess in detail how this worked for the Seljuqs; the medieval Islamic sources present the Seljuqs' lifestyle through the distorting mirror of the Muslim religious and bureaucratic elite. The Seljuq Turks have no real voice of their own.

However, despite being military warlords and 'Turkish nomadic outsiders', the Seljuq sultans decked themselves in the usual trappings of Perso-Islamic rulers. Their courts employed many officials and servants. The most important of these was the chamberlain who controlled access to the sultan's presence. The court also included a chief executioner, the holder of the royal parasol, scribes, religious scholars, Sufis, doctors, artists, interpreters, jesters, astrologers, cooks and many others. It was an intrinsic sign of a ruler's prestige for him to have an entourage of public intellectuals, despite his being unschooled, even illiterate. A veritable galaxy of Persian and Arab poets flocked to the Seljuq courts. The job of the cooks must have been very onerous. Indeed, it was said that Sultan Alp Arslan used to slaughter fifty sheep a day. Doctors were essential since there was always the danger of infected water on campaign.

The Seljuq sultan had many regular formal duties. He received envoys from Muslim and non-Muslim lands. He inspected his troops. He held circumcision celebrations for his male relatives. And he gave banquets to consolidate his relationships with tribal chiefs on whose auxiliary military support he relied. When the court went outside the royal enclosure, the ceremonial parasol would be held over the sultan's head.

The giving and receiving of gifts were important facets of court ceremonial. The first Seljuq sultan, Tughril, received a present from a vassal that included multi-coloured garments, horses and three well-nourished sparrow hawks. Exotic animals, such as the giraffe, were also welcome gifts and would be kept in a menagerie.

Malikshah is singled out by Ibn Khallikan in his famous biographical dictionary for his love of the hunt: he writes that 'all power was concentrated in the hands of the vizier, whilst the sultan (Malikshah) had nothing more to do than show himself on the throne and enjoy the pleasures of the chase'.[10] Indeed, Malikshah is reported to have shot seventy gazelles in one day; in each hunting place he made towers of the hooves of gazelles and wild asses.

The sultans also liked to listen to music, to watch dancing, to play chess and backgammon, and to hear tales of exotic lands. Wine-drinking was an integral part of Seljuq court life, and some Seljuq rulers, such as Malikshah's son Barkyaruq, are described in the sources as being addicted to wine.

The women of the Seljuq ruling family were involved in court politics, and they acted as patrons of religion and learning. Many of them had their own viziers. The power of queen-mothers increased further after the fragmentation of Seljuq territories, and some ruled after the death of their husbands. A famous example of this was Terken Khatun, Malikshah's wife, after his death in 1092. She was reported to have owned ten thousand *mamluk*s. She ruled the kingdom and led the armies. No wonder Nizam al-Mulk in his famous *Book of Government* railed against royal women who meddled in politics: 'In all ages nothing but disgrace, infamy, discord and corruption have resulted when kings have been dominated by their wives'.[11]

Overall, seeing nomadic Turkish chieftains sitting on thrones and wearing crowns must have been a novel and not altogether enjoyable experience for their Persian and Arab subjects, long used to seeing ethnic Turks only as slave bodyguards, military commanders and eunuchs guarding the harem.

## The Seljuqs of Rum (Anatolia)

The year of 1194 was not the end of the Seljuq Turkish presence in the Middle East. The initial disruptive Turcoman presence in eleventh-century Anatolia had been followed by the establishment there of several embryonic Seljuq successor states, such as the Danishmendids and the Artuqids, which governed in a manner similar to that of the Great Seljuqs. Above all, the Seljuq state of Rum, founded in 1077 by Malikshah's cousin Sulayman, survived until 1307. The Rum sultans made Konya their capital.

They were Turks. But, unlike their Great Seljuq predecessors, many of them bore Persian names such as Kay-Khusraw, Kay-Qubadh and Kay-Ka'us. Moreover, their administrators and the religious elite in their cities were Persian. And with the terrifying thirteenth-century Mongol invasions of the eastern Islamic world, a mighty torrent of Persian refugees poured into Anatolia, particularly Konya.

The Rum Seljuq state – with a diverse population of Byzantine Greeks, Armenians, Kurds, Turcomans and Persians – was especially successful in the period from 1220 to 1250 and laid the foundations for the subsequent Islamisation of Anatolia. Indeed, Seljuq Anatolia houses the earliest substantial single body of medieval *madrasa*s in the whole Muslim world; thirteen of these are in Konya. There were also Sufi cloisters in Anatolian towns, especially in Konya, where such famous figures as Jalal al-Din Rumi could reside and teach.

### Concluding reflections

Empires built by usurping nomadic warlords are notoriously ephem-
eral, and nomadic traditions sit lightly on the civilisations they
conquer. As with the nomadic Mongols in Iran and China, it was to
be expected that indigenous Perso-Islamic statecraft would eventu-
ally prevail over the incoming Seljuq Turks. But the military power
of the Turks was an essential ingredient, too. Thus, in the Seljuq
period a fascinating symbiosis of ancient Persian culture, Sunni
Islamic norms and Turkish steppe tradition came into being.

By the thirteenth century, there was a solid Muslim presence in
Byzantine Anatolia; this had begun with Turcoman raids from the
eleventh century onwards and had been put on a firmer footing by
the Seljuq state of Konya. Byzantine Christian Anatolia further west
was now set to be Islamised under Turkish leadership. The Turkish
conquest of Constantinople in 1453 was the culmination of this
process. The land now known as Turkey was soon to be born.

### Notes

1. For an overview of Seljuq history see Peacock 2015 and Bosworth 1968.
2. Pellat 1969, p. 93.
3. Ibn Hassul 2015, p. 77.
4. This was a new regnal title for the Muslim world, but an ancient one for the Central Asian steppe peoples.
5. For a detailed discussion of this pivotal battle, see Carole Hillenbrand 2007.
6. Ibn al-Athir 1964, vol. 10, p. 211.
7. Durand-Guédy 2010.
8. Nizam al-Mulk wrote a famous *Mirror for Princes* on good Perso-Islamic government: Nizam al-Mulk 1960.
9. Ibn al-Athir 1964, vol. 10, p. 28, explicitly states that the Umayyad general Maslama (d. 738 AD) had built the mosque. Ibn al-Athir is prob-ably recycling a folkloric memory, for Maslama was never able to enter the city.
10. Ibn Khallikan 1843–71, vol. 1, p. 413.
11. Nizam al-Mulk 1960, pp. 179–80.

# CHAPTER THREE

# Seljuq Art: An Overview

*Robert Hillenbrand*

THE PURPOSE OF this chapter is not to give a whistle-stop tour of
the major masterpieces displayed in the *Court and Cosmos* exhibi-
tion, but rather to sketch some general and tentative propositions
that may help to explain both the art that was in the exhibition and
the architecture that was not. In what follows, the emphasis will
lie squarely on the art of the Great Seljuqs, although the Seljuqs of
Rum will also figure prominently. Much of this essay will also be
relevant to the art of such Seljuq successor states as the Artuqids and
Zangids. It may seem strange to mention architecture in a museum
context, but it is unwise to ignore it just because it is not there. After
all, that is where most of the money went. That, too, was what had
the greatest public impact. And architecture more than any other art
form bore the names of the great and the good. This was the preferred
method of permanent self-advertisement and memorial for rulers
and elites throughout the medieval Muslim world. Architecture
provided the necessary space for such people to proclaim the full
panoply of their titles and to broadcast their power and piety. But
given the scope of the exhibition, architecture will not be a major
focus of what follows here.[1]

## The Great Seljuqs

First, then, who produced Seljuq art, and who were its patrons? Not,
it seems, the Seljuqs themselves, for all that it bears their name.
True, much of the period covered by the *Court and Cosmos* exhibi-
tion is indeed politically dominated by the Seljuq dynasty, alongside
several Turcoman or Turkish states operating within the Seljuq
orbit, whether in Anatolia, the Jazira, Syria or Greater Iran, which
itself extended to Central Asia and Afghanistan. But one should not
be misled by dynastic labels, since they tell only part of the story.
Above all, such labels suggest that the architecture and art of the

period was produced by craftsmen of Turcoman blood and nomadic Turkic culture – but that is rarely so. An outstanding exception may well be the architect Atsiz al-Sarakhsi, who placed his name on the inside of the domed mausoleum of Sultan Sanjar at Merv (Figure 2.7). But essentially the visual culture of this period in the orbit of the Great Seljuqs was the work of urban craftsmen reared in Persian traditions. They held fast to those traditions. Further west, in Anatolia, the Jazira and Syria, other traditions – Byzantine, Armenian, Syriac and Arab – also came into play. It is true that ideas, motifs and themes originating in the Eurasian steppe – for example, those of shamanistic significance,[2] such as the tree of life, sun and moon rosettes, animals such as deer, bulls, falcons, lions, dogs, fish, not forgetting fantastic creatures such as sphinxes, sirens, harpies, dragons and double-headed eagles,[3] which may be totemistic or apotropaic, or serve as *tamgha*s – make themselves felt, especially in Anatolia, but they occur spasmodically at best. Seljuq art is Persian far more than it is Seljuq, with the proviso that its range of cultural reference is significantly wider in many works produced to the west of Iran.

It is worth looking in more detail at the entire issue of patronage. Very little Seljuq art apart from buildings – an important but crucial exception – can be associated with royal patrons or those of high status. The rarity of Qur'an copies whose dating and provenance is incontestably Seljuq makes this an obvious area for future research, although recent work on Ghaznavid and Ghurid Qur'ans has identified copies made for Sultan Ibrahim and other exalted patrons.[4] Too little really detailed work has been done on Persian Qur'an copies of the Seljuq period to permit more than very preliminary conclusions to be drawn. Besides, the religious nature of these manuscripts opens up the possibility that they were ordered by members of the religious elite for use in mosques, *madrasa*s or other religious buildings. And the very descriptor 'Seljuq' is itself dubious and often begs the question, for Qur'ans datable between the eleventh and thirteenth century are not rare, but come from many regions – they are not just from Buyid or Seljuq Iran, but Iraqi, Anatolian, Ghaznavid, Ghurid, Khwarazmshahi lands and so on. The differences between these isolated examples suggest that one should posit the existence of well-established regional schools. Similar conclusions suggest themselves in the field of architecture. Yet much of the spade-work required to define these regional subsets of 'Seljuq' art remains to be done.

A brief glance at the pattern of Ilkhanid art underlines this gap in current knowledge. From metalwork to illustrated manuscripts, from monumental Qur'ans to luxury textiles, there is enough surviving material to permit definitions of what royal taste was in Mongol times. Not so for the Seljuqs, with, as already noted, the single but very significant exception of architecture. Perhaps the finest and

most celebrated example of undoubtedly
Seljuq metalwork, the so-called Bobrinski
Bucket (Figure 3.1), was made in Herat
in 1163, not for a ruler or an *amir* or any
member of the political elite, but for a man
who styled himself 'pride of the merchants'
and who hailed from Zanjan, a thousand
miles to the west.[5] The Wade Cup (Figure
3.2), the only piece of comparable quality
and complexity, is anonymous, while the
Tiflis Ewer (Figure 3.3), despite its techni-
cal mastery and the rhetorical flourishes
of its lengthy poetic inscription, mentions
no patron. The two silver bowls in the Keir
and Sarikhani collections, respectively,
again yield no clues that point to high-
level patronage. And only a single piece
of luxury pottery – the Freer plate of 1210
– mentions a patron of significant status,
in this case an *amir* (Figure 3.4).[6]

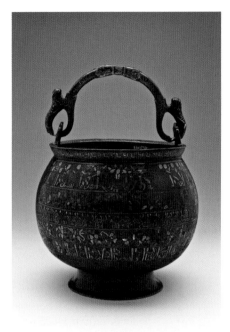

Second, what about the roots, the origins
of so-called Seljuq art? The art of the period
from 1055 to 1220 in the eastern Iranian
world – which continued in Anatolia for
almost a century and in certain parts of
the Jazira even longer, while the eastern
Iranian world absorbed most of the shock
of the Mongol invasions and experienced
some decisive changes of direction as a
result – does indeed have its fair share of

**Figure 3.1** *The 'Bobrinski Bucket'.
Twelfth to early thirteenth century,
Iran, Herat. Bronze (brass), silver and
copper; cast, forged and decorated
with inlay. H. 18.5 cm. The State
Hermitage Museum, St Petersburg,
Inv. no. IR-2268. Source: Photograph
by Vladimir Terebenin, © The State
Hermitage Museum*

innovation. This is especially so in ceramics and metalwork, which
saw the introduction of many new types of pottery and the rapid
development of the inlay technique in metalwork, whose wide
potential is shown, for example, by the idea of creating inscriptions
that look like people. But for the moment it is appropriate to focus
on something else. For this is essentially an art of consolidation. It
refined and improved on ideas that earlier had been expressed only
tentatively. In this period, then, standard forms were forged for many
architectural types on the basis of experiments carried out earlier,
particularly in the previous two centuries. The four-*iwan* plan, the
monumental domed chamber, the tomb tower and the elaborately
decorated slender cylindrical minaret all illustrate this process in the
domain of architecture.[7] So does the decisive triumph of baked brick
in structure and ornament.[8] In other arts, the hard work of manag-
ing the transition from pre-Islamic, principally Sasanian, modes to
Islamic ones, and creating a distinctively Persian voice in the process,
saw many new ideas come to the fore, particularly after *circa* 900,[9]

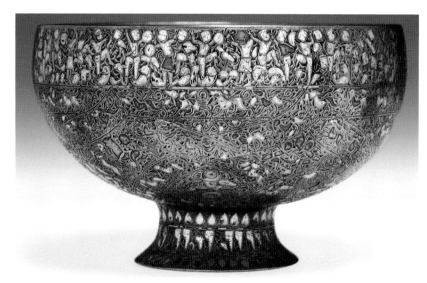

**Figure 3.2** *The 'Wade Cup'. Thirteenth century, Iran. Cleveland Museum of Art, Purchase from the J. H. Wade Fund 1944.485. Source: Courtesy of The Cleveland Museum of Art*

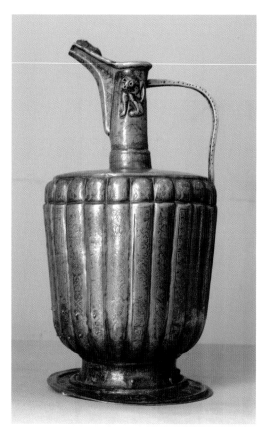

and here too it was in Seljuq times that they found definitive expression. The heavy, repetitive forms of Sasanian stucco ornament were transformed beyond recognition, thanks to a new repertoire of biomorphic and sometimes even animal forms executed in fluid pneumatic carving.[10] Gone was the reliance on simplified and abstracted motifs obviously suited to mass production by means of moulds. Instead, designs incorporate a plethora of small-scale, delicate vegetal details employing multiple levels, with strong contrasts created by powerfully three-dimensional motifs and

**Figure 3.3** *The 'Tiflis Ewer' by Mahmud b. Muhammad al-Harawi. 1181–82 AD, Herat, Khurasan. Brass; raised, repousse, engraved, inlaid with copper and silver. Georgian National Museum, Simon Janashia Museum of Georgia, Tbilisi, 19-2008:32. Source: Courtesy of the Georgian National Museum*

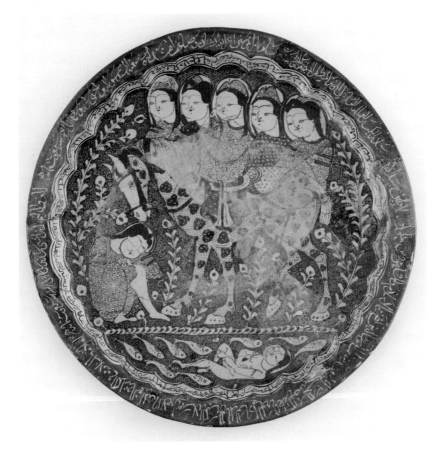

**Figure 3.4** *Plate by Shams al-Din al-Hasani Abu Zayd. 1210, Iran, Kashan. Stone-paste painted over glaze with lustre. Freer Gallery of Art, Smithsonian Institution, Washington DC, Purchase from Charles Lang Freer Endowment, F1941.11. Source: Courtesy of the Smithsonian Institution*

surface hatching. In many *mihrab*s a series of recessed rectangular frames of diminishing size controls this exuberant will to ornament, with a rich palette of colours to add further visual interest. All this allowed much more scope for originality, imagination and even fantasy on the part of the individual artist. Grand Sasanian themes such as hunting, ritual or ceremonial scenes were scaled down and popularised, and also transferred onto humbler materials, losing much of their majesty in the process.[11] One notes a steady growth in the expressive potential of Arabic inscriptions,[12] whether of modest size on portable objects or on a monumental scale in architectural decoration. Pottery became a bearer of meaning, both in its increasingly rich iconography and as a vehicle first for proverbs and eventually for poetry.[13] Religious themes, principally in the form of Qur'anic texts, began to infiltrate all the arts to an unprecedented

degree as conversion to Islam gathered pace. In large-format display Qur'an copies, stately, angular, intricate and endlessly varied Kufic scripts, hard to decipher but austerely beautiful, formed an objective correlative to the awesome enigmas of the sacred text. But a much more readable cursive script was also evolving and was increasingly used for Qur'ans.[14] In summary, the period between the arrival of the Arabs and that of the Seljuqs, from about 650 to 1050, saw both painful adjustments between old and new, and many hesitant attempts to strike out in new directions. This was especially marked in the last third of that period, as Persian dynasties and their elites challenged Arab domination on many fronts, looking back to pre-Islamic times for inspiration.

Third, what is missing? We have lost the most luxurious objects, those made for the court. Instead, we have shadows of them in humbler materials. The objects in gold and silver tableware, the bejeweled hangings and carpets, the ultra-rich brocades, the luxury objects fashioned from precious woods, ivory and rock crystal have – with minor exceptions – gone with the wind. We should not imagine that we have the art of the court before us. What we have instead, especially for Iran, is the art of a well-to-do class of urban patrons eager to ape art of a higher status and cost.[15] Not surprisingly, something gets lost in translation. It is more than a matter of a change in medium. Iconography gets simplified, and inconsistencies creep in. Thus, the princely cycle of courtly pursuits acquires elements from popular culture, such as stick-fighting or bearded men engaged in what looks like a solemn ritual dance.[16]

Fourth, this is an art that reached its zenith after 1150, and thus in a period of political decline, proving once again that the rhythms of artistic output do not necessarily correlate with those of political supremacy. This distances it still further from the world of the court. It seems that the decline in the power and wealth of the Seljuq state coincided with a shift in disposable income to the mercantile, bureaucratic and scholarly class, a shift whose benefits were spread widely across the region and no longer concentrated in a few major urban centres. And it is tempting to suggest that the two trends – less money for the state, more money for prosperous citizens – were related, although the details are for the economic historians to explain. One result at least is plain. Much more was made for the market; the popularity of non-specific benedictory inscriptions is a clear pointer in this direction, as is the rarity of named patrons and the generic nature of so much of the subject matter. The popularity of *Shahnama* scenes on Kashan pottery (Figure 3.5)[17] suggests a strong attachment to the heroic Iranian past on the part of this clientele, which in turn points to a developed national sentiment.[18] Such literary tastes also explain the frequent appearance of poetry on these wares, even if that poetry has a lingering flavour of the fortune cookie.[19]

Fifth – and it seems, as a direct result of this process – far more was produced across the board. In architecture it is four times as much as in the previous two centuries, and perhaps a similar proportion may be suggested for the other two media of which numerous examples have come down to us, namely pottery and metalwork. It is highly unlikely that this greater mass of material is merely an accident of survival. Instead, we are most likely looking at a step change across the entire landscape of the visual arts. A new confidence is palpable. The fact that there is so much more of everything allows patterns of style, technique, subject matter and production to emerge. One such finding is that local

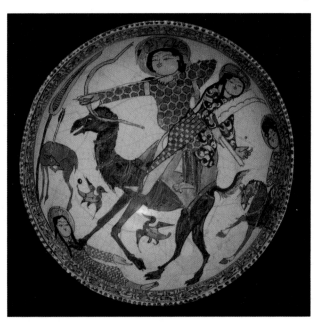

**Figure 3.5** *Bowl with Bahram Gur and Azada. Late twelfth to early thirteenth century, attributed to Iran, probably Kashan. Stone-paste; glazed (opaque monochrome), in-glaze- and overglaze-painted, gilded. The Metropolitan Museum of Art, Purchase Rogers Fund and Gift of The Schiff Foundation, 1957, 57.36.2. Source: Courtesy of The Metropolitan Museum of Art*

schools emerge with greater clarity than before – Kashan for lustre and *mina'i* pottery, Herat for inlaid metalwork, Ghazni for stone sculpture with strong Indian elements,[20] and in the field of architecture well-developed local schools in Azerbaijan, Khurasan and the Isfahan oasis. The greater rate of production triggers multiple variations on a given theme, whether it is the tomb tower in Azerbaijan, the qibla dome chamber in the Isfahan area, the cramming of extensive narrative scenes into the ungrateful format of dishes with plunging sides in the *mina'i* technique,[21] or the planetary, astrological and zodiacal themes so frequently found in inlaid metalwork.[22]

Sixth – and this is a major change – art becomes visually denser. The earlier emphasis on a few large motifs with plenty of space around them, for example in metalwork, gives way to a surface incorporating more fields, whether these are panels, cartouches or bands, so much so that frequently all the available space is full to bursting. Accordingly, surfaces become much busier (Figure 3.6). There is much more going on. This is an art that demands more of the observer, for the artist is loading every rift with ore and displaying a new virtuosity in the execution of finicky detail.[23] Sometimes the infill is a pretty piece of inconsequence, but often enough the pattern that fills

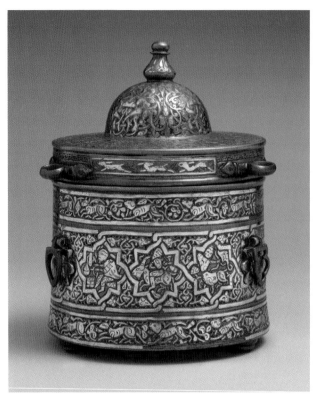

**Figure 3.6** *Inkwell with Zodiac Signs. Early thirteenth century, attributed to Iran. Brass; cast, inlaid with silver, copper, and black compound. The Metropolitan Museum of Art, Harris Brisbane Dick Fund, 1959, 59.69.2a, b. Source: Courtesy of The Metropolitan Museum of Art*

a given space is excerpted from a much larger design of remarkable complexity and sophistication. Figural art, whether found on cartouches or panels, or spread out across horizontal bands, takes on a much more important role and evokes a world of courtly pursuits – hunting, music-making, acrobatic displays, dancing, board games and scenes of combat.[24] And spatial factors are often at play, too. Even on a flat surface, as in a Qur'an leaf datable to *circa* 1176,[25] the artist can evoke several contrasting planes.

Seventh, a zest for innovation and fascination with technical experiments complements the drive for consolidation, for patiently fashioning, by trial and error, the optimum form for a given function. This urge to experiment typically expresses itself in multiple variations on a given theme, and that in turn enriches the art form in question, giving it extra depth and resonance. Thus, the already assured brickwork techniques in play at the Samanid tomb in Bukhara, datable before 943, were developed still further in the Seljuq period. Outset fret and recessed patterns supplemented flush brick ornament, as did bricks whose actual surface was carved. The repertoire was further extended by prefabricated panels affixed to the plain surfaces of a building. The later Kharraqan tomb of 1087 boasts some seventy patterns in brick.[26] When working on the Gunbad-i Surkh in Maragha, dated 1148, I counted thirteen different brick sizes in one of the corner columns, and the addition of bricks of various sizes glazed light blue enlivened and counterpointed the monochrome networks of the tympanum. This period saw the first experiments in Islamic Iran in the use of permanent, all-weather colour in architecture. And this was also the period that saw the first attempts to replicate Chinese seal script, by torturing the

Arabic alphabet into brick shapes.[27] Hence the admiring comment of Lutyens: 'Speak not of Persian brickwork, but of Persian brick magic'. The museum of vaulting techniques in the Friday Mosque of Isfahan tells the same story.[28] Other forms also took classic shape in Seljuq times: the developed zone of transition, which served as the engine room of a domed chamber, and the *muqarnas* or honeycomb vault.[29] The ingredients of the magic are simple: a standard fired brick measuring 24 cm by 24 cm by 5 cm, easy to heft, and strong, quick-setting mortar. The rest is down to the imaginative genius of the mason.

As in architecture, so in other media. The Byzantines knew about inlaid metalwork, as the doors of Haghia Sophia proved, but they had made little of the discovery. Under the Seljuqs, however, it transformed the entire medium, which moved rapidly from humble to precious materials, from a few dominating motifs to a multitude of competing accents, from a single colour to polychrome virtuosity, from a few inscribed words to lengthy girdling inscription bands, from mainly royal themes to subject-matter that illustrates daily life, or presents a menagerie of fantastic creatures,[30] or evokes the heavenly bodies. In ceramics, the invention of a stone-paste or frit body produced lighter and stronger ceramics and greatly extended the repertoire of potters. Indeed, it led eventually not just to lustre and *mina'i* but also to double-shell (Figure 3.7), underglaze painted, *laqabi* and numerous other sub-categories of wares decorated with knife or brush.[31] It also allowed potters to produce passable copies of the distinctive white glaze of Chinese porcelain, with a semi-transparent, perforated, porcellaneous body.[32] Much less work has been done on Seljuq textiles, but the medieval texts assembled by Serjeant make it clear that Iran produced an astonishing variety of expensive textiles at this

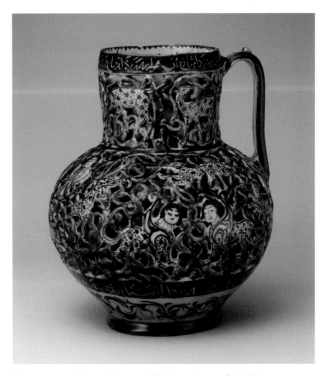

**Figure 3.7** *Pierced jug with Harpies and Sphinxes. 1215–16, attributed to Iran, Kashan. Stone-paste; openwork, underglaze-painted, glazed in transparent turquoise. The Metropolitan Museum of Art, Fletcher Fund, 1932, 32.52.1. Source: Courtesy of The Metropolitan Museum of Art*

time.[33] The few surviving pieces bear out the literary record and contain many a surprise, such as inscriptions written back to front.

### The Seljuqs of Rum in Anatolia and other Seljuq successor states

Let us turn briefly to the art of the Seljuqs of Rum, which is largely confined to the thirteenth century, and to the art produced by the Zangids, Artuqids and other Seljuq successor states, which is also an important part of the overall picture. Many continuities with the art of the Great Seljuqs are attested, and thus much of the general discussion so far applies to Anatolia with only minor tweaking. But it is only fair to acknowledge some major changes of direction that distinguish the trajectory of Rum Seljuq art and that of the lesser contemporary Anatolian dynasties from the art of the Great Seljuqs. It is worth exploring some of the reasons for this. For a start, virtually all of this art was produced after the disappearance of the Great Seljuqs, so one must expect the further development of ideas that were only embryonic a century earlier. The much more lavish use of colour in architecture, including large fields of technicolour glazed tile mosaic, is an outstanding example of this trend.[34] Moreover, Anatolia in this period is in many ways a component of a much larger Iranian world. But it is a junior partner in size, wealth and population. The principal expression of its art was in architecture, which has become much better known in recent years thanks to a small but very active cohort of younger scholars, Turkish[35] as well as non-Turkish.[36] This architecture, which benefitted from the geographical compactness of the Rum Seljuq state, perhaps responded both to the climate of the Anatolian plateau, which at times is more severe than that of some regions of Iran – hence the relative scarcity of large courtyards – and to different economic circumstances. Thus, the north-south network of caravanserais can be related to the bustling slave trade from southern Russia fostered in the Black Sea ports, with its terminus in the dry dock at Alanya whence ships departed for Egypt carrying slaves destined for the Mamluk armies.[37] The impact of neighbouring Iranian traditions makes itself felt strongly in the twelfth century, and that process accelerated in the wake of the Mongol invasions of the eastern Iranian world, which caused the westward migration of thousands of Iranian refugees. Thus, Konya attests the presence alike of Rumi, a native of Balkh in northern Afghanistan, and of Muhammad al-Tusi, the craftsman who signed a tilework panel in the Sirçali Medrese, who came from the Mashhad area in eastern Iran.[38] Itinerant Sufis were a significant element in Anatolian society and served as conduit for folk traditions and beliefs that offered a popular alternative religious experience to that of orthodox Islam.[39]

The phenomenon of the wandering scholar was as well-established in the Islamic as in the medieval European world – after all, the

Prophet Muhammad himself had reputedly said 'Seek knowledge, even unto China'. It was not only Sufis and scholars who travelled. The signatures of Iranian craftsmen with *nisba*s like Maraghi, Arrani, Marandi and so on are found adorning several buildings of distinctly Iranian flavour in eastern Anatolia,[40] and there is even the signature of a mason from Hisn Kayfa in the Jazira (current Southeastern Turkey) on a palace in Firuzabad in the Deccan.[41] So many kinds of people were on the move. Next, the demography of Seljuq Anatolia also had little in common with that of Iran, for there were large populations of Greek Orthodox, Syriac, Georgian and Armenian Christians.[42] To take a single consequence of this, the prevalence of stone as the favoured building material in Anatolian architecture before 1300, and especially of delicately precise stereotomy – including two-tone masonry, high drums, conical roofs and strategically positioned figural sculpture – may well reflect the presence of other traditions there,[43] notably those of Armenian architecture, in which all these features were commonplace.[44] And the Turkic flavour of much of this figural carving reflects yet another alien presence, namely elements from the Eurasian steppe, including an accompanying undertow of magical and shamanistic beliefs,[45] that are much less pronounced in the eastern Iranian world of the eleventh to thirteenth centuries, despite important exceptions in the Ghaznavid and Qarakhanid spheres.[46] Sometimes this sculpture, which is usually executed on a small scale, is strategically positioned, for example in or beside a portal or in a tympanum, but it is also found much more randomly placed. Sometimes these images invoke good fortune, but tribal totems also occur, as do references to Turkic personal names – many of these are connected with animals or birds. Alongside the religious element expressed in most public buildings and in display Qur'ans, there is a steady focus on the secular, expressed most naturally through the depiction of people and animals. Such images are often found on buildings that served for worship, which suggests that popular or Turkic culture trumped the Islamic orthodoxy proclaimed by the *ulema*.

The demography of Anatolia and the Jazira – so different from that of Iran, although it produced some fascinating cross-cultural masterpieces like the Innsbruck bowl (Figure 3.8)[47] and several Syriac Gospel books[48] – helps to explain why in the thirteenth century this region attests a much smaller output in the portable arts than does the rest of the Iranian world. Nevertheless, it does boast the earliest surviving example of a major illustrated Persian manuscript, the romantic poem entitled *Varqa va Gulshah*.[49] A minor school of metalwork centred at Is'ird has been proposed,[50] obviously operating within the orbit of Mosul, and several schools of pottery, such as that of Samosata.[51] Konya seems to have been the principal centre for luxury ceramics, and *mina'i* tiles with very varied and exquisitely painted courtly themes decorated numerous Seljuq palaces,

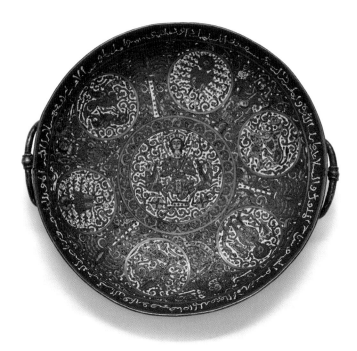

**Figure 3.8** *Plate of Rukn al-Dawla Dawud. First half of the twelfth century, Anatolia or Caucasus. Copper; gilded, cloisonné, champlevé enamel. Tiroler Landesmuseum Ferdinandeum, Innsbruck, K 1036. Source: Courtesy of the Tiroler Landesmuseum Ferdinandeum*

for example at Qubadabad,[52] Kayqubadiya, Aspendos and elsewhere, from 1174 onwards – that being the date of the largely ruined palatial kiosk at Konya.[53]

All this is enough to show that in their art the Seljuqs of Rum were anything but clones of the Great Seljuqs of Iran. But there is more. In Anatolia, royal and official patronage was dispensed on a lavish scale, by sultans, queens, princesses, a quintet of viziers and numerous *amir*s. Dozens of *madrasa*s survive, perhaps a response to the high visibility of Christians in the land,[54] as well as the rapid rate of Islamisation among the Turkish elite.[55] Equally notable are almost a hundred caravanserais strategically located along the most travelled cross-country routes, which underpinned commercial links with Iran, Iraq and Syria and testify to strong state control.[56] Rum Seljuq woodwork – notably *mihrab*s, *minbar*s, doors, window shutters or Qur'an stands (Figure 3.9) – constitute the fullest body of such work in the contemporary Islamic world,[57] while Konya and Divriği have yielded quantities of brightly-coloured animal carpets, the earliest large body of Islamic carpets known.[58]

It is perhaps appropriate to end, not with a summary of the preceding text, but by lifting the curtain to disclose what happened after the Seljuq period. Put briefly, the Mongols came. Under their patron-

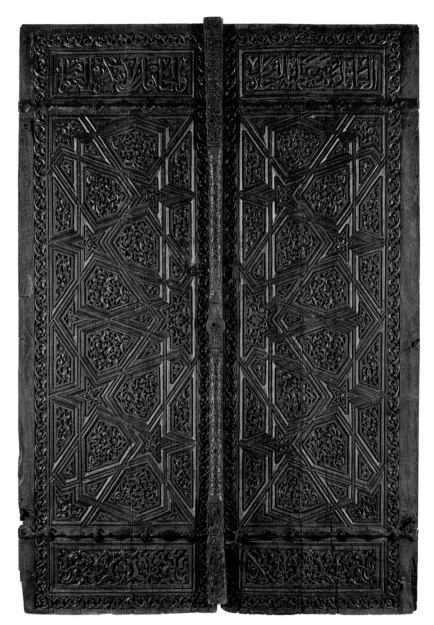

**Figure 3.9** *Window shutters (door?). Late thirteenth century, Anatolia, Konya, probably from the Beyhekim Mosque. Wood (walnut); carved, cast metal appliques. Museum of Islamic Art Doha, WW.56.2003.1.2. Source: Photograph by Samar Kassab, © Museum of Islamic Art Doha*

age architecture displayed an increased zest for colour and sheer size; the illustrated book became perhaps the major art form of the court; and ideas, motifs, techniques and modes from China infiltrated the entire world of the Islamic visual arts east of the Mediterranean – a

quantum leap from the mere flirtation with Chinese art that had distinguished earlier periods. But basic forms in architecture and textiles, pottery and metalwork steadily maintained their currency and long outlasted Mongol hegemony. That, in brief, is the achievement of the Seljuq period: it set the gold standard for many centuries to come.

## Notes

1.  The proceedings of a conference on *The Architecture of the Iranian world, 1000–1250*, held at the University of St Andrews in April 2016, are to be published by Edinburgh University Press (ed. R. Hillenbrand); these papers will give an up-to-date picture on recent work on the architecture of this period.
2.  For the cultural background, see Roux 1982 and Roux 1983, pp. 59–103. For other overviews of Seljuq art, see Fehérvári 1974, p. 1–12; Gray 1994, pp. 1–3 (essentially a series of questions); and the following entries in the *EI2*: Hillenbrand, 'Saldjukids. Persia', cols 959a–964b; Rogers, 'Saldjukids. Anatolia', cols 964a–970b; and Korn, 'Seljuqs vi. Art and Architecture'. For a unique insight into the medieval nomadic Turkic world, see Çağman 2005.
3.  See a series of articles by G. Öney, conveniently tabulated in Creswell 1973, cols 122, 160, 189, 290, 323–24; and Gierlichs 1995.
4.  Karame 2017, vol. 1, pp. 106–90.
5.  Ettinghausen 1943.
6.  Guest and Ettinghausen 1961, pp. 28–9. For the Wade Cup, see Rice 1955, Ettinghausen 1957, and Ettinghausen 1959; for the Sarikhani bowl, see Allan 2011, pp. 54–55; for the Tiflis ewer, see Canby, Beyazit, Rugiadi and Peacock 2016, pp. 153–56; for the Keir bowl, see *ibid*. p. 268.
7.  Bloom 2012.
8.  For the background to this, see Esfanjary 2017, pp. 190–213.
9.  Kühnel 1956.
10. Denike 1939, pp. 51–53 (Termez), and Zeymal 1996, p. 822 (Khulbuk).
11. Hillenbrand 2006.
12. Grohmann 1957; Blair 1998, pp. 80–84; Rice 1955, pp. 23–33.
13. Ghouchani 1986.
14. Blair 1998, pp. 143–94.
15. Ettinghausen 1970.
16. Pope and Ackermann 1964, pl. 770.
17. Schmitz 1994.
18. Stern 1971.
19. Watson 1985, pp. 151–52; Bahrami 1936, pp. 182–85; Bahrami 1937; Bahrami 1949, pp. 116, 119–23.
20. Rugiadi 2010; Flood 2009, figs 120–24, 126–27, 134 and 153; Kalter 1987, pp. 63–64.
21. Holod 2012.
22. Baer 1938b and Carboni 1997.
23. Rice 1955, pls I–II and VII–XI.
24. Ettinghausen 1943.
25. Saint-Laurent 1989.
26. Stronach and Cuyler Young 1966, p. 19.

27. Smith 1936, pp. 323–24.
28. Galdieri 1972–84.
29. Smith 1939, pp. 6–10 and figs 19, 21–22; for the earlier *muqarnas* squinch at Gulpaygan, see Korn 2007, p. 253.
30. Baer 1965.
31. Lane 1947.
32. Schnyder 1994.
33. Serjeant 1972, pp. 40–111.
34. Meinecke 1976.
35. See the studies by Oya Pancaroğlu and Suzan Yalman on the Rum Seljuqs or Mengujekids. On the Artuqids, see Beyazit 2016b.
36. See, for example, the many publications of Scott Redford, and also McClary 2017, Blessing 2014, and Wolpert 2003, as well as important articles by all three of these authors.
37. Vryonis 1971, pp. 240–44; Preiser-Kapeller 2015, pp. 136–44.
38. Meinecke 1976, vol. 2, pp. 260, 271 and 298.
39. Wolpert 2003; Vryonis 1971, pp. 363–402; Peacock 2013a.
40. Meinecke 1976, vol. 1, pp. 12–16, 35–45, 64–67 and 78–81; Pickett 1997, pp. 34–39.
41. Michell and Eaton 1992, p. 34; for a related phenomenon, see Shokoohy 1994.
42. See Shukurov in this volume.
43. Such as those from Georgia; for an example, see McClary 2017, pp. 103–4.
44. Cuneo 1988 and Strzygowski 1918.
45. Roux 1984, pp. 59–98.
46. See note 9 above.
47. Canby, Beyazit, Rugiadi and Peacock 2016, cat. 6; Redford 1990; Steppan 1995.
48. Leroy 1964.
49. Melikian-Chirvani 1970 and Daneshvari 1986.
50. Allan 1978.
51. Öney 1994.
52. For a summary account, with full bibliography, see Meinecke, 'Kubadabad'.
53. Sarre 1936.
54. Cuneo 1988, vol. 2, map in endpapers, records no less than 111 surviving Armenian churches on Turkish soil, and given the wholesale destruction of Armenian monuments in the last 150 years, this is powerful proof of the strength of the Armenian presence in medieval Anatolia. Of course, the full picture also involves the Orthodox, Syriac and Georgian communities.
55. Peacock 2017.
56. Erdmann 1961, and Erdmann and Erdmann 1976.
57. Rogers, 'Saldjukids', cols 967b–968a and 969a–970a.
58. Erdmann 1977.

# PART TWO
# RULERS AND CITIES

CHAPTER FOUR

# Rum Seljuq Caravanserais:
# *Urbs in Rure*

*Scott Redford*

THIS ESSAY TAKES as its subject the caravanserais of the Rum Seljuq sultanate of Anatolia, most of which were built in an extraordinary flurry during the first half of the thirteenth century, when the state was wealthy, but still sought to participate more actively in the commercial boom then encompassing the eastern Mediterranean and Black Sea basins.[1]

Caravanserais were built along trade and travel routes in the countryside in order to provide secure accommodation not only for travellers and merchants, but certainly also pilgrims, soldiers and others, as well as their pack animals, goods, and all else that goes with a caravan. After their construction, their upkeep, salaries, provisions and other expenses were met by an endowment (Arabic *waqf*, modern Turkish *vakıf*) of agricultural and pasture land. While it is self-evident that the considerable expense of building and endowing a caravanserai had as its aim the facilitation of trade and wealth generation for the state, building a caravanserai was also considered an act of piety – good works (Arabic *khayrat*, modern Turkish *hayrat*), as it provided for the well-being of Muslims.[2]

Until the advent of the skyscraper, commercial architecture does not usually feature in studies of architectural and artistic expression. In Islamic as in other art histories, religious and palatial architecture are more often studied and privileged. For reasons that this essay hopes to explore, the Rum Seljuqs – like the Great Seljuqs, their cousins and predecessors in Iran and Central Asia – transformed what were utilitarian structures in other Islamic states into often monumental and creative expressions of dynastic accomplishment.[3] Rum Seljuq caravanserais contained many features extraneous to what might seem to be the primary economic motivations for their construction along major routes of trade and communication. And because the portals of caravanserais were the main site of their

architectural decoration and inscription, the latter part of this essay will examine certain of these.

The location, size and ornamentation of many Rum Seljuq caravanserais represent the personal choices of patrons as much as state policy. Indeed, the building and endowing of buildings was an individual (and not a state) act, however much it must have been coordinated by state actors. This realisation leads us to consider a different idea of a state, one with power concentrated in the hands of a tiny ruling elite, where lines between public policy and private benefaction overlapped.

While we only have clues about the state building apparatus that served these elite patrons, an organisation that would have been necessary given the number of buildings built and the standardisation of building plans and design elements, the constituent elements of this apparatus – architects, masons, designers, scribes and others, too – must have been modest in size.[4]

Despite this concentration of wealth and power in the hands of the Rum Seljuq elite – the sultan and royal family, and *amir*s, great and small – subjects of the sultan also built caravanserais. Important to the process of beginning to fathom this relationship between building, commerce and the state is the notion that elite-built caravanserais – large, even massive, and built along main routes between cities – were not built for profit. Caravanserais built in towns (as well as outside cities), also used for the storage of goods and the residence of merchants, but likely smaller, were for-profit and sometimes owned by members of the same ruling elite. Although no urban caravanserais (like rural caravanserais, also called *khan*s)[5] have survived, contemporaneous foundation deeds (Arabic *waqfiyya*) mention the existence of many: it was their rental income that helped support religious, charitable and educational establishments like *madrasa*s and hospitals.[6] The earliest surviving foundation deed from Seljuq Anatolia, dated 1201–2, concerns a *madrasa* in the capital of Konya and mentions a city caravanserai owned by the daughter of a Seljuq *amir*, as well as a caravanserai, in the countryside west of Konya, built not by a member of the ruling elite, but rather by a merchant from Tabriz – a city in northwestern Iran – and resident in Konya.[7]

In addition, three different *waqfiyya*s from the later thirteenth century mention three different urban *khan*s that are not listed as belonging to a particular individual or used for a particular kind of merchandise, but are named after a particular ethnic group: Armenians. Two of these *khan Arman*, Armenian caravanserais (or caravanserais for Armenians), were located in Konya, and one in the north-central Anatolian town of Sivas. The 1280 Gök Medrese *waqfiyya* mentions an Armenian *khan* in Sivas that had thirteen rooms. The 1281 *waqfiyya* of the İnce Minareli Medrese in Konya mentions an Armenian *khan* there that had ten rooms on two stories. And the 1272 *waqfiyya* of Nur al-Din, son of Jaja, men-

tions another one outside Konya's southern Larende Gate, which had sixteen rooms.[8] *Waqfiyyas* mention these buildings because they were revenue-generating parts of Islamic foundations endowed by Muslims. Other, and perhaps most, Armenian caravanserais must have been owned by Christian Armenians themselves, and so are invisible in these documents. In addition to information gleaned from legal documents, there is another piece of evidence concerning the for-profit building of caravanserais: the extraordinary tri-lingual foundation inscription (in Syriac, Armenian and Arabic) of a caravanserai, the Hekim Han in Malatya province, dated 615/1218 and commemorating its construction by a Syriac Christian deacon to provide for his son.[9]

Two principal cities of the Rum Seljuq dynasty were the capital Konya, located at the southwest edge of the central Anatolian plateau, and Kayseri, to its east. It is not surprising, then, to find that the first surviving Seljuq caravanserai dated by inscription (584/1188) is located on the route linking these two cities.[10] The first documented burst of Rum Seljuq caravanserai building, in the second decade of the thirteenth century, demonstrates the sultanate's interest in connecting with trade networks, not between its major cities, but beyond its borders. West of Konya, three caravanserais were built leading *away* from Seljuq realms, towards those controlled by the Laskarid Empire of Nicaea.[11] And, after the Seljuq capture of the Mediterranean port of Antalya, there was a second period of building activity on routes connecting Konya and Antalya, lending credence to larger conceptualisations of the economic role of caravanserais in the interterritorial terrestrial and maritime trade of the time.

In the subsequent two decades, Rum Seljuq caravanserai building paralleled the efflorescence of the sultanate. This period lasted less than fifty years, dwindling after Sultan Gıyaseddin Keyhüsrev II's defeat by the Mongols in 1243. During the time of plenty, the logic of building caravanserais continued to be state-concerned with economic and military goals, with larger caravanserais built at crossroads, and with extensions of caravanserai building from Kayseri north to the Black Sea coast, eastward and southward towards Ayyubid and Artuqid realms, and from Antalya eastward along the Mediterranean coast towards the port of Alanya and beyond it to the territories of the Armenian Kingdom of Cilicia. In addition, caravanserais were also built at Muslim shrines in border regions, in Seyitgazi to the northwest and Eshab-i Kehf to the southeast of the Seljuq realms.[12]

Similar to other forms of building such as mosques and fortifications, caravanserais expressed the hierarchy of the Seljuq elite that built them; this hierarchy – as much as state policy, routes, economic dictates and topography – seems to have informed the choice of caravanserai sites, as well as the size and nature of caravanserais built at these sites. Sultans built the largest caravanserais, in the most prominent locations – several of these are still called Sultan

Han today. Sultanic caravanserais were not only larger, but also had special features: kiosk mosques, *muqarnas* portals, bath houses and quarters for elite accommodation.

Court *amir*s and royal wives also built caravanserais on major routes, but these were smaller and not located at crossroads. Smallest of all were the caravanserais built on lesser-travelled mountain routes, the patrons of which were lesser *amir*s.[13] This hierarchical approach is evident in the reigns of the two sultans Izzeddin Keykavus and Alaeddin Keykubad, which spanned the period from 1210 to 1237. In addition to hierarchy, personal interests seem to have been at work: one can detect clusters of building activity related to patrons, likely reflecting their ties to and land holdings in different parts of the sultanate. For example, the *amir* Mübarizeddin Ertokuş built a caravanserai near Lake Eğirdir in south central Anatolia; he also built a *madrasa* in a nearby town and served as Seljuq governor in Antalya, which was not far away, where he constructed further buildings. The chronicler Ibn Bibi hints that he was from this region, and the architectural evidence seems to corroborate this, leading us to think that Ertokuş may have had land holdings in the areas that he used to endow these buildings.[14]

In building so many caravanserais, the Seljuqs were doubtless interested in encouraging trade: the trade treaties they made with the Venetians and the Lusignans of Cyprus bear textual witness to this.[15] Nonetheless, we know nothing about the state organisation of the caravan trade itself: in fact, scraps of surviving evidence seem to indicate that much, if not all, was in private hands. We have seen evidence for a Tabrizi merchant building a caravanserai west of Konya. Other thirteenth-century foundation documents mention special markets for the products of Turkmen nomads in towns around the central plateau.[16] A thirteenth-century Egyptian historian mentions Turkmen nomads from Anatolia trading horses and mules.[17] Finally, we have seen documents providing evidence of urban caravanserais, some of them connected with Armenians. If we jump several centuries ahead to the fifteenth century and look at the period of the early Ottoman Empire, we see that the silk trade in the early Ottoman capital of Bursa then was largely in the hands of Iranian and Armenian merchants, and that Turkmen nomads provided the beasts of burden for this long-distance trade. In fragmentary form, we may possibly have evidence for similar cooperation in Seljuq Anatolia as early as the twelfth and thirteenth centuries.[18]

How did caravanserais function? Only one endowment deed for a caravanserai survives, that of the Karatay Han. This document mentions, among many other things, cooking meals for travellers, a horse doctor, a pharmacy, a cobbler, cleaning, conducting of Islamic prayers, ministering to the sick, burying the dead and multiple levels of administration. As rich and revealing as they are, endowment deeds for caravanserais or other buildings are prescriptive, reflecting

the founder's ideal as much as proof of actual practice. Two scraps of epigraphic evidence give us precious, and different, information about the actual implementation of caravanserai administration. Carved in similar locations at the entrance to the covered halls of two neighbouring caravanserais in southern Turkey, two brief inscriptions in a thirteenth-century hand name one Abu'l Karam son of Salar as the *katib*, or administrator, of both caravanserais. The reason these inscriptions were carved on the side of the second portal – that is, the portal leading into the stables – seems to be that the front portal, and with it the courtyard that formed the first half of the caravanserai, was never completed. As such, they may provide evidence for a drastically reduced state role in caravanserai building and administration as early as the mid-1240s, soon after the Mongol defeat of the Seljuqs.[19]

The remainder of this essay will examine caravanserais (including the ones just mentioned) that demonstrate visually the break between state traditions of self-representation in the oddly personal way that rule, authority and legitimacy expressed themselves at the time. Its subject is those sultanic caravanserais whose construction was initiated by one sultan and completed by his son and successor. To add to a story that could be presented simply as one of father-son rivalry, the son acceded to the Seljuq throne under dubious circumstances and possessed a character and taste different from his father.

The reign of Rum Seljuq Sultan Alaeddin Keykubad I (r. 1219–37) was a time of centralisation of authority and prosperity. This sultan looked to the architecture of Syria, as his brother and predecessor had done, importing from Syria architects and with them the styles of building there. The Damascene architect Muhammad bin Khawlan, who had earlier worked on the central mosque of Konya, designed the palatial Sultan Han caravanserai west of the town of Aksaray, with its bichrome marble portals, for this sultan in 1229 (Figure 4.1). Despite its many rebuildings, it is still the most ostentatious of all Rum Seljuq caravanserais, and the one that expresses most directly the mainstream Sunni Islamic aspirations (as well as the wealth) of the Rum Seljuq sultanate during the reign of this ruler.

Despite its stylistic and inscriptional proclamations, this Sultan Han is a building peculiar to Anatolia. For one, Syrian caravanserais of the time were neither big nor elaborately decorated. The banded geometric ornament to either side of the *muqarnas*-topped main portal, while rigorously standardised, also betrays the Rum Seljuq interest in displaying patterns derived from the most important Seljuq regalia, the bow and arrow. And the side niches flanking the main entrance display the kind of lavish ornament not found elsewhere – Erdmann called it a simplified imitation of Ibn Khawlan's decoration for the Alaeddin Mosque in Konya; Ögel notes that it is a miniature facade in and of itself (Figure 4.2).[20]

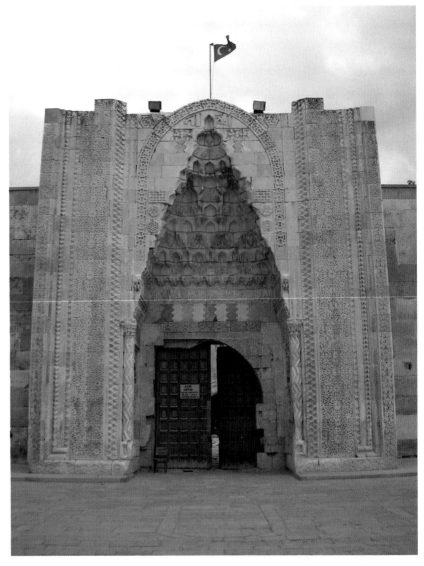

**Figure 4.1** *Entrance portal of the Sultan Han. 1229, Aksaray, Turkey.*
*Source: Photograph by Dominik Tefent, 2007; Wikimedia Commons*

Sultan Alaeddin Keykubad I died in 1237, likely poisoned by a cabal of court *amir*s, one of his wives and their son: it is this last who acceded to the throne as Sultan Gıyaseddin Keyhüsrev II. At the time of his death, Alaeddin had four sultanic caravanserais in the works, with the back hall (or stables) completed, but not the courtyard and entrance portal (caravanserais were built back to front). The new sultan turned two of these, today's Ağzıkara and Zazadin Hans, over to *amir*s for completion, and these more or less continued the style of the hall portals completed under Alaeddin's reign. A third caravan-

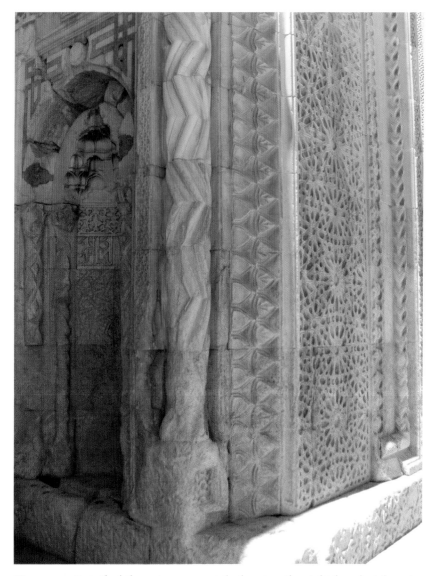

**Figure 4.2** *Detail of the entrance portal, showing the right-hand niche, of the Sultan Han. 1229, Aksaray, Turkey. Source: Photograph by Jose Luis Filpo Cabana, 2012; Wikimedia Commons*

serai, known today as the Karatay Han, was completed in the new sultan's name, only to be usurped by an *amir* named Karatay after his death. In the Karatay Han the remarkable difference between the taste in architectural decoration between father and son can be noted. Most evident is the introduction of human and animal imagery more prominently than before to the front half of the caravanserai: human and animal gargoyles for the rainspouts around the exterior of the building, the carving of a huge pair of knotted confronting dragons

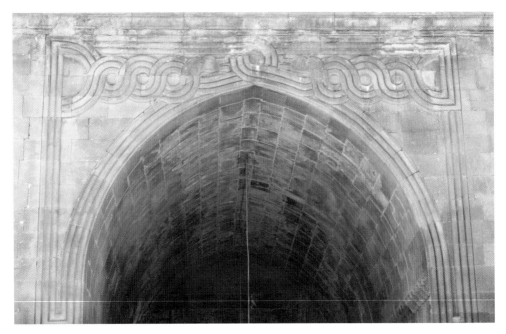

**Figure 4.3** *Courtyard* iwan, *detail showing the carving of knotted confronting dragons above the* iwan *arch, of the Karatay Han. Early thirteenth century, Bünyan district, Kayseri Province, Turkey. Source: Photograph by Christian 1311, 2014; Wikimedia Commons*

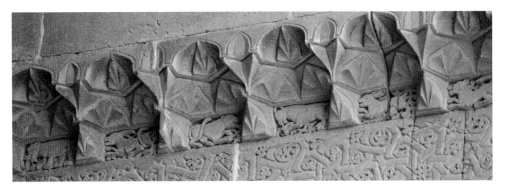

**Figure 4.4** *Frieze around the hall* iwan, *with detail showing an animal frieze, of the Karatay Han. Early thirteenth century, Bünyan district, Kayseri Province, Turkey. Source: Photograph by the author, 2013*

above an *iwan* in the courtyard, and in a playful animal frieze that surmounts another *iwan* just inside the entrance (Figures 4.3, 4.4). Figural decoration is also found on the portal, while the hall portal, built under the father, has none.

The last caravanserai begun by Sultan Alaeddin Keykubad I and completed by his son Sultan Gıyaseddin Keyhüsrev II was the Eğirdir Han, a caravanserai in south central Anatolia, near the shores of Lake

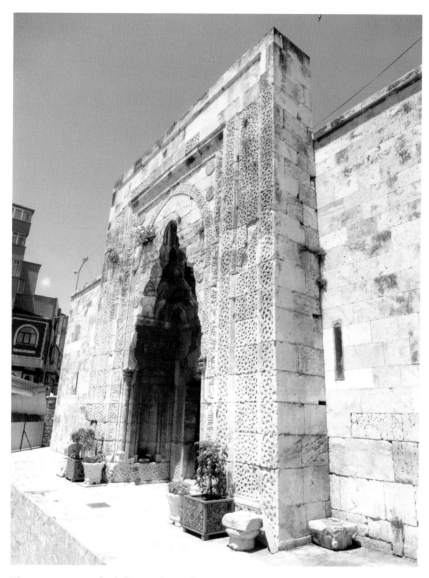

**Figure 4.5**  *Portal of the Taş/Dündar Medrese, lifted from the Eğirdir Han. Early thirteenth century, Eğirdir, Turkey. Source: Photograph by the author, 2016*

Eğirdir. Today, the Eğirdir Han is in ruin. In fact, its spoliation began as early as the beginning of the fourteenth century, when its main portal was removed and transported to the town of Eğirdir, where it was reassembled and repurposed as the portal for another building, the Taş or Dündar Bey Medrese (1301; Figures 4.5, 4.6).[21] This trans-planted caravanserai façade is largely complete.[22] It resembles those of other caravanserais built for Alaeddin Keykubad, denoting a style or set of conventions that either reflect Alaeddin's personal taste, or

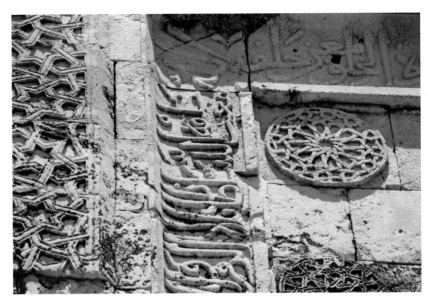

**Figure 4.6** *Detail of the upper left corner showing the inscription on the portal of the Taş/Dündar Medrese, lifted from the Eğirdir Han. Early thirteenth century, Eğirdir, Turkey. Source: Photograph by the author, 2016*

part of the standardisation of architecture and architectural decorative production mentioned above. Despite conforming to the more sober norms of caravanserai portals built under Alaeddin Keykubad, the inscription of this caravanserai portal belongs to his son and successor Gıyaseddin II. This inscription is peculiar, in both placement and content. It is dated 635/1237–38, soon after the accession of the new sultan. It is also very long and awkwardly located within a curved moulding surrounding the portal, a space that was certainly not originally intended for inscriptional purposes. Figure 4.6 shows how gauchely this inscription turns one corner. The long narrow space chosen for the new sultan's inscription demanded something much longer than customary for foundation inscriptions. The resultant inscription, the most prolix such text from Seljuq Anatolia, contains many titles, some invented, some part of the Rum Seljuq inscriptional repertoire, and one of the two longest genealogies in the Rum Seljuq inscriptional record. However, it is most notable for its bombast and belligerence, betraying a new approach to inscriptional content, surely reflecting the personal preferences of the new sultan and perhaps even the circumstances of his accession to power, making it worthy of translation and reproduction here in its entirety:

> The building of this blessed *khan* was ordered by the greatest sultan, the great shah of shahs, master of the napes of nations, lord of the sultans of the Arabs and the non-Arabs, sultan of the

land and the two seas, Dhu'l Qarnayn of the age, master of the
Khusraw of the age, the second Alexander, sultan of the sultans
of the world, he who is supported by heaven, victor over enemies,
glory of the armies of those who profess the unity of God (that is,
Muslims), slayer of infidels and polytheists, crusher of heretics
and dissidents, extirpator of rebels and tyrants, pillar of truth,
implement of morals, succor of the deputy of God (the Caliph),
supporter of the deputy of God (the Caliph), sultan of the lands of
Rum, Armenia, Syria, Diyar Bakr, and the Franks, crown of the
house of Seljuq, Ghiyath al-Dunya wa'd-Din, Father of Victory,
Khusraw son of Kayqubadh son of the happy sultan Qilij Arslan
son of Mas'ud son of Qilij Arslan, partner of the Commander of
the Faithful (the Caliph), may God perpetuate his kingdom to the
east of the world and its west, in the year 635 (1237–38).[23]

The new sultan's style continued to be expressed in overblown
and newly minted titles (like those comparing him to Alexander
the Great) that deviated from those of his father. What interests
the art historian even more, as in the Karatay Han, is the licence
that the new sultan's patronage seems to have given the design of
caravanserai portals: once again an expression of the personal nature
of sovereignty, and the use of caravanserai portals as a major locus
of its manifestation. The two caravanserais portals I would like to
examine briefly here are the same two bearing the ancillary inscrip-
tion of their administrator, who was mentioned above. Neither
seems to have been completed, and neither has a surviving courtyard
and courtyard facade, but the vaulted back halls of both were con-
structed, albeit with very different portals.

The first caravanserai is the İncir Han, the first sultanic com-
mission of Sultan Gıyaseddin Keyhüsrev II, dated by inscription to
636/1238–39, just one year after the date of the inscription on the
portal of the Eğirdir caravanserai. Due to the İncir Han's physical
proximity to Eğirdir and the closeness of these dates, it is possible to
think that certain members of the team of builders working on the
Eğirdir caravanserai moved to the İncir Han; indeed, there are some
resemblances between the two portals.[24] However, the İncir Han's
is like no other Rum Seljuq caravanserai portal, with an inscription
that is large in size, although not as long as that at Eğirdir (and repro-
ducing some of the new titles found there, such as the ones referring
to Alexander) taking the place of *muqarnas* vaulting, which we have
seen as a previously reliable indicator of the sultanic status of cara-
vanserais. In addition, there is a new, personalised configuration of
Seljuq regalia, with two prominent bosses displaying the astrological
sign Leo, one used on the coins of Sultan Gıyaseddin II and likely his
personal sign of sovereignty.[25] Most innovatively, a scalloped barrel
vault, the elements of which form the outline of a series of bows,
surmounts and surrounds the inscription (Figure 4.7).

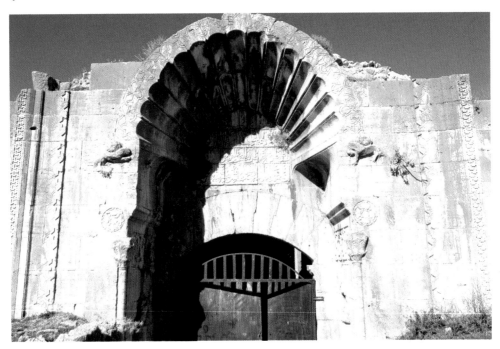

**Figure 4.7** *General view of the portal, showing the scalloped barrel-vault, foundation inscription and carved reliefs of lion and sun and quatrefoils to either side, at the İncir Han. 636/1238–39, Burdur Province, Turkey. Source: Photograph by the author, 2011*

The second caravanserai, the Susuz Han, is only 20 km south of the İncir Han. It has a more traditional portal, with a *muqarnas* hood flanked by bands of geometric ornament, the reticulated patterns scattered with animal and human representations. The portal's two side niches, however, are the most unusual. They consist of miniature versions of a portal, one that, unlike those at the Sultan Han, do not imitate an actual building. These identical niche 'portals' combine winged figures and dragons topping and framing a niche. Two angels flank a round element, now defaced (left niche) and missing (right niche), which may have been a personified moon or sun figure. The angels hover above confronted dragons attacking a human head. The dragons' long bodies rise directly out of acanthus colonettes below them. They contort not into a pretzel knot, representing eclipse, as was more common at the time, but into what I have interpreted as bow patterns. With the capitals representing the tree of life and the earth from which it springs, the dragon a chthonic as well as celestial beast, and the bow, the ultimate symbol of rule for the Seljuks and other medieval Muslim monarchs in the Seljuq era, these dragons combine sultanic and cosmic sovereignty, fitting into an unconventional cosmic conceit, with the earth below and the heavens above. This is in keeping with both the innovation and grandiosity of the new sultan's patronage (Figure 4.8).[26]

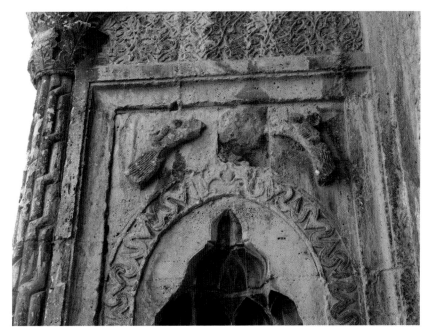

**Figure 4.8** *Detail of the portal's left-hand side niche showing flying angels above confronted dragons, at the Susuz Han. Early thirteenth century, Burdur Province, Turkey. Source: Photograph courtesy of Benni Claasz Coockson, 2007*

History was not kind to Sultan Gıyaseddin Keyhüsrev II: he was defeated by the Mongols in 1243 and died three years later. After this defeat, the Rum Seljuq state, vassal to the Mongols, began its long, slow dissolution. Beside the two caravanserais mentioned here, three others built in this same region are attributed to the last years of his reign, in large part because they are plain and have facades with no decoration at all, likely due to the disruptions visited on the Seljuq building apparatus after this defeat. After the sultan's death in 1246, the established hierarchy of Rum Seljuq architectural patronage seems to break down further. In the subsequent decade, sultanic caravanserais were either arrogated by ruling *amir*s, as was the case of the Karatay Han, or imitated by powerful *amir*s like Sahib Ata and Muineddin Pervane, who were carving out their own spheres of influence within formerly united lands of the sultanate and who used the building of Sultan Han-like caravanserais as ways to express their own ambitions. Caravanserais continue to serve as much more than wayside inns: after a few decades as totems of wealth and prosperity of a more-or-less unitary state, they came to represent the interests of rivals for power in a weakened vassal principality.

*Urbs in Rure* means 'The City in the Countryside'. In some ways, this contrast of monumental building and a natural setting (as we still sometimes see in the Turkish landscape today) is deceiving,

as soon after their construction caravanserais gave rise to settlements, providing all manners of goods and services for travellers.[27] Nonetheless, it is striking that in the first half of the thirteenth century the Rum Seljuq ruling elite elevated the caravanserai to the position of what can only be considered the major architectural expression of the state. Certainly, the sultanic caravanserais are larger and more impressive than any Seljuq palace that we know, and most mosques as well. Why would this be the case? The parallels between thirteenth-century stone caravanserais in Anatolia and eleventh-to-twelfth-century brick and mudbrick caravanserais in Iran and Turkmenistan raise one possibility: the relationship between the state and its most unruly subjects, who also represented its greatest military ally and potential foe – that is, Turkmen and other nomadic groups. Indeed, one way to look at the choice of Konya – an otherwise unremarkable, formerly Byzantine provincial city – for the Rum Seljuq capital is its location at the edge of the Anatolian plateau, a principal home of Turkmen nomads. Another explanation for the prominence and splendour of caravanserai building, one specific to Anatolia, would have been to extend control of the state from towns into the countryside at a time when most of the subjects of the sultanate, especially rural ones, must still have been Christian. Quite obviously, these rural populations would not have been able to parse the subtleties of caravanserai inscriptions and changes in portal design schemes, but all concerned – peasant, Muslim and non-Muslim, nomad, farmer, merchant, soldier, *amir* and even sultan – had to enter and exit these impressive structures through one and only one portal, and thereby pass under and by the images, ornaments and inscriptions it carried. These portals carried significance in different ways to all who passed through them.

## Notes

1. Key works for Rum Seljuq caravanserais remain Erdmann 1961, and Erdmann and Erdmann 1976. Much more recent is a collection of essays on prominent Rum Seljuq caravanserais: Acun 2007. Architectural historian Ayşıl Tükel Yavuz has devoted her scholarly career to the study of many aspects of Rum Seljuq caravanserais. Her numerous publications include Yavuz 1996, 1997, 2006 and 2011. The chapter on caravanserais in Hillenbrand 1994b examines the phenomenon of the caravanserai throughout the Islamic world. The insensitive rebuilding (not restoration) of so many caravanserais in Turkey in recent years is a cause for dismay.

2. Despite this, and the presence of mosques in most caravanserais, there are clues to a more ecumenical use of these buildings. The deed of foundation (*waqfiyya*) of the Karatay Han states that its doors are open to anyone, '. . . Muslim or infidel, man or woman, free or slave . . .' The first two lines of the foundation inscription of the Kırkgöz Han near Antalya records that 'The construction of this commissioned, endowed, secure ribat was ordered *for all peoples residing in it, and travellers from*

*it* towards the east of the world and its west' (emphasis added). For this inscription see Redford 2009, p. 353. See Turan 1948, pp. 95–96, for the passage in the *waqfiyya* of the Karatay caravanserai translated above.

3. For a brief overview of medieval Islamic caravanserais in Iran, Afghanistan and Turkmenistan, see Hillenbrand 1994b, pp. 338–46. A recent archeological survey has documented very large Seljuq caravanserais between the oasis city of Merv and the Amu Darya/Oxus river in Turkmenistan. Because they were built of mudbrick and have never been excavated, they do not provide the information that better-preserved Rum Seljuq caravanserais built in stone do. See Wordsworth 2016.

4. See Redford 2009 for a review of the place of the production of foundation inscriptions and therefore scribes in the Rum Seljuq elite, as well as the relationship between foundation deeds and foundation inscriptions. The problem of architectural workshops and their production exceeds the modest word limit and scope of this essay.

5. The word *karvansara* is used in contemporaneous Persian language texts but building inscriptions in the main name them using the Persian *khan*, or occasionally the Arabic *ribat*.

6. Erdmann 1961, pp. 164–67, identified one possible Seljuq-era urban caravanserai in Kayseri, which he dated to the mid-thirteenth century.

7. Turan 1947. Zümre (Dhimra) Hatun is mentioned twice. She was a goldsmith or a jeweller who owned a *khan* in Konya. Her father was a Christian *amir* named Bar Muni, and she is called *'al-Qunyawiyya'* – that is, from Konya. Al-Haj Bakhtiyar bin Abdallah al-Tabrizi al-Tajir (the merchant), the owner of the caravanserai to the west of Konya, is mentioned on the same page, p. 232.

8. Bayram and Karabacak 1981, pp. 40 and 57; Temir 1989, pp. 31, 44 and 116; Kuçur 2009, pp. 342–43.

9. See Erdmann 1961, pp. 63–67, for the inscription of the Hekim Han in the eponymous town of Hekim Han in Malatya province, southeast Turkey. Since Syriac was the language of the founder and Arabic the inscriptional language of the ruling dynasty, the employment of Armenian here underlines its importance as a regional and commercial language.

10. Baş 2010.

11. Redford 2016a.

12. For Eshab-i Kehf, see Erdmann 1961, pp. 187–88. A Seljuq caravanserai at the base of the hill at Seyitgazi has recently been discovered as part of a disused police station and is currently being excavated by archeologists from Eskişehir Museum. I am grateful to Benni Claasz Coockson for this information.

13. For a recent redating of the Sertavul Han in the Taurus Mountains between the towns of Karaman and Mut, one of these mountain caravanserais, see Redford 2016b.

14. Redford 2018.

15. Turan 1958, pp. 109–46.

16. See Temir 1989, pp. 33 and 36, for the Turkmen references, and Yinanç 1984, p. 303, for the Turkmen market in Ereğli.

17. Mamluk historian Ibn 'Abd al-Zahir reports that around the year 1273 (and likely previously), Armenians attacked a caravan of Turkmen merchants as they passed through the Anti-Taurus mountains east of Cilicia, driving horses and mules that they were bringing from Anatolia

(*Rum*) to sell to the Mamluks, foes of the Armenians and their Mongol
allies; Ibn Abd al-Zahir 1976, p. 432.

18. İnalcık, 'Harir. ii The Ottoman Empire', mentions that during the
Ottoman Empire, pack animals for caravans were rented from Turkmen
tribes, and a late-fifteenth-century document gives the cost of renting a
horse for the round-trip from Tabriz to Bursa at 400 *akçe*.

19. Redford forthcoming.

20. Erdmann 1961, p. 88; Ögel 1966, p. 17. On the bow and arrow, see
Redford 2005.

21. Doğan 2008, pp. 63–79.

22. Erdmann 1961, pp. 125–26, Doğan 2008, pp. 199–207, Bozer 2007.

23. Expanded and corrected reading by the author based on the inscription
published in Doğan 2008, pp. 199–200. Even though there are many
differences between the two, the repetitive nature of this inscription,
its mixture of titles, and its mistakes call to mind the inscription on a
gilded and enamelled glass plate made for the same sultan. See Bakırer
and Redford 2017. Here, too, the inscription expands to fill the space
allotted it.

24. Erdmann 1961, pp. 108 and 113, notes the originality of the composition
while drawing attention to continuities in some decoration between the
İncir Han, the Susuz Han and the Ağzıkara Han.

25. Önge 2007.

26. Gierlichs 1995, pp. 162–63, with bibliography of earlier studies.

27. Above, we heard about a variety of caravanserai activity as prescribed by
the *waqfiyya* of the Karatay Han caravanserai. Leiser 2017, pp. 220–22,
summarises and analyses two encounters of the famous mystic Jalal
al-Din Rumi with prostitutes in two different amirial caravanserais, as
recounted by Shams al-Din Aflaki, the biographer and grandson of Rumi
in his *Manaqib al-Arifin*.

# PART THREE
# FAITH, RELIGION AND ARCHITECTURE

CHAPTER FIVE

# The Religious History of the Great Seljuq Period[*]

*D. G. Tor*

*For Patricia, always*

THE CONQUEST OF Islamic Central Asia and the Middle East by the Great Seljuq Dynasty (1040–1194) inaugurated fundamental change in the Islamic world, not only in the specific areas over which they ruled. Their advent was accompanied by great destruction and ongoing social, cultural and military tension between the nomadic newcomers and the settled populations they had conquered.[1] It also inaugurated nearly a millennium of alien Turco-Mongol rule over the autochthonous populations of the Middle East and Central Asia.[2] However, the Seljuqs also, for the first time since the caliphal political dissolution of the ninth century, reunited the Islamic heartlands, from the Mediterranean to Central Asia, into one realm. They ruled on a grander scale than had been seen for the previous two hundred years, and, perhaps in consequence, they had grander conceptions of their own authority.[3]

In fact, the Seljuqs posed a challenge to what hitherto had been the classical Islamic political ideal, with its theoretical insistence that all authority flowed from the caliph. Seljuq rulers, from Tughril Beg onwards, instead arrogated to themselves what had been the universal political authority of the caliphs, as seen, for instance, in the Seljuq appropriation of the caliphal title of 'sulṭān'.[4] Seljuq political pretensions in turn gave rise, on the one hand, to ongoing hostility between the Seljuq sultans and the Abbasid caliphs, but, on the other, to new formulations of Islamic political theory during the period under examination, by some of the greatest figures of the Islamic intellectual tradition, such as al-Juwaynī and al-Ghazālī.[5] But it was arguably in the transformation of religious life and practice that the Seljuq period had the longest-lasting effect.

The tenth century had been a seminal period for both Sunni and Shi'ite religious development. Regarding Sunnism, it witnessed the

ongoing process of the formation of what came to be the Sunni *mad-hhabs*, a process largely completed by the latter part of this century; this was accompanied by the beginnings of what subsequently, under the Seljuqs, came to be their characteristic institution: the *madrasa*.[6]

This was a formative period for Imāmī Shi'ism as well: it began with the Lesser Occultation and then, around the time of the Buyid rise to power, the Greater Occultation. It was this absence of the Imam, together with the Buyid tolerance of the open exercise of Shi'ism, that fostered the laying of the intellectual foundations of Imāmī Shi'ism in the classic writings produced during this period in the Buyid lands by figures such as al-Kulaynī (d. 329/940–41); Ibn Babawayhi (923–91); Shaykh al-Mufīd (948–1022); Sharīf al-Murtaḍā (965–1044); and Shaykh al-Ṭūsī (996–1067).[7]

This process of what one might term religious differentiation through *madhhab* formation led in turn to an unusual degree of religious factionalism or *'aṣabiyya/ta'aṣṣub*. But while such factionalism was a constant throughout these years, its nature changed under the Seljuqs. During Buyid times, *fitna* was largely a Sunni-Shi'ite affair (with periodic anti-*dhimmī* riots thrown in for good measure) and seems to have stemmed from Sunni outrage at the Shi'ites' being allowed to practice openly religious rites such as their special call to prayer and public observances of *'āshūrā'*.[8]

That kind of Sunni-Shi'ite friction virtually ceased under the Seljuqs, since public displays of Shi'ism were again suppressed and the Shi'ites were restored to their, in Sunni eyes, proper subordinate place and therefore ceased outraging public sensibilities. In fact, from the very outset of Seljuq rule in Iraq – and presumably in the other lands they ruled as well – the Shi'ite call to prayer of 'Come to the best of works' was banned and the Sunni call 'Prayer is better than sleep' mandated; and we are informed by the chroniclers that '(The Shi'ites) did as they were ordered from fear of the sultanate and its power'.[9]

## *Madrasa* and *madhhab*

With the suppression of the public expression of Shi'ism under the Seljuqs, a different kind of religious *ta'aṣṣub* came to the fore, one based on the fierce, mutually exclusive zeal of the various Sunni *madhhabs*. Nor should this fact surprise us: it was only gradually, over a long period of time, and especially in the face of the Mongol disaster, that Sunnis eventually came to see their own differences as far less significant than they had hitherto considered them to be. The end result of this gradually changing perspective was the modern widespread acceptance of the view that more than one Sunni *madhhab* could be tolerated (however grudgingly).

This was not yet the case, however, in the eleventh century, as can clearly be seen from the Seljuq evidence. In the early days of

the triumph of the *madhhab* and the *madrasa* – indeed, since each *madhhab* claimed it was following the true practice of the Prophet, the idea that the Prophet would or could have espoused more than one religious path did not make logical sense in the theological context of the time.[10] As a result, each *madhhab* viewed itself as the sole true Islam, and intra-Sunni violence was, accordingly, the hallmark of the Seljuq era, with the Seljuqs themselves, and some of their viziers, leading the partisan charge.[11] Government-sponsored *madhhab*-based partisanship culminated in episodes such as the famous case of the Seljuq vizier al-Kundurī, who, to the ritual cursing of the Shi'ites in the mosques of Khurasan, added the Ash'arites for good measure, thus causing the flight of many prominent Shafi'ite clerics from the region.[12] Or, similarly, in the anti-Shāfi'ī inquisition instituted by Sultan Mas'ūd in Rayy around the year 1143, when he imprisoned, tortured and fined the two leading Shāfi'ī clerics, forced them to perform a public recantation of doctrinal views that were not congruent with Ḥanafī doctrine, and made them sign documents to that effect, which were then circulated throughout the Seljuq lands, in tandem with persecutions of Shāfi'īs in many other cities.[13]

Given the role of the sultans and their viziers in the Sunni partisanship of the Seljuq era, it is time to re-examine the question of the Seljuq rulers in Sunnism generally, but especially their fostering and propagation of the institution of the *madrasa*, which was the prime institution associated with Seljuq Sunnism and Sunni partisanship. For many decades now, Makdisi's article debunking the so-called 'Sunni Revival' has held sway in the field.[14] However, he overstated his case.[15] For the Seljuqs did indeed bring a new and militant Sunnism, and a new kind of Sunni *ta'aṣṣub*, to the Middle East; while they did not invent the *madrasa*, it was under their aegis and that of their viziers, that the *madrasa* was disseminated and reached its full flowering and that the *ulema* were subsumed into the ruling establishment.

The Seljuqs saw themselves, in fact, in their self-proclaimed role of Sultan, the universal temporal power, as having inherited that epithet's accompanying duty of the political and military upholding of pure Islam against its enemies – first and foremost the heretical Fatimid caliphate, which had been making such inroads before the Seljuqs' arrival and whose dominion had extended from the Atlantic Ocean to the Syrian desert and the Arabian Holy Cities. It was at least in part in answer to the challenge of the Fatimid establishment of al-Azhar and its *dā'ī* (missionary) programme that the Seljuqs propagated and fostered the *madrasa*.

The *madrasa* is of course, as previously mentioned, the prime institution associated with Seljuq Sunnism and Sunni *ta'aṣṣub*. *Madrasa*s first appeared in the late tenth century, with the crystallisation of the *madhhab* and its concomitant necessity for training in a set curriculum of legal and religious studies. But, as noted by

both Halm and Melchert,[16] 'the earliest examples appear to have been founded by the men who taught in them'; they bore what Halm termed a 'private character',[17] and they were also few and far between. This all changed with the coming of the Seljuqs, who were deeply interested in fostering what the *specula regis* literature terms 'right religion', and also in taming and controlling the *ulema*.[18] The *madrasa* was an ideal tool for such purposes, as noted by Melchert:

> Once a patron had endowed a mosque as a pious foundation (*waqf*), it passed out of his effective control; for example, though it might have been established for a particular teacher of jurisprudence, it was not in the patron's power to appoint a successor to that teacher. By contrast, the patron who founded a *madrasa* might retain, for himself and his heirs, the right to appoint or even dismiss the faculty and staff. The importance to potential founders of such continuing control is illustrated negatively by the rarity of *madrasa*s in lands where Malikite law prevailed, for Malikite law is peculiar in denying such control.[19]

This useful feature, together with the need for an institutional counterpart to the Fatimid al-Azhar and the steady stream of *dāʿīs* it was producing,[20] accounts for the *madrasa*'s new prominence and proliferation under the Seljuqs, to the point where many later Muslim historians were under the mistaken impression that the very institution of the *madrasa* was itself the brainchild of Nizam al-Mulk.

Whereas there are only a handful of pre-Seljuq references to *madrasa*s,[21] Seljuq officials of all kinds, both before and after the famous *madrasa* propagator Nizam al-Mulk, are known to have established such institutions, invariably either Ḥanafī or Shāfiʿī. For instance, the Seljuq *mustawfī* Sharaf al-Mulk Abū Saʿd, when he arrived in Baghdad in Ṣafar of the year 459/January 1067,[22] built and established on behalf of his master Alp Arslan a *madrasa* upon the tomb of Abū Ḥanīfa.[23] Nizam al-Mulk alone is known to have founded Shāfiʿī *madrasa*s in Baghdad, Balkh, Nishapur, Herat, Isfahan, Basra, Marv, Amul and Mosul.[24] The *madrasa*s were partisan institutions *par excellence* and contributed to the inter-*madhhab ʿaṣabiyya* of the later eleventh century. The case noted by Halm of the *raʾīs* of Bayhaq who built separate *madrasa*s for Hanafites, Shafiʿites, Karrāmīs and evidently Zaydīs or Muʿtazilites was most unusual and a rare exception.[25] Far more typical was the partisanship of patrons such as Nizam al-Mulk, who commenced building his Shāfiʿī *madrasa* in Baghdad in 457/1065, and Sharaf al-Dawla Abū Saʿd the Comptroller, who in 459/1067 built his *madrasa*, as previously mentioned, at the shrine of Abū Ḥanīfa for the eponymous *madhhab*.[26]

Indeed, the *madrasa* frequently played a key role in the *madhhab*-based sectarian riots that began to transpire during the Seljuq period.

Two things are noteworthy in this context: first, that the *madhhab* becomes a prime identifier for religious activities and religious figures who are now mentioned in the literary sources with the specific denotation of their *madhhab* and who devote their pious works toward *madhhab*-affiliated ends, rather than general ones. Thus, the obituaries of religious figures are strewn with descriptions indicating the primacy of *madhhab* affiliation: for instance, that of Abū Ya'lā al-Ḥanbalī, of whom it is written upon his death in 458/1066 that 'through him the *madhhab* of Aḥmad became widespread';[27] that of the Imām Abū Bakr Aḥmad b. al-Ḥusayn b. 'Alī al-Bayhaqī, who died the same year and is described as 'an Imām in *ḥadīth* and *fiqh* according to the Shafi'ī *madhhab*';[28] or that of the Qadi of Iraq and Mosul, Abū'l-Ḥusayn al-Simnānī, who died in 467/1073 and was succeeded by his son Abu'l-Ḥasan, both of whom are described as 'extremist Ash'arites (*mughālayn fī madhhab al-Ash'arī*)'.[29] One such *madhhab* partisan, the illustrious Muḥammad b. Abdallah b. al-Husayn al-Nāṣihī, who died in 485/1091, is described as one of the foremost Ḥanafi *fuqahā'* – 'the most praiseworthy of his era among the *aṣḥāb Abī Ḥanīfa*, and the most knowledgeable among them in the *madhhab*'.[30] Among many other positions, including that of Chief Qadi and teacher in 'the Sultan's madrasa', he served as Qadi of Rayy.[31]

In short, one of the critical religious transformations of Seljuq times was that the *madhhab* had become the primary focus of Sunni religious identity; the immediate result of this transformation was the outbreak of *madhhab*-based *ta'aṣṣub*, frequently violent and even lethal.[32] Indeed, major cities suffered greatly from this factionalism: not only Nishapur, which famously self-destructed, but also, for instance, Rayy, the capital of the Western sultanate.[33] As noted by the thirteenth-century geographer Yāqut, who visited the city in 617/1220, before the Mongols had touched it, Rayy had been largely destroyed by, first, *fitna* between Sunnis and Shi'ites and then, after the Sunnis had won, an all-out war between the Ḥanafīs and Shāfi'īs.[34]

### *Madhhab*-based *ta'aṣṣub*

Many prominent figures in the Seljuq ruling class are explicitly accused of *madhhabī ta'aṣṣub*. Tughril Beg's vizier 'Amīd al-Mulk al-Kundurī,[35] for instance, is described as follows:

He was strong in partisanship of the Shāfi'ī *madhhab*, fighting many battles on behalf of al-Shāfi'ī. His partisanship went so far that he asked the sultan to permit the cursing of the Shi'ites upon the minbars of Khurāsān, who allowed this; so he ordered the cursing, and added to them the Ash'arites, but the people of Khurāsān rejected this with disdain, among them the Imām

Abū'l-Qāsim al-Qushayrī, and the Imam Abū'l-Maʿālī al-Juwaynī, and others apart from these two, so that they left Khurāsān (because of this).[36]

It should be noted that, when it comes to *taʿaṣṣub* in this period, one of the worst *madhhab* fanatics was Sultan Alp Arslan himself. Niẓām al-Mulk repeatedly notes in his *Siyāsat-nāme* that he, Nizam al-Mulk, lived in perpetual fear of disfavour or worse, since he himself was a Shāfiʿī whilst the sultan was a Ḥanafī. According to Nizam al-Mulk,

(Alp Arslan) in his own *madhhab* was so strong and firm that frequently upon his tongue there proceeded (the words) 'Alas! If only my vizier were not of the Shāfiʿite *madhhab*!' ... and I for that reason, because he regarded his *madhhab* with such seriousness and firm belief, and held the Shāfiʿite *madhhab* in dishonor – I lived in continual worry and fear of him.[37]

The mortal fear that Nizam al-Mulk expresses in the face of Alp Arslan's bigotry crops up again later in his work. He relates that, when he learned that the ambassador of the Khan of Samarqand was falsely claiming that he, Nizam al-Mulk, was a closet Shiʿite:

I became greatly afflicted at heart from terror of the sultan. I said [to myself]: 'He holds the Shāfiʿite *madhhab* shameful and at every opportunity reproaches me [about it]. If he should in any fashion hear that the [Chigils] describe me as *rāfiḍī*, and [should hear] that this description came before the Khān of Samarqand, he would not grant me protection of my life'.[38]

So frightened was Nizam al-Mulk that, by his own account, he spent 30,000 dinars in hush money to ensure 'that this talk never reached the ear of the sultan'.

Nizam al-Mulk's account of the extremes to which *madhhab*-based prejudice could be taken was apparently well-founded. If we look at the wider society and religious politics of the period, the sharp *madhhabī* partisanship of Seljuq times found expression not merely in the erection of *madrasa*s, but also in deadly violence and mayhem. It is noteworthy in this context that, whereas in the decade prior to the Seljuq conquest of Baghdad (the city for which we have the most detailed information) Sunni-Shiʿite riots were the dominant form of social strife, within months of Tughril Beg's arrival, internecine Sunni conflict reared its head and became, in fact, more prevalent than Sunni-Shiʿite strife.[39] As mentioned previously and as in the case of Alp Arslan, each *madhhab* was convinced that its own way was the sole true Islam as practiced and taught by the Prophet and that all or most others, therefore, were espousing religious error

and required correction. Consequently, intra-Sunni violence was the hallmark of the Seljuq era.[40]

Perhaps the most prominent and characteristic form this violence took is that between two rival *madhhab*s, each vying to assert itself as the sole orthodox Sunni *madhhab*. This type of intra-Sunni violence is, for instance, well-chronicled in Baghdad between the Shafi'ites and Hanbalites. Thus, in 447/1055–56 there was a riot between Shafi'ī and Hanbali *fuqahā'* in Baghdad over their differing prayer practices; their followers joined in, and the *Hanābila* went to mosques in the Barley Gate quarter and prevented the imam from reciting aloud the *Bismillāh*.[41] In 475/1082–83 the followers of the two *madhhab*s were at one another's throats again, after a prominent Shafi'ī shaykh, a preacher in the Nizamiyya *madrasa*, had been labeling the Hanbalites infidels for their theological beliefs, and street battles broke out between his followers and a group of Hanbalites.[42]

At other times, violence was the outcome of contempt rather than rivalry for supremacy. This was invariably the case when it was the turn of the Mu'tazilites to come under attack. In one such instance, in the year 456/1064, the 'preacher of the Mu'tazilite *madhhab*', Abū 'Alī b. al-Walīd, was insulted and abused by a mob 'in order to prevent him from [attending] the prayers in the mosque, and from teaching on behalf of this *madhhab*'. This mob, which is explicitly described as believing in the permissibility of the spilling of the blood of the followers of this *madhhab*, and deeming them infidels, then 'attacked [the preacher] and wounded him'. The outcome of this episode was the cursing of the Mu'tazilites in the Mosque of al-Manṣūr, the main Friday mosque of Baghdad.[43]

Such *madhhab*-based violence was in no way limited to Baghdad. The famous Seljuq-era wars in Nishapur between Hanafis, on the one hand, and Shafi'is, on the other, in which the great Shafi'ī cleric al-Qushayrī played a whole-hearted role, are notorious. Such strife included, during the violent *fitna* of 446/1054, al-Qushayrī's being held in durance vile until rescued by his fellow Shafi'īs through force of arms, in response to which he wrote a treatise, *Shikāyat ahl al-sunna*.[44] In fact, as Halm has noted, the ascendance of the Hanafī faction drove al-Qushayrī from Nishapur, to which he returned only after Nizam al-Mulk's patronage restored the Shafi'ī position there.[45]

Al-Qushayri's son Abū Naṣr was apparently an equally pugnacious Shafi'ī partisan; he came to Baghdad in 469/1077 on his way to Mecca and preached in the Nizamiyya Madrasa, which provoked confrontations with the Hanābila. In the words of one source,

> There occurred because of him fitnas with the Hanābila, because he spoke in favor of the Ash'arite *madhhab* (in the Nizamiyya Madrasa) . . . His followers and partisans were numerous, but nevertheless his Hanbalite opponents, together with their followers,

attacked the Nizamiyya Madrasa market and killed a number of
people . . . and matters became grave between the two parties.[46]

These deadly riots continued into the following year, 470/1078,
when, so the sources state:

> There was . . . a fitna between the people of the Madrasa Market
> and the Tuesday Market (Sūq al-Thulāthā') because of reli-
> gious beliefs, and they plundered one another's neighborhoods.
> Mu'ayyad al-Mulk, son of Nizam al-Mulk, was in a house that was
> part of the madrasa. He sent for the 'Amīd and the prefect, who
> both came with troops, and they beat the people. A group of them
> from both sides were killed, and they dispersed.[47]

Such religious riots also had political consequences; in this case, the
Caliph's vizier was dismissed by Nizam al-Mulk. Moreover, even
after the situation had calmed down, inter-madhhab tension contin-
ued simmering, for full-scale fitna between Hanbalis and Shafi'is in
Baghdad erupted again in 475/1082, after an inflammatory Ash'arite
preacher in the Nizamiyya Madrasa averred that the Ḥanābila
were kuffār.[48]

One lesson to be drawn from the list of participants in these
deadly altercations and riots is the peculiar pervasiveness of the
madhhab-based ta'aṣṣub that was the hallmark of the Seljuq era.
Note that it is not street riffraff, but some of the greatest religious
leaders of their generation who were actively engaged in such strife.
The partisan violence instigated by both al-Qushayrī and his son was
noted above, but the same held true for other major religious figures
as well. Thus, in the year 488/1095, Abū'l-Qāsim al-Juwaynī, the son
of Imām al-Ḥaramayn and leader of the Shafi'is of Nishapur, together
with the Ḥanafī qadi of Nishapur, Muḥammad b. Aḥmad b. Sā'id,[49]
and his constituency, in an exercise in Shafi'i-Ḥanafī community
building, went on a rampage against the Karrāmiyya of that city,
killing a number of them and destroying their madrasas.[50]

## The treatment of dhimmīs in early Seljuq times

Given the bigoted religious context of early Seljuq times, it is perhaps
at least initially counterintuitive that in another important area of
religious history – that is, inter-confessional relations – religious
minorities experienced fewer deadly attacks by Muslims under the
Seljuqs than they did under the Buyids. However, this is probably
due to the same cause that led to the decline in Sunni-Shi'ite street
warfare. One of the ways in which Seljuq Sunnism was most clearly
felt lay in the Seljuqs' by and large making sure, from the moment
they arrived on the scene, that dhimmīs and heretics knew their
assigned, inferior place in the social and political order and remained

submissively and discreetly in it. It is also possible, of course, that the perceived decline in such riots is due not to any empirical change, but merely to the Muslim chroniclers' having lost interest in them when confronted with the far more absorbing spectacle of Sunni inter-*madhhab* violence. Finally, it is also possible that the Muslim religious partisans were so busy attempting to eradicate rival *madhhab*s that they had little time left over for dealing with *dhimmī*s.

In any case, when one compares the reported general level of anti-*dhimmī* riots and violent persecution in Buyid and Seljuq times, the latter period appears far quieter. On the governmental level, the extra-legal oppression of *dhimmī*s by Buyid officials was quite common. Thus, for instance, we read in the obituary of one Buyid official, known as al-Muwaffaq, who died in the year 394/1003, that when he had served as governor of Baghdad under the Buyid ruler Bahā' al-Dawla and knew that he was about to lose power and possibly be mulcted, 'he had seized the Jews, taken from them much money, and then fled to the Baṭīḥa'.[51] Two years later, '(he) became vizier to Bahā' al-Dawla . . .',[52] the exploitation of religious minorities clearly having constituted no impediment to political advancement.

Usually, however, it was not government officials who persecuted *dhimmī* communities, but rather popular mobs. Instances of this include the Sunni slaughter of Christians in Baghdad in the year 403/1012;[53] in 422/1031, it was the turn of the Jews to be killed by a Sunni mob.[54] Sometimes, there was more of a partnership in persecution between Muslim mobs and the Muslim officials responsible for public order, when the latter simply stood by while the former vented their fury on *dhimmī*s. Thus, in 437/1045, when the chief of police arrived at the scene of a particularly fierce Sunni-Shi'ite *fitna*, during which numerous people had been killed, and prevented the Muslims from fighting one another, 'the mob turned upon the Jews, burned down the ancient synagogue and plundered the Jews' houses'.[55] Even the regular army troops engaged in violence against *dhimmī*s. When the Turkish soldiery rioted in Baghdad in 446/1054 demanding their pay, for good measure they also 'rode to the Christian Quarter (*Dār al-Rūm*) and plundered it, and they burnt the churches and the monasteries . . .'[56]

Such examples can be found after the advent of the Seljuqs as well, although they were, as previously noted, far less frequent during this period than outbursts of *madhhab*-based violence, no doubt also due at least in part to better public order in early Seljuq times. Thus, in Āmid in the year 478/1085–86, 'the population of the city agreed to plunder the houses of the Christians' because they had held positions of authority under a recently overthrown set of local rulers, 'and so they wreaked vengeance upon them'.[57] This incident draws our attention to the important point that many of the instances of violence directed against *dhimmī*s in Seljuq times occurred, as did this last one, in response to *dhimmī*s being perceived by Muslims

as having overstepped their assigned lowly position in the divine scheme of the ordering of society: they were perceived – if one may borrow a term from a society of a different place and time, but which also prescribed an inferior legal status for certain categories of people – as being 'uppity'. And, indeed, most of the appearances of *dhimmī*s in the sources of Seljuq times occur not in the context of pogroms, but rather in connection with the more stringent enforcement of the legal disabilities imposed upon them.

The drive for stricter enforcement of the discriminatory practices mandated by Islamic law began already in Buyid times. Thus, at the beginning of the year 429/1038, the members of the Muslim male elite were summoned for the solemn reading of a caliphal rescript. The presence of both the Catholicos of the Nestorian Christians and the Resh Galuta of the Jews was required, and a proclamation regarding the *dhimmī*s was read aloud, stating the following:

> Whereas God, may He be exalted, in His unchanging might and incomparable omnipotence has chosen Islam as *the* religion, sanctioned it, ennobled it, and raised it high . . . (and) humiliated whoever is hostile to it; and has said, may He be exalted: 'And he made the word of the Infidels the lowest; the word of Allah is indeed the Highest, and Allah is mighty and wise'.[58] And He (also) said: 'It is He who sent His Apostle with guidance and the true religion, in order to make it triumph over every (other) religion'.[59] And whereas . . . the *Rāshidūn* Caliphs imposed upon the *ahl al-dhimma* . . . a pact based upon outward signs and lowliness and abasement, and separation from the Muslims in order to enhance the greatness of Islam and its people, but when(ever) neglect befalls this tradition and this dereliction of duty is persisted in, these communities throw off the calls of prudence, and imitate the Muslims in their attire; therefore the Commander of the Faithful saw (fit to) advise all of the *ahl al-dhimma* to modify their external apparel . . .'[60]

Apparently, half a century later under the Seljuqs, matters were perceived as lax in other respects, and so in 478/1085, the Caliph al-Muqtadī issued an order that all Jewish houses higher than the permitted limit be destroyed, their gates near the Friday mosque blocked off, and that the Jews be obligated 'to lower their voices in reading the Bible in their houses, and to show the external signs upon their heads . . .'[61] Two years later, in 480/1087, the caliph issued similar directives for Jews in more distant parts of Iraq.[62] In this case, it is stated explicitly that the initiative to enforce the outer signs of their status as *dhimmī* was successful.

## The acceptance of Sufism into mainstream religious life

Another profound religious transformation that took place under the Seljuqs was their acceptance and integration of Sufism into official religious life. Thus, according to Ibn Munavvar, the brothers Tughril and Chaghri Beg, shortly after the establishment of Seljuq rule, together made a pilgrimage to the great Sufi mystic Abū Saʿīd Abī'l-Khayr Mayhanī, and he, because of his approval of them, supposedly used his mystical powers to bestow dominion upon each of them over their respective territories.[63]

In a similar vein, shortly after Malikshah's death, the Sufi shaykh Aḥmad-i Jām, one of the great Sufi holy men of the period, was, according to the hagiography written by one of his disciples, praying for Sultan Barkyāruq when he was purportedly visited by an angel. The angel ordered him to pray for Sanjar instead, which he promptly did, becoming thereafter Sanjar's spiritual protector, a sort of human guardian angel, depicted as spiritually responsible for the continuation of Seljuq rule.[64] It should be noted, again, that these contacts mark the crowning sign of the acceptance of Sufism; the Seljuqs are the first reported major rulers to have adopted Sufi mystics as their patrons, mascots and associates in court, and whose correspondence with Sufi figures such as Aḥmad-i Jām and al-Ghazālī is preserved.[65]

## The subsumption of the Sunni clerics into the Seljuq state

There is one final transformation in religious life wrought by the coming of the Seljuqs that must be discussed, since it is arguably the most consequential and long-lasting: to wit, the close tying and subsequent subservience of the Sunni *ulema* to the government under the Seljuq rulers, and their incorporation into the court and other official institutions. This was, of course, a major sea-change in the behavior of Sunni clerical leadership, whose founding fathers – men such as Abdallāh b. al-Mubārak, Sufyān al-Thawrī and al-Fuḍayl b. ʿIyāḍ – had been notable for their refusal not only to hold any public office, but also to have any truck whatsoever with rulers and officials, and above all never to accept a penny from them, even for redistribution as alms. Indeed, Ibn al-Mubārak had been unwilling even to meet with the caliph.[66] While over the intervening centuries relations between court and clergy had become less frosty and more cordial, especially under the rule of Sunni Persianate dynasts such as the Saffarids, the Samanids and the Ghaznavids, the clerics still held themselves aloof from the court. We do not read of court clerics, nor of *ulema* serving as viziers, nor of Sufi saints spreading their spiritual protection over rulers.

All of this changed dramatically in Seljuq times, during which some of the most respected and prominent Sunni religious figures endorsed Seljuq rule, took salaries from the Seljuqs and held positions

under them, becoming permanent fixtures in the court. Indeed, this novel tying of the *ulema* to the dynasty is explicitly noted by at least one author of the time:

> The sultans of the House of Seljuq were held in honor because upon the face of the earth, especially the two Iraqs and the land of Khurāsān, the 'ulamā' flourished, and they wrote works of *fiqh* and collected histories and *ḥadīth*, innumerable books on both the clear and the intricate passages of the Qur'ān; and they compiled exegeses and sound histories that made firm and fixed the foundation of religion in (all) hearts, so that the desires of bad religions ceased . . . and every great one from amongst the 'ulamā' was seen by mortals in the arranging (*tartīb*) of the Seljuq dominion, for example Khwāja Imām Fakhr al-Dīn Kūfī, Khwāja Imām Burhān and Abū Faḍl Kirmānī, Khwāja Imām Ḥusām Bukhārī and Muḥammad Manṣūr Sarakhsī . . . And by the blessing of the pen of their *fatwa* . . . and their guarding the subjects on the path of the Sharī'a, the kingdom of the sultans of the House of Seljuq arose.[67]

The Seljuqs, for their part, did their best to cultivate such ties. Thus, upon the Seljuq conquest of Khurasan, one of the very first reported actions of Tughril Beg was to seat himself upon Mas'ūd's throne in Nishapur and to ask for guidance from the local qadi.[68]

Alp Arslan apparently routinely surrounded himself with Sunni men of religion; they are frequently mentioned in the sources as having been present among the sultan's companions and in his retinue. These included the prominent Ḥanafī imams Mushaṭṭab b. Muḥammad al-Farghānī[69] and Abū Naṣr Muḥammad b. 'Abd al-Malik al-Bukhārī al-Ḥanafī, who is described as Alp Arslan's personal 'imam and faqīh', and whom he lugged along on military campaigns.[70] Not only Alp Arslan, but also Malikshah and Sanjar are reported to have brought along Ḥanafī clerics in their entourage when going off to war. Sanjar's cleric, in fact, was Abū Ḥafs 'Umar b. Abd al-'Azīz Ibn Māza al-Bukhārī, one of the foremost shaykhs of the Ḥanafis.[71] But the most effective tool that the Seljuqs wielded for binding the clerics to them was their patronage of the *madrasa*.

The idea of respectable Sunnis accepting salaried positions from rulers was so novel that the Seljuqs, when they and their viziers first began establishing *madrasa*s, sometimes experienced embarrassing scruples on the part of the prominent clerics chosen to man such positions. Thus in the year 459/1066, for instance, when the first *mudarris* of the Nizamiyya Madrasa of Baghdad, Abū Isḥāq al-Shīrāzī, was supposed to deliver his inaugural talk, and the audience was assembled and awaiting him, he failed to appear because, at the eleventh hour, he had been seized by religious compunctions, decided to cleave to traditional Sunni norms, and refused to accept a government-financed post. A stop-gap replacement was hastily

found for him, and it took Nizam al-Mulk several weeks of heavy pressure to convince his original nominee, reluctantly, to backtrack and accept the post.[72]

While it is unsurprising that the Seljuqs should have been anxious to embrace the Sunni clerics, it is rather startling that the clerics should have embraced them; yet, so they did. One can speculate as to the reason – overwhelming fear of Isma'ilism and a realisation that, now that Sunnism had real competition, it needed corresponding resources and backing to succeed; together with the rise of the *madhhab* and inter-*madhhab* rivalry, and the fact that its characteristic vehicle and institution, the *madrasa*, required large-scale funding.

Whatever the cause, the fact is that the Sunni clerics bestowed their blessings upon the Seljuqs and their rule, fraternised with them and gave them their religious sanction. To quote Nizam al-Mulk's grandiloquent statement to his employer during the revolt of Qutlumush in the year 456/1063–64, Alp Arslan had 'an army out of Khurasan which will render you victorious and will not forsake you; and which will cast before you arrows that do not miss. These are the *ulema* and the ascetics . . .'[73] Some of the great Sunni religious leaders who were closely associated with the Seljuq court and held office under them included al-Ghazālī and Imām al-Ḥaramayn al-Juwaynī, both of whom occupied posts at one of the Nizamiyya Madrasas. The latter composed a treatise, at the instigation of Nizam al-Mulk, as a justification of the sultanate and the Seljuqs at the expense of the caliphate.[74] Seljuq sultans from Tughril Beg onward, as noted by Madelung, also 'continued to rely on central Asian Ḥanafī scholars as advisers and envoys in diplomatic missions'.[75]

This process reached its peak under Sanjar, who actually employed *ulema* in the vizierate. In 511/1117–18, for example, he hauled the cleric Shihāb al-Islām 'Abd al-Razzāq al-Ṭūsī 'out of the corner of the *madrasa* in order to appoint him to the vizierate'.[76] Other clerical viziers include 'the *'ālim* Naṣīr al-Dīn Maḥmūd b. al-Muẓaffar b. Abī Tawba al-Khwārizmī', described in his eulogy as having been 'a master of and expert in the jurisprudence of the legal school of Imām Shāfi'ī'.[77]

Towards the end of the Seljuq era, however, the clerics were to pay a high price for their close association with the ruling dynasty: the Seljuqs' political enemies identified the clerics, especially the Ḥanafī clerics, with the Seljuq regime to such a degree that they targeted the *ulema* along with Seljuq government officials. Thus, for instance, after Sanjar's defeat at the battle of Qaṭwān in 1141, the Khwarazmshah seized and imprisoned Abu'l-Faḍl al-Kirmānī, the leader of the Ḥanafites, together with 'a group of the *fuqahā*'', because of their identification with Sanjar's rule.[78] And after the downfall of Sanjar in 1153, when the Oghuz went on their rampage in Khurasan, they classed the *ulema* together with government functionaries and

exterminated them wholesale.[79] In the elegiac words of the sources, 'the (Oghuz) killed them with torture and showed them neither mercy nor compassion . . . Mouths and palates which had . . . been the imparters of the Shariʿa sciences and the source of the founts of wisdom . . . were stuffed with base dirt . . . until they perished'.[80]

## Conclusion

In conclusion, let us summarise the important religious changes brought about during the rule of the Seljuqs, with their aid and abetment: first, the cessation of the Ismāʿīlī inroads and territorial encroachment,[81] and the official championing of Sunni causes and institutions – a championing which, *pace* Makdisi, had been sorely lacking, at least west of Khurasan, since the diminution of the caliphate in the early tenth century. Second, the flowering and propagation of the *madhhab*-based *madrasa* system and, concomitantly, the flourishing of intra-Sunni religious *ʿaṣabiyya*, led to the replacing of Sunni-Shiʿite civil disorders by intra-Sunni *madhhab*-based ones. Third, the strengthening of Sunni superiority in the public sphere, which included both the suppression of the public expression of Shiʿism and a stricter enforcement of the disabilities imposed upon *dhimmī*s, was accompanied by a decrease in the violent persecution of both these groups. Fourth, for the first time, rulers fully accepted and integrated into the mainstream Sufi holy men. Finally, above all, the subsumption of the Sunni *ulema* under the Seljuq administration culminated by Sanjar's time in the complete vitiation of the long-standing Sunni principle of eschewing contact with rulers. It was this last change, fraught with the most significant consequences for the altered relationship, and the abandonment of clerical independence, that was most enduring.

## Notes

* This chapter was originally printed as part of a longer piece in a special thematic issue of *Der Islam* 93 (2016). The author is grateful to Stefan Heidemann, *Der Islam*, and De Gruyter Press for granting permission to reprint. The author is also grateful to Michael Cook and Jürgen Paul for their comments and suggestions.

1. See, for example, al-Ḥusaynī 1984, p. 11; Ibn al-Athīr 1979, vol. 9, pp. 381–88, 457–58, 538, etc.; Ibn al-Jawzī 1992, p. 116; Sibṭ Ibn al-Jawzī 1951, vol. 12, pp. 264, 265–66; the unbridled licence of Tughril Beg's Turkmens in Baghdad in 455/1063, Sibṭ Ibn al-Jawzī 1951, vol. 12, p. 409, and so forth. Probably the best analysis of the ongoing tension between nomad and sedentary, and the delicate balancing act between the two that the Seljuq rulers attempted to perform, can be found in Khazanov 1994, pp. 264–67.

2. A point already made many years ago by, among others, Masson Smith regarding Iran; see Masson Smith 1978, p. 57. In other respects, Turkic customs were adapted to already extant patterns and norms; it was

surely not accidental, for example, that the Turkic steppe custom of division into Eastern and Western realms (on which see Golden 1982, p. 52) followed not only the geographical line of the Great Desert, but also separated the 'Irāqayn and points west from Khurasan and its appendages. The steppe tradition of the bifurcation of the empire, with the eastern part holding primacy, can be traced back to the very first Turkish kaghanate of the Kök Turks in the sixth century; thus, Sinor 1990, pp. 297–98, states that 'from its very inception the Türk empire was to some extent bifocal. The eastern parts . . . had the primacy, if not the supremacy, of the two halves'. This traditional supremacy of the East found expression only when Sanjar became Great Sultan in 1118 and moved the Seljuq capital to Marv.

3.  In the words of Crone 2004, p. 234: 'as conquerors who reunited the Islamic world from Transoxiana to Syria, the Seljuqs were much too powerful to masquerade as governors'. See also Peacock 2015, p. 6: 'The scale of the state the Seljuqs founded dwarfed any earlier Muslim Turkish polity – indeed, in terms of area, it was second only to the Abbasid caliphate at its height and was considerably larger than any of the other contemporary Muslim empires such as the Fatimids in Egypt or the Almoravids in Morocco and Spain'. Furthermore, see Tor 2017. The earliest primary sources reflect this awareness that the Seljuqs constituted something new and different in scale and quality in Islamic rulership; see, for example, Nīshāpūrī 2004, p. 2: 'It is known that among the nation of Islam, after the Ṣaḥāba and Rāshidūn caliphs, and after the (descendants) of the son of the uncle of Muṣṭafā . . . the greatest kings and the most worthy in the governing of creation (were) from among the kings of the House of Saljūq . . .'. Similarly, al-Rāvandī 1365/1945f, p. 65, writing in 1194, perceives the Seljuqs as something exceptional in Islamic history: 'And in the nation of Islam, after the Rāshidūn caliphs, in the realms of Banū'l-'Abbās, there have been no kings greater and more pious than the House of Seljuq'.

4.  For 'sulṭān' as a prerogative of the caliphs and for the Seljuqs' appropriation of the title, see Tor 2013. For Crone 2004, p. 234, Tughril in 449/1058 received the title of sultan 'from the caliph'. Seljuq convictions of a special political destiny were apparently reinforced from the Turkic side as well; see Turan 1955, which, despite its obvious nationalist tendencies, nevertheless does make a valid point, however exaggerated.

5.  On these tensions, see for example Tor 2009; Hanne 2007; Peacock 2015, chapter 3 (pp. 124–55). On the new political theories to which this situation gave rise, see Crone 2004, pp. 243–47 and Hillenbrand 1988.

6.  See Melchert 1997, passim. Algar, 'Iran IX', p. 443, notes that it was in the tenth century that the term Sunnism 'entered general currency as a designation for the majoritarian mode of Islamic belief and practice, in Persia and elsewhere'.

7.  See Halm 2014, pp. 43–58.

8.  See, for example, Ibn al-Athir 1964, s. a. 438/1046–47, 441/1049–50, 443/1051–52, 445/1052–53; 445/1053–54, and so forth.

9.  Ibn al-Athīr 1979, vol. 9, p. 632. Note also how virtually every Sunni quarter in Baghdad banded together when necessary to ensure the suppression of other public Shi'ite observances; see, for instance, in 458/1066 in Ibn al-Jawzī 1992, vol. 16, pp. 94–95.

10. Although some exceptionally broad-minded people were willing to admit the possibility that two were acceptable: 'In all the world, there are two *madhhabs* that are good and hold to the straight path: one is the Ḥanafī, the other the Shāfi'ī, may God have mercy upon the two; all the others consist of hot air, reprehensible innovation, and dubiousness' (Niẓām al-Mulk 1378/1958f, p. 129). However, given that he himself was Shafi'ite and his employer fanatically Hanafite, he could hardly have said anything else.

11. Even the most cursory glance at inter-*madhhab* violence during early Seljuq times demonstrates how anachronistic it is to retroject to these times the later Sunni idea that there is more than one acceptable *madhhab*. In Peacock's words, 'Sunnism was polarised by bitter disputes between adherents of the three law schools (*madhhabs*) of the Islamic east: the Hanbalis, Hanafis and Shafi'is. These madhhabs lent their name not just to factional disputes among the *kātibs* . . . but to bitter rivalries that split communities in virtually every town in the Seljuq domains, frequently erupting into *fitna* (civil disorder)' Peacock 2015, p. 249.

12. In the words of Ibn al-Athīr 1979, vol. 10, p. 33, 'He was extremely partisan (*shadīd al-ta'aṣṣub*) against the Shāfi'ites . . . (to the point that when) he consulted with the sultan regarding the cursing of the *rāfiḍa* upon the pulpits of Khurasan, and the sultan gave him permission for this, (Kundurī not only) ordered the cursing of them, but added to (the Shi'ites) the Ash'arites . . .' In fact, this was what famously led to the flight of the Imām al-Ḥaramayn al-Juwaynī from Khurasan.

13. See Madelung 1988, pp. 34–35; and Ansari 2016.

14. Makdisi 1973, pp. 155–68.

15. See Tor 2011.

16. Halm 1975, pp. 438–39; Melchert, 'Education iv.', p. 183.

17. Halm 1975, p. 439.

18. The sources insist on the Seljuq sultans' 'pure religion and good beliefs' (for instance, Qazvīnī 1944, p. 426), their encouragement of the same, and their 'revival of the signs of religion' (Nīshāpūrī 2004, p. 2). Regarding the Seljuqs' cultivation of unusually close relationships with the 'ulamā', including examples of their stationing at court and appointment to political positions, especially under Sanjar, see for instance Khwāndmīr 1938, p. 189; Kirmānī 1959, pp. 58–59; Dhahabī 1998, vol. 20, p. 97; Bundārī 1889, p. 278.

19. Melchert, 'Education iv.', p. 183. *Pace* Ephrat 2000, pp. 85–86, who downplays the central role of the *madrasa* in Seljuq times, possibly because of her exclusive focus on Ḥanbalites, since the Seljuqs and their officials never patronised this *madhhab*.

20. As noted by Halm 1975, p. 438, at the very outset of his study.

21. Ibid. p. 438.

22. Possibly in connection with the arrival of the sultan's sister, Arslān Khātūn, the caliph's wife, although the two are not explicitly linked in the sources; Ibn al-Athīr 1979, vol. 10, p. 55.

23. Ibid. p. 54.

24. Melchert, 'Education iv.', p. 183, citing Makdisi 1961, p. 44.

25. Halm 1975, p. 443.

26. See, for example, Ibn al-Jawzī 1992, vol. 16, pp. 91, 100, on the construction of these respective institutions.

27. Ibn al-Athīr 1979, vol. 10, p. 52; for a very personal and (unsurprisingly) fulsome eulogy, see Ibn Abī Ya'lā 1997, vol. 2, pp. 166–97; Ibn

al-Jawzī 1992, vol. 16, pp. 98–99, is scarcely less laudatory. Al-Khaṭīb al-Baghdādī n.d., vol. 2, p. 256, states that there was no one among the Ḥanbalites more intelligent than Abī Yaʻlā.

28. Ibn al-Athīr 1979, vol. 10, p. 52; described in similarly *madhhab*-specific terms in Dhahabī 1994, vol. 30, pp. 438–41.

29. Ibn al-Athīr 1979, vol. 10, p. 93. Unfortunately, the obituary by Dhahabī 1994, vol. 31, pp. 192–93) is quite brief and mentions only his Ḥanafī affiliation.

30. Dhahabī 1994, vol. 33, p. 137.

31. Dhahabī 1998, vol. 19, pp. 19–20.

32. Although Bulliet 1972, pp. 38–39, followed by Peacock 2015, p. 267, holds that *madhhab* affiliation was merely a blind or pretext for polit-ically-based factionalism, this theory does not withstand examination: first, because it does not explain why such factionalism was universal throughout the Islamic world, not just in Nishapur, if the root cause was local political factionalism; second, it does not explain why *madhhab*-based *taʻaṣṣub* and violence should have been universally attributed, throughout the Seljuq lands, to religious affiliation where those local Nishapuri political conditions did not exist. Indeed, the reduction of religious *madhhab* identity to putative economic or political factions ignores, without explanation, the plain evidence of all the primary sources, which universally employ religious terminology in reporting such *taʻaṣṣub*. Nor can Bulliet's theory explain why it resulted at least twice in major religious inquisitions or could have inspired the kind of attitude Nizam al-Mulk describes on the part of Alp Arslan. Part of the problem is that Bulliet's analysis seems to reduce the *madhhab*, which was a comprehensive religious path – including preaching, theology, lifestyle, and social and mosque affiliation – to 'the minutiae of legal procedures' (Peacock 2015, p. 267). Above all, the *madhhab* in this period was regarded as the exclusive, sole path to salvation. This is why members of rival *madhhabs* called one another *kuffār*; the *madhhab* was not limited to the narrow, dry-as-dust disputations of clerical legal-ists. For an analysis of factionalism more generally as a 'loyalty of category', see Mottahedeh 2001, pp. 158–67.

33. See Tor 2016, pp. 380–85.

34. Algar, 'Iran IX.', p. 444.

35. On whom see Hillenbrand 2015; this piece, however, does not discuss Kundurī's religious partisanship.

36. Ibn al-Athīr 1979, vol. 10, p. 33. Dhahabī 1994, vol. 30, p. 423, describes him as '*mutaʻaṣṣiban li-madhhabihi*' and a Muʻtazilite. For a political, rather than a religious interpretation of these events, see Bulliet 1972, pp. 71–72.

37. Nizām al-Mulk 1378/1958f, p. 129.

38. Ibid. p. 131.

39. This is not to say that Sunni-Shiʻite strife ceased completely; see, for instance, the riots of 480/1085–86 and 482/1087–88; the fullest account can be found in Ibn al-Jawzī 1992, vol. 16, pp. 270, 281–84; brief mention is made in Ibn al-Athīr 1979, vol. 10, pp. 162, 170. Ibn Kathīr n.d., vol. 12, pp. 148, 149, places the first *fitna* in 481, not 480, as does Sibṭ b. al-Jawzī 1951 vol 13, pp. 192, 194. For a discussion of some of the Sunni-Shiʻite riots in pre-Seljuq times, see Tor 2007, pp. 268–86.

40. Madelung 1985, p. 111, is understating the case, by omitting all mention of actual violence, when he describes eleventh-century Baghdad as 'a

city where most of the important schools of Islamic religious thought were represented by some of their leading minds and opposed each other in active competition'.

41. Ibn al-Athīr 1979, vol. 9, p. 614; Ibn al-Jawzī 1992, vol. 15, p. 347, according to whom there was also a separate, larger Sunni-Shi'ite *fitna* at this time; Ibn Kathīr n. d., vol. 12, p. 73. These examples show that, while Madelung 1985, p. 124, was correct in describing the 'Transoxanian and Turkish Ḥanafism' to which the Seljuqs had converted in the early eleventh century as 'militant and intolerant', such an attitude needs to be viewed in the broader religious context of the times, which show it to have been quite typical; *madhhab*-based *'aṣabiyya* was by no means limited to Turkish Ḥanafites.

42. Ibn al-Athīr 1979, vol. 10, pp. 164–65; Ibn al-Jawzī 1992, vol. 16, pp. 224–25; Sibṭ b. al-Jawzī 1951, vol. 13, p. 142.

43. Ibn al-Jawzī 1992, vol. 16, p. 88, repeated by Ibn Kathīr n. d., vol. 12, pp. 100–1. On the Mosque of al-Manṣūr, see Le Strange 1924, pp. 33–37.

44. *Shikāyat ahl al-sunna bimā nālahum min al-miḥna*; Halm 1971, p. 224 ff. For the pre-Seljuq background of *madhhab* partisan violence in the city, see Bulliet 1972, pp. 30–32.

45. For a thorough overview of Shāfi'ism in Seljuq Nishapur, see Halm 1974, p. 53–66. The same work has very little material on Shāfi'ism in Rayy, mostly in Ash'arite form (pp. 133–37).

46. Ibn al-Athīr 1979, vol. 10, pp. 104–5; according to Ibn al-Jawzī, al-Qushayrī *fils* also insulted the Ḥanbalites in his preaching, labeling them anthropomorphists, and was offering Jews money to convert to Islam; Ibn al-Jawzī 1992, vol. 16, p. 181; similarly Bundārī 1889, p. 52, regarding anthropomorphism. Sibṭ b. al-Jawzī 1951, vol. 13, p. 100, merely accuses al-Qushayrī of 'criticising the Ḥanbalites' from his pulpit. Note that the Anno Domini date conversion by Ephrat 2000, p. 86, is incorrect.

47. Ibn al-Athīr 1979, vol. 10, p. 107; for a Ḥanbalite account see Ibn al-Jawzī 1992, vol. 16, pp. 190–91, and Sibṭ b. al-Jawzī 1951, vol. 13, pp. 109–10; both this *fitna* and the previous year's one have been analysed quite extensively by Makdisi 1963, pp. 350–71; see also Holtzman 2016, pp. 668–75.

49. Ibn al-Athīr 1979; Makdisi 1963, pp. 371–75.

49. See al-Ṣarīfīnī 1414/1993, p. 76.

50. Ibn al-Athīr 1979, vol. 10, p. 251.

51. The great swamps of southern Iraq that frequently served as a refuge for those fleeing from the government; see Le Strange 1924, p. 42.

52. Ibn al-Jawzī 1992, vol. 15, p. 45; Ibn Kathīr n.d., vol. 11, p. 312.

53. Ibn al-Jawzī 1992, vol. 15, p. 92.

54. Ibid. p. 213.

55. Ibid. p. 302.

56. Ibn al-Athīr 1979, vol. 9, p. 597. On Dār al-Rūm as the Christian quarter of Baghdad, see Le Strange 1924, pp. 207–8.

57. Ibn al-Athīr 1979, vol. 10, p. 143.

58. Qur'an 9:40.

59. Qur'an 9:33.

60. Ibn al-Jawzī 1992, vol. 15, p. 264.

61. Ibid. vol. 16, pp. 242–43.

62. The Khurasan road and the Mazyadid territories; Ibn al-Jawzī 1992, vol. 16, p. 270.

63. Ibn Munavvar 1381/1961, vol. 1, p. 156.
64. Ghaznavī 1345/1926f, p. 237.
65. Ghaznavī 1345/1926f, p. 331ff, the *Risāla-yi Samarqandiyya*; al-Ghazālī 1915, pp. 3–5, 6–10.
66. See Tor 2007, pp. 42–59; Athamina 1992.
67. Rāvandī 1365/1945f, pp. 19–20. A similar sentiment can be found in Qazvīnī 1358/1980, pp. 138–39.
68. Bayhaqī n. d., pp. 670–74. The report of these events is translated by Bosworth 1963, pp. 252–57; for a critical discussion, see also Paul 2005, pp. 576–77, who was, however, interested in a very different aspect of these events.
69. Niẓām al-Mulk 1378/1958f, p. 218.
70. Al-Ḥusaynī 1984, p. 49; Bundārī 1889, p. 41.
71. Dhahabī 1998, vol. 20, p. 97; Bundārī 1889; al-Ḥusaynī 1984, p. 95.
72. Ibn al-Athīr 1979, vol. 10, p. 55; Ibn al-Jawzī 1992, vol. 16, pp. 102–3; Sibṭ b. al-Jawzī 1951, vol. 12, pp. 452–53.
73. Ibn al-Athīr 1979, vol. 10, p. 36.
74. See Hallaq 1984, pp. 26–41.
75. Madelung 2002, p. 45.
76. Khwāndmīr 1938, p. 89. Corroborated by Kirmānī 1959, pp. 58–59. See also Klausner 1973, p. 107.
77. Kirmānī 1959, pp. 69–72; Bundārī 1889, p. 268, who lists him under the *nisba* of 'al-Marwazī', mentions only his close relations with the clerics, without, however, noting the fact that he himself was also an *'ālim*.
78. Ibn al-Jawzī 1992, vol. 18, p. 17.
79. Nīshāpūrī 2004, p. 65; Mirkhwānd 1339/1920f, vol. 4, p. 318.
80. Rashīd al-Dīn 1983, vol. 2, p. 244, elaborating on Nīshāpūrī 2004, p. 65.
81. Obviously, the Ismāʿīlī revolt centred on Alamut, while apparently terrifying the Sunnis of the time, was a completely different kind of threat from, for instance, the Fatimid conquest of Southern Syria. Once the Seljuqs arrived on the scene, the threat was transformed from an external one, invasion, to an internal one of sedition.

CHAPTER SIX

# Domes in the Seljuq Architecture of Iran

*Lorenz Korn*

### Domes in Islamic architecture

OVER CENTURIES, AND from early on, the dome has become an iconic element of Islamic architecture, to a degree that domes are used as signifiers of Islamic identity (religious and cultural) in the architectural 'language' of the present. Already with the earliest preserved monumental building in the history of Islam, the Dome of the Rock in Jerusalem (dated 72/692), the dome became a prominent feature in the religious architecture of this new culture, while mosques of the first centuries of Islam used the dome only sparingly, either in small dimensions or as wooden constructions over one bay of a basilical hall, so that the contribution to the appearance of the mosque space was rather limited. For the secular realm, domed halls were built in places of central importance, as written sources inform us about the early caliphal residences in Damascus and Bagdad and as residences of the Umayyad dynasty in Bilad al-Sham demonstrate.[1] However, the 'glorious' period of the dome began when large mausolea, constructed to bury and commemorate people of importance, multiplied during the Fatimid and Seljuq periods in the central Islamic lands.[2] It was also under the Seljuqs in Iran that monumental domes became a crucial element of mosque architecture – an innovation of significant consequence for the later development of mosque architecture.

Much has been written about the dome in Islamic architecture, either in the context of the architecture of a given building, as a stylistic element of a period, or in terms of construction and design.[3] There is no overarching interpretation of the Islamic dome as such – the ways in which domes were used are too varied, the purposes of buildings too different to allow for a concept of interpretation that is at the same time specific in meaning and applicable to all 'Islamic' domes.[4]

Within the Islamic World, Iran can be considered a centre of innovation concerning dome construction and design. A background can be seen in the Sasanian period, with the two palaces at Firuzabad as early outstanding examples, while domes were also built in smaller dimensions in fire temples of the Zoroastrian cult.[5] It is difficult to follow what became of this tradition during the Early Islamic period. Apparently, dome constructions were used in palaces, such as the one built for Abu Muslim in Marv, while religious architecture employed the dome only on a small scale. An example for the latter consists of the Nine-Dome Mosques of which substantial remains have survived in Balkh.[6] Iranian scholars have also devoted much work to exploring the history of design and construction of domes in their country.[7]

## Domes of the Seljuq period

The Seljuq period has been attributed particular importance for the shaping of Iranian architecture.[8] It has been considered original, archaic and full of significant beginnings. One of the reasons for this must be seen in the preservation of monuments, since only a limited number of buildings have survived from the preceding centuries. Besides, many elements that contributed to the appearance of these monuments have been lost, such as wall plaster and colour.

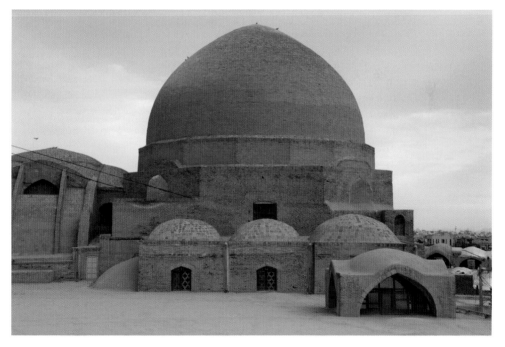

**Figure 6.1** *South Dome, viewed from northwest, of the Great Mosque of Isfahan. Circa 479/1086, Isfahan, Iran. Source: Photograph by the author, 2012, © L. Korn*

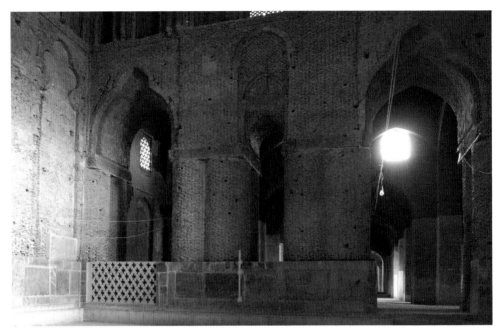

**Figure 6.2** *South Dome, interior lower zone looking west, of the Great Mosque of Isfahan. Circa 479/1086, Isfahan, Iran. Source: Photograph by the author, 2000, © L. Korn*

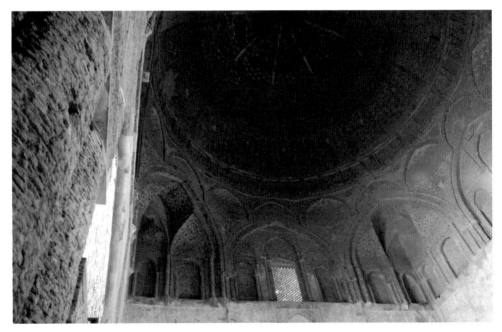

**Figure 6.3** *South Dome, interior zone of transition and vault looking southeast, of the Great Mosque of Isfahan. Circa 479/1086, Isfahan, Iran. Source: Photograph by the author, 2012, © L. Korn*

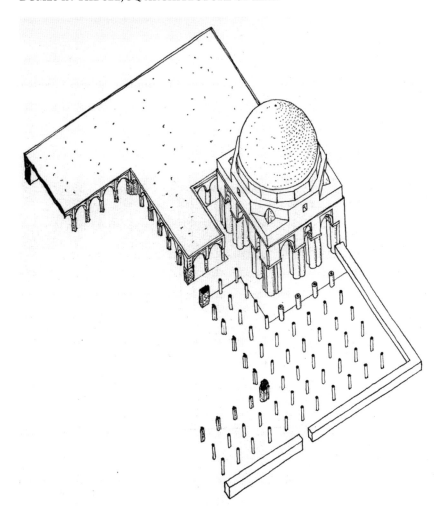

**Figure 6.4** *Schematic reconstruction of the insertion of southern dome hall into the existing prayer hall of the Great Mosque of Isfahan, Isfahan, Iran. Source: After Galdieri 1972–84*

However, it is possible to argue that Islamic architecture in Iran unfolded in a particular manner during the fifth to sixth/eleventh to twelfth centuries. The *madrasa* and forerunners of the Sufi convent, of which none has survived of this period, were established as new functional types, while mausolea and minarets multiplied and began to dominate the silhouette of cities together with mosque domes; brick patterns in combination with stucco were used to decorate surfaces in a previously unknown fashion.[9]

Within the Seljuq period, the Great Mosques of central and western Iran stand out with their impressive dome constructions, preserved in at least a dozen places (Figures 6.1–6). Most of them were inserted into extant mosque buildings of the hypostyle type (Figure 6.4). In

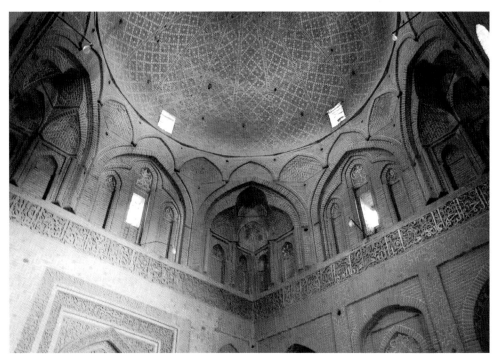

**Figure 6.5** *Interior looking west of the dome hall in the Great Mosque of Ardistan. 553/1158, Ardistan, Iran. Source: Photograph by the author, 2011, © L. Korn*

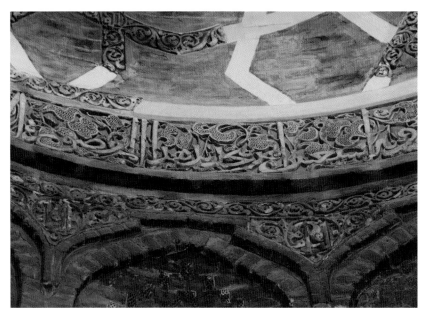

**Figure 6.6** *Stucco inscription at the springing of the dome, southeastern section, in the Great Mosque of Qirva. 575/1179, Qirva, Iran. Source: Photograph by the author, 2013, © L. Korn*

construction and design they can be derived from earlier domes in Iran, whereas the source of inspiration and purpose are still a matter of debate; in other words, the question why mosques received monumental dome halls during the Seljuq period has not been fully answered. The explanation most popular in Iran, according to which this was a revival of the pre-Islamic *chahar taq*,[10] fails to explain why this happened during the Seljuq period and not earlier under the Samanids and Buyids, who were instrumental in reviving Persian culture in the field of literature. It is also not in keeping with some of the architectural features of the mosques. A religious aspect that is almost commonplace should not be overlooked: these domes highlight the most important part of the mosque, the space in front of the *mihrab*, for which there were precedents in other mosques further west, such as Qairawan and Cordoba. At the same time, the dome hall can also be understood as a monumental *maqsura*, the place reserved for the ruler.[11] This coincides with the fact that the re-shaping of mosques during the Seljuq period was not limited to the building of large domes, but also comprised the transformation of the courtyard with four *iwan*s. It has been suggested that these changes can be understood as an introduction of palatial elements to the mosque – royal associations which the mosque acquired independently from the actual presence of rulers in communal prayer.[12] From a brief glance at the religious literature of the time, it appears that a renewed attention to communal prayer lay behind these activities in refurbishing the appearance of Friday mosques.[13] This interpretation offers a better explanation than a one-dimensional view of mosque building as a pro-Sunni statement of Seljuq elites.[14] It should also be remarked that mosque architecture in southern and eastern Iran, where rebuilding and new construction were also frequent during the Seljuq period, was dominated by large *iwan* constructions instead of monumental dome halls.[15] Beyond the function for the building itself, mosque domes, together with minarets, also signaled from afar the presence of the mosque in the city. Thus, they contributed to the religious identity of the community and ultimately helped to create sacred topographies.

A similar function can also be attributed to the domes of mausolea (Figures 6.7–10): They created a visual marker of the spot where an influential person was buried. Different from mosque domes, mausolea were built in all regions of Iran from Khurasan (Marv, Radkan) and the Caspian region in the north (Gunbad-i Qabus) to the southeast (Abarquh, Kirman) and to Azerbaijan (Maragha and Urumiya).[16] The particular character of the mausoleum as a memorial building on a centralised plan (frequently round or octagonal, sometimes square) made dome constructions the natural choice for roofing, although the exterior was frequently designed as a pointed conical or polyhedral hood.

For a more comprehensive understanding of dome building during the Seljuq period, several aspects need to be discussed and various

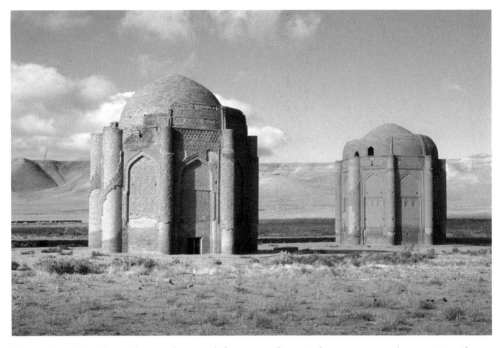

**Figure 6.7** *View from the northeast of the mausolea at Kharraqan. 460/1067–68 and 486/1093–94, Kharraqan, Iran. Source: Photograph by the author, 2000, © L. Korn*

approaches will have to be taken. In the domes of Seljuq Iran, one can detect influences and inspiration from various sources that took effect at different levels. The following remarks, however, will limit themselves to aspects of construction and design.

## Construction and design

Building domes challenges the ability of the architect on several levels, since the stability of a dome depends on various factors, such as span and profile, material of construction, thickness of the shell, and characteristics of supporting elements such as walls and pillars. The first Islamic centuries had seen the triumphal course of baked brick in many monumental buildings in Iran and Central Asia. In this medium, technical improvements were achieved, which made it possible during the Seljuq period to build brick domes with a span of 15 m, which have withstood more than nine centuries of climatic and seismic stress.[17]

### Dome shells and ribs

In most cases, domes were built with a single shell. Ribs were used to strengthen the structure of the vault of the large domes but were integrated with the interior layers of the shell (unlike Gothic vault-

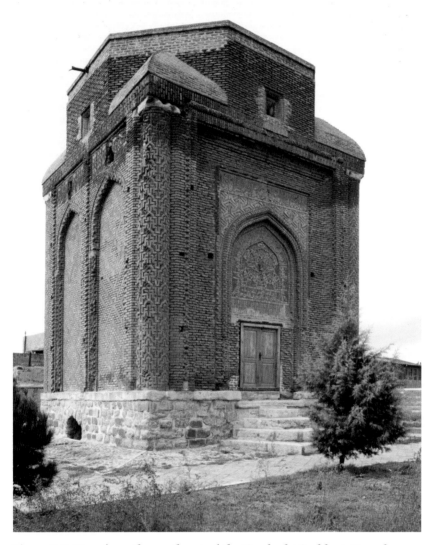

**Figure 6.8** *View from the northeast of the Gunbad-i Surkh at Maragha. 542/1142, Maragha, Iran. Source: Photograph by the author, 2000,* © *L. Korn*

ing technique). In the South Dome of the Great Mosque of Isfahan (*circa* 479/1086; Figure 6.3),[18] Barsiyan (498/1104–5)[19] and Ardistan (553–55/1158–60; Figure 6.5),[20] the ribs form meridian lines that rise vertically from the springing of the dome to its apex. It can be assumed that these vertical ribs were made together with the adjacent (horizontal) brick masonry, as the vaulting proceeded. There were smaller segmented vaults – for example, in the lateral halls of the Great Mosque of Isfahan (*circa* 515/1121 and later) – where it is most likely that ribs were actually constructed first and the

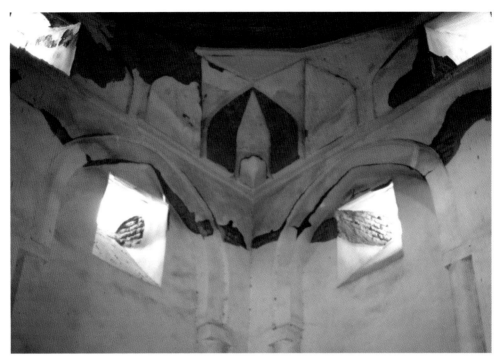

**Figure 6.9** *Interior zone of transition of the Gunbad-i Surkh at Maragha. 542/1142, Maragha, Iran. Source: Photograph by the author, 2000, © L. Korn*

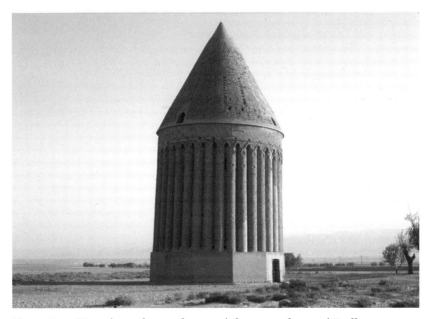

**Figure 6.10** *View from the northwest of the mausoleum of Radkan. 602/1205–6, Radkan, Khurasan, Iran. Source: Photograph by the author, 2000, © L. Korn*

expanses of the vault filled in later.[21] Here, the smaller dimensions allowed the use of wooden centering arches to support the construction while it was under way. However, the ribs in the mausoleum of Sultan Sanjar at Marv (*circa* 550/1150) were obviously additions to the vault, built underneath the inner shell; this can be seen where parts of the ribs have fallen down.[22] This design points to an aspect that has to do more with taste than construction: Apparently, the builder aimed at creating the appearance of structural elements even when they were merely decorative. A parallel can be seen in the use of corner colonettes on walls and pillars, which builders of the Seljuq period used frequently. In other cases, the interior surfaces of domes were enlivened with stepped patterns formed by the brick bonding and underlined with stucco – for instance, in the Masjid-i Gunbad at Sangan-i Pa'in (531/1137)[23] and in the Great Mosque of Zavara (mid-sixth/twelfth century).[24] More intricate patterns of intersecting lines forming stars were created by the brick bonding in the North Dome of the Great Mosque of Isfahan (481/1088–89) and in the Great Mosque of Gulpaygan (508/1114–15).[25] While the eight-pointed star pattern at Gulpaygan relates to the eight arches of the zone of transition below, the pattern at Isfahan is unique in its pentagonal layout. Transferring this design into the three-dimensional vault must have been particularly challenging for the brick masons, even if this pattern is only part of an interior revetment of half-brick thickness that was applied to the shell of the dome as an inner lining.

A significant innovation of the Seljuq period was the double-shell dome. The earliest preserved example seems to be the eastern mausoleum at Kharraqan, dated 460/1067–68 (Figure 6.7).[26] This mausoleum and its sibling, erected 486/1093–94 by the same builder, have two separate shells springing from the same level. Apparently, this design served to achieve harmonious proportions of the building in both interior and exterior. It is hard to imagine that these mausolea in a provincial area should have been the first cases of a double-shell dome. There must have been buildings in other, more central places that set the example for this innovation. Other tomb towers combine the inner dome with an outer conical roof, as can be reconstructed for mausolea in Maragha (Figure 6.8) and still be seen at Radkan in Khurasan (602/1205–6; Figure 6.10).[27] The mausoleum of Sultan Sanjar shows a further refinement in the manner of construction and use of material: Here, the two shells split about halfway up. As an additional measure to relieve the vault, blind arcades are placed in the massive brick masonry of the lower parts. Whether these arcades were actually visible on the outside, as they are presently after the great reconstruction works of the early 2000s, cannot be said with certainty.

For Seljuq mosque domes, no double-shell constructions are attested. The exterior bulbous domes towering over the courtyard and prayer halls, as we see them in Mashhad and Samarqand,

belong to a later period. In the Great Mosque of Isfahan, both of the Seljuq domes achieve their slightly pointed profile (Figure 6.1) with a single-shell construction, and the same is true for the mosque domes that were built during the following decades. At Burujird, the dome of the Great Mosque (c. 533–39/1139–45)[28] received a separate outer shell of steel and brick in the late twentieth century, but this was not envisaged before. The profiles of domes were certainly designed with great care, but probably with relatively simple means of applied geometry, while more exact mathematical methods for the calculation of arched profiles were developed during the ninth/ fifteenth century.[29]

### Zone of transition

The circular dome spanning a room of square plan requires a transition. In pre-Islamic Iran and Central Asia, the preferred solution to this old problem was the squinch, bridging the corner with an arch, whereas Byzantine architects cultivated the pendentive. However, niches in the corners of the square, creating an octagon at the springing of the dome, were also used in the Mediterranean and became part of the early Islamic repertoire (for example, in the Mosque of Qairawan). As the squinch transfers the load of the dome to the springing points of its arch – that is, on eight points of the square – a logical step for the design of the zone of transition was the insertion of another four arches in between, so that the whole dome rests on eight arches. This can be seen in the Mausoleum of the Samanids in Bukhara (first half of the fourth/tenth century).[30] In modified form, the eight arches in the transition zone became as good as standard in all mosque domes of the Seljuq period. There were variations in how the corner arches were filled: the simplest solution were spherical shells (for example, in the Masjid-i Gunbad at Sangan-i Pa'in). A variant current in the Qazvin region were plain squinches with a groin rising from the corner and curving towards the springing of the dome (in the Great Mosque of Qazvin, 500–9/1106–16, and its regional sequels).[31] More elaborate designs evolved from splitting the diagonal niche in the corner into two small quarter-domes which, in turn, support a little vault in between. This tripartite solution can be seen in the Mausoleum of Tim (Uzbekistan, 367/978) and in the Davazdah Imam in Yazd (429/1038); it has been connected with the origin of *muqarnas* (see below). The tripartite designs of the squinches of the Great Mosque of Isfahan (Figure 6.3) demonstrate how this solution was further refined. In the domes of Isfahan and those mosques which were modelled after it (Barsiyan, Ardistan and Zavara), the tripartite design is continued from the corner squinches to the other four arches, under which a central window is flanked by two niches (Figure 6.5). In this way, certain forms continue through all of the eight arches. Another offshoot from the splitting of niche

vaults was *muqarnas*, this architectural element of characteristic shape that uses corbels and niches in superimposed rows. Stucco elements that must have been used as *muqarnas* cells applied to architecture have been found in Nishapur.[32] Wherever *muqarnas* was applied first, its full development is intimately connected with the history of vaulting and domes in Seljuq Iran. A complete dome built of seemingly load-bearing *muqarnas* can be seen in the small mosque of Sin near Isfahan (529/1134–35).[33] As a filler of squinches, *muqarnas* in four superimposed rows was used in the Great Mosque of Gulpaygan. The system of eight arches was altogether abandoned in favour of a continuous *muqarnas* zone in the Great Mosques of Marand and Urumiya, with a close parallel in the mausoleum of Gunbad-i Surkh at Maragha (542/1147–48; Figure 6.9).[34] In sum, architects of the Seljuq period experimented with new forms in the zone of transition in the dome halls of the great mosques, and a geographical division becomes visible between the regional styles of Isfahan, Qazvin and Azarbaijan.[35]

For mausolea the situation was different from that of the mosque domes, since circular or octagonal ground plans were frequently used. This facilitated dome construction without a sophisticated zone of transition. In an octagon, little pendentives in the corners were easy to build. In the case of the mausoleum of Shahzada Husain va-Ibrahim in Isfahan (probably built for Caliph al-Rashid, d. 532/1138),[36] the transition via sixteen blind niches was adopted from mosque domes. For mausolea on a square plan, similar solutions as in mosque domes were applied.

## Walls and plan

Wall thickness and foundations indicate that the builders of the Seljuq domes were already acting on the basis of sound experience, even if no brick domes of such large dimensions as in Isfahan, Qazvin and Marv had been built before. While the walls of tombs were usually not pierced with arcades or windows to any great extent, the dome halls that were constructed in mosques naturally had to offer access not only from the courtyard but also from the sides, where adjacent parts of the prayer hall were located. This made arcaded openings necessary. However, these were kept to a limited size. In the South Dome of the Great Mosque of Isfahan (Figure 6.2), the arched passageways between the massive pillars that form the lateral walls add up to 7.7 m, little more than half the length of the wall (15 m). Similar relations apply to the other mosques' domes. In many cases, the lateral walls of the dome chamber have two arcades each, contrasting with the central arcade on the courtyard side that corresponds to the *mihrab* niche opposite. This creates a clear sense of direction, as a path on the middle axis is opened for the approach to the *mihrab* from the courtyard, whereas the transverse

axis of the dome hall is blocked by a pillar. From the point of view of ritual prayer, this orientation of the room towards the *qibla* appears obvious. It counteracts the centralising tendency that the dome creates together with the square of the ground plan.

## Proportions and elevation

Some authors have published drawings to demonstrate how mosques and mausolea were planned to exact and harmonious proportions, and that the Golden Ratio is, inevitably, at the base of the splendid appearance of some domed buildings.[37] There is no doubt that this is true for the design of the North Dome at Isfahan; here, the Golden Ratio can be found in the elevation of the interior walls, as well as with respect to overall proportioning. In fact, it is not easy to determine to what degree of exactitude domed buildings were planned, and to what degree the builders actually adhered to the calculations. In some buildings, considerable aberrations of up to ten percent can be found in some details, such as the width of niches and the height of minor ledges, but it seems that the tolerance for major elements (for example, height of cornices) was limited to one percent.[38] In any case, all statements about proportions related to height remain uncertain or at least inexact until the original floor levels can be ascertained. On the other hand, is seems clear that careful design and planning of the construction comprised not only the plan, but also the elevation of a domed building. Builders had to estimate the height of their buildings when they laid the foundations of the necessary strength, and they had an idea about the design of the domed room. The interior elevation was derived from the system of arcades in the wall zone and from the height of the zone of transition that was necessary to accommodate the usual eight arches. There was some leeway in the height of pillars and wall segments at the very bottom of the building, but once the first layers of brick were laid and the first springings of arches reached, everything else more or less developed from the system of arcades and squinches that the architect had chosen to apply.

Still, the design of the mosque interiors suggests a strict division into the three distinct zones of wall (with arcades), zone of transition, and the vault of the dome (Figure 6.5). Only in one case – namely, the North Dome in Isfahan – did the architect go so far as to integrate the whole architectural design of the interior and connect the walls with the zone of transition through vertical profiles. There is no other case in which the horizontal divisions between the three zones were de-emphasised in this way.

## Towards an aesthetic of architectural space, construction and surface decoration

The design of domed buildings of the Seljuq period followed certain rules, part of which were applied to make the construction of the dome possible, while other parts were developed from conventions of design and changes of taste. There were significant differences according to the purpose of the building: while tomb towers were lavishly decorated on the exterior, obviously meant to impress the beholder from the outside, mosque domes were largely designed from the interior, with the additional aspect that the dome constituted an important element in the silhouette of the city.

Brick patterns and stucco were applied on those surfaces of buildings intended to be seen from nearby or medium distance. These decorations were envisaged from the beginning and panels prepared to fit.[39] Tile decoration was used sparingly from the mid-twelfth century onwards. Large expanses of turquoise tiles, used to cover the exterior of the dome of sultan Sanjar's mausoleum at Marv, were probably an exception. Brick and stucco elements were correlated and contributed to a unified but lively impression of the architecture – all the more as we have to imagine them painted in several colours (Figure 6.10). Reconstructing the appearance of mosque and mausoleum interiors remains a task for which scientific analyses of pigments are required as a basis.

It can be remarked that the factor of lighting remained largely under-developed during the Seljuq period: Mausolea had only small windows high up in the walls. Dome halls of mosques received daylight through the large arcade opening to the courtyard. In addition, openings at the foot of the dome brought some light in the upper sphere. Large windows in the zone of transition, as in the mausoleum at Sangbast, appeared late and remained exceptional in a climatic region where direct light went along with extreme temperatures.

It can be concluded that the Seljuq period brought new solutions that were prepared long before and needed time to develop. In some mosque domes, windows were also inserted at the foot of the dome shell, which do not always correspond with the principal axes of the dome hall.[40] It has become clear that the design of vaults and particularly the zone of transition during the Seljuq period was not just a story of structural achievements, but also influenced by other factors, such as aesthetic preferences. It is possible to attribute the application of 'unnecessary' niches, *muqarnas* corbels and intersecting arches to an ambition to give the vaulted room a more interesting design. According to the prevailing taste during the Seljuq period, these details would not contradict the structure of the building, but underline some of its given characteristics. More importantly, the shape of the major architectural elements was adapted to form a satisfying whole – be it in regard to arcades

and niches in the wall zone, or the squinches, niches and tympana of the zone of transition. Reaching a certain span and height of a dome and building it in an aesthetically satisfying manner were both challenges for which respective solutions went hand in hand during the Seljuq period in Iran.

## Notes

1. Creswell 1989, pp. 40–90, 304–30; Bloom 1993; Hillenbrand 1994a, pp. 384–409.
2. Leisten 1998.
3. See, for example, Ögel 1972 and Giese-Vögeli 2007. For vernacular methods of construction, see Godard 1949b. For the mausoleum of Sultaniya as an outstanding example of post-Seljuq Iranian dome architecture, see Blair 1992, chapter 4; and the internet site by Marco Brambilla, *Sultaniyya.org*. For iconographic interpretations of ornaments in Iranian domes, see Finster 2007.
4. Grabar 1963.
5. For Sasanian art, see Erdmann 1943; Herrmann 1977; Overlaet 1993.
6. For the mosque in Balkh, see Adle 2015, p. 95–99. For Islamic architecture in Iran of the pre-Seljuq period, see Finster 1994; Anisi 2007. For Central Asia, see Khmelnitskiy 1992 and 1996–97. For the epigraphic material, see Blair 1992.
7. Pirniya 1370/1992; see also the material gathered by Haǧǧī Qāsimī 1383/2004a, 1383/2004a and 1389/2010.
8. Schroeder 1964; Grabar 1968, pp. 629–39; Brandenburg and Brüsehoff 1980; Hillenbrand 1994a, pp. 102–3; Hātim 1389/2010.
9. Korn, 'Saljuqs vi'.
10. Godard 1936a and 1951.
11. As suggested by the inscriptions in the domes of Qazvin and Qirva (Figure 6.6); see Sourdel-Thomine 1974, pp. 23–34; Hillenbrand 1972, p. 68; Grabar 1990, p. 52.
12. Sourdel-Thomine 1970, pp. 112–14; Finster 1994, pp. 168–69.
13. Korn 2018.
14. For the religious politics of Nizam al-Mulk, aiming at establishing an order beyond confessional divisions, see Glassen 1981.
15. For Khurasan, see Godard 1949a; see also the relevant material gathered in Haǧǧī Qāsimī 1383/2004a.
16. Hillenbrand 1974.
17. On dome constructions, see Smith 1947; Godard 1949b; Galdieri 1972–84, vol. 1, pp. 361–79, figs 1–5; vol. 3, pp. 100–8, figs 7–22; Pirniyā 1370/1992; Navāʿi and Haǧǧī Qāsimī 1390/2011, pp. 150–60.
18. Galdieri 1972–84, vol. 3, pp. 100–1, figs 7–9. For the Great Mosque of Isfahan in general, see also Grabar 1990; Genito and Saieidi Anaraki 2011.
19. Smith 1937, esp. p. 21.
20. Godard 1936b, pp. 288–96; Šīrāzī 1359/1980.
21. Galdieri 1972–84, vol. 3, pp. 78–81.
22. Sayan 1999, pp. 91–99; Mamedov 2004.
23. Korn 2010.
24. Godard 1936b, pp. 296–305. The date of 530/1125 that Godard proposed was never substantiated; instead, the reading of 564/1168–69 in the

courtyard inscription (see Ṣāliḥī Kāḫakī 1391/2012) suggests that the dome hall may have been built a few years before this date.

25. Korn, Fuchs et al. 2015.
26. For Kharraqan, see Stronach and Cuyler-Young 1966.
27. Diez 1918, pp. 43–46.
28. Siroux 1947; for the building inscription, see Blair 1994.
29. Dold-Samplonius 1992.
30. Stock 1989, 1990, 1991.
31. For Qazvin see Wilber 1973; Sourdel 1974. On domed mosques related to Qazvin, see Hillenbrand 1972, 1975, and 1976.
32. New York, Metropolitan Museum of Art, Inv. no. 38.40.252.
33. Smith 1939.
34. For Marand, see Siroux 1956; for Maragha, see Godard 1936c.
35. Hillenbrand 1976.
36. Schroeder 1964, p. 1023.
37. Navā'i and Ḥaǧǧī Qāsimī 1390/2011, pp. 115–47.
38. Measured in the photogrammetric interior elevations of the South Dome of the Great Mosque of Isfahan and the dome hall of the mosque in Barsiyan (Archive of the Iranian Cultural Heritage Organization, Isfahan, and Italian State Archive, Rome), as well as AutoCAD sections of the dome halls of the Great Mosque of Burujird, based on a 3D laser scan taken in the Great Mosque of Burujird in 2013 (Korn forthcoming).
39. Korn 2012.
40. Galdieri 2022.

CHAPTER SEVEN

# The Politics of Patronage in Medieval Mosul: Nur al-Din, Badr al-Din and the Question of the Sunni Revival

*Yasser Tabbaa*

## Introduction

MOSUL WAS RULED during the twelfth and first half of the thirteenth century by the Zangids, a Turkish dynasty that drew its legitimacy from its affiliation with the Great Seljuqs, its political alignment with the Abbasid Caliphate and its pursuit of the sectarian policies of the so-called Sunni Revival. In many respects, the Zangid dynasty of Mosul was the quintessential Seljuq successor state, having been founded by the Atabeg Aq Sunqur, after whom it was often referred to as *al-Dawla al-Atabikiyya* (the Atabeg State), and then ruled more-or-less independently by his son 'Imad al-Din Zangi (r. 1127–46) and his successors. Zangi quickly filled the vacuum between the weakened tribal Arab dynasties in the Jazira and the Crusaders in the Levant, becoming the ruler of a substantial region extending from Mosul to Aleppo.

Following Zangi's assassination in 1146, his domain was divided between his two eldest sons, Sayf al-Din Ghazi I and Nur al-Din Mahmud. Ghazi was granted the province of Mosul, and his progeny would rule it until the Mongol invasion, although only nominally during the reign of Badr al-Din Lu'lu' (r. 1233–59). Nur al-Din was given Aleppo, from which he would expand southwards to Damascus in 1154 and eventually Egypt in 1168. Nur al-Din's southward turn and his increasing preoccupation with Fatimid Egypt did not divert him from the affairs of Mosul, for he was directly involved in confirming his nephew's role and reorganising the city's administrative structure. In fact, as I hope to demonstrate, Nur al-Din continued to enjoy considerable influence, verging on outright control, over the entire Zangid domain until his death in 1174.[1]

In spite of their commonalties as post-Seljuq sovereigns, Nur al-Din and Badr al-Din could not have been any more different in terms of their religious policy and architectural patronage. Comparing their

architectural patronage in Mosul reveals considerable differences in the application of these policies, particularly with regard to the Shi'i and Christian communities in the city. Nur al-Din was the ultimate promoter of the Sunni revival, a cause that shaped his purposeful religious policy, his architectural patronage and especially his single-minded determination to counter Shi'ism and end the Isma'ili Fatimid state. Although better known in medieval Europe as an anti-Crusader, it should be emphasised that in the 1160s Nur al-Din sent three expeditions to defeat the Fatimids and none to free Jerusalem, which would fall to Salah al-Din al-Ayyubi in 1187, sixteen years after the end of the Fatimids. In fact, it seems that Nur al-Din's earlier anti-Crusader zeal turned in his later reign into an anti-Shi'i and anti-Christian policy, implemented through the systematic suppression of Shi'ism in Syria and Christianity in northern Syria and the Jazira.

Badr al-Din Lu'lu', on the other hand, was a manumitted Armenian slave who began his career as *atabeg* to young Zangid princes in 1211, before usurping Mosul from them, ruling it from 1233 until his death in 1259.[2] His tolerance of sectarian and religious minorities, specifically Shi'ism and Christianity, extended to his patronage of several Shi'i shrines and the toleration, even support, of the building and restoration of Christian churches and monasteries. Examining the monuments erected by these two patrons in terms of their historical context, architectural features and unusual inscriptions, this essay aims to reassess their quite varied sectarian messages that range from strict adherence to Sunnism to a generous embrace of moderate Shi'ism.

## The patronage of Nur al-Din in Mosul (1170–72)

Nur al-Din's involvement in the affairs of Mosul can be read through the Mosque al-Nuri, built between 1170 and 1172, which was his most important foundation outside Syria. In his exposition of Nur al-Din's meritorious acts, the Syrian historian Abu Shama wrote:

(Nur al-Din's) mosque in Mosul is the ultimate in beauty and excellence. It is especially noteworthy that he entrusted its construction and the supervision of its expenses to Shaykh 'Umar al-Malla, . . . who was a pious man. He was told: 'Such person is not suited for the task'. He replied: 'If I were to assign this task to one of my associates . . . I know that he would oppress some of the time and a mosque cannot be founded on oppression'.[3]

This short anecdote provides interesting insights into the last and most important foundation of the Syrian sovereign, first because the mosque was built in a city on which he exerted considerable influence

but was not directly ruled by him. Although Muslim sovereigns have often restored or added on to monuments outside their domain of authority, their acts of patronage generally focused on a handful of ancient shrines and sites of pilgrimage, including Mecca, Medina and Jerusalem for the Sunnis and the shrines of the Imams for Shi'is. Entire monuments built outside a sovereign's region of control were far less common and nearly always associated with political control rather than pious offering. Second, short of the hapless man as 'Umar al-Malla is often described, he was in fact a Sufi leader of some note and the pole of opposition to the Christians of Mosul, in particular to the Christian vizier Fakhr al-Din 'Abd al-Masih. Third, it seems likely from Nur al-Din's rather hands-off approach to the project that he was more concerned with the intention and message of the mosque than the details of its construction.[4]

Although Nur al-Din began his mosque in 1170, his involvement with Mosul dates back much earlier, to 1146 and 1149, when he twice oversaw the succession of Zangid rule in Mosul. In fact, by the second succession, Nur al-Din was already the elder of the Zangid household, and his name was officially pronounced in the Friday sermon. But it was the third succession after the death of his nephew Qutb al-Din Mawdud in 1170 that witnessed Nur al-Din's deepest intrusion into the politics of Mosul. At the peak of his powers, Nur al-Din would play a decisive role in this succession, going as far as to send a military expedition that threatened to bring Mosul directly under his control if his conditions were not met. Interestingly, these conditions had less to do with the choice of successor and everything with containing the influence of the Christians in Mosul, who were then represented by the vizier Fakhr al-Din 'Abd al-Masih. As Nur al-Din is quoted saying: 'My intention is not the city itself . . . (but) to remove this Christian from governing Muslims'.[5]

To that end, following his successful campaign in al-Jazira and Mosul, Nur al-Din ordered 'Abd al-Masih banished to Aleppo and forced him to convert to Islam, changing his name to 'Abdullah. Nur al-Din would subsequently impose various repressive measures against local Christian communities, including increasing the *jizya* tax, restrictions on the building of Christian structures, the confiscation of monastic endowments and even the outright destruction of churches and monasteries. It is undoubtedly because of these repressive measures that Syriac Christian writers, including Michael the Syrian and Bar Hebraeus, were harshly critical of Nur al-Din.[6]

During his lengthy sojourn in Mosul, Nur al-Din ordered the foundation of a Friday mosque near the centre of the old city, a place that is described by Muslim chroniclers as an empty lot and by Christian writers as the location of the Church of St Paul. The mosque was completed in just under two years, for in 1172 Nur al-Din visited Mosul for the fourth and last time, during which he drew up the substantial endowment of the mosque, appointed its officials and

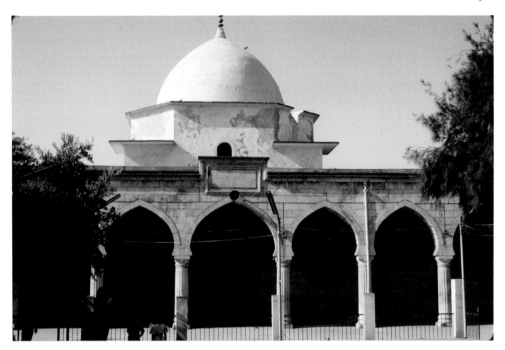

**Figure 7.1** *Sanctuary façade, as rebuilt in 1945, at the Mosque al-Nuri. 1172 and later, Mosul, Iraq. Source: Photograph by the author, 1979*

also founded a *madrasa* next to it, which is perfectly consistent with his patronage of Sunni institutions all over Syria.

Regrettably, the Mosque al-Nuri was entirely rebuilt around 1945 – with completely new arches, vaults and a *maqsura* dome – making its proper study, even during my first visit in 1979, very difficult (Figures 7.1, 7.2).[7] Fortunately, about forty years before this rebuilding Herzfeld attempted a rather hasty documentation of the mosque, producing its current plan and attempting a reconstruction of its original plan and design. Furthermore, in 1979 I came upon an archive of large glass negatives at the Iraqi Institute of Antiquities and Museums that documented the mosque's appearance around the same time (Figure 7.3). Although Herzfeld suggested that the Mosque al-Nuri had been built several decades earlier and that Nur al-Din only restored it, all historical and archeological evidence argues against his chronology and strongly suggests that the entire original structure was built by Nur al-Din between 1170 and 1172.[8]

In short, as I have argued elsewhere, the Mosque al-Nuri in Mosul was founded and completed by Nur al-Din with a broad but shallow sanctuary focused on a large dome (Figure 7.4). Its original support system consisted, as it did until recently, of squat octagonal piers made in sections of the soft blue marble common in Mosul since Assyrian times. The octagonal shaft ended in concave triangular cells that supported a square frieze and a square console inscribed

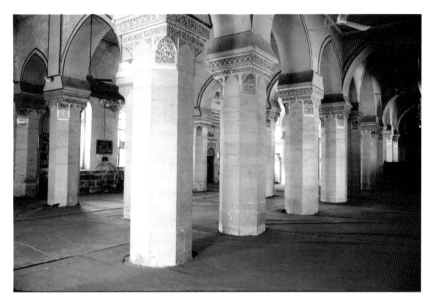

**Figure 7.2** *Interior, as rebuilt in 1945, in the Mosque al-Nuri. 1172 and later, Mosul, Iraq. Source: Photograph by the author, 1979*

on their southern side with continuous and quite legible Qur'anic inscriptions. Such inscribed capitals are very rarely seen in Islamic architecture, and their extensive use in this otherwise poorly built mosque confirms Nur al-Din's strict adherence to basic Islamic principles, Qur'anic scripture and prayer.

Curiously, some of these columns were buttressed by shorter bundled columns with lyre-shaped capitals, a column type that is found in several churches and monasteries in and around Mosul (Figure 7.5). The presence of these rather archaising capitals and especially an exquisite *mihrab*, dated to 1148, threw off Herzfeld's chronology, leading him to propose that the mosque had been built around 1148 by Sayf al-Din Ghazi I and that Nur al-Din's works were little more than the restoration of a pre-existing mosque.[9] But historical and archeological evidence suggests otherwise, for all contemporary sources attribute the building of the mosque to Nur al-Din without mentioning an earlier phase. As for the earlier *mihrab* and the bundled columns, later sources tell us that both were in fact brought to the mosque in the nineteenth century: the *mihrab* most likely from the so-called Umayyad Mosque and the columns from a destroyed church, where such columns are generally found.[10] The misshapen dome seen in old photographs most likely represents two phases, an original hemispherical dome that was later restored with a conical exterior. In short, the Mosque al-Nuri was entirely built by Nur al-Din following a regional Jaziran mosque type that blends the plan of the Great Mosque of Damascus with a Seljuq-style dome.[11]

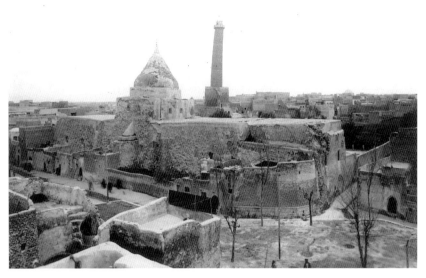

**Figure 7.3a** *Exterior from the southeast of the Mosque al-Nuri. 1172 and later, Mosul, Iraq. Source: Photograph courtesy of the Iraqi Institute of Antiquities and Museums*

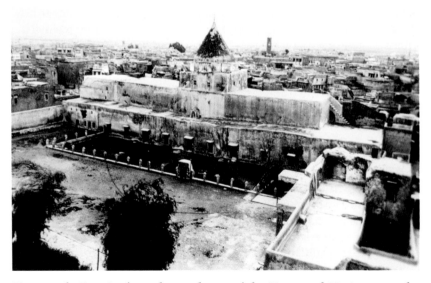

**Figure 7.3b** *Exterior from the northwest of the Mosque al-Nuri. 1172 and later, Mosul, Iraq. Source: Photograph courtesy of the Iraqi Institute of Antiquities and Museums*

The Mosque al-Nuri lacks any historical inscriptions from the time of Nur al-Din but contains numerous Qur'anic and pious inscriptions. These have survived as short friezes on the octagonal capitals, marble bands with inlaid black inscriptions and a large undated stucco panel that is now at the Iraqi Museum. Although

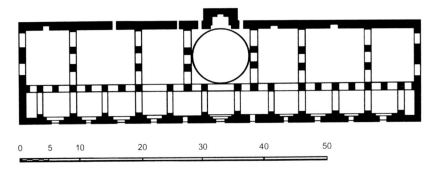

0     5    10              20          30          40          50

**Figure 7.4** *Reconstructed plan of the sanctuary of the Mosque al-Nuri. 1172 and later, Mosul, Iraq. Source: By author*

the Qur'anic excerpts on the capitals are quite commonplace – 2:255 (Throne Verse); 9:18 (on the erection of mosques); and 24:36–37 (also on building houses for God) – their use as continuous friezes on capitals is nearly unique in Islamic architecture. The inlaid friezes, which may have originally flanked the mihrab, contain most of 2:148–50, rather uncommon verses that address the question of the *qibla* (Figure 7.6). As for the large and undated stucco panel that once crowned the *mihrab*, it seems to date to a later restoration, according to Herzfeld by Badr al-Din, although this is by no means certain. The stucco panel focuses on a square Kufic text that reads: 'Muhammad, Abu Bakr, 'Umar, 'Uthman, 'Ali, al-Hasan, al-Husayn, may God be pleased with them all' (Figure 7.7). This encomium, known in some twelfth-century inscriptions, may underline the ecumenical embrace that characterised the period of Badr al-Din.[12]

Although not especially compelling for their content, the inscriptions of the Mosque al-Nuri command our attention for their visibility, which is enhanced by their northern location on the capitals and by the contrasting colour of the inlaid friezes. Surrounding the worshipper by evocative Qur'anic verses that would have been audibly reinforced during the Friday sermon, these inscriptions deliver an exoteric message within a saturating atmosphere, directly linked to Nur al-Din's pronouncements and his strident Sunni policy.

Equally strident was the minaret of the Mosque al-Nuri, the so called *al-Hadba'* (the hunchback), whose lofty bent profile became a symbol of Mosul before its horrific destruction in 2017. Standing at the northwestern corner of the enclosure, the circular minaret rose to a height of 56 metres from a slightly battered rectangular base, which is also ornamented on all four sides with brick strapwork (Figure 7.8). Its circular shaft is divided by guilloche mouldings into seven zones which are lavishly ornamented in varieties of *hazar baf* and strapwork ornament that recall Seljuq Iranian minarets. In sum, the mosque – with its tripartite prayer hall, large *maqsura* dome and lofty minaret – resembles a host of Jaziran mosques that were

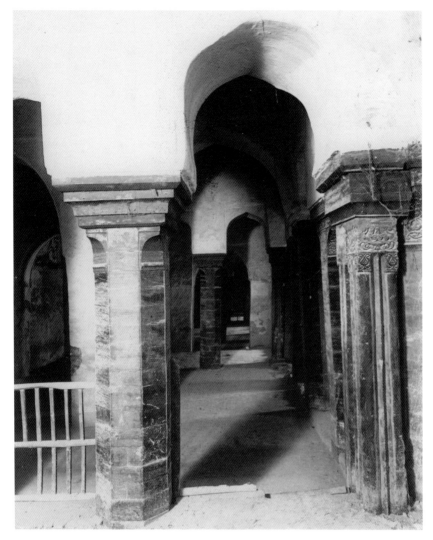

**Figure 7.5** *Interior*, circa *1920*, *of the Mosque al-Nuri. 1172 and later, Mosul, Iraq. Source: Photograph courtesy of the Iraqi Institute of Antiquities and Museums*

founded in the twelfth and thirteenth centuries in regions that had a large Christian population.

## The architectural patronage of Badr al-Din Lu'lu'

Surprisingly little has survived from the Zangid rulers who ruled Mosul before Badr al-Din's take-over in 1233. Sixteen *madrasas* and ten *khanqah*s are known to have been built by these rulers, but with the exception of a handful of stone *mihrab*s and portals, preserved mainly at the Mosul Museum and the Iraq Museum in

**Figure 7.6** *Inscribed marble panel from the Mosque al-Nuri. Undated, Mosul, now in the National Museum of Iraq, Baghdad. Source: Photograph by the author, 1979*

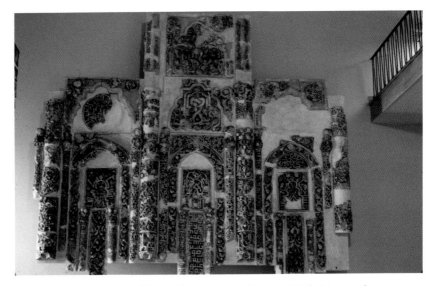

**Figure 7.7** *Stucco panel from the Mosque al-Nuri. Mid-thirteenth century, Mosul, now in the National Museum of Iraq, Baghdad. Source: Photograph by the author, 1986*

Baghdad, none of these monuments has survived.[13] Saʿid Daywahji has suggested that Badr al-Din, in his efforts to promote Shiʿism, had converted some of these *madrasa*s into Shiʿi shrines, such that, for example, the shrine of Yahya b. al-Qasim was built adjacent to an earlier *madrasa*.[14] Several of these shrines, all possessing a pyramidal roof sheltering an interior brick *muqarnas* vault, once dotted the landscape of old Mosul. Sadly, all these shrines and many more have been leveled by Daesh during its recent occupation of Mosul.

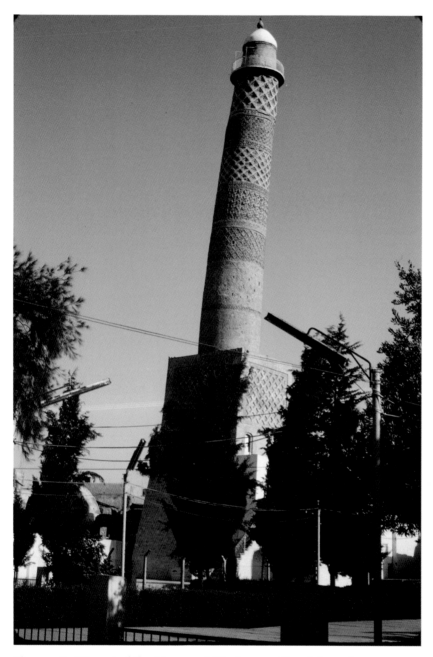

**Figure 7.8** *Minaret of the Mosque al-Nuri. 1172, Mosul, Iraq. Source: Photograph by the author, 1979*

Two of these shrines – those of Imam Yahya b. al-Qasim and Imam 'Awn al-Din – stand out for their historical importance and degree of preservation and will be the focus of this discussion of Badr al-Din's architectural patronage. The shrine of Imam Yahya stood at the foot

of Mosul's citadel, Bash Tabiya, about midway between the citadel and Qara Serai, a lovely pavilion whose two-story remains face the Tigris. Such informal pavilions were quite common in medieval Islamic architecture, and the Qara Serai resembles in particular the Alaeddin Keyqubad kiosk at the foot of the Konya citadel, built at approximately the same date.[15]

The shrine of Imam Yahya b. al-Qasim was founded by Badr al-Din Lu'lu' in 637/1239 adjacent to his Madrasa al-Badriyya, which has entirely vanished. Although no archeological work has been done in its vicinity, it seems likely that the shrine was part of a complex that included the citadel and the Qara Serai kiosk, a royal/religious complex that was enclosed by a low wall separating it from the city. In fact, contemporary sources describe Badr al-Din's frequent visits to this shrine where he would meet with notables, teachers and jurists in order to discuss the history of Imam 'Ali and the various *hadith*s that extol his virtues and those of the *ahl al-bayt*.[16] Furthermore, Badr al-Din was temporarily interred in the shrine after his death in 1258 before his remains were allegedly moved to Najaf, to be buried near the shrine of Imam 'Ali.[17]

The shrine stood until recently about 100 m south of the citadel on the western bank of the Tigris, into which it was gradually sinking long before its ultimate destruction in 2017 (Figure 7.9). The pyramidal dome of the shrine rose from a slightly battered rectangular base whose four sides were once ornamented with brick patterns enhanced with turquoise glazed tiles. Entered from the north, facing the citadel, its main façade was flanked by two large panels of glazed brick geometric patterns and exquisite floriated Kufic inscriptions. These are surmounted by Badr al-Din's foundation inscription, which, in evident humility to the interred saint, gives his name simply as 'the poor slave Lu'lu' b. 'Abdullah' (Figure 7.10). Traces of glazed bricks on the other three sides and on the pyramidal dome suggest that the monument was originally lavishly decorated with blue-glazed tile ornament, which is rather rare in Mesopotamia.

Three steps lead down to a dark interior centred around a new cenotaph; the original magnificent carved wood cenotaph has been moved to the Mosul Museum. A lavishly decorated marble dado surrounded the lower walls and culminated in an elaborate *mihrab* located in the southeastern corner (Figures 7.11, 7.12). Made of typical soft blue veined marble, the dado was ornamented in two distinct styles that seem to belong to two different periods. The first, from Badr al-Din's period, consisted of deeply carved arabesque patterns undergirded by two raised inscription bands, the lower in a majestic *thuluth* and the upper in an exquisite cursive hand that resembles contemporary manuscript scripts. The second style comprised blue marble panels that were inlaid with white marble inscriptions. These date to the late thirteenth century, when the shrine was

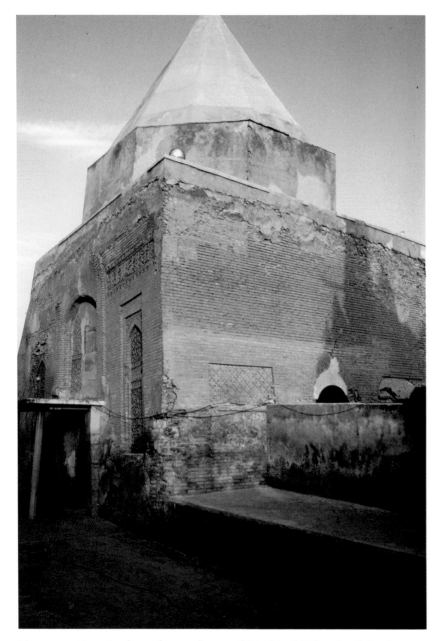

**Figure 7.9** *Exterior from the northwest of Mashhad Yahya b. al-Qasim. 637/1239, Mosul, now destroyed. Source: Photograph by the author, 1986*

restored by a certain Ibrahim b. 'Ali, who is identified as 'the servant of the sacred shrine'. This inscription included the well-known Shi'i prayer for the Twelve Imams, the name of the patron and a Qur'anic passage (76:7–10), a passage often found in Shi'i foundations (Figure 7.12). A third inscription band, made out of carved brick and quite

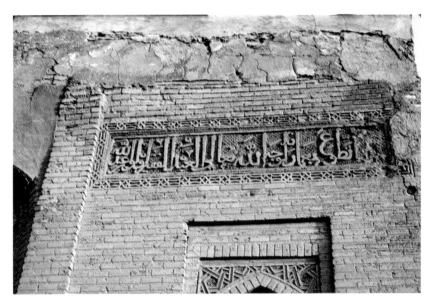

**Figure 7.10** *Exterior with inscription frieze of Mashhad Yahya b. al-Qasim. 637/1239, Mosul, now destroyed. Source: Photograph by the author, 1986*

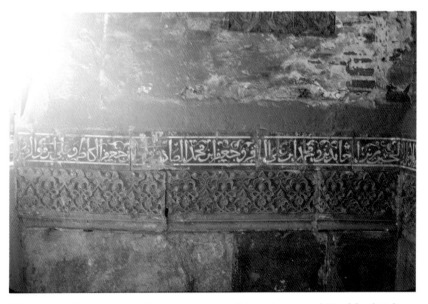

**Figure 7.11** *Interior, marble ornament and inscriptions of Mashhad Yahya b. al-Qasim. 637/1239, Mosul, now destroyed. Source: Photograph by the author, 1986*

likely part of the original structure, surrounded the shrine just below the springing of the dome. This inscription also gives the name and abbreviated titles of the founder and the name of the supervisor of construction, Sanbak al-Badri, a slave of Badr al-Din.

The wooden cenotaph, the marble inscriptions and the frieze at the springing of the dome contain inscriptions, Qur'anic and pietistic, of a distinctly Shi'i character. In addition to the well-known encomium for the Twelve Imams, the *mihrab* is surrounded by verses 20:12 and 11:72, and the cenotaph with 2:255 – verses whose reference to the sacrifice, blessing and purity of *ahl al-bayt* have long had a specifically Shi'i interpretation.[18]

A majestic *muqarnas* dome covers the shrine, rising rigorously and logically from four squinches that develop into a sixteen-sided star ending in a small eight-pointed star at the apex (Figure 7.13). The construction of the *muqarnas* cells out of small glazed brick tiles, also seen at Imam 'Awn al-Din, differs from the earlier plaster domes of southern Iraq and contributes to the pristine geometry still visible in the better-preserved portions. Overall, the location, opulence and inscriptions of the Mashhad of Imam Yahya suggest that it was built as a private

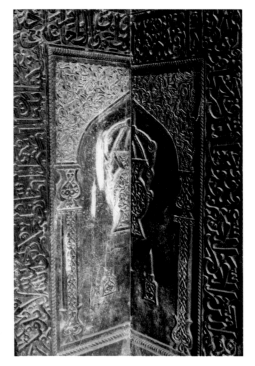

**Figure 7.12** *Interior and corner* mihrab *of the Mashhad Yahya b. al-Qasim. 637/1239, Mosul, now destroyed. Source: Photograph by the author, 1986*

shrine/chapel for Badr al-Din and his circle, a clear indication of his Shi'i inclination in the second half of his reign. Although we cannot be certain about Badr al-Din's sincerity, his self-identification as 'Waliyy Al Muhammad' and his burial in Najaf strongly argue for his conversion to Shi'ism.[19]

The shrine of Imam 'Awn al-Din, founded by Badr al-Din in 646/1248, occupies a more central but less dramatic location than Imam Yahya's (Figure 7.14). Taller and more attenuated than the shrine of Imam Yahya, it is entered from the west through an elaborate blue marble portal framed by a delicate cursive Qur'anic inscription (containing the Throne Verse) and surmounted by a larger *thuluth* inscription that affirms the merits of building mosques (24:36; Figure 7.15). A third inscription, made of white marble inlaid in the stones of the lintel, consists of just six words that prominently give the name and brief titulature of Badr al-Din as *al-Sultan al-Malik al-Rahim Badr al-Dunya w'al-Din*. The joggled voussoirs of this lintel end in two suspended keystones, a typically Mosulite form seen in other portals dating to the period of Badr al-Din, including the portals at the monasteries of Mar Bahnam and Mar Ahudemmeh (Figure 7.16).[20]

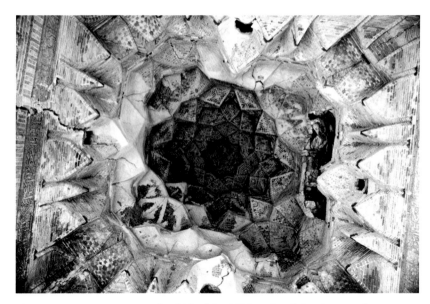

**Figure 7.13** Muqarnas *vault of Mashhad Yahya b. al-Qasim. 637/1239, Mosul, now destroyed. Source: Photograph by the author, 1979*

This marble frame once surrounded a magnificent wooden door whose two jambs were sheathed in brass sheets that were overlaid with brass strips to form a complex geometric pattern. Signed by another *mamluk* of Badr al-Din ('Umar b. al-Khidr . . . al-Maliki al-Badri), the portal closely resembles a nearly contemporary one that once belonged to the Great Mosque of Cizre before being moved to the Museum of Islamic and Turkish Art in Istanbul.[21]

As at the shrine of Imam Yahya, the interior of the Mashhad Imam 'Awn al-Din is a few steps below street level, except that the floor here, during my two visits in 1979 and 1986, was inundated by about two feet of water. The marble revetment around the walls had largely vanished, although its fragments were kept at the Mosul Museum. Taller and more complex than Imam Yahya's shrine, the dome here springs from fully developed *muqarnas* squinches and progresses similarly to sixteen- and then eight-pointed stars (Figure 7.17). The fact that the shrine was until recently surrounded by a cemetery with old and recent tombs points to its continued veneration in later centuries.

### The Architectural patronage of Nur al-Din and Badr al-Din compared

Very little has been written in English on Badr al-Din, and none of these works shed much light on his proclivities towards Christianity and especially Shi'ism. Nevertheless, contemporary sources occasionally and quite critically refer to his benevolent attitude towards

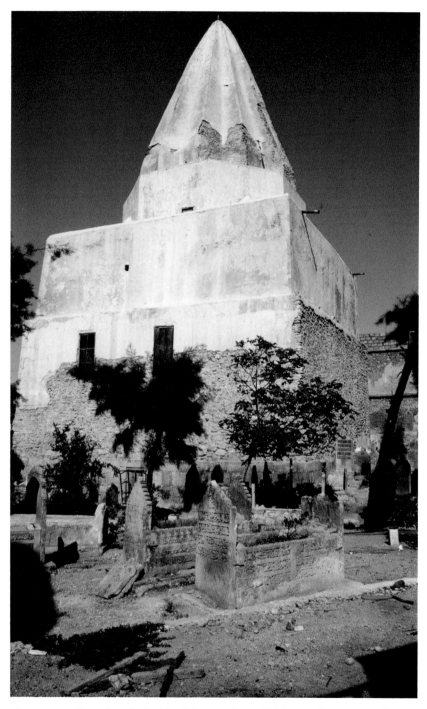

**Figure 7.14** *Exterior of Mashhad Imam ʿAwn al-Din. 646/1248, Mosul, now destroyed. Source: Photograph by the author, 1979*

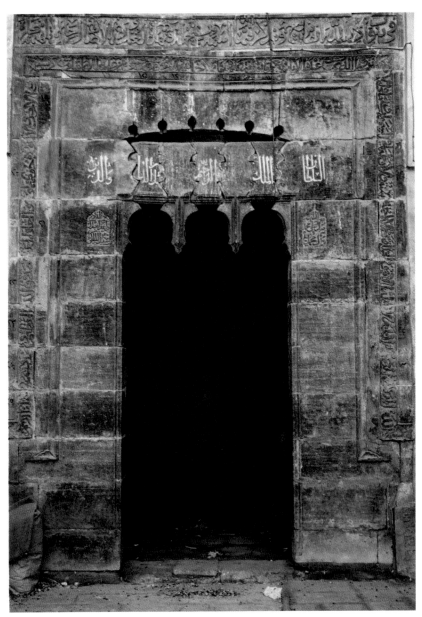

**Figure 7.15** *Portal of Mashhad Imam 'Awn al-Din. 646/1248, Mosul, now destroyed. Source: Photograph by the author, 1979*

the Christians of Mosul, noting, for example, that he had the city decorated for Palm Sunday (*Sha'aneen*) and that he himself took part in the festivities. Churches and monasteries prospered during his reign, including Mar Behnam, Mar Matta, Mar Ahudemeh and others. Not surprisingly, he was well-regarded by the same Christian historians who had reviled Nur al-Din.

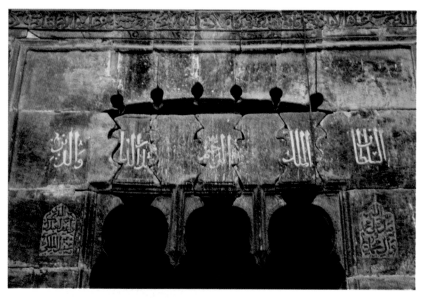

**Figure 7.16** *Portal detail of Mashhad Imam 'Awn al-Din. 646/1248, Mosul, now destroyed. Source: Photograph by the author, 1979*

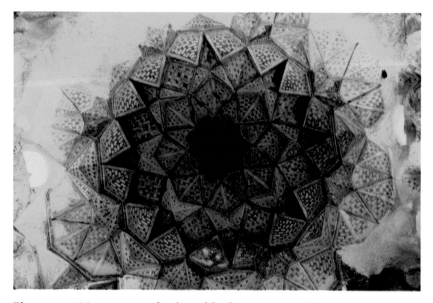

**Figure 7.17** Muqarnas *vault of Mashhad Imam 'Awn al-Din. 646/1248, Mosul, now destroyed. Source: Photograph by the author, 1979*

Badr al-Din's support of Shi"ism, to which he most likely converted, is somewhat more difficult to explain. It could be linked to the ecumenical policies of the Abbasid Caliph al-Nasir (r. 1180–1225), for whom a specifically 'Ali-centered mystical Shi'ism was promoted in order to foster an *esprit de corps* among his *futuwwa*

legions that he had created in order to oppose the last Seljuqs in
Baghdad.[22] But Badr al-Din's Shi'ism was far more pervasive and not
linked to Sufism, for he is known to have converted both *madrasa*s
and *khanqah*s (Sufi convents) into Shi'i shrines. Rather, it seems
that his turn to Shi'ism was due in part to a great Sufi rebellion
threatening his reign around the time that he had commenced to
usurp rule from the last Zangid sultans.[23] This rebellion was led by
the charismatic Sufi leader Shaykh Hasan Shams al-Din al-'Adawi,
who, claiming Umayyad descent and appealing to Arab ethnicity,
called for opposing both Badr al-Din and the Zangids and, quite
curiously, the establishment of a new Umayyad dynasty. His *tariqa*
al-'Adawiyya, which would later be assimilated into the Yazidi faith,
gained numerous adherents who spread throughout the region.[24]

Badr al-Din's battle against Shams al-Din and his 'Adawiyya
disciples proceeded along both ideological and military lines.
Ideologically, Badr al-Din sought first to discredit Shams al-Din by
denouncing his alleged lineage and accusing him of the usual charges
of religious laxity and sexual perversion. Soon afterwards, he resorted
to opposing Shams al-Din's charismatic Sufism by Imami Shi'ism,
pronouncing his allegiance to *ahl al-bayt* and spreading the Shi'i
faith in Mosul, where it was already well represented. Adopting the
epithet of *waliyy al Muhammad* with its well-known resonance, he
proceeded to build elaborate shrines for various Shi'i saints all over
Mosul and in Sinjar and Tikrit while also converting earlier Sunni
structures for Shi'i piety. He is not known to have built any mosques
or *madrasa*s, nor even a mausoleum for himself, which was common
practice among medieval Sunni dynasts.[25] It was not until 1254, five
years before the end of his reign, that he had Shams al-Din and many
of his followers mercilessly killed.

About three-quarters of a century apart and ostensibly belong-
ing to a general trend towards Sunni orthodoxy, Nur al-Din and
Badr al-Din are poles apart in terms of their religious and sectarian
policy and architectural patronage. Obsessed by Sunni orthodoxy,
Nur al-Din persecuted both Shi'is and Christians, although he was
favourably disposed towards Sufis, and built numerous mosques,
*madrasa*s and *khanqah*s. Not surprisingly, he is nearly beatified by
contemporary and later historians, who often placed him in the ranks
of the Companion Caliphs. Numerous books in Arabic and European
languages have been written on him, including a three-volume study
by Nikita Eliseéff and my own unpublished dissertation.[26]

Badr al-Din, on the other hand, is not nearly as well regarded or
studied, although his reign marks the peak of cultural life in medi-
eval Mosul. In addition to his numerous architectural foundations,
he also commissioned a famous illustrated manuscript of *Kitab al-
Aghani* and some astonishing inlaid metalwork.[27] Regrettably, all
his architectural monuments have nearly vanished without being
properly studied. Their remarkable fusion of northern and southern

Iraqi forms, borrowings from regional Christian architecture, and the purposeful use of Qur'anic and pious inscriptions all point to an especially high point in medieval Islamic architecture.

Comparing the architectural patronage of Nur al-Din and Badr al-Din in Mosul also problematises the notion of the 'Sunni Revival', which has recently been questioned for its potentially simplistic sectarian polarisation that does not adequately address the commonalities of popular piety.[28] There is little question, of course, that shrines often appealed to a wide spectrum of the population regardless of their sectarian or religious affiliation, such that Sunnis, in particular, sought the blessing and intercession from Shi'i, Christian, Jewish, or even pagan shrines.

However, popular piety as a social practice was itself subject to influence and manipulation by dominant political forces, which could encourage, condone, divert, or prohibit such pietistic ambivalence and sectarian pluralism. Islamic history is certainly replete with examples of dynasties, both Sunni and Shi'i, not just suppressing pious pluralism but also prohibiting the veneration of saints of the wrong sect and even destroying their shrines. Of these, the Wahhabi destruction of the shrines of *ahl al-bayt* in the *Jannat al-Baqi'* (a cemetery near Medina) in the eighteenth and nineteenth centuries is perhaps the most notorious, although the Safavid destruction of Sunni shrines and mausolea in Baghdad in the sixteenth century provides an opposite and equally powerful example. Although these suppressive political measures never actually stopped cross-sectarian piety, there is little question that politics played a significant role in shaping and even redirecting it towards those shrines that had been sanctioned and supported by the prevailing dynasties.

Nur al-Din and Badr al-Din shaped the history of Mosul in quite different ways, and their legacies corresponded fairly closely to the general sectarian transformation in northern Syria and the Jazira from the late twelfth century onwards. In a region whose two main cities, Mosul and Aleppo, witnessed a decisive shift in the thirteenth century and later from Shi'ism to Sunnism, it comes as no surprise that contemporary and later chroniclers favoured Nur al-Din's Sunni orthodoxy and religious intolerance over Badr al-Din's ecumenical support of Imami Shi'ism and Eastern Christianity. Nur al-Din and his successors fostered a dogmatic trend that has continued until today, while Badr al-Din represents a short-lived and often forgotten period of tolerance.

## Notes

1. There exists not a single book in English dedicated to the history of the Zangid dynasty of Mosul. But this history is otherwise available in Said Daywaji's various Arabic publications, including *Tarikh al-Mawsil*. See also the short monograph Patton 1992. For Nur al-Din and the early Zangids, see Elisséeff 1967.

2. As such, he was the first former slave to become sultan, anticipating the rise of the Mamluks in Egypt by twenty-five years.

3. Abu Shama 1998, pp. 20–21.

4. Tabbaa 2002.

5. Abu Shama 1998, p. 482.

6. See al-Antaki 1990, pp. 289–90, 295–99. In fact, these Christian sources allege that Nur al-Din wrote a letter to the caliph of Baghdad that calls for the forced conversion or outright slaughter of all Christians in Muslim lands. On that, see Fiey 1959, pp. 35–36.

7. Even this rebuilt mosque was blown up, along with the famous brick minaret, in 2017, at the hands of ISIS/Daesh.

8. Sarre and Herzfeld 1911, vol. 2, pp. 216–30.

9. Ibid. pp. 22–25. Herzfeld offered this tentative chronology some-what apologetically since the Mosque al-Nuri was very poorly lit internally.

10. It is virtually impossible to ascertain the entire chronology of the Mosque al-Nuri or to determine the various sources of the later columns and other architectural fragments. For example, the *mihrab*, dated 543/1148, that was brought to the mosque in the nineteenth century had salvaged pieces from several unknown monuments.

11. Tabbaa 2002, pp. 343–48.

12. Ibid. pp. 348–51. For a complete reading of the inscriptions on this stucco panel see Salman and Totonchi 1975, pp. 38–41.

13. The most complete discussion of the medieval architecture of Mosul, with special emphasis on the period of Badr al-Din, remains Sarre and Herzfeld 1911, esp. vol. 2, pp. 238–70.

14. See Daywaji 1982, pp. 316–17, and also Daywaji 1957. Daywaji in fact lists no less than four *madrasa*s that Badr al-Din converted into Shi'i shrines, including Madrasa al-Nizamiyya, which became a shrine for Imam 'Ali al-Asghar; Madrasa al-'Izziyya, which became a shrine for Imam 'Abd al-Rahman; Madrasa al-Nuriyya, which became a shrine for Imam al-Bahir; and Madrasa al-Badriyya to which he added the shrine of Imam Yahya b. al-Qasim.

15. See, for example, Redford 1994, pp. 215–32.

16. Daywaji 1982, p. 360; and Daywaji 1968, pp. 171–82.

17. Daywaji 1968, p. 173.

18. Ibid. pp. 174–75, where Daywaji gives a list of six shrines in and around Mosul, nearly all built by Badr al-Din, that contain the same encomium.

19. See Daywaji 1982, p. 316, who adds that Badr al-Din held frequent gatherings in which books that praised Imam 'Ali and that mourned the martyrdom of Imam al-Husayn were read.

20. Sarre and Herzfeld 1911, vol. 2, pp. 294–303; and most recently Snelders 2010.

21. For an illustration of the door at Imam 'Awn al-din, see Daywaji 1982, p. 432; and Sarre and Herzfeld 1911, vol. 2, p. 269. See also Canby, Beyazit, Rugiadi and Peacock 2016, pp. 64 and 221.

22. Hartmann 1975.

23. Badr al-Din's turn to Shi'ism as a reaction to the Sufi 'Adawi movement is not specifically addressed in historical chronicles, although it has been surmised by modern Iraqi historians, including Daywaji 1982, p. 316; and Tariq 1982.

24. On the Yazidi or Ayzidi faith, see Kreyenbroek and Rashow 2005, pp. 4–5.

25. Shiʻi sovereigns and princes rarely built mausoleums for themselves, but preferred to immortalise their names by associating themselves, through patronage, with the shrines of prominent Shiʻi saints.
26. Tabbaa 1982; Elisséeff 1967.
27. Canby, Beyazit, Rugiadi and Peacock 2016, pp. 61–64. See also Hillenbrand 2017, which for the first time provides colour illustrations of all six frontispieces of this important manuscript.
28. Mulder 2014. See also my review of this book in the *Journal of Shiʻi Studies* 1 (2016).

# PART FOUR
# IDENTITIES: RULERS AND POPULACE

CHAPTER EIGHT

# Ghaznavid, Qarakhanid and Seljuq Monumental Inscriptions and the Development of Royal Propaganda: Towards an Epigraphic Corpus

*Roberta Giunta and Viola Allegranzi[1]*

THE EPIGRAPHIC MATERIAL with provenance from the eastern Iranian area, attributable to a period from the late tenth to early thirteenth centuries, represents a primary source for understanding a political-cultural framework in transformation. The rise of three important dynasties of Central Asian Turkic origin – the Ghaznavids (977–1086), the Qarakhanids (*circa* 992–1213), and the Great Seljuqs (1040–1194) – brought about a renewal and evolution in the political context of the eastern Islamic regions and in strategies of propaganda and legitimisation of power.[2] The monumental inscriptions also attest to the stimulus imparted by building programmes in certain urban centres, which developed as seats of religious, scientific and literary debate and thereby intensified the network of exchanges within the confines of the caliphate.[3]

Given that there is no pre-existing comprehensive study of the epigraphic material related to these dynasties, it would be desirable to begin with the systematic organisation and cataloguing of all possible inscriptions, both whole and fragmentary. Following this, it will then be possible to carry out detailed comparative analyses, which can demonstrate innovations in content as well as in the linguistic and palaeographic forms of these documents.[4] Previous epigraphic studies touching on this overall region have often achieved interesting results, but have dealt exclusively with the presentation of single inscriptions or groups deriving from a specific context.[5] This circumstance, together with quite frequent shortcomings in methodology, has brought about a dispersal of the available data and limits the comprehension of epigraphic practices encountered in contexts that are often distant and diverse, which might inform us concerning the diffusion of models and the mobility of artisanal skills.

The project underlying this essay concerns the development of a corpus of Ghaznavid, Qarakhanid and Seljuq inscriptions, which integrates with the research that the authors have pursued for a

number of years.[6] It is designed to address a series of difficulties, above all involving the state of conservation of the texts. These are often extremely fragmentary and/or decontextualised, sometimes without adequate photographic or graphic documentation. In fact, the great part of the materials derives from sites that are now partially or completely destroyed, where archaeological research has not always enabled thorough dating and where it may now be impossible to conduct further fieldwork. Moreover, many of the monuments that did preserve inscriptions *in situ* have quite recently been subject to massive restoration interventions, which have entirely or partly obliterated the epigraphic bands.[7] Moreover, the complex historical-political framework of the Iranian pre-Mongol world is known only through a limited number of sources and is still the subject of research and debate.[8] These obstacles make it difficult to reconstruct the original locations and functions of the inscriptions, to identify the patrons and addressees, and to arrive at precise dating.

In this first stage of the project, the development of the epigraphic corpus concentrates on those monumental inscriptions that reveal at least one of the names of a ruler, the name of a high political office holder, or a date. Attempts are then made to resolve any uncertainties in the initial textual analysis, through cross-checking against numismatic and historiographic sources.[9] The inscriptions that appear to lack historic-documentary information (ruler, office holder, date) will be examined later – that is, after the first project stage has enabled the application of comparative palaeographic analysis for purposes of dating. The established chronology may subsequently help in attributing (and interpreting) inscriptions sponsored by other contemporary dynasties and those executed on artefacts which, more often than not, are anonymous and decontextualised.

### The corpus

The 'royal inscriptions' attributable to the Ghaznavid, Qarakhanid and Seljuq dynasties present numerous specificities and raise investigative problems of various kinds. Good progress has been made in collecting and analysing the texts entered in the Ghaznavid section of the corpus. This task has benefitted from the involvement of the current authors in the activities of the Italian Archaeological Mission in Afghanistan and in the management, reorganisation and study of the mission's archival records, which until this time have gone largely unpublished.[10] The inscriptions originate exclusively from Ghazni, capital of the dynasty until 1173.[11] Almost all of these items were added to the state collections through the activities of the French Archaeological Delegation to Afghanistan (1923) and especially the Italian Archaeological Mission in Afghanistan (1957–78).[12] Except for numerous pieces recovered during excavations of the supposed palace of Mas'ūd III, these inscriptions were not collected from

their original contexts, and it is impossible to trace the monuments to which they pertain. In fact, many years of study were necessary to arrive at a deeper understanding of the material, to facilitate the reassembly of inscription fragments found in distant parts of the city and beyond, to propose interpretations for incomplete texts, to reconstruct royal protocols and finally to advance hypotheses based on the evolution of writing styles.

The names of seven Ghaznavid dynastic rulers – Sebuktigīn (r. 977–97), Maḥmūd b. Sebuktigīn (r. 998–1030), Masʿūd I b. Maḥmūd (r. 1031–40), Mawdūd b. Masʿūd I (r. 1041–48), Ibrāhīm b. Masʿūd I (r. 1059–99), Masʿūd III b. Ibrāhīm (r. 1099–1115) and Bahrām Shāh b. Masʿūd III (r. 1117–50) – recur in inscriptions of civil and funerary character.[13] All of these inscriptions are carved in low relief in marble, except for the epigraphic bands of two minarets, which are in baked brick.[14] The most frequently surviving name is that of Ibrāhīm b. Masʿūd I. The inscriptions of this ruler were certainly part of an extensive building programme, promoted in a phase of dynastic rebirth,[15] subsequent to the severe defeat that Ibrāhīm's father Masʿūd I suffered in 1040 at Dandanqan, at the hands of Seljuq troops guided by Ṭughril Beg and Chagrī Beg.

Despite the severe fragmentation of texts and the generally poor state of conservation, the Ghaznavid inscriptions present significant features. Among these are the frequent indication of a genealogical line (in ascending or descending order), a telling reflection of a strongly centralised state; the absence of the name of the caliph; absence of the names of ministers or other important officers of the state; the use of the title of sultan; the abundance of *laqab*s; the use of metrical inscriptions in Persian language; the coexistence of different writing styles on the same support; the elaboration of some varieties of Kufic script; and the introduction of cursive script.

The Qarakhanid inscriptions are few in number, from widely distributed sites of both Transoxiana and Ferghana, and present difficulties for proposing confident attributions to known political personages. This is partly a reflection of the complex political organisation of this dynasty, in which a confederation of states was controlled by different and often competing branches of the family. Beginning in 1040, the Qarakhanid dominions were composed of western and eastern khanates, the former with a capital at Samarqand, the latter with two capitals at Balasagun and Kashgar; to this there was soon added an independent state in Ferghana, with Uzgend as the main centre. This context complicates the task of reconstructing the dynastic chronology based on a thorough genealogy.[16]

The only Qarakhanid inscriptions recovered by excavation are from the pre-Mongol site of Afrasiyab (Samarqand).[17] The other epigraphs have been recorded on still-extant structures and standing remains, but even these have suffered severe degradation. The large majority of texts are executed in baked brick or carved in

stucco.[18] Three inscriptions, all highly fragmentary, are attributed
to sovereigns of the western khanate. The inscription in the domed
hall of the Mausoleum of al-Ḥakīm al-Tirmiḏī at Termez has been
attributed to Aḥmad b. Khiḍr (r. 1086?–89 and 1092–95).[19] Moreover,
the several fragments of painted epigraphic bands excavated from
the site of a royal pavilion on the lower terrace of the citadel of
Samarqand/Afrasiyab and the fragmentary inscription on a panel
originating from this same citadel, interpreted as the construction
text of a Qarakhanid mausoleum, could be related, respectively, to
the names of Masʿūd b. Ḥasan (r. 1160–71) and the honorifics of
Ibrāhīm b. al-Ḥusayn (r. 1178–1203).[20] Another three texts cite some
authorities of Ferghana. The inscriptions ornamenting the interior
of the mausoleum of Shāh Faḍl at Safīd Buland (Ala-Buka district,
Kyrgyzstan) seem to allude to the governor of Ferghana, Muḥammad
b. Naṣr (d. after 1056), and to his son ʿAbbās b. Muḥammad;[21] the
name and titles of the latter personage also appear in a graffiti dated
1041, recorded in the Vorukh valley (a Tajik enclave in Kyrgyzstan).[22]
Finally, the khan of Ferghana, al-Ḥusayn b. al-Ḥasan (r. *circa* 1137–56)
is mentioned as the patron of the northern mausoleum in Uzgend,
built in 1152.[23] By contrast, the epigraphic fragments do not permit
identification of the personage cited in the inscription on the portal
of the Ribat-i Malik (see the second case study below), nor of those
mentioned in the historical texts on the façade of the southern mau-
soleum of Uzgend (1185–87).[24]

The Ferghana inscriptions show the most complete Qarakhanid
titling, with the name of the authority preceded by numerous titles
and *laqab*s, expressed in Arabic or Turkic language, and followed
by a genealogical string emphasising the descent from a specific
branch of the family. As with the Ghaznavid inscriptions, none of
the Qarakhanid epigraphs mentions the name of the caliph. Again,
we see the use of Persian language, of cursive script and of new varie-
ties of Kufic script.

The Great Seljuq inscriptions compose the largest section of the
corpus. These are often conserved in entirety, sometimes *in situ*
and generally in moderate to good condition. These advantages have
contributed to the inscriptions drawing more profound attention
from scholars,[25] but such interest is also due to the importance of
the Seljuqs throughout the Iranian and Near Eastern areas, as well
as the close relations between some of the rulers and the Abbasid
caliphal line. Almost all of these texts concern events of construc-
tion, restoration, or reconstruction; they are written in simple or
floriated Kufic, or, more rarely, in cursive, and carved in relief on
bricks or stone slabs. The provenance is from a very extensive ter-
ritory, reaching from Khurasan to Syria and Anatolia, and includes
materials from some of the central cities of the caliphate, among
them Isfahan, Damascus, Aleppo and Jerusalem. The preliminary
stage of gathering and cataloguing the materials included the exami-

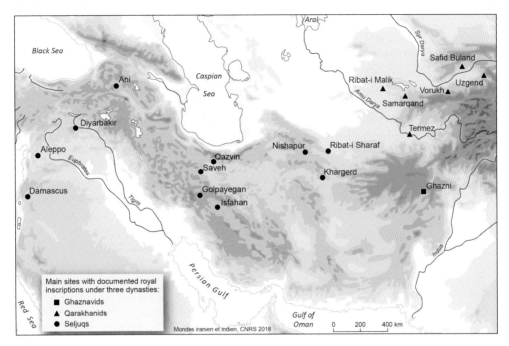

**Figure 8.1** *Main sites with documented royal inscriptions of the Turkic dynasties, late tenth to early thirteenth century. Source: © Mondes iranien et indien, CNRS 2018*

nation of more than thirty one inscriptions. The largest group (about twenty inscriptions) is ascribed to the twenty-year reign of Malik Shāh b. Alp Arslān (r. 1073–92), with provenance of Ani (Armenia), Damascus and Aleppo (Syria), Jerusalem, Diyarbakır (Anatolia) and Isfahan (Iran). The five inscriptions pertaining to the Great Mosque of Damascus also mention his brother Tutush, who controlled Syria from 1078 to 1095; the inscription of the Mausoleum of Ṣāliḥīn in Aleppo quotes his son 'Aḍud al-Dawla Abū Shujā' Aḥmad.

The remaining inscriptions date back to the sultanates of three of Malik Shāh's sons, Maḥmūd I b. Malik Shāh (r. 1092–94; Diyarbakır), Muḥammad Tapar I b. Malik Shāh (r. 1105–18; Diyarbakır and Damascus, as well as Saveh, Qazvin, Golpayegan and Isfahan in Iran), and Sanjar b. Malik Shāh (r. 1118–57; Diyarbakır and Isfahan). Finally, a further inscription in Diyarbakır bears the name of Maḥmūd II b. Muḥammad I (r. 1118–31).[26] Particular attention must be paid to some fragmentary epigraphic bands originating from sites in the eastern regions, which present greater problems in deciphering and interpretation, in particular from Khargird in Quhistan, Nishapur and the Ribāṭ-i Sharaf in Khurasan.[27]

The complexity of the Seljuq sultanate is reflected in almost all the 'royal inscriptions' recorded to date (Figure 8.1). Ample space is provided for mention of the authorities in power, well codified and noted pursuant to a rigid hierarchy. Some cases – for instance, the

inscriptions of the Great Mosque of Damascus, the al-Aqsa Mosque of Jerusalem and the inscription on the minaret of Saveh – include mention of the supreme caliphal authority.[28]

## Innovative features of epigraphy under the Turkic dynasties

A first comparative analysis of the inscriptions produced in the eastern Iranian area following the advent of the Turkic dynasties highlights some specificities that distinguish them from both pre-ceding and contemporary Islamic epigraphic traditions. The follow-ing sections present the major epigraphic innovations observed in the corpus, which also constitute lines for further in-depth research.

### Language

Arabic remained essentially the sole language of the inscriptions produced across the entire caliphate until at least the tenth century. However, during the eleventh century the use of New Persian[29] began to gain ground in the epigraphy of the eastern Islamic provinces.[30] The first known instances of inscriptions entirely composed in Persian pertain to the western Qarakhanid territories (for example, the inscriptions of Safid Buland and the Ribāṭ-i Malik) and from the Ghaznavid capital (the inscriptions from the Ghaznavid palace and other areas of Ghazni city).[31] Although none of these texts bears a date, the mentions of some rulers and the related archaeological dating suggest that most of them pertain to a period from the second half of the eleventh to the early decades of the twelfth century. The common feature of this group of inscriptions lies in their composition in poetic form. Epigraphic Persian thus seems to make its appearance in specific types of monuments (palaces, mausoleums), in the form of inscriptions in verse that flank texts of other kinds executed in Arabic (texts of construction, Qur'anic inscriptions, expressions of well-wishing). This tradition would then expand and evolve during successive eras; in the second half of the twelfth century the newly erected Qarakhanid monuments continue to be embellished with epigraphic bands in Arabic and Persian (for example, the mausole-ums of Uzgend and the painted pavilion excavated in Afrasiab). The only observed case of Persian used for a foundation text in prose is that at the entrance to the northern mausoleum at Uzgend (1152). As a final note, research to date has not detected any use of Persian in the inscriptions of the Great Seljuqs.[32]

### Names and honorifics

The large part of the proper names of the Ghaznavid, Qarakhanid and Seljuq rulers are of Arabic origin, signalling their adhesion to the Arab-Muslim onomastic model. However, there are also cases

where the name of the sovereign descends from Iranian or Turkic traditions: examples include 'Bahrām' (which was already the name of several Sasanian kings) for the former, and 'Arslān' (referring in Turkish to 'lion', a totemic animal) for the latter.[33] The honorific titles inserted in the official protocols of the rulers and on coinage were as a rule conferred by the caliph in person and are naturally expressed in Arabic. In royal inscriptions produced over the course of the eleventh and twelfth centuries, the name of the sovereign is preceded by numerous honorifics that emphasise his political and religious merits. The multiplication of titles and *laqab*s is witnessed in particular in the Seljuq and Qarakhanid inscriptions, while in extant Ghaznavid inscriptions the family lineage is particularly emphasised through the chain of patronymics (*nasab*s; see the first case study below). In some Persian inscriptions (such as at Safid Buland, Ribāṭ-i Malik and Ghazni), the titles of Arabic origin are transcribed in a Persianised form that adapts to the sound and metric structure of the text (for example, 'Sayf-i dawlat' for 'Sayf al-dawla'). This is a pattern that can also be observed in Persian works of prose and verse of the same era. The eastern Islamic potentates equally express their linguistic plurality through the use of hybrid titles, combining terms that originate from the various Arabic, Persian and Turkic royal protocols (for example, Malik Shāh, Malik Arslān, Shāhanshāh al-aʿẓam).[34] As noted above, the Qarakhanid honorifics demonstrate the widest variety of titles of Turkic origin, always accompanying honorifics in Arabic and always transcribed in the latter language. This goes along with the impetus given to the creation of a Turko-Islamic literary tradition in the first Qarakhanid period.[35]

*Script*

The inscriptions of the three dynasties are executed in a rich variety of Kufic script styles, developed in a process begun in the Samanid era and best known from the pottery vessels of Khurasan.[36] Beginning in the first half of the eleventh century, pronounced regional variations developed in many of the styles of Kufic script already in use in the western areas of the caliphate,[37] accompanied by the appearance of new graphic solutions, often strikingly ornamental. In the most remarkable cases, the stonecutters concentrated this treatment in the terminal parts of the letters, developing an ever more harmonious effect in the upper epigraphic field, without detracting from the legibility of the texts. This is particularly the case in the variants of the so-called 'bordered Kufic',[38] in both vegetal and geometric types, of which the Seljuq inscription of Khargird offers an excellent example.[39] The Ghaznavids also developed a new style known as 'square Kufic', without decorative elements, but with the words arranged in a manner forming square or rectangular cartouches or

lozenges. At present, the oldest known exemplar of this particular script is from Ghazni, on the fragment of a marble slab that also preserves the portion of an epigraphic band bearing the honorific of Ibrāhīm b. Masʿūd I in cursive.[40] It also seems that the Ghaznavids were the first in the entire Muslim world to use cursive script in monumental epigraphy, as witnessed in the epitaph of Maḥmūd b. Sebuktigīn (m. 1030) and in a construction text bearing the name of Mawdūd b. Masʿūd I (r. 1041–48).[41] The oldest Seljuq inscriptions in cursive can be dated to the reign of Malik Shāh (for instance, the inscription of Nishapur and an inscription of the Great Mosque of Isfahan; see the third case study below). The use of cursive seems to appear in Qarakhanid inscriptions by the end of the eleventh century. The examples dating from the second half of the twelfth century show that this script was already fully developed by this time, including in the western regions of the caliphate.

## Three case studies

This section of the chapter presents three case studies in order to illustrate some of the issues involved in the analysis of these epigraphic documents and to demonstrate the need and potential benefits of adopting a cautious, critical approach in interpreting the epigraphic documents derived from problematic architectural and archaeological contexts. The cases presented here deal with each of the three dynasties.

*Fragments of epigraphic bands containing portions of names and honorifics: a marble arch of the Ghaznavid Ibrāhīm b. Masʿūd I*

In 1923, the French Archaeological Delegation in Afghanistan documented the upper right corner of the epigraphic frame of an arch, no longer in its original context (Figure 8.2). The information was published two years later by Samuel Flury.[42] The scholar ascribed the fragment to Ibrāhīm b. Masʿūd I, on the basis of a brief portion of the honorifics of this ruler. No information was published on the position of the piece, which had been discovered reused, in the back wall of an architectural niche. In 1958 the fragment was again documented by the Italian Archaeological Mission, now specifying that it had been found in the niche, which was within the Ziyārat ʿAlī Muḥammad Abū Abī Sayyid ʿArabī, situated 200 m west of Ghazni's citadel.[43] Some twenty years later, in 1978, the Italian Mission conducted test excavations in the immediate vicinity of the minaret of Bahrām Shāh, and from these recovered the upper left corner of a marble arch. Giunta had the opportunity to study the fragment and its inscription; based thereupon, she established not only that the piece pertained to the reign of Ibrāhīm b. Masʿūd I, but also that it was the left part of the same frame published by Flury, in spite of being recovered some

1000 m from the first fragment.[44] Later yet, in 2002, during the registration and organisation of Ghazni's archaeological materials in the reserves of the National Museum of Kabul, the Italian Mission recorded the presence of a marble frame fragment bearing the name of Maḥmūd b. Sebuktigīn. The provenance of the fragment was unknown; however, Giunta inserted it among the inscriptions in the name of this ruler – in spite of some uncertainties, due to a style of cursive script that seemed to fit better in the epigraphic production of the second half of the eleventh century.[45] Several years later, through continued study and numerous attempts at reconstructing portions of epigraphic bands, including the preparation of new drawings, it became clear that this piece and the two other fragments definitely belonged to the frame of the same arch of Ibrāhīm and that the name of Maḥmūd was only mentioned as part of the genealogical lineage of this later ruler.

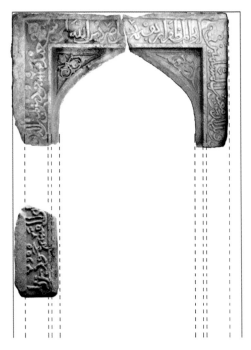

**Figure 8.2** *Graphic reconstruction of the arch of Ibrāhīm b. Masʿūd I (Ghazni). Source: Drawing by Giunta and Passaro, 2015, © R. Giunta and C. Passaro*

[...] مويد الدين مغيث المسلمين أبي المظفر إبراهيم //
بن ناصر دين الله أبي سعيد مسعود بن يمين الدو[لة ... //
...] أبي القسم محمود بن نا[صر...]

*Uncertainties about function and reading: the Qarakhanid inscription on the arch of the portal of the Ribāṭ-i Malik*

This inscription has long been known to the scholarly community (Figure 8.3);[46] however, its function and attribution are far from being resolved. There still exists debate over the history of this complex, which lies on the road connecting the cities of Bukhara and Samarqand. Based on historiographic sources, the Ribāṭ-i Malik was long considered a caravanserai constructed by the Qarakhanid sovereign Shams al-Mulk Naṣr b. Ibrāhīm (r. 1067–80). However, recent studies have shown that the structure underwent important transformations over time and have proposed that the monument initially served as a Qarakhanid extra-urban residence, ultimately becoming a caravanserai in the post-Mongol era.[47] Scholars generally accept the dating of the first stage of the complex to the second half of the eleventh century, but the epigraphic sources have not

yielded an exact date.[48] In fact, although many consider the portal
inscription a foundation or restoration text,[49] the surviving parts do
not contain any date and do not inform us about the monument's
function. From the first part of the text, the honorific title *sultān-i
jahān* ('Sultan of the World' in Persian) can be reconstructed, but this
does not correspond to any official title transmitted by the numis-
matic or historiographic sources; this makes it difficult to identify
an association with a dominant historic personage. The inscription
presents the further specificity of being composed entirely in Persian
language and in verses, as shown by the repetition of the rhyme *-āy*.
The reading is complicated by the use of a variety of Kufic script in
which many letters can be confused on account of their almost iden-
tical shapes and by the absence of diacritical marks. These features,
together with some lacunae, have so far prevented a full reading of
the text.[50] However, the definite passages show that the inscription
refers to a building (most likely the Ribāṭ-i Malik itself) constructed
by a 'Sultan of the World' and with God's blessing, which turns
out to be an earthly paradise. These were recurring themes in the
Persian panegyric poetry of the time, probably cited for the purpose
of celebrating the splendour of the monument and the associated
magnificence of its patron. Thus, in spite of its prominent position,
the inscription on the Ribāṭ-i Malik's portal probably did not func-
tion as a foundation text, but as a laudatory and commemorative
welcome address. This does not preclude the possibility that a more
traditional (Arabic?) text recording the patron's official titles and
undertaking was inscribed on some of the lost parts of the building.
First-person examination of the inscription allowed Allegranzi to
advance a new version of the extant text:

[...] سل[طان] جهان که کرد این جای بنای زین را[ه][51](؟) خلق(؟) و ایمنی بودش رای

از بهر خدای ک[ر]د [آن](؟)عالی جای از وی بتمامی تند(؟) بر[س](؟)[]د خدای

مانند بهشت گشت این جای خراب بر منظر(؟) فراو(؟) [...][52]

[The Sul]tan of the world who erected a building in this place,
pondered over the people (?) and safety of this route (?).
For God he has done [that] (?) an elevated place,
thank to him quickly(?) [it was brought (?)] to completion. God
transformed this place in paradise;
destruction at the sight (?) [. . .]

*Interpreting the construction history of the Great Mosque of
Isfahan: a Seljuq Qur'anic epigraph in cursive*

Among the Seljuq inscriptions of the Great Mosque of Isfahan, those
running along the abacuses of the pilasters within the southern
domed hall are clearly different. In the 1970s, an architectural survey
discovered a further part of this same epigraphic band on the north-

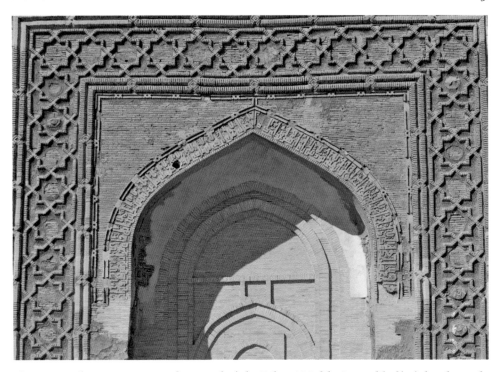

**Figure 8.3** *The inscription at the portal of the Ribāṭ-i Malik. Second half of the eleventh century, Navoyi, Uzbekistan. Source: Photograph by the author, 2015,* © *Viola Allegranzi*

ern side of the abacus of the eastern pilaster on the external facade of this hall (Figure 8.4). Unlike the other inscriptions of the domed hall – moulded in baked brick and executed in a particularly sober Kufic script – this epigraphic text is carved in plaster and executed in a very refined cursive on a background scroll. The surviving portions can be traced to Qur'anic verses 9:18–19 and 23:6. The choice of these verses, almost certainly used for propagandistic purposes, is already a matter of discussion.[53] However, it seems also useful to reflect on the dating of the entire plaster epigraphic band, particularly given the existence of cursive script used for the transmission of Qur'anic verses. This aspect is noteworthy indeed because, according to the current state of knowledge, the oldest cursive inscriptions (dating to the eleventh century) seem to have been meant mainly for the transmission of historical-documentary information (names and titles of authoritative figures, dates, construction texts), while Kufic writing continued to be reserved for religious expressions and Qur'anic verses.

This domed hall, once a free-standing pavilion, dates back to the reign of Malik Shāh b. Alp Arslān (r. 1073–92), celebrated in the Kufic inscription that runs beneath the dome and also mentions his powerful minister Niẓām al-Mulk. This inscription is undated but has

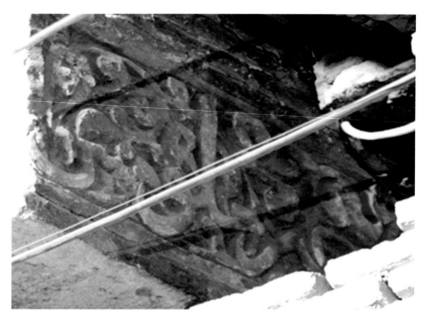

**Figure 8.4** *The Qur'anic cursive inscription in the domed hall of the Great Mosque of Isfahan. Late eleventh century, Isfahan, Iran. Source: Photograph by the author, 2014, © Roberta Giunta*

been attributed to 1086–87.[54] The epigraphic band on the northern exterior wall of the domed hall was obliterated by the addition of the southern iwan, which incorporated the pavilion into the plan of the mosque – an event variously situated during the course of restoration works after the fire that damaged the mosque in 515/1121–22.[55]

A re-examination of the archaeological data and an overall reconsideration of the Seljuq monumental inscriptions could shed light on the period when the epigraphic plaster band was created. It still remains to be determined whether it was carried out at the same time as the construction of the domed hall, or in a subsequent reworking, prior to the construction of the iwan. In the first case, it would be one of the oldest Qur'anic inscriptions in cursive script in the entire Islamic world but, above all, the first cursive Qur'anic inscription commissioned by the Seljuqs. It would in fact precede the three texts of endowment of the dome in the Great Mosque of Qazwin (509/1116).[56]

**Notes**

1. Roberta Giunta authored the section entitled *The Corpus* and the first and third cases studies; Allegranzi is the author of *Innovative Features of Epigraphy under the Turkic Dynasties* and of the second case study.
2. Among the numerous historical studies, some of the most relevant are Bosworth 1963, 1977; Biran, 'Il-Khanids'; Peacock 2010, 2015.

3. See Durand-Guédy 2010; Karev 2013; Allegranzi 2014.

4. The only two previous repertories of Islamic inscriptions are Combe, Wiet, Sauvaget et al. 1931–96 (hereafter *RCEA*), and Soudan and Kalus 2017 (hereafter *TEI*). Both of these were specifically conceived as relatively simple instruments for gathering information concerning a maximum number of epigraphic items. Given this, they do not provide for comment, nor the analysis of texts and their context. The *TEI* provides important updates to the *RCEA*, particularly concerning the inscriptions from the Eastern Islamic area, including texts in Persian and Turkic languages. The combination of these repertories thus compensates for the scarce attention provided to inscriptions from the Islamic context in the published volumes of the *Corpus Inscriptionum Iranicarum* (1955–).

5. Among the most significant studies are de Khanikoff 1862; Flury 1925; Bombaci 1966; Sourdel-Thomine 1974; 1978, 1981; Nastič and Kočnev 1995; Nastič 2000; Giunta 2005a. However, there are also studies that deal with a more substantial number of inscriptions on the basis of geographic (Babadjanov and Rahimov 2011), geographic-chronological (Blair 1992) or linguistic (O'Kane 2009) parameters.

6. See Giunta 2001, 2003, 2005a, 2010, 2015, 2017, 2018; Allegranzi 2015, 2016, 2017 and 2019.

7. Examples would be the loss of the interior wall decoration of the mausoleum of Shāh Faḍl at Safid Buland (Blair 1992, figs 76–78) and the transformation of that of the mausoleum of al-Ḥakīm al-Tirmidhī at Termez (Blair 1992, fig. 112, and Babadjanov and Rahimov 2011, p. 391).

8. See Bosworth 1963, pp. 7–24; Bartol'd 1968, pp. 1–63; Meisami 1999. Notable among more recent studies are Fourniau 2001; Herzig and Stewart 2015.

9. This investigative method had previously given encouraging results in the study of elements in the Ghaznavid and Ghurid honorifics (Giunta and Bresc 2004).

10. In 2004, Roberta Giunta was appointed vice-director of the Mission, with responsibility for the Islamic section and direction of the Islamic Ghazni Archaeological Project (Giunta 2005a). Viola Allegranzi has been a member of the mission research team since 2008. The mission has instituted an online archive (http://ghazni.bradypus.net), supported by co-financing from the Gerda Henkel Foundation and the University of Naples 'L'Orientale' (2011–13; 2019–20).

11. On this date, the city passed under the control of the Ghurid sultan Muʿizz al-dīn Muḥammad b. Sām (1173–1203), and the last Ghaznavid ruler, Khusraw Malik (1160–86), transferred to Lahore, from where he continued to exercise power until the collapse of the dynasty. It should be noted that there are no known epigraphic inscriptions from the archaeological site of Lashkari Bazar, near Bust, bearing the names of a ruler or a date from the period of Ghaznavid reign (Sourdel-Thomine 1978).

12. The Ghaznavid section of the corpus includes a small number of examples from public and private collections held in other nations. Their provenance is unknown.

13. Giunta and Bresc 2004, pp. 166–216; Giunta 2005a. The name of Muḥammad b. Maḥmūd (1030–31) appears on an emerald seal, held in a private collection (Bivar 1987; Giunta 2005a, p. 526, n. 4). Also, the names of Bahrām Shāh b. Masʿūd III and Khusraw Malik b. Khusraw

Shāh (1160–86) appear on three glass medallions: that bearing the name of Bahrām Shāh was recovered during excavations of the palace of Termez (Field and Prostov 1942, p. 145; Carboni 2001, p. 275), those with the name of Khusraw Malik are said to originate from Ghazni (Carboni 2001, pp. 272–74, nos 73a, 73b).

14. Concerning the inscriptions on the two minarets, see in particular Sourdel-Thomine 1953, pp. 108–22.

15. These inscriptions are thus far the only documentation of this building programme carried out in the capital. No relevant historiographic sources are known as of yet.

16. Kočnev 2001 offers the most thorough study on the genealogy. Relying largely on numismatic sources, the author corrects some previous interpretations of the dating.

17. On the history of the excavations at Samarqand, see Grenet 2004.

18. The existing studies on Qarakhanid inscriptions often provide imprecise or incomplete deciphering of the texts and palaeographic information, thus requiring further verification and revision. In the case of items with provenance from the regions of Samarqand and Bukhara, the study has benefitted greatly from first-person examinations by Viola Allegranzi, made possible by missions to Uzbekistan in the years 2015 and 2017 (See Allegranzi 2016; 2017, pp. 381–408).

19. Blair 1992, p. 168, no. 63. The updated chronology is based on Kočnev 2001. We also note that in recent works published in Uzbekistan the inscription is ascribed to the third quarter of the twelfth century (Babadjanov and Rahimov 2011, p. 385).

20. See Karev 2005 and Masson 1971, respectively.

21. Nastič and Kočnev 1988; Nastič 2000.

22. Blair 1992, p. 115, no. 42.

23. Âkubovskij 1947.

24. Umnâkov 1927; Nastič and Kočnev 1995. Some studies based on historical sources attribute the foundation of the Ribāṭ-i Malik to the Qarakhanid sovereign Shams al-Mulk Naṣr b. Ibrāhīm (460–72/1068–80). See Bartol'd 1968, pp. 248, 315; Karev 2013, pp. 125, 126. According to epigraphic and numismatic data, at least two individuals, a sovereign and a military commander, were involved in the construction of the southern mausoleum of Uzgend, completed by 1187 (Nastič and Kočnev 1995, pp. 190–96).

25. Some of the more in-depth studies are Kay 1897; van Berchem and Strzygowski 1910; Diez 1918; Herzfeld 1921; Gabriel 1935; Wiet 1940; Godard 1949a; Miles 1965; Grabar 1990; and Blair 1992, esp. pp. 149–52, 158–67.

26. Almost all the Seljuq inscriptions are classified in the *RCEA* (vols 7 and 8) and in the *TEI* (in both cases with previous bibliography).

27. The epigraphic fragments in terracotta recovered during the excavations at the site of Tepe Madrasa in Nishapur are now dispersed between the Metropolitan Museum of Art (New York) and the National Museum of Iran (Tehran). For these, there is a hypothesis of attribution to Malik Shāh (see Blair 1992, pp. 170–71, no. 64; Canby, Beyazit, Rugiadi and Peacock 2016, pp. 257–58, no. 162). The inscription of Khargird, also in the National Museum of Iran, could be traced to the powerful Seljuq minister Niẓām al-Mulk (Blair 1992, pp. 149–52). The inscription on the iwan of the Ribāṭ-i Sharaf seems to be the sole epigraphic document bearing the name of Sanjar b. Malik Shāh (r. 1118–57; see

Godard 1949a, pp. 10–13). Note that the inscription bearing the name of Ṭughril III b. Arslān Shāh (r. 1176–94), executed on a panel in gypsum plaster, allegedly excavated in the vicinity of Rayy (Iran) and held at the Philadelphia Museum of Art (no. 1929-69-1), is considered highly suspect (see Hillenbrand 2010; Canby, Beyazit, Rugiadi and Peacock 2016, pp. 76–77, no. 16).

28. This usage was justified on the basis of the 'theory of imamate'. On this, see Crone 2004, pp. 232–49; Campanini 2011.

29. New Persian refers to the Persian language transcribed in the Arabic alphabet, which gained widespread usage following the Islamic conquest. Note, however, that bilingual inscriptions in Arabic and Middle Persian (Pahlavi) were executed in the first half of the eleventh century in northern Iran (Blair 1992, p. 85, no. 31, and p. 88, no. 32).

30. On the introduction and expansion of Persian in Islamic epigraphy, see O'Kane 2009.

31. Umnâkov 1927; Bombaci 1966; Nastič 2000; Allegranzi 2017, 2018, 2019. An inscription in Arabo-Persian with provenance from a mausoleum built at Zalamkot (Swat, Pakistan) in 1011 (Rahman 1998), and a Buyid inscription executed at Persepolis in 1046, in which a few Persian words are inserted to communicate the date (Blair 1992, p. 118, no. 43), should also be mentioned.

32. However, it should be noted that the inscription on the mausoleum of Mu'mina Khātūn at Nakhchivan (Azerbaijan, 1186) concludes with some verses in Persian (Jacobsthal 1899, p. 21). This monument was founded by the local Eldiguzids, a very influential line of Atabegs in the late Seljuq period.

33. Concerning the use of Turkic names in the Ghaznavid period, see Bosworth 2001, where previous studies are exhaustively listed; see also Perry 2006. It is noteworthy that most studies so far have focused on the names of Turkish officers and *ghulāms*, while the issue of Turkish names and titles adopted by rulers is less investigated. An exception is represented by Pritsak's essay on the Qarakhanid lineage (Pritsak 1954), even if further numismatic studies have shown that it is not possible to deduce the hierarchy of the entire Qarakhanid family on the basis of their Turkic titles, as had been hoped (Kočnev 2001, pp. 50, 51).

34. The Buyid dynasty had already adopted the ancient Iranian title *shāhanshāh*, as early as the tenth century. See Madelung 1969.

35. Vásáry 2015.

36. See Kračkovskaâ 1949; Volov 1966. Very few monumental epigraphs have been conclusively ascribed to the Samanid rulers, making it difficult to reconstruct accurately the evolutionary process of writing styles in the Khurasan and Transoxiana regions, which may have begun as early as the first half of the ninth century.

37. The most distinctive are the different Kufic styles with ornamental apexes, and above all what is known as floriated Kufic (see Grohmann 1957; Tabbaa 1994; Blair 1992).

38. The term derives from the French 'coufique à bordure ornementale', first used by Flury 1925.

39. See Blair 1992, pp. 149–52.

40. This fragment was first reported by Bivar 1986.

41. Giunta 2001; Giunta 2005a, pp. 527–28, 532–34.

42. Flury 1925, pp. 74–75, no. 3, pl. XIII.I.

43. We greatly appreciate the painstaking work of Dr Martina Massullo, in

locating and geo-referencing information from the *ziyārāt* of the city, and of her development of a map with indications of cemetery areas (Massullo forthcoming).

44. Giunta 2001, pp. 534–35.

45. Ibid. pp. 528–29.

46. Umnâkov 1927 provided the first epigraphic study on the monument, whose ruins have attracted scholarly attention since the mid-nineteenth century.

47. See Karev 2013, p. 126 (with bibliography). Nemceva 2009 provides the most recent summary of archaeological research on Ribāṭ-i Malik.

48. Umnâkov 1927, pp. 187–88, published a Qur'anic inscription recorded from a minaret, in the southwest corner of the site, which was later destroyed. Nemceva 2009, figs 61, 63, also documents a fragmentary inscription found inside the complex, attributed to the twelfth century for archaeological and stylistic reasons.

49. See, for example, Blair 1992, p. 153, no. 58.

50. The reading of the inscription by Umnâkov 1927, p. 187, is repeated by Bombaci 1966, p. 37 – who notes certain similarities with the poetic inscriptions of the Ghaznavid palace at Ghazni – and by Blair 1992, p. 153, no. 58. A slightly different version, still with omissions, is provided in Babadjanov and Rahimov 2011, p. 493.

51. The last character is damaged and an alternative reading of the passage would be *rā[d] khulq*—that is, 'generous disposition'.

52. The damaging and restoration of the two jambs of the archway prevent us from defining the length of the lacunae at the beginning and end of the text.

53. See in particular Grabar 1990, pp. 32–33; Scerrato 1994.

54. See, for example, Blair 1992, pp. 160–63.

55. A Seljuq inscription which celebrates the restoration of the building following the fire is carved on the north-eastern gate of the mosque (see Giunta 2018, pp. 13–14).

56. *RCEA*, vol. 8, nos. 2965–67.

# CHAPTER NINE

## Inscribed Identities: Some Monumental Inscriptions in Eastern Anatolia and the Caucasus

*Patricia Blessing*

STUDIES ON INSCRIPTIONS in medieval Islamic monuments in Anatolia have primarily concentrated on the historical content, including the date of the foundation and the patron. Often more so than chronicles of the time, inscriptions reflect the complex dynamics of religious and political identity, language and frontier cultures that were at stake in late-thirteenth-century Anatolia, as the region shifted between Seljuq and Mongol rule.[1] Inscriptions became an expression of a frontier society at the intersection between Byzantium, the Christian kingdoms of the Caucasus and the Islamic world. Based on case studies of architecture and epigraphy, this chapter discusses the location of inscriptions on buildings, exploring how these placements, together with the use of different types of script materials and sizes, were part of a carefully conceived scheme.[2] This analysis will show that inscriptions were placed deliberately in order to establish a specific way of perceiving the monument and its patron.

Carved in stone or inlaid in cut-tile mosaic, foundation inscriptions and other monumental inscriptions in medieval Anatolia are largely in Arabic, although there also exist Persian ones, such as the no-longer extant quotations from the *Shahnama* on the city walls of Konya, as mentioned by Ibn Bibi, historiographer and author of the major chronicle of the history of the Rum Seljuq Sultanate in the thirteenth century.[3] Qur'an passages are important elements in overall programmes of inscriptions in a monument; yet often they have not been well studied and are neglected in many of the epigraphic surveys.[4] Full inscription cycles can serve as guides through the building and confer a carefully crafted view of the patron. This observation points to the problem of literacy and the question of how widespread an understanding of the formulaic Arabic in these texts was in Anatolia, where Greek, Armenian and Turkish were dominant, while Persian was the literary language of the Seljuq court.[5]

## Late-thirteenth-century inscriptions in Sivas: the Çifte Minareli Medrese and the Buruciye Medrese

The Çifte Minareli Medrese in Sivas (Figure 9.1) is one of three monumental *madrasa*s built in this city in 1271–72.[6] The portal of the monument reflects what is considered typical for pre-Ottoman Islamic architecture in central and eastern Anatolia, such as the central portal with a *muqarnas* niche above the doorway, and a set of sculpted frames that form three sides of a rectangle on the façade, as it was consolidated in the first half of the thirteenth century, particularly during the reign of 'Ala al-Din Kayqubad (r. 1220–37).[7] (Unlike many examples such as the Sultan Han near Kayseri built in

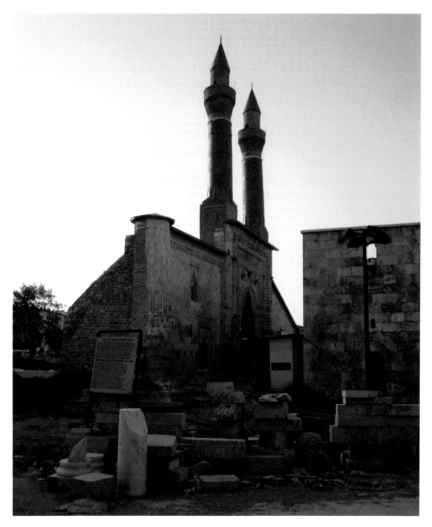

**Figure 9.1** *View of the Çifte Minareli Medrese. 1271–72, Sivas, Turkey. Source: Photograph by the author*

1232, the Çifte Minareli Medrese does not, however, have a salient portal block.) The minarets of the Çifte Minareli Medrese, built in brick and adorned with tiles, are considered an import from Iran. The stone carving on the portal, with its floral motifs jutting out from the surface of the wall, shows close connections to other monuments in the region of Sivas.

The patron of this monument, Shams al-Din Muhammad al-Juwayni (d. 1284), was not a Muslim ruler of Anatolia. Rather, he was a dignitary of the Mongol court in Iran and with no known connections to Anatolia, as far as chronicles relating to the region and to the Mongol Ilkhanids in Iran of the same period tell us, except for an oft-cited episode in which Juwayni intervened with the Ilkhanid ruler Abaqa Khan to protect Sivas from looting.[8] The foundation inscription on the portal of the Çifte Minareli Medrese uses royal titles for the patron and omits the name of a ruler, breaking the epigraphic protocols for foundation inscriptions in Seljuq Anatolia, which in turn were based closely on those used in Zangid and Ayyubid Syria.[9] This points to the power vacuum in Anatolia at the time, in the decades following the Mongol conquest of Anatolia in 1243. At that time, the Seljuq sultans of Anatolia were relegated to the role of nominal rulers and progressively lost more and more of their power over the course of the second half of the thirteenth century. From the 1240s to the 1280s, former Seljuq notables such as Jalal al-Din Qaratay (d. 1254) and Sahib 'Ata Fakhr al-Din 'Ali (d. 1285) took over in collaboration with the Mongols and became major patrons of architecture in cities across Anatolia.[10] This situation further bolstered the confidence of an Ilkhanid vizier like Shams al-Din Muhammad al-Juwayni who in 1271 acted with ease fairly independently on the frontier of the Mongol realm and, moreover, under the aegis of an overlord who had not yet converted to Islam.[11]

The situation began to change after the Mamluks invaded Anatolia in 1277 and briefly threatened the Ilkhanid realm. At that point, the Ilkhanid rulers began to impose closer control on the region; beginning with Ghazan Khan's conversion to Islam in the 1290s, the Ilkhanid rulers were named as overlords in the foundation inscriptions of central and eastern Anatolia. The Seljuqs, in turn, nearly disappeared from the epigraphic record, with the exception of small foundations in cities such as Tokat, where occasionally the utterly powerless Seljuqs are still mentioned in the early fourteenth century.[12] The Seljuqs slowly disappear from the historical record, and Ghiyath al-Din Masud II (d. 1308 or 1310) is the last of their dynasty to be mentioned in any inscription.s[13]

In foundation inscriptions, often applied to portals, the standards of epigraphy and titles closely resemble those consolidated in the Islamic world by the twelfth century, and there exist parallels particularly close to Ayyubid examples in northern Syria.[14] The Madrasa al-Firdaws in Aleppo (Figure 9.2), founded in 1235–36, shows an

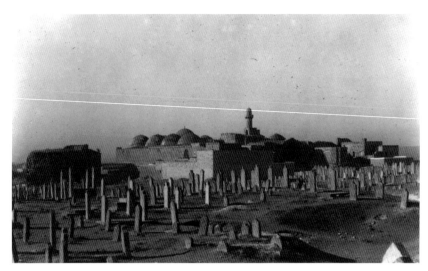

**Figure 9.2** *View of Madrasa and Mosque al-Firdaws. 1235–36, Aleppo, Syria. Source: Photograph by K. A. C. Creswell, Ashmolean Creswell Archive, EA.CA.5837, © Ashmolean Museum, University of Oxford*

inscription in the foundation of a royal female patron, Dayfa Khatun. The overall logic of including patron and overlord, along with copious amounts of praise and information about the monument and its date, is the same as in those inscriptions made for male patrons, even though some titles are gendered.[15] Thus, inscriptions were part of a larger Islamic vocabulary of rule and public display of power that the Seljuq sultans in Anatolia had adopted.

A further example of the use of inscriptions in medieval Anatolia is the foundation inscription on the portal of the Buruciye Medrese in Sivas (Figure 9.3), built in the same year as the Çifte Minareli Medrese. The inscription mentions the name of the patron (al-Muzaffar b. Hibatallah al-Barujirdi), the name of the ruling Seljuq sultan and the date of construction:

> This madrasa was built in the days of the rule of the great sultan Ghiyath al-Dunya wa-l-Din Abu'l-Fath Kaykhusraw b. Qilij Arslan – may God perpetuate his rule – by the weak slave, who is in need of the mercy of his forgiving Lord, al-Muzaffar b. Hibatallah al-Barujirdi – may God forgive him and his parents and all Muslims – in the months of the year 670 (1271–72).[16]

When facing the Buruciye Medrese, however, the viewer immediately notices another large inscription in *naskhi* script, running along the façade just below the cornice (Figure 9.4), to the left and right of the portal. It was first published by Max van Berchem and Halil Edhem in 1917 and was too poorly preserved to allow for a full reading, but might perhaps be a prayer or religious invocation.[17] The importance

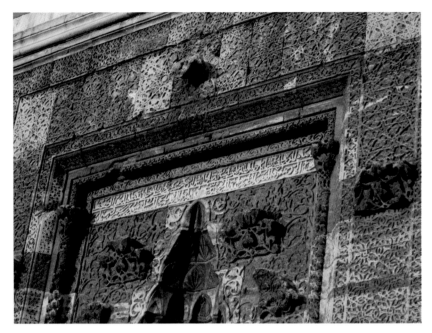

**Figure 9.3** *Foundation inscription of the Buruciye Medrese. 1271–72, Sivas, Turkey. Source: Photograph by the author*

of this inscription for the overall programme is obvious from the way in which the large letters dominate the façade. This inscription takes visual precedence over the foundation inscription on the façade, presenting the founder's prayer to God in a prominent manner: it is written in much larger script than the foundation inscription, even if both are placed relatively high up on the façade, above the *muqarnas* niche. Moreover, the foundation inscription is placed on a rectangular slab of stone placed above the *muqarnas* niche and only extends as far as the width permitted by the innermost frame of the portal block.

The pattern of subordinating historical inscriptions to those of religious content is repeated throughout the Buruciye Medrese. The self-representation of the patron tends towards a stylisation of piety with a preeminence given to sacred texts. By contrast, the historical inscriptions are more difficult to decipher because of their less visible placement and smaller script. Upon entering through the portal, the viewer is faced with the main *iwan* at the north-eastern end of the building. A large inscription carved in *naskhi* script on a background of scrolls and tendrils forms a frame to its opening (Figure 9.5). The text of the inscription is the so-called Throne Verse (Qur'an 2:255), a common passage in building inscriptions across the medieval Islamic world.[18] For instance, in the Gök Medrese in Tokat, an undated monument built probably in the 1270s or 1280s, the same verse is placed as a band on the main *iwan*, again in monumental cursive

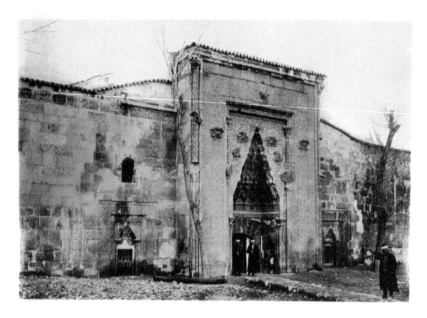

**Figure 9.4** *View of the Buruciye Medrese. 1271–72, Sivas, Turkey. Source: Max van Berchem and Halil Edhem (Eldem),* Matériaux pour un Corpus Inscriptionum Arabicarum: Troisième Partie: Asie Mineure *(Cairo: Imprimerie de l'Institut français d'archéologie orientale du Caire, 1917), plate XXIII*

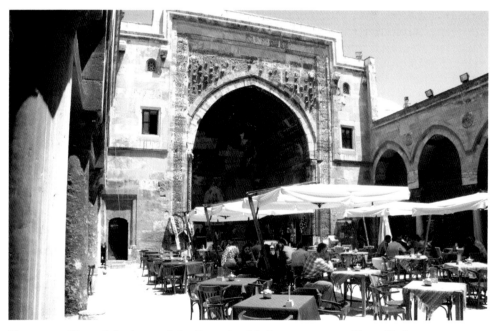

**Figure 9.5** *View of the* iwan *of the Buruciye Medrese. 1271–72, Sivas, Turkey. Source: Photograph by the author*

script, yet rendered in coloured tile mosaic rather than carved in stone.[19] In both monuments, the large letters of this inscription, rendered on a background of vegetal scrolls, immediately attract the gaze to the main *iwan*.

In the Buruciye Medrese, a further inscription band runs around the interior of the main *iwan*, at a height of about two metres above the floor level. This inscription is badly deteriorated to the point of being illegible in most parts; yet, the *basmala* at its beginning suggests perhaps a religious text, or at least that a Qur'anic or hadith passage might have followed afterwards, even if another text (possibly historical in nature) followed later.[20] Use of the *basmala* at the start of inscriptions is not consistent in Seljuq and Ilkhanid Anatolia. In the Sahib Ata Mausoleum in Konya, for instance, an inscription dated to 1283 includes Qur'an passages, hadith and historical content (in that order); rather than with the *basmala*, it begins with the invocation *qawluhu subḥānuhu ta'ālā* – that is, 'His word, his glory, [God] the All-high'.[21] The script and the horizontal positioning of the inscription reflect its counterpart on the façade of the building. By that token, the dominant position of the sacred text over the historical record of the founder's actions is transposed into the interior: the text of the foundation inscription, identical to that on the façade described above, appears on eight medallions that are placed in the spandrels of the arches forming arcades on the two long sides of the courtyard (Figure 9.6). Also carved on medallions of stone are extracts from the *waqfiya* of the *madrasa*. These medallions are no longer integrated into the walls of the building but stored in the main *iwan*; their original location has not been reconstructed.[22] Therefore, limits emerge with regard to an argument based on the placement of these texts. With the addition of his mausoleum within the *madrasa*, in a domed chamber located to the left of the portal, the founder al-Muzaffar b. Hibatallah al-Barujirdi assured that the foundation would be connected with his name. Inside the mausoleum, the brick dome is decorated with blue and turquoise tile work, and an inscription at the base of the dome refers to the patron's burial. Qur'anic inscriptions visually dominate the programme; they are located in the most conspicuous places of the building, such as the façade of the main *iwan*, and carved in larger script than those of historical content. Thus, the message of the founder's piety shifts to the foreground, a pattern that continues throughout the building.

The exact setup of epigraphic programmes is often difficult to trace elsewhere, for two reasons: first, full inscription programmes have not been examined for many medieval buildings in Anatolia, and, second, inscriptions have often been damaged or disappeared entirely. However, there exist other monuments that provide insights into the complex ways in which epigraphy did the work of propaganda and identity formation. For the Karatay Madrasa in

**Figure 9.6** *View of the courtyard arcade with inscription medallions of the Buruciye Medrese. 1271–72, Sivas, Turkey. Source: Photograph by the author*

Konya (649/1252, portal possibly 1220s–30s), built by Jalal al-Din Qaratay, Scott Redford has argued that its complex inscription programme emphasises the founder's piety, the building's role in providing education, as well as the political realities of the day.[23] In particular, intercession emerges as a prominent theme – an important aspect, as Redford notes, in this funerary *madrasa* commissioned by an elderly patron.[24] With the Mongol conquest of Anatolia and the disappearance of direct patronage by the Seljuq sultans, inscriptions changed, and some patrons took considerable freedom in using royal titles, as the case of the Çifte Minareli Medrese in Sivas shows. As noted above, for the most part standard epigraphic protocol was still observed, and the powerless Seljuq sultans continued to be mentioned as overlords, even though the Mongols were actually in charge. This changed once the Ilkhanid sultans converted to Islam towards the end of the thirteenth century: they were now absorbed into those same epigraphic protocols that had been established for the Muslim rulers of Syria in the late twelfth century.

### Patrons and architects in Ilkhanid inscriptions

The foundation inscription of the Yakutiye Medrese in Erzurum, built in 1310, is one such example (Figures 9.7). The patron, Jamal

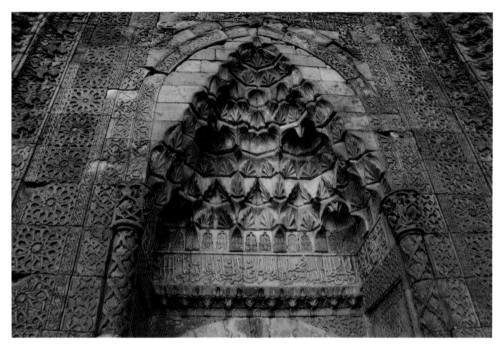

**Figure 9.7** *Detail of the portal of the Yakutiye Medrese. 1310, Erzurum, Turkey.*
*Source: Photograph by the author*

al-Din Yaqut al-Ghazani, is named along with the ruling Ilkhanid
sultan, Uljaytu (r. 1304–16). Moreover, the previous Ilkhanid sultan,
Ghazan Khan (r. 1295–1304), and one of his wives are mentioned.[25]
The patron's *nisba*, al-Ghazani, might suggest a patronage connec-
tion between Ghazan Khan and Jamal al-Din Yaqut in his earlier
career. Inside the building, a long *waqf* inscription gives a detailed
account of property connected to the monument (Figure 9.8). The
first part of the inscription refers to the patron and his allegiance to
the Ilkhanid ruler; it then begins to describe the properties belonging
to the endowment.[26] These include villages in the region and proper-
ties within the cities of Bayburt and Erzurum. The second part of
the inscription continues to list villages and urban properties that
provided income for the maintenance of the monument. Explicitly,
it mentions the 'well-known baths that the founder built in Bayburt',
which have not been preserved. This indicates that Jamal al-Din
Yaqut commissioned other monuments. These pieces of information
form a detailed record about the Yakutiye Medrese and its patron,
unequalled in the narrative sources of the period. Hence, the inscrip-
tions are a crucial source for architectural history, in that they are
often the only textual record available about a specific building.
This is the case for the Yakutiye Medrese and its patron, as well as
for the Buruciye Medrese, in terms of references to further buildings
sponsored by the same patron, if these are no longer extant, and

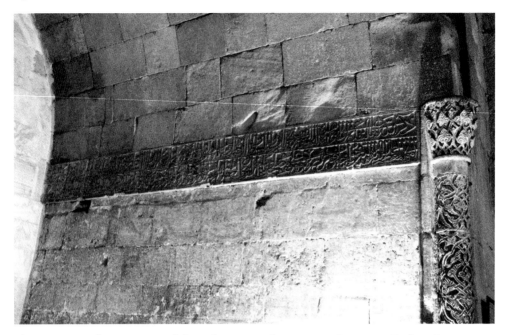

**Figure 9.8** Waqf *inscription of the Yakutiye Medrese. 1310, Erzurum, Turkey. Source: Photograph by the author*

details about a patron's titles and date of death, if a mausoleum is part of the structure.

So far, the inscriptions discussed here have yielded information about the patrons, but not the makers of the monuments. Rare signatures of such figures involved in the creation of buildings – other than the patrons – are the only hints at the identity of those who created these monuments. Signatures appear on several buildings commissioned by Sahib 'Ata Fakhr al-Din 'Ali, a statesman who rose to power amidst the succession conflict between two Seljuq pretenders in the 1260s and who managed to make arrangements with the Mongol overlords to stay in power until his death in 1285.[27] Two of the monuments that were commissioned by Sahib 'Ata Fakhr al-Din 'Ali and show the signature of one Qaluyan are the Sahib 'Ata Complex in Konya (1258–85) and the Gök Medrese in Sivas (1271–72).[28] The fact that the signatures in Konya and Sivas are prefaced with the general phrase 'work of . . .' ('*amal*, in Arabic) poses the further problem of assessing his role. Often, Qaluyan has been described as an architect; yet, he could also have been responsible for the stone carving on the portals, or for the tile work. The name is not a Muslim one, but was Qaluyan Armenian or Greek? Where was he from? Had he converted to Islam? In this case, the inscriptions do not even come close to giving a satisfactory answer to questions about builders.

## Armenian inscriptions in the Ikhanid empire:
## Mren, Selim Caravanserai

There is no room here for a full discussion of Armenian epigraphy in medieval Anatolia and the Caucasus; hence, the present focus will be on a few examples from the late thirteenth and early fourteenth centuries. In Mren, an Armenian site near the medieval city of Ani in northeastern Anatolia, a certain Samadin acquired the area from its Mkhargrdzeli governors in 1261 and built a palace in 1276.[29] The inscription reads:

> In the year 710 in the time of the rule over the world of Hulegu Khan, I, Sahmadin, son of Avetik, bought this kingly place from Artashir, son of Shahinshah for the acquisition of means for my benefit and that of my children. May God allow us to benefit from them for eternal time.
> In the year 725 in the time of Abaqa Khan, just as the baron did not have a summer residence and palace, I, Samtin, bought these vineyards and gardens that are called Arkaiutyun (kingdom), each one from its respective owner, inscribed in my mind, without [building] master, the plan, laid out the foundation of this palace and garden and finished it in ten years. May God allow the Baron Sahmadin to benefit from them from generation to generation. 40,000 gold *dinar* were spent on this palace.[30]

The inscription, now completely destroyed along with most of the palace, was located above the ruins of a portal in the photographs that archaeologist Nikolai Marr took of the monument during his fieldwork in the late nineteenth century.[31] Since the structure was already badly damaged when it was first recorded, it is not possible to make an argument that takes into account a larger inscription programme that might have existed. The palace recalls the post-Mongol monuments of Sivas and Erzurum – in particular those of the latter city, with their close connections to Armenian architecture and more broadly conceived references to Islamic architecture, such as the *muqarnas* on the portal. As Mattia Guidetti has argued for the early-thirteenth-century church of St Gregory in Ani, commissioned by the merchant Tigran Honents, patrons in Ani as well as Mren specifically chose such forms, not as references to particular buildings or to Islamic architecture *per se*, but to participate in a broader, cross-cultural elite context that includes Islamicate forms.[32] The inscription is written in the first person (not unusual for medieval Armenian inscriptions) and tells a story of the patron's confidence and wealth. Thus, in terms of the content recorded, there are some similarities between this inscription and those on the buildings that Muslim patrons commissioned, as discussed in the previous examples: titles, names and financial aspects (even though in Islamic

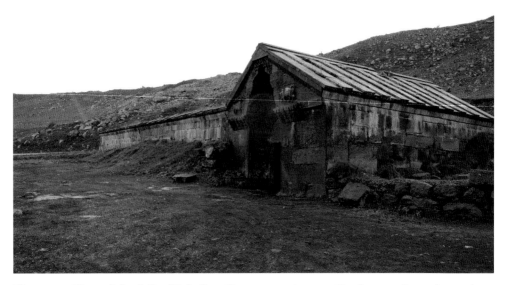

**Figure 9.9** *View of the Selim/Orbelian Caravanserai. 1332, Vardenyats Pass, Armenia.*
*Source: Photograph by the author*

architecture the latter notion is recorded in *waqf* inscriptions, rather than foundation inscriptions).

In present-day Armenia, on the Vardenyats Pass along the road leading from Areni to the southern shore of Lake Sevan, the so-called Selim or Orbelian Caravanserai (Figure 9.9) built in the early fourteenth century offers insights into the connections between epigraphic traditions. Over the entrance of the monument, rows of *muqarnas* affirm the use of such elements in the architecture of the region, and more *muqarnas* are found around the skylights inside. In the interior of the building, just to the right of the entrance, an elaborate inscription in Armenian states (Figure 9.10):

> In the name of the Almighty and powerful God, in the year 1332, in the world-rule of Busaid Khan, I, Chesar son of Prince of Princes Liparit and my mother Ana, grandson of Ivane, and my brothers, handsome as lions, the princes Burtel, Smbat and Elikom of the Orbelian nation, and my wife Khorishah daughter of Vardan [and] of the Senikarimans, built this spiritual house with our own funds for the salvation of our souls and those of our parents and brothers reposing in Christ, and of my living brothers and sons Sargis, Hovhannes the priest, Kurd and Vardan. We beseech you, passersby, remember us in Christ. The beginning of the house [took place] in the high-priesthood of Esai, and the end, thanks to his prayers, in the year 1332.[33]

On the left side of the entrance, an inscription in Persian was hastily cut into the stone and is only partially legible.[34] It is unclear

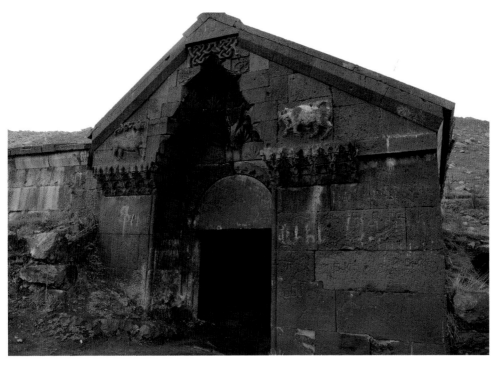

**Figure 9.10** *Portal of the Selim/Orbelian Caravanserai, Vardenyats Pass, Armenia. 1332. Source: Photograph by the author*

when the Persian inscription – which, to my knowledge, has been neither read nor published – was added to the building. While an Arabic inscription located on the tympanum over the entrance has been published, it is no longer legible; only faint traces remain.[35] In published versions of the text, this inscription contains the name of the Ilkhanid Sultan Abu Sa'id (r. 1316–35) who formally served as the overlord of the region since it was part of the Ilkhanid realm, but the caution remains that I am unable to verify the contents of this lost inscription.[36] The Selim Caravanserai was part of the same trade network that provided an essential link between central eastern Anatolia and western Iran, and additional caravanserais were built on this stretch of road in the late thirteenth and early fourteenth centuries.[37] The fact that the patron of the Selim Caravanserai was a local Armenian prince points to the notion that here, as in Anatolia, local patrons took over construction projects and asserted their political and religious identities.

The connections to the trade routes running from Iran to the Mediterranean and the Black Sea link the Selim Caravanserai to the same networks that were crucial for the wealth of the merchants of Mren and Ani, and they also enabled the Seljuqs and later the Ilkhanids to benefit economically from their hold over Anatolia. Political and religious identities appear in the content of inscriptions, often quite

explicitly so with references to Qur'an passages and with the various titles used by these patrons – be it in an Islamic or Christian context, each with its own conventions when it comes to presenting politics in epigraphy. Cultural identity, while difficult to separate precisely from religious affiliations, is to some extent reflected in the language of inscriptions. This is perhaps more so the case in Armenian and Georgian ones,[38] where there is an overlap with the languages that the patrons spoke. By contrast, in the Seljuq and Ilkhanid contexts inscriptions are largely in Arabic (and, more rarely, in Persian), while the patrons spoke an assortment of languages: Turkic dialects, Mongolian, Persian (for instance, in the case of a patron like Shams al-Din Juwayni) and maybe even Chinese. Still, similar intentions were behind the inscriptions – assertion of a patron's role, identity, wealth and political allegiance – even if the epigraphic conventions in Armenian and Arabic were vastly different. And in all these cases discussed above, placement and visibility mattered, as did careful carving (or placement of pieces in cut-tile mosaic) along with calligraphy. Such inscriptions and their use in monuments illuminate the larger problem of cross-cultural identities that often are much more complex than the presumed divisions between Muslim and Christian patrons, and between cultural groups.

## Notes

1. Yıldız 2006; Blessing 2014.
2. Blessing 2013, pp. 431–46.
3. Yalman 2011; Yalman 2012, pp. 151–86.
4. Gharipour and Schick 2013, pp. 1–9; Eastmond 2015b, pp. 3–9.
5. Hillenbrand 2005, pp. 157–69; Melville 2006, pp. 135–66; Ettinghausen 1974, pp. 297–317.
6. For a full discussion, see Blessing 2014, pp. 69–122.
7. Wolper 1999, pp. 65–80; Ünal 1982.
8. Rashid al-Din 1957, vol. 3, pp. 144–47 of the Persian text and vol. 3, pp. 90–91 of the Russian translation; Rashid al-Din 1998, vol. 3, p. 537; Aubin 1995, p. 24. On Juwayni, see also Spuler, 'Djuwaynī'.
9. On the formation of epigraphic protocol in Zengid Syria and its relevance for later dynasties, see Elisséeff 1952–54.
10. Crane 1993; Rogers 1971; Blessing 2014, pp. 7–13 and 39–66. For the historical background on this period, the most detailed study is Yıldız 2006.
11. Blessing 2014, p. 129.
12. On this transformation of inscriptions and for examples in Tokat, see Blessing 2014, pp. 183–92.
13. Cahen 2001, p. 225; Blessing 2014, p. 129, n. 13.
14. There is no systematic, transregional study of this question. For the Zengids and a discussion of some of the general principles of rulers' titles, see Elisséeff 1952–54. For Ayyubid examples, see the survey of Ayyubid monuments in Egypt and Syria in Korn 2004, pp. 162–70; for Ilkhanid architecture, the most comprehensive study remains Wilber 1955, even though epigraphic programmes are not systematically dis-

cussed there. For examples in Iran, see the catalog of monuments up to 1106 in Blair 1992, pp. 17–210.

15. Tabbaa 2000, pp. 17–34.
16. Arabic text in Blessing 2014, p. 90; *RCEA*, no. 4642.
17. Blessing 2014, p. 92.
18. Dodd and Khairallah 1981, vol. 1, pp. 64–65, and examples from Anatolia, Egypt, India, Iran Sicily, and Greater Syria in the index of verses, vol. 2, pp. 9–19 (also ones that extend to include adjacent verses 2:254 and 2:256–57). As Gharipour and Schick note, Dodd's and Khairallah's conclusions are hampered by the limited scope of material included in their study; see Gharipour and Schick 2013, p. 8. The verse also appears in the Karatay Madrasa in Konya; see Redford 2015b, p. 155.
19. Blessing 2014, plate 5.
20. In post-Mongol and pre-1340 architecture in central and eastern Anatolia, the author has not encountered inscriptions that start with the *basmala* and then immediately move to a foundation text.
21. For the full inscription in English and Arabic, see Blessing 2015.
22. *Waqf* inscriptions were more common in Ayyubid than in Anatolian Seljuq architecture; see Korn 2004, vol. 1, pp. 168–70.
23. Redford 2015b.
24. Ibid. pp. 164–65.
25. 'Jamāl al-Dīn Khwāja Yāqūt al-Ghāzānī ordered the construction of this tomb during the days of the rule of Uljāytū sulṭān – may God eternalize his rule – from the benefits of the benefaction of Sulṭān Ghāzān and Bulughān Khātūn may God enlighten [their proof] in the year 710 (1310)'. See Blessing 2014, p. 144; *RCEA*, no. 5276.
26. For the full text of the inscription in Arabic and English, see Blessing 2014, pp. 154–56.
27. On his life, see Cahen 2001, pp. 190–95.
28. Brend 1975, pp. 160–85; Tuncer 1985; Kâhya et al. 2001, vol. 1, pp. 441–49 and 690–701; Blessing 2014, pp. 115–17.
29. Manandian 1965, pp. 178, 187–90. For images, see: http://www.virtualani.org/mren/index.htm (accessed 1 February 2018). On cross-cultural interactions in medieval Ani, see also Shkirtladze 2018.
30. Author's translation after the Russian translation in Marr 1893–94, pp. 82–83.
31. Image published in Marr 1893–94, p. 82.
32. Guidetti 2017, pp. 155–87. For the overall scope of cross-cultural interaction in the eleventh- to fourteenth-century eastern Mediterranean, see Hoffman and Redford 2017. Related discussions on the Caucasus are found in Foletti and Thunø 2016.
33. http://www.armeniapedia.org/index.php?title=Selim_Caravanserai (accessed 1 February 2018). For a plan of the monument, see https://sites.courtauld.ac.uk/crossingfrontiers/armenia/selim-caravansarai/ (accessed 21 February 2018).
34. During my visit to the site in April 2016, heavy rain made it impossible to take clear photographs of the inscription or to create a squeeze.
35. Author's observation on site, 27 April 2016.
36. Harut'yunyan 1960, pp. 17–26 and 128; Iakobson 1950, p. 105.
37. Ünal 1969–70; Gündoğdu 1998, 2007, p. 408; Blessing 2014, pp. 178–79.
38. For medieval Georgian inscriptions, see Eastmond 2015c.

CHAPTER TEN

# Grasping the Magnitude: Seljuq Rum between Byzantium and Persia

*Rustam Shukurov*

THE ANATOLIAN MULTILINGUAL and multicultural space from the twelfth through the beginning of the fourteenth centuries evades generalising appraisal. Our vision of Anatolian culture is rather fragmented and hence simplified. One scholarly optics deals with Muslims only; another focuses exclusively on the surviving Byzantine Greek cultural vestiges; yet another considers the area as being predominately Turkic or Armenian; and so forth. As a result, we are thus far unable to elaborate any clear vision of the Anatolian space as a single whole with all its ethnic, cultural and religious diversity.[1]

As it seems, one of the problems consists of the fact that we are unable to elaborate a uniform methodology in our description strategies towards various segments of the Anatolian cultural space – that is, Christian Greek, Christian Georgian, Christian Armenian, Muslim Persian and Kurdish, Muslim Turkic, Christian and Muslim Arabic, Christian Syriac and so on. Different ethno-cultural entities require different analytical optics, primarily due to substantial differences in the source-base surviving from each cultural segment. Another problem consists in the still poorly studied invariant features of an Anatolian mentality, which were common to all the ethno-cultural segments formed in the very specific circumstances of cultural and mental *polyglossia*. The discrepancy of methodologies and still unresolved problems of a specific Anatolian mentality are the main obstacles that prevent us from giving a balanced general description of Anatolian culture.

In this essay, I would like to illustrate the noted methodological difficulties and also look for some new approaches in an attempt to grasp the immensity of the Anatolian multilingual and multicultural space. I will focus on Greek and Persian ethno-cultural identities which, as I will show, constitute two major forces within Anatolian culture.

## Anatolian Romanness

Let me first illustrate the peculiarity and even oddness of Anatolian local mental patterns. Muslim Anatolia under the Seljuqs was known to its neighbours by many names. I will focus on the two most prevalent designations for Anatolia: 'Rome' and 'Persia'.

The immediate neighbours to the East normally designated Byzantium as 'Rome', 'Roman lands' (and its inhabitants as 'Romans'): Armenians called the land Հռովմ/Հռովմ *horom/hrom*, Georgians ჰრომ *hrom*, Syrians ܪܗܘܡܝ *rhōmī*, and Persians and Arabs روم *rūm*. Apparently, all these terms went back to the interconnected Aramaic רהומא/ܪܗܘܡܝ, *rhōmī* and Parthian *frwm* which designated 'Rome' and the 'Roman Empire' and derived from the Greek Ῥώμη. The Parthian designation for 'Rome' differs from the Aramaic and Syriac phonetic shapes of the term in its spelling of the Ancient Greek aspirated *rho*. It was the Parthian form which subsequently was borrowed by the Pahlawi (*hrōm*, also the Sogdian *βr'wm*), Armenian and Georgian. The Arabic and New Persian languages inherited the Pahlawi *hrōm* with the omission of the aspirated component in the Ancient Greek *rho*.

It was the Parthian and Aramaic form that subsequently was borrowed by the Pahlawi, Armenian, Georgian, Arabic and finally Neo-Persian and Turkish languages.[2] The term came into common usage during the Roman conquests of the Eastern Mediterranean – that is, in the first century BC. Subsequently, Byzantium regarded itself as the continuation of the Roman Empire and was also regarded as such by its Eastern neighbours, who continued to designate the Byzantines as 'Romans' and their state as the 'Roman' state. In the eleventh through fourteenth centuries, the terms listed above were reserved primarily for designating Byzantium.

However, quite curiously, after the Seljuq conquest of Anatolia in the last decades of the eleventh century, both Muslim and Christian authors of the Orient kept identifying Muslim Anatolia as the 'Roman land' and its inhabitants as 'Romans' – or, in our terms, as 'Byzantium' and the 'Byzantines'. Of course, although the term 'Rūm' as applied to Muslim Anatolia denoted the 'Muslim segment of Byzantium', the main emphasis in the semantic content of 'Rūm' here was unmistakably on 'Byzantium'.[3]

Of course, the contemporaries had good grounds to keep designating Muslim Anatolia as 'Roman lands'. The only summarising picture of the Greek Christian population and culture in Anatolia of the twelfth to thirteenth centuries belongs to the pen of Vryonis and needs to be further developed and detailed.[4] In many regions and especially urban areas, the Greek Orthodox population had been for many centuries fairly numerous and might have constituted a majority. Before the population exchange between Turkey and Greece in the 1920s, there were more than one million Greeks in Anatolia, or about 10 percent of the entire population (according to the Ottoman

census of 1914).[5] Consequently, it can be assumed that in previous times and especially in the twelfth and thirteenth centuries the percentage of Greek Christians was significantly larger. William of Rubruck maintained that, 'As regards Turkia, you should know that not one man in ten there is a Saracen: on the contrary, they are all Armenians and Greeks',[6] thus suggesting that Muslims were less then 10 percent of entire population. Rubruck's ratio seems plausible.[7]

In fact, many Greeks in Muslim service are found in the sources of the twelfth and thirteenth centuries, including both common persons and nobles, local Greeks and defectors from Byzantium who left their homeland for various reasons, Christians and converted Muslims. Christian contingents in the army of Anatolian Muslims received mention in thirteenth-century sources; one may think that these incorporated local Greeks. There existed houshold slaves and freedmen who could rise to great heights in the political hierarchy of Muslim states.[8] The profound influence of Greeks in Muslim Anatolia was caused not only by their great numbers, but also by their retaining, reproducing and developing prestigious Byzantine everyday culture, cuisine, craftsmanship and so on. Greek artists and architects worked for Muslim patrons. Greek women, who were supposed to transmit their cultural experience to their children, were desirable nuptial partners for non-Greeks of all social standing. Anatolia, and especially its central and eastern parts, was incorporated into the ecclesiastical administrative system of the Constantinopolitan Patriarchate and was covered by the network of metropolitans and bishoprics that nurtured the local Christians. In addition to the Greek Orthodox sees, the Syrian Melkite church flourished in nearby Diyarbakr, while the Armenian church was active in Erzincan. It must be emphasised that the metropolitan sees and bishoprics functioned only in those areas where the Christian population was large enough. The Christian religion, being a part of cultural tradition, circulated throughout sedentary zones; moreover, it could have been practiced even by those who formally professed Islam. As one of the official languages, Greek was common in the chanceries of local Muslim rulers. Moreover, the Greek tongue, on the level of informal everyday communication, played the role of *lingua franca* between the speakers of different languages. Many of these aspects of Byzantine Greek presence in Anatolian culture are well-known and well-studied.[9]

To illustrate the profound entrenchment of Byzantine cultural tradition in the Anatolian mentality, I will refer to a precedent coming from diplomatic relations. According to Rashīd al-Dīn, in 1258 the Seljuq sultan 'Izz al-Dīn Kaykāwus II (r. 1246–62) paid a visit to the Mongol Khan Hulagu (r. 1256–65), bringing among other gifts a pair of deluxe royal boots decorated with a portrait of the sultan himself:[10]

Hulagu-khān was angry with the sultan 'Izz al-Dīn for his dis-respect towards Bayju Noyon and the battle against the latter. After the conquest of Baghdad, the sultan 'Izz al-Dīn became very apprehensive and decided to rescue himself from the abyss of that crime with subtle cunning. He ordered boots to be sewn, extremely beautiful and kingly, and his portrait was depicted on their *na'lcha*. During the gift-giving ceremony, he presented them to the Sovereign. When the Sovereign's glance fell on the por-trait, the Sultan kissed the ground and said: 'My hope is that the Sovereign will exalt his slave's head by his blessed foot'.

The text says that the sultan's portrait was placed on the part of the boots called *na'lcha* (or *na'lja*), which in modern and late medi-eval Persian dictionaries is explained as 'nails on the heel' or 'sole'. Arends translates *na'lcha* into Russian as подборы ('heelpiece'), thus suggesting that the image was on the sole of the boots. It is unlikely that this was so. It is hardly possible to imagine a portrait on the heel or sole: this would be difficult to implement, it would have no deco-rative value for external viewers, and I could find no parallels in the history of medieval costume. Decorations on boots were placed on its woven or leather upper, not on the sole or heel. *Na'lcha* as a sole or heel in the story may have appeared either because of the mistake of an informant or scribe, or of the hyperbolised account by Rashīd al-Din, who entered the Ilkhanid service only after 1265 and was not an immediate eyewitness. It is possible, however, that *na'lcha* here – as a composite of the Arabic *na'l* (originally 'sandal', 'shoe' and 'sole')[11] and the Persian diminutive suffix *-cha* – at that time signified some other part of the boot and that this specific meaning is not registered in the dictionaries I have consulted.

In Islamic Iran, it was not customary to place kings' portraits on shoes, and this puzzled Hulagu and later Rashīd al-Dīn who told the story. Evidently, 'Izz al-Dīn Kaykāwus here followed a Byzantine prac-tice, which he essentially reinterpreted and modified. In Byzantium, it was common to add imperial portraits on ceremonial clothes, including headdresses, and also to depict insignia on ceremonial shoes (Figures 10.1a, b). Byzantine ceremonial shoes may have had images of eagles. In Palaiologan times, such shoes were worn by the emperor (red *tzangia* with eagles of stones and pearls on the sides at the calves and on the instep), *despotes* (violet and white shoes with eagles of pearls and golden thread) and *sebastokrator* (blue shoes with gold-woven eagles on a red field).[12] Byzantine practice is the closest parallel to the unusual gift of the sultan.

At the same time, the official costume of the Rum Seljuq sultans included special royal shoes or boots, most likely red in the Byzantine style, which were regarded as a symbol of supreme power. According to the anonymous *Ta'rīkh-i āl-i Saljūq*, the body of the sultan Ghiyāth al-Dīn Kaykhusraw I, who was killed in battle in

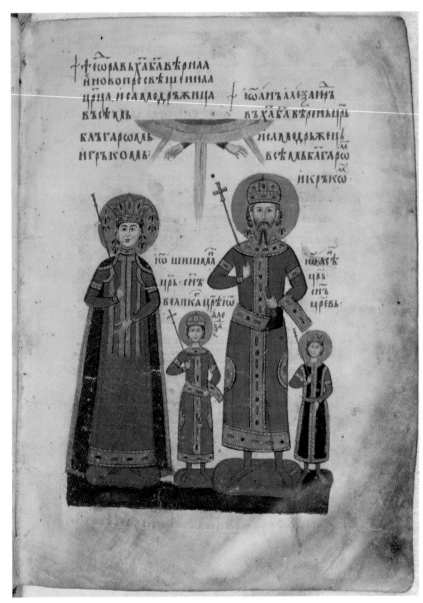

**Figure 10.1a** Portrait of Bulgarian Tzar Ivan Alexander, *folio 3r from* The
Gospels of Tsar Ivan Alexander. *1355–56, Bulgaria. The British Library,
Add. 39627. Source: © The British Library Board*

1211, was found on the battlefield due to his boots (*mūza*), presum-
ably of red colour. Pachymeres maintained that the sultan 'Izz al-Dīn
Kaykāwus II, who lived in Constantinople from 1262 onwards, was
shod in red boots.[13] On the other hand, the seals of 'Alā al-Dīn
Kayqubād I (grandfather of Kaykāwus) bore a type of sultan's portrait.
These Seljuq seals undoubtedly followed Byzantine practice, and,

**Figure 10.1b** *Detail from* Portrait of Bulgarian Tzar Ivan Alexander, *folio 3r from* The Gospels of Tsar Ivan Alexander. *1355–56, Bulgaria. The British Library, Add. 39627. Source: © The British Library Board*

as one may imagine, the idea of an official sultan's portrait was not alien to the Rum Seljuqs.[14]

It is also possible that the sultan showed considerable slyness and implicitly humiliated the khan, feeling certain that the latter would not understand this. Only subjects wore clothes with a ceremonial portrait of the king, but not the king himself. If this really were so, then Kaykāwus acted in a 'Byzantine' manner.

In any case, the sultan's boots provide a remarkable example of the borrowing of Byzantine concepts; however, this story places them within new contexts and syntactic links that were not common to the Byzantine tradition itself. The particular elements of Byzantine state symbolism – imperial portraits on cloth, leather, coinage and seals, ceremonial boots decorated with imperial insignia – were reinterpreted and remixed into something that very persistently resembles Byzantine practice but did not match it exactly.[15] In any case, a specific Byzantine optics was embedded in the Anatolian mentality and configured the way in which Anatolian Muslims invented and crafted something completely new, as in the above-described case of 'Izz al-Dīn Kaykāwus.

## Anatolian Iranism

The noted application of the name 'Rūm' to Muslim Anatolia was absolutely alien to the Byzantines. Byzantines did not share the conviction of Asian Muslims and Christians about the 'Byzantine-Roman' identity of Anatolian Seljuqs and never used the term 'Roman' for describing them. The Byzantines instead used to call Anatolian Seljuqs 'Persians' (Πέρσαι), their lands Persia (Περσίς) and their language Persian (Περσική), sometimes associating them

with the Achaemenid and Sasanid Persians of old. Of course, the Byzantines were perfectly aware of the Turkic roots (Τοῦρκοι) of the invaders seizing the eastern provinces from the Romans. However, typologically they considered the states of the Seljuqs and other Anatolian dynasties to be 'Persian'. This is exemplified well by the usage of Byzantine historians of the time: for instance, the Anatolian Muslims were designated solely as 'Persians' by Tzetzes (twelfth century), Prodromos (twelfth century), Eustathios of Thessalonike (twelfth century), Kinnamos (twelfth century), Akropolites (thirteenth century), Pachymeres (fourteenth century) and Kantakouzenos (fourteenth century), while Attaleiates (eleventh century), Psellos (eleventh century), Anna Komnene (twelfth century), Choniates (twelfth century) and Gregoras (fourteenth century) interchangeably used both 'Persians' and 'Turks'.[16] Scholars of Byzantine history often explain the name 'Persians' for Anatolian Muslims as a result of so-called 'Archaisation' or 'Classicism' – that is, a deliberate assigning of old classical names to new ethnic entities. However, the 'Archaising theory' in the present context is overly superficial and inaccurate. Byzantines had many reasons for calling Anatolian Muslims 'Persians'.

Quite paradoxically, the Byzantine practice of qualifying Muslim Anatolia as Persia closely matches contemporary scholarly interpretations of the Anatolian Muslim space as 'Persianate'. Muslim Anatolian culture is sometimes defined as Persianate due to the outstanding role of the Persian language, textual culture and art. Persian was the language of belles-lettres and of the royal courts throughout Muslim Anatolia; the Seljuq sultans not only spoke Persian and issued orders and commands in it, but also compiled verses in that language. The Seljuq administrative structure imitated that of the Iranian Seljuqs. Anatolian art and architecture were inspired by art from Persia, including Khurasan whence artists migrated to work in Anatolian workshops. Muslim Anatolian rulers were deeply involved in the cultural life of Greater Iran, patronising many Persian poets and scholars from abroad, such as Shihāb ad-Dīn Yahya Suhrawardī-yi Maqtūl (d. 1191), Afḍal al-Dīn Khāqānī (d. 1199), Abū al-Faḍl Ḥubaysh Tiflīsī (d. circa 1203/4), Muḥammad b. ʿAlī Rāwandī (d. after 1205), Niẓāmī-yi Ganjawī (d. 1209), Shihāb al-Dīn Abu Ḥafṣ Suhrawardī (d. 1234) and many others.[17] It is quite probable that it was Suhrawardī-yi Maqtūl's exhortation, as Yalman has suggested, that prompted the Seljuq sultans to reproduce in their throne names the Shahnama's sequence of the Kayanid royal names: Kaykhusraw, Kaykāwus and Kayqubād (albeit the Seljuq sequence was exactly in an order opposite to the epic's).[18]

Thus, from the East the Anatolian Seljuqs were seen as Byzantines, while from the Byzantine West they were definitely considered Persians. Of course, in the Byzantine West and the Muslim and Christian East, there existed a number of other designations for

Anatolian Muslims. The Byzantines and all the Near Eastern nations knew about the Turkic element in the identity of the Seljuqs and others and might call them Turks. The Anatolian Muslims were known mostly as Turks to the Latins – that is, the Western Europeans who found themselves in the Near East in the capacity of Crusaders, missionaries and merchants and who were especially sensitive to tribal differences and identities. All the neighbours, both Christian and Muslim, knew that the Anatolian Muslims confessed Islam; therefore, Byzantine, Armenian, Syriac and Georgian Christians might call them, each in their own language, 'Muslims', 'Hagarenes', 'Ismaelites', 'Infidels', 'Pagans' and the like.

However, I would like to stress that the first two designations with which I started – the 'Romans' and the 'Persians' – were the most common and generic terms for Anatolian Muslims among their immediate western and eastern neighbours. This contradictory practice of the East and the West is well known to experts; yet, it still needs to be comprehended and conceptualised in a broader context. This joint Persian and Roman identity seems even more strange and perplexing, if we keep in mind that both conflicting identifications were shared by the inhabitants of Muslim Anatolia themselves, who in many ways confirmed their Persian identity and at the same time commonly identified themselves as *rūmī* – namely, Romans.

## A prosopographic approach

In the subsequent discussion, I will delve further into the meaning of the conflicting identities of Anatolian Muslims and try to visualise those reasons that allowed their neighbours to call them both Persians and Byzantines at the same time. One of the possible tools to contextualise the problem of ethno-religious and cultural diversity in Anatolia is prosopographic study, which may provide additional and more precise information on the demographic composition of Anatolia. It was demography that in many ways determined the cultural configuration of Anatolia. Here I would like to share some preliminary results of employing a prosopographical analysis of Anatolian demography and specifically of its Persian segment. Prosopography gives a vivid picture of the physical presence of Iranian natives in Muslim Anatolia.

The Anatolian prosopography project aims at compiling from textual sources an electronic database of all persons who between 1071 and 1307 lived among the Muslim segments of Anatolia, including the Seljuq Sultanate and the Anatolian principalities of the Danishmandids, Mangujaks and Saltuqids, as well as the early Aegean emirates, Jandarids, Qaramanids and so forth. At the current initial stage of compiling the database, I have checked for these purposes local Anatolian historiography and hagiography,[19] some documentary material,[20] inscriptions occasionally including

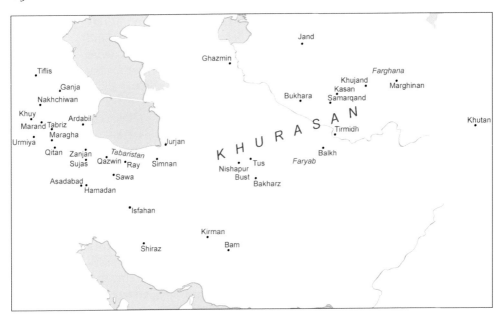

**Figure 10.2** *Iranian place-names mentioned in Anatolian* nisbas. *Source: Map by*
*the author*

epigraphs on artefacts,[21] and some Anatolian manuscripts. The time
span of the manuscripts consulted extends from the end of the twelfth
century through *circa* 1330.[22]

The sources already consulted refer to approximately 2,000 names
of Muslims who lived in Anatolia in the twelfth through the thir-
teenth century. From the entire list of names, I have chosen those
who are referred to by their *nisba* – that is, an indication of a per-
son's place of origin, ancestry, or ethnic affiliation. Those bearing an
Iranian *nisba* (it may be the indication of a city, village, or region)
constitute around 120 persons – in other words, around six percent
of the entire number of names. At the same time, one has to keep
in mind that not all the persons mentioned in the sources owned a
*nisba*, whatever their origin was.

The Iranian *nisba*s allow one to outline the regions and cities
of Iran from which residents emigrated to Anatolia for any reason;
in some rare cases, *nisba*s belonged to immediate descendants of
Iranian immigrants.[23] Figure 10.2 represents the map of Greater
Iran with those localities from where natives are found in Anatolia
indicated. In northwest Iran, these are Tabriz, Urumiya, Ardabil,
Khuy, Nakhchiwan, Tiflis, Ganja, Marand, Sawa, Zanjan, Hamadan,
Asadabad, Qazwin, Rayy, Simnan, Tabaristan and Jurjan. For central
Iran there were immigrants from Isfahan, Bam, Kirman and Shiraz.
Eastern Iran is represented by the natives of Khurasan, Nishapur,
Bust, Tus (Mashhad), Balkh, Faryab, Tirmidh, Bukhara, Samarqand,
Kasan, Farghana, Ghazmin, Jand, Khujand and Khutan.

Table 10.1 Distribution of professions among Anatolian Persians

| Affiliation | Percentage |
| --- | --- |
| *ulema* | 36.4 |
| *amir*s (civil officers) | 32.5 |
| *qadi*s | 18.2 |
| scribes | 10.4 |
| *amir*s (military officers) | 3.9 |

The ratio of Persian natives from different parts of Iran among the Anatolian Muslims is quite telling: northwest Iran yielded 55.8 percent of immigrants, east Iran 35.6 percent, and central Iran as little as 7.8 percent. While the prevalence of northwest Iranians is quite explicable, extremely interesting and even surprising are the large numbers of the natives of Greater Khurasan from Nishapur to Mawarannahr and Farghana and of adjacent Persian-speaking territories like Jand and Khutan: more than one-third of Anatolian Persians were natives of eastern Iran. Apparently, Anatolia was one of the favourite destination points for Khurasanian emigrants.

The professional affiliation of the holders of the Persian *nisba*s indicates that most of the Anatolian Persians mentioned in the corpus were intellectuals (Table 10.1). The Khurasanians were very frequent among the *ulema*, especially Sufi mystics, judges and scribes. Northwest Iranians were more often found among civil officers.

Since it is impossible here to expand and detail the statistical ratio discussed above, I will limit myself to the only example concerning the little-studied problem of Anatolian scriptoria and scribes. In this study, the activity of the Khurasanian scribes is quite curious. The database provides the names of three Bukharans, one Samarqandan and one Faryabian. Quite active, as it seems, was Muḥammad b. Maḥmūd b. al-Ḥājj *al-mulaqqab bi-*Ḥamīd al-Mukhliṣī al-Bukhārī, who is known from two manuscripts. He copied the first one in Konya in 584/1286 – *Laṭā'if al-Ḥikmat* by the famous Sirāj al-Dīn Maḥmūd Urmawī who held the office of *qāḍī al-quḍḍāt* in Konya.[24] *Kitāb-i Sharḥ-i Abiyāt-i Kalīla wa Dimna*, authored by Faḍl Allāh al-Isfarāyinī, is another of Mukhliṣī-yi Bukhārī's manuscripts, which he copied in 676/1278, probably also in Konya.[25] Another Bukharan, Muḥammad b. Muḥammad b. 'Umar al-Bukhārī, copied in Tokat in 691/1291 the treatise *Tafsīr al-Kathīr al-Tām* by Najm ad-Dīn Abū Ḥafṣ 'Umar al-Nasafī.[26] Finally, Muḥammad b. 'Īsā al-Bukhārī al-Mawlawī, who possibly lived in Anatolia, in Rajab 683/1284 copied Abū'l-Ma'ālī Munshī's *Kalīla wa Dimna*.[27] In Shaban 591/1195, Muḥammad b. Aḥmad b. 'Abd al-'Azīz b. 'Abd al-Ghaffār al-Samarqandī copied in Sivas *Mukhtalif al-Riwāya*, which had been compiled by his fellow citizen Naṣr Abū Layth Samarqandī.[28] Finally, in Sivas in 668/1269 a certain Maḥmūd b. Mas'ūd b. Muḥammad b. 'Alī al-Faryābī copied the famous Arabic treatise *Sharḥ-i Ḥirz al-amānī*

by Abu'l-Qāsim al-Shāṭibī.[29] As we see, Khurasanian scribes were particularly active in Konya, Sivas and Tokat. Especially curious is that four of the five scribes copied the works of Khurasanian authors.

## New and old Persians

Available sources preserve extant information about the thirteenth-century resettlements of Persians to Anatolia, referring to several massive waves of immigration.[30] In the 1220s and 1230s, many Khurasanians and other Iranians arrived in Anatolia after fleeing the Mongols. Especially after the death of the Khʷārazm-Shāh Jalāl al-Dīn in 1231, many of his subjects finally found asylum in Anatolia. Such was, for instance, the fate of the parents of the historian Ibn Bībī: his father Majd al-Dīn Muḥammad Tarjumān and his mother Bībī Munajjima had served at the court of Jalāl al-Dīn Khʷārazm-Shāh and after 1231 first moved to Ayyubid Damascus and soon afterwards to the Rum Seljuq court.[31]

Curiously, the subsequent massive wave of Iranian immigrants was prompted by the establishment of direct Mongol control in Anatolia after 1262 and especially in the late 1270s. The Ilkhanid Mongols of Tabriz sent to Anatolia civil officers who, along with their numerous attendants, were almost exclusively Iranians. In some sense, the Mongols directly or indirectly contributed much to the Persianisation of Anatolia.

However, new flocks of Persian immigrants were not always welcomed by the local Persian-speakers in Anatolian cities. As the Rum Seljuq historian Āqsarāyī attests, the influx of Persians from the Ilkhanid empire dramatically increased over the last decades of the thirteenth century. Āqsarāyī also gives some indications of misunderstanding between the 'old' and 'new' foreign Persians. He stated:

> If he were a native of Tabaristan (ṭabarī), he would be cut off from trustworthiness and faith, and if it was someone from Kirman or from Khurasan, there would be no other effect than a disadvantage for the poor, while from a native of Rayy and Shiraz no good deeds might come out.[32]

Here Āqsarāyī, probably attempts to play with words indicating a phonetic closeness of ṭabarī (native of Tabaristan) and the Persian tabar ('ax') which cuts off. However, such a word-play seems quite dubious because of the orthographic difference between ط and ت and indicates the mediocre level of Āqsarāyī's literary technique. Elsewhere the same author complains specifically about the prevalence of Khurasanian foreigners by saying: 'The Khurasanians (may God protect us from them) are willing to come to this realm [that is, to Anatolia]. With the presence of Khurasanians what good will be this life for us?'[33] The latter remark is in full conformity with

the above-noted high percentage of the Khurasanians given by prosopography.

Āqsarāyī's irritation with the Persian newcomers might have encountered similar feelings on the part of Iranian newcomers. The famous Sufi writer Najm al-Dīn Dāya Rāzī was a disciple of Najm al-Dīn Kubrā, a famous Khʷarazmian mystic. Owing to the advance of the Mongols, Najm al-Dīn Dāya went from Khurasan to Anatolia where he spent several years, probably in the early 1220s. However, finally he left Anatolia in great disappointment at the total religious and spiritual ignorance (*jahl-u nāshinākht*) of the population.[34] 'Abd al-Raḥmān Jāmī believed that Najm al-Dīn Dāya Rāzī met the famous local mystics Ṣadr al-Dīn Qūnawī and Jalāl al-Dīn Rūmī in Konya. The latter two men asked Dāya to lead their joint evening prayer. In both initial *rak'at*s of the prayer, Dāya recited the *sura* 'The Unbelievers' (Qur'an, 109), starting with the words 'Say: O ye unbelievers!' In fact, this is a deviation from the normal prayer practice, because it is desirable to use different passages from the Qur'an in each of the two prayer cycles. Jalāl al-Dīn Rūmī, reflecting on this deviation, proposed that the first recitation of 'O ye unbelievers!' was addressed to Ṣadr al-Dīn Qūnawī, while the second one to Rūmī himself.[35] Although the authenticity of Jāmī's story may be questioned on chronological grounds, it conforms to Dāya's dissatisfaction with Anatolian intellectualism and spirituality in general. Apparently, Anatolia preserved some provincial flavour for visitors from major centres of Persian and Arab intellectual life.

## Speaking Persian

The immigrant Persians continued to practice their native Persian dialects in Anatolia. Aflākī, speaking about Jalāl al-Dīn Rūmī's personality, testified that 'when Lord Mawlānā was offended with somebody and his anger exceeded its ordinary bounds, he exclaimed *ghar-khʷāhar* and hit him, for it was a swearword of the Khurasanians'.[36] The expression *ghar-khʷāhar* – that is, 'one having a whore sister' – represents a common swearword model in the Eastern dialects of Persian, in which 'sister' may be optionally replaced by any other person (mother, daughter and so forth). In particular, such swearwords are still in common use in the Zarafshan dialects of Persian (Tajik).[37] It is remarkable that Aflākī specifically indicated for the reader the Khurasanian origin of the expression, implying that it was not in common usage among all the Persian-speakers in fourteenth-century Anatolia.

In the thirteenth century, apparently the main language of the Muslims in major Anatolian urban centres was Persian. I may add to many other well-known justifications of this point a few more arguments. More than any other early Anatolian author, Aflākī, due to the genre of his *Manāqib*, mirrored the spoken ambience

of thirteenth-century Konya. Persian spoken elements are especially visible in two categories of words: micro-toponymics of Konya and nicknames of Anatolian residents, both often carrying jocular meaning, which unmistakably indicates the full-fledged life of a highly idiomatic and metaphoric language. For instance, Aflākī refers to the gates *Darwāza-yi khalqa-ba-gūsh* in Konya – that is, 'The Ring-in-the-Ear Gates' – in which '[the one having] a ring in the ear' may have implied 'slave'.[38] Other city gates were called *Darwāza-yi asp-bāzār* – namely, 'The Horse-Market Gate', with the inverted word-order in *asp-bāzār* again indicating a high level of Persian fluency.[39] One of the Konya bathhouses was called *Hammām-i zīrwā* – that is, 'The Cumin-Pottage Baths'[40] – while one of the mosques was known as *Masjid-i marām* or 'The Desire Mosque'.[41] Some Anatolian nicknames strengthen the feeling of a presence of living vernacular language: for instance, one was nicknamed for a particular reason *Tīzbāzārī*, or '[the one] of the ebullient market', probably the person due to whom sales and purchases in the market became lively.[42] The other one was called *Dīwdast* or '[the one] having a demon's hand' – that is, a very large and strong hand.[43] Such surprising and paradoxical place-names and nicknames, begotten by living popular imagination, were quite typical throughout the Iranian world from Bukhara to Isfahan, and Konya was no exception. Such names could not be invented by a scholar or an officer who learned Persian for a purpose.

As has been shown by Tietze and Lazard, Persian borrowings in the Anatolian Turkish dialects, which were recorded as late as in the twentieth century, cannot be limited to and explained only by the influence of Persian literature on Ottoman high culture. The Anatolian Turkic dialects indicate the presence of the rudiments of spoken Persian in the Anatolian linguistic space. Spoken Persian introduced to the local tongues linguistic elements which differed from those found in the literary Ottoman language.[44] Curiously, the distribution of these spoken Persian elements in the Modern Turkic dialects intersects in many (but not all) cases with the physical presence of Iranians in Seljuq Anatolia. These spoken Persian elements are attested in all those cities in references to the presence of Persians appearing in the thirteenth-century sources (Figure 10.3).

This map shows the distribution of Persians in thirteenth-century Anatolia, as they appear in our sources. Indicated here are the cities in Seljuq Anatolia where the above-mentioned Persian *nisba*s appeared. These are the major cultural and economic urban centres of Anatolia: Konya, Aksaray, Kayseri, Sivas, Malatya, Erzincan and so forth. The major part of textual and artistic production, which constituted the core of Seljuq Anatolian culture, was created in these cities. As far as our sources testify, a predominant and dominating part of the Muslim population in these urban centres was probably Persian.

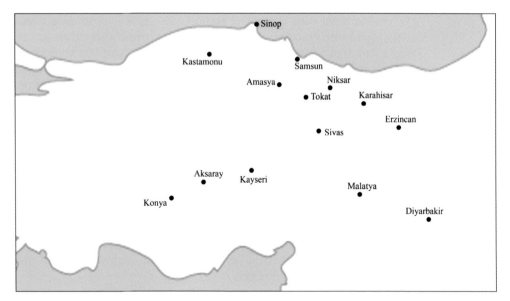

**Figure 10.3** *Thirteenth-century Anatolian cities with attested presence of Persians.*
*Source: Map by the author*

Paradoxically, the Byzantine designation of the Anatolian Muslim space as Persian seems to be very close to historical reality and coincides with contemporary scholarly reflection. Prosopography in conjunction with other analytical tools may contribute to elaborating a clearer and more precise vision of Persian elements in the Muslim Anatolian space. However, in order to better define the role of other segments of Anatolian culture – Greek, Armenian, Syriac, Georgian, Kurdish and so forth – analytical strategies may differ somewhat.

## An attempt at typology: Irano-Greek culture

I fully support the idea that Peacock and Yıldız have recently formulated on the typological proximity between Medieval Muslim India and Muslim Anatolia, due to the specific role of Persian culture in both of these spaces and the modes of interaction of the Persian element with local 'vernaculars'.[45] Continuing this interpretational logic, I suggest that, whatever the role of other ethno-cultural groups in Anatolia, typologically the Anatolian cultural space of the twelfth and thirteenth centuries should be characterised as Irano-Greek. Persian and Greek elements constituted the invariant core of Anatolian identity, which of course was remodelled and rethought to a certain extent by other active ethno-linguistic entities in the Anatolian space. In the outskirts of the Iranian world, thus, there were formed two typologically similar hybrid types of culture: in one case, the Iranian element interacted with the local Greek soil, and in the other case with the Indian substratum.

What has been said about the Irano-Greek typology of Anatolian culture does not attempt to obscure or depreciate the existence of Turkic identity in Anatolia. The Turkic languages, folklore, traditions and customs did indeed exist in Anatolia; the sources provide ample evidence for that. However, the Turkic cultural element remained on the margins of the dominant Irano-Greek world both geographically and axiologically, in the status of a nonliterate vernacular culture shared predominantly by mono-ethnic groups of nomadic Turks. In the civilised Anatolian space, the Turkic culture, because of its low status, was viewed as not prestigious and therefore undesirable. This may explain why Turkic nobility and the middle strata (and maybe the lower ones, too) tried to overcome their 'Turkic-ness' by marrying brides from 'cultured' peoples, studying the Persian and Greek languages and mastering the urban culture. Turkic identity in Anatolia underwent a century-long path of acculturation and seeking its own cultural voice before it would absorb and replace the old Iranian and Greek traditions.

## Notes

1. For a comprehensive evaluation of the contemporary state of research on Anatolian culture, see the introductory chapters in Peacock and Yıldız 2013, pp. 1–16; Peacock, de Nicola and Yıldız 2015, pp. 1–16.
2. The idea, quite popular among scholars of the Middle Ages and modern times, that the Neo-Persian and Arabic term 'Rūm' was first introduced by the Arabs is not correct. See, for instance, Georgacas 1971, pp. 71–83 and esp. 76–78.
3. In Georgian sources, both Byzantium and Muslim Anatolia more frequently were referred to by a synonymous term საბერძნეთი *saberdzneti* 'Greece', 'Romania', 'Roman lands', just confirming the general tendency to terminologically equate Byzantine Christian and Persian/Turkic Muslim segments of Anatolia; see, for instance: Makharadze and Lomouri 2010, p. 438 and n. 48 (chapter by Erekle Zhordania); for a more detailed discussion, see Zhordania 2019, pp. 63–65.
4. Vryonis 1971, especially Chapter VII: 'The Byzantine Residue in Turkish Anatolia', pp. 444–97.
5. Tetik 2005, pp. 607, 663–65. Bruce Clark estimates the number of Anatolian Greeks at that time as 'closer to' 1.5 million; see Clark 2006, pp. 58, 93. Some authors even speak of up to 2.5 million Anatolian Orthodox Greeks in the 1910s; see Lekka 2007, p. 137.
6. William of Rubruck 2010, p. 276. Rubruck's estimation has been questioned by Vryonis, Ménage and Jackson: Vryonis 1971, p. 183; Ménage 1979, p. 57; William of Rubruck 2010, p. 276, n. 3. However, I would rather support Claude Cahen's cautious acceptance of Rubruck's figures; see Cahen 1988, p. 111.
7. For the incomplete and not always precise data of the sixteenth-century Ottoman *defters* and other numerical estimations of the Greek population in Anatolia at various times, see Ménage 1979; Vryonis 1971, pp. 444–50, 179–84.
8. For more details, see Vryonis 1971, pp. 351–402; Apanovich 2007,

2009; Korobeinikov 2005b, 2009, 2014, pp. 48, 68, 83, 87, 145 etc; 2016;
Métivier 2009, 2012; Yıldız 2011.

9.  See, for instance, Vryonis 1971, pp. 233, 470, 475–96; Cahen 1988, p. 187;
    Delilbaşı 1993; Eastmond 2010; Asutay-Effenberger 2012; Redford 2014,
    2015a; Korobeinikov 2003, 2005a; Kafadar 2007; Uyar 2015; Preiser-
    Kapeller 2008; Warland 2014; Yalman 2017; Balivet and Pezechki 2017;
    and Shukurov 2001, 2013a. The idea of the Greek language as a *lingua
    franca* in Anatolia was first formulated and developed in Oikonomidès
    1999. For the Greek manuscripts originating from Muslim Anatolia,
    see, for instance, Kotzabassi 2004, especially pp. 179–88 for the Eğirdir
    collection of Byzantine manuscripts.
10. Rashīd al-Dīn 1957, p. 66 (p. 48 of the Russian translation):

هولاكوخان از سلطان عز الدين جهت بى التفاتى با بايجو نويان و مصاف با وى رنجيده بود بعد از
استخلاص بغداد سلطان عز الدين بغايت مستشعر گشت خواست تا بدقايق حيل خود را از ورطه آن
گناه مستخلص گرداند فرمود تا موزه دوختند بغايت نيكو و پادشاهانه و صورت اورا بر نعلچه آن
نقش كردند در ميانه تكشميشى آن را بدست پادشاه داد چون نظرش بر آن نقش افتاد سلطان زمين
بوسيد و گفت مأمول بنده آنست كى پادشاه بقدم مبارك سر اين بنده را بزرگ گرداند.

11. Lane 1863–93, p. 3035.
12. Pseudo-Kodinos 2013, pp. 78–79 and n. 135, pp. 36–39, 44–45, 294–95
    (commentary); Pseudo-Kodinos 1966, pp. 144, 148, 320; Piltz 1994, pp.
    13–14; Parani 2003, pp. 31, 51, 72.
13. Jalali 1377/1999, p. 86 (*yakē rā dīdand aftāda wa mūzahā-yi hamīn
    dar pāy būd*); Pachymérès 1984–2000, vol. 2, 185.9 (ἐρυθροβαφὲς πέδιλον
    ὑποδούμενος).
14. Yalman 2012, pp. 155–59.
15. In a similar way, in the twelfth and thirteenth centuries Byzantine
    imperial and iconic images and Byzantine court titles were borrowed
    and reworked in the new models of official representation by Anatolian
    Muslim rulers. See Vryonis 1971, pp. 463–75; Oikonomidès 1983;
    Shukurov 2001, 2004; Georganteli 2012.
16. For the usage of these authors, see *The Thesaurus Linguae Graecae*. For
    more on the specific features of the Byzantine classification of nations
    and the Byzantine concept of 'Persia,' see Shukurov 2016, pp. 11–44.
17. For Persian verses of Ghiyāth al-Dīn Kaykhusraw I, see Ibn Bibi
    1390/2012, pp. 91–93. See also, for instance, Riyāḥī 1369/1991; Yazıcı
    2010; Cahen 1988, pp. 101–224; Melville 2006; Hillenbrand 2001, 2005;
    Bozdoğan and Necipoğlu 2007; Blessing 2014; Peacock and Yıldız 2016.
18. See Yalman 2012. For a possible Byzantine source for such an odd idea
    to build a regular order of rulers' names, unprecedented in the whole of
    Islamic history, see Shukurov 1995.
19. Ibn Bibi 1390/2012; Aksaraylı 1944; Jalali 1377/1999; al-Aflākī 1959–61.
20. Turan 1948, 1958; Erzi 1963.
21. *RCEA*; *TEI*; Redford and Leiser 2008; Redford 2014.
22. See also the online Database of medieval Anatolian texts and manu-
    scripts in Arabic, Persian and Turkish, initiated by A. C. S. Peacock.
23. Although *nisba*s are not always reliable to determine the provenance of
    an individual, a possible statistical error is not a concern in this context
    of this chapter.
24. Bibliothèque Nationale de France, Département des manuscrits, Persan
    121. For more details on the manuscript and the author of the treatise,
    see the Database of medieval Anatolian texts.

25. Bibliothèque Nationale de France, Département des manuscrits, Supplément persan 1442. See also Jackson 2017, who mentions Mukhliṣī-yi Bukhārī.
26. Milli Kütüphane, Ankara, 06 Mil Yz A 674.
27. Staatsbibliothek zu Berlin, Ms. or. oct. 4046.
28. Bibliothèque Nationale de France, Département des manuscrits, Arabe 825.
29. Konya Bölge Yazma Eserler Kütüphanesi, 44 Dar 482.
30. For some information concerning twelfth-century Persian immigrants, see Madelung 2002, pp. 50, 52, 53–55.
31. Ibn Bibi 1390/2012, p. 395.
32. Aksaraylı 1944, p. 300:

اگر طبری بود از امانت و دیانت بری و اگر کرمانی و خراسانی بود جز سر گردانی ضعفا از و
فایده صورت نمی بست و از رازی و شیرازی کارسازی ممکن نگشت

33. Ibid p. 117:

خراسانیان عافانا الله منهم درین ملک خواهند درآمدن بوجود خراسانی مارا این زندگانی چه فایده
دهد

34. Rāzī 1352/1974, p. 30–32; for Dāya's activity in Anatolia, see Peacock and Yıldız 2016, p. 289–95.
35. I have had at hand an old edition of the treatise: Jāmī 1858, pp. 499–500.
36. al-Aflaki 1959–61, p. 152:

چون حضرت مولانا از کس رنجیدی و مکابره او از حد شدی غر خواهر گفتی و درهمش کوفتی
چه اصطلاح شتم خراسانیان همین بوده است

37. For *ghar* ('whore, prostitute'), see Dehkhodâ's *Loghatnâme* غر. For the discussion of the subtle topic of Zarafshanian swearword models, I am indebted to the novelist and scholar Qādir-i Rustam, the editor of the most authoritative version of Rūdakī's *Dīwān* (Rūdakī 1387/2009).
38. al-Aflaki 1959–61, pp. 258, 629.
39. Ibid. p. 273. Expressions constructed according to this model are ample in written and spoken Persian; see, for instance, Niẓāmī's *yūnān-zabān*: Niẓāmī 1380/1960, p. 46.723.
40. al-Aflaki 1959–61, p. 557.
41. Ibid. pp. 139, 143 etc. (see Index).
42. Ibid p. 245; this is the nickname of Nūr al-Dīn, disciple of Mawlānā.
43. Ibid p. 280, and also Index; this is the nickname of *adīb* Fakhr al-Dīn, disciple of Mawlānā.
44. Tietze and Lazard 1967.
45. Peacock and Yıldız 2016, pp. 21–22.

# PART FIVE
# MAGIC AND THE COSMOS

# A Seljuq Occult Manuscript and its World: MS Paris persan 174

*A. C. S. Peacock*

IN THE EARLY thirteenth century, the Arab chronicler Ibn al-Athir, working in Mosul, wrote of the ancestor of the branch of the Seljuq dynasty that ruled in Anatolia:

> It is remarkable that Qutlumush knew astrology (*'ilm al-nujūm*) and was excellent at it, although he was a Turk, and knew other sciences of the scholars. His descendants (that is, the Seljuqs of Anatolia) still seek out these sciences of the ancients and are close to those who profess expertise in them. As a result there is a stain on them for their faith.[1]

Ibn al-Athir's comment contrasts with the stereotypical image of the Seljuqs as the pious defenders of Sunni Islam by which they are portrayed in many sources – an image that has been challenged by much contemporary scholarship.[2] Although recent work has shown how the representation of the Seljuqs as pious figures was at least in some cases the result of a legitimising political strategy, the implications of Ibn al-Athir's statement have been ignored. In this short essay, I wish to explore the 'sciences of the ancients' – in other words, the occult, in which, as Ibn al-Athir claims, the Seljuqs had a notable interest, through one particular Persian manuscript. This is manuscrit persan 174, now held in the Bibliothèque Nationale in Paris, written in central Anatolia for the Seljuq court around 1272–73. Although the rich illustrations of this manuscript have occasionally attracted the interest of art historians,[3] the texts it contains remain unpublished and ignored by scholarship. This is in keeping with a general disdain among modern historians of the Islamic world for such occult texts,[4] meaning that our view of religiosity in the period is skewed towards that presented by the normative texts of exoteric Islam. Yet, MS persan 174 sheds a fascinating light on the role of the occult sciences at the Seljuq court at a critical juncture – the

period in the late thirteenth century when the Mongol invasions had overwhelmed the Middle East and the Seljuq dynasty in Anatolia survived only as puppets of the Mongols, the titular Seljuq sultan being a child.

## The occult in Anatolian court life

To understand our manuscript, it is first necessary to present its context. The most important of the occult sciences was astrology, which had a long pedigree in the Islamic world, having received patronage from the Abbasid caliphs; from astrology most other occult sciences ultimately derived. Astrology was perhaps not originally really distinguished from astronomy, both being described under the heading *'ilm al-nujūm* (lit. 'the science of the stars'). Indeed many of the most famous Muslim astronomers were also astrologers. For instance, the great astronomical tables (the *Zij-i Ilkhani*) compiled by the noted scholar Nasir al-Din Tusi (d. 1274) were written with an explicitly astrological purpose of understanding the influence of the stars on worldly affairs. Seljuq interest in *'ilm al-nujūm* is suggested by the large observatory built at Isfahan by the Great Seljuq Sultan Malikshah (d. 1092),[5] but was also widespread in society: the most important occult text from the Great Seljuq period to come down to us, the *Dustur al-Munajjimin* or 'Rules of Astrologers', was in fact produced in Ismaili circles.[6] A preoccupation with astrology is also reflected in the astrological motifs that decorate both Artuqid and Anatolian Seljuq material culture such as architecture and objects – mirrors, bowls, candlesticks and coins.[7] The intensification of this interest during the thirteenth century may have been spurred on by the unusual planetary activity in the form of comets, meteors and the like that the period witnessed.[8] Indeed, towards the end of the twelfth century, the Anatolian Seljuq Sultan Qilij Arslan (r. 1156–92) was persuaded by astrologers that the apocalypse was imminent, according the testimony of the Syriac chronicler Bar Hebraeus.[9] We have several works dealing with such themes composed at Qilij Arslan's court by the scholar Hubaysh-i Tiflisi, who wrote manuals on astrology and dream interpretation for his royal patron.[10]

Not just astrology but a whole range of occult sciences such as geomancy became increasingly popular from the thirteenth century onwards. This trend was perhaps partly a response to the breakdown in religio-political order precipitated by the Mongol invasions and to developments in Sufism that increasingly saw the occult (especially the *'ilm al-ḥurūf*, the science of understanding the occult meanings of the letters of the Arabic script) as a valid method for comprehending the divine plan.[11] There is also evidence that a wider range of occult sciences was starting to penetrate courtly circles. The polymath 'Abd al-Latif al-Baghdadi (1162–1231) spent a considerable time in Erzincan in eastern Anatolia in the early thirteenth century.

In one of his works, he mentions his encounter with an émigré alche-
mist who sought to use 'Abd al-Latif to find an entree into the Seljuq
court, promising to enrich Sultan 'Ala' al-Din Kayqubad's treasury
with innumerable jewels through his craft.[12] Baghdadi is highly criti-
cal of such 'tricksters' (*muḥtālūn*), as he calls them, but his remarks
suggest their appeal to the elite. Further, occult works started to be
diffused to a wider audience through Persian versions, especially
from the later thirteenth century, such as Nasir al-Din Tusi's trans-
lation of pseudo-Ptolemy's guide to horoscope-making, the *Kitab
al-Thamara*, which circulated in Anatolia.[13] Occult elements also
appear in texts primarily concerned with other subjects. For example
Dunaysiri's *Nawadir al-Tabadur*, a Persian manual of useful infor-
mation composed for the military commander of Afyonkarahisar
in western Anatolia in the second half of the thirteenth century
which covers topics as diverse as logic, mathematics, agriculture
and the dangers of wine-drinking, also contains substantial sections
discussing astrology, horoscopes and other occult sciences such as
*ikhtilāj* (prognosticating the future from unusual body movements)
and *firāsat* (physiognomy).[14] Occult knowledge was just another
topic among many the rudiments of which an educated individual
needed to master.

### The author and dedicatee of MS Persan 174

MS persan 174 is best known for its 51 illustrations, predominantly
of supernatural beings such as jinn, angels and planetary bodies
(Figure 11.1), being the sole illustrated manuscript to survive that
can unambiguously be attributed to a Rum Seljuq courtly milieu.[15]
However, the Persian text itself presents considerable challenges,
which may be one reason for its neglect by scholarship. At some
point, presumably after the manuscript reached France in the sev-
enteenth century, it was rebound; in the process, many folios were
misplaced; others were evidently lost at this point or earlier. In some
places the text is poorly preserved, apparently having been damaged
by water, leading to fading or outright illegibility. Reconstructing
the original text is thus like completing a difficult jigsaw puzzle, but
with some of the pieces missing.

The manuscript is sometimes referred to as the *Daqa'iq al-
Haqa'iq*, or 'Fine Points of Eternal Truths'; however, this is in fact the
name of only one of at least five works which it comprises, dealing
variously with astrology, talismans, angels, jinn, magic and poetry.[16]
Indeed, the manuscript may originally have been considerably more
extensive, for the author refers to having composed seven different
treatises, of which he lists the titles of three: *Sanhajal al-Arwah*,
*Daqa'iq al-Hadhiqin* and the *Kunuz al-Mu'azzimin*.[17] However, it
is far from clear which folios (if any) of the surviving manuscript
are to be associated with these works, and whether they in fact did

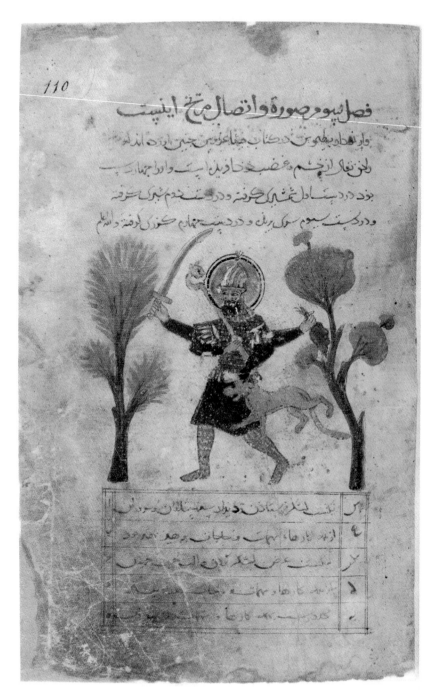

**Figure 11.1** The Personification of the Planet Mars, *folio 110a from Ms persan 174. Circa 1272–73, Anatolia. Bibliothèque Nationale de France. Source: © Bibliothèque Nationale de France*

comprise part of it. Their titles are too vague to allow us to guess the contents, except in the case of the *Kunuz al-Mu'azzimin* ('Magicians' Treasures') which evidently dealt with *'azā'im*, or invocatory spells. At any rate, none of the five or so works in the manuscript seems to be complete, possibly in part as a result of its botched rebinding. However, it is also probable that some of the works were never finished. The *Daqa'iq al-Haqa'iq*, for instance, is furnished with a table of contents (fol. 52a–53b) which itself is incomplete, suggesting the work was never finished.

Apart from the *Daqa'iq*, the contents of one other work are reasonably distinct, the *Mu'nis al-'Awarif* or 'Agreeable gifts', which is in verse. We can be sure of the dates and places of composition of these two works, which are given on their frontispieces (Figures 11.2, 11.3). The *Daqa'iq al-Haqa'iq* was composed in Aksaray in central Anatolia in Ramadan 670/April 1272, while the *Mu'nis al-'Awarif* was compiled the following year, in Shawwal 671/May 1273 in Kayseri. Both of these towns were major centres in which the Seljuq sultans had palaces. It is tempting to assume that the composition of the *Daqa'iq al-Haqa'iq* and the *Mu'nis al-'Awarif* in neighbouring cities, at similar times of the year, reflects the periods when the sultan and his court were physically present there, for the Seljuq court generally led an itinerant existence, only seasonally visiting central Anatolia.[18] The manuscript – most likely in the author's own hand – seems to have been intended for presentation to the Seljuq sultan of Anatolia, Ghiyath al-Din Kaykhusraw III (r. 1264–84), who would have been about ten or twelve years old when it was written. This is suggested by both the presence of illustrations, which would have been expensive to produce, and the extensive passages praising the sultan in the *Mu'nis al-'Awarif*.[19] The author also includes a poem addressed to his friends and allies in Aksaray whose names and titles suggest they were senior officials: the Akhi 'Izz al-Din, Ahmad Shir-dil ('the lion heart') and the philosopher of the world (*faylasūf-i jahān*) Shams al-Din Baglar, although none can readily be identified with figures known to us from chronicles of the period.[20] However, at the end of the *Mu'nis al-'Awarif* the author includes a section complaining to the sultan of his condition in terms that suggest he may have made some kind of mistake.[21] He seems, then, to have been a figure somewhat on the outer circles of court life.

Who was our author? He identifies himself prominently at the start of the *Daqa'iq al-Haqa'iq* as Nasir al-Din Muhammad b. Ibrahim b. 'Abdallah *al-rammāl al-mu'azzim al-sā'atī al-haykalī* (fol. 51a), while at the start of the poetic *Mu'nis al-'Awarif* (fol. 133a) he adds the information that his pen name is Nasiri. Even these few words provide a fair amount of information about our author, who does not appear to be attested in any other source. *Al-rammāl* describes one of his occupations – a geomancer, a specialist in using sand or soil for divination. However, curiously geomancy does

**Figure 11.2** *Frontispiece of the* Daqa'iq al-Haqa'iq, *folio 51a from*
*Ms persan 174,* circa *1272–73, Anatolia. Bibliothèque Nationale de France.*
*Source: © Bibliothèque Nationale de France*

**Figure 11.3** *Frontispiece of the* Muʾnis al-ʿAwarif, *folio 133a from Ms persan 174.* Circa 1272–73, Anatolia. Bibliothèque Nationale de France. *Source:* © Bibliothèque Nationale de France

not feature prominently in the text as it has come down to us. He is also *al-mu'azzim*, a specialist in making invocatory magic spells (*'azā'im*). *Al-sā'atī* is slightly harder to interpret, but it may suggest he was an expert in the auspicious time to do things (a science normally known as *ikhtiyārāt* which commonly features in almanacs produced for a courtly audience). Another interpretation would be that he was someone who claimed to have knowledge of the final hour (*al-sā'a*) – the Day of Judgement and the end of the world. Finally, *al-haykalī* refers to his expertise in astral talismans (*haykal*).[22] In other words, our author – to whom I will refer by his pen name Nasiri – boasts of his expertise in a whole range of different occult sciences.

Nasiri also calls himself by another name, which is not entirely clear, but may read 'al-Siwasi' – from Sivas (fol. 133a). This may refer to his habitual place of residence. However, evidence from other parts of the manuscript suggests he had another *nisba*, or name referring to his origins, al-Sijistani, which appears on fol. 84a.[23] This indicates that he or his family were connected to, and probably originated from, the region of Sistan on the modern borderland of Iran and Afghanistan. Seljuq Anatolia attracted plenty of migrants from the east, fleeing the Mongol invasions or simply seeking their fortune in this prosperous corner of the Muslim world, most famously the great Sufi poet Jalal al-Din Rumi and his family who were from Balkh in the north of modern Afghanistan (see Shukurov in this volume). This eastern connection is confirmed by some of the anecdotes and references found elsewhere in this work – for instance, stories about the kings of Sistan (fol. 64a), about the Ghaznavid dynasty that ruled in what is now Afghanistan (fol. 35b) and about a magician in the great city of Merv located in modern Turkmenistan (fol. 75b). The manuscript thus suggests the interconnected nature of the Seljuq world – a text composed in Anatolia which nonetheless emphasises traditions deriving from its author's Central Asian origins.

## The contents of the manuscript

Let us now briefly review the contents of this manuscript, which as noted above is a compilation of various texts (*majmū'a*), all connected with the occult and all, it seems, fragmentary. The table of contents to the *Daqa'iq al-Haqa'iq* indicates that this text at least may never have been completed, for it has 44 spaces for chapter headings, of which only twelve are given, and just four of these chapters survive intact; similarly, the programme of illustrations was never completed, for there are numerous blank folios or spaces left for them to be added (for example, fols 1a, 21a). Even from the twelve headings that are given it is evident that the *Daqa'iq* claimed to be a comprehensive manual of the occult:

On the names of God
On the names of the invocative prayers [*tamkhīthā*]
On the angels and their stations
On calling on the stars
On the constitution of the heavenly bodies
On the chest of wonders
On the glories of our Lord (*nazishhāhā-yi mawlānā*)
On the images of the planetary bodies
On the science of the Indians
On the science of the Greeks
On the science of divination through names and letters (*sīmiyā'*)[24]
On the science of alchemy

Doubtless, further branches of the occult sciences were to be discussed in the remaining chapters. As the chapter headings indicate, while the *Daqa'iq* is rooted in Muslim piety, it also draws on other currents, such as the learning of the Greeks and Indians, which are explicitly mentioned here. These constituted the 'sciences of the ancients' to which Ibn al-Athir referred; Greek and in particular neo-Platonic learning had a high place in the intellectual culture of Islam and influenced a wide array of fields of knowledge from philosophy to the occult sciences.

Another example of Greek-Hellenistic influence in the text are excerpts from the book of Hermes Trismegistos, the Hermetic occult writings.[25] An interest in these texts is reflected in other contemporary manuscripts from Anatolia, such as the *Mukhtar al-Hikam* by the tenth-century scholar Mubashshir b. Fatik, which dealt with tales of Hellenistic philosophers and wise men; a copy of this text was made by a scribe from Kayseri in 661/1263.[26] Another important figure in MS persan 174 is Alexander the Great (Figure 11.4), known by his Arabic name of Dhu'l-Qarnayn, and his vizier, Balinias (fols 69a, 71a, 79a), who is frequently portrayed as the authority for spells.

The primary theme running through the surviving parts of the text is how to invoke the aid of supernatural beings, whether God, angels, jinn or the planetary bodies, and the talismans associated with them.[27] It is advice for the *mu'azzim*, the magician specialising in such invocations (*'azīma*).[28] An important part of this thaumaturgical magic is the ability to address these supernatural bodies by their correct names, thereby enabling one to harness their power. The idea that God has 99 names is widespread in Islam, but the *Daqa'iq* claims He has no fewer than 124,000, with each name said to have created a prophet as well as angels.[29] The divine names thus play a role in generating the cosmic order. Particular attention is also given to the angelic names, and these reveal other influences beyond the Hellenistic ones outlined above. Many of the angelic names cited are evidently taken directly from the Hebrew, as often occurs in Islamic occult literature. Metatron (Figure 11.5), known

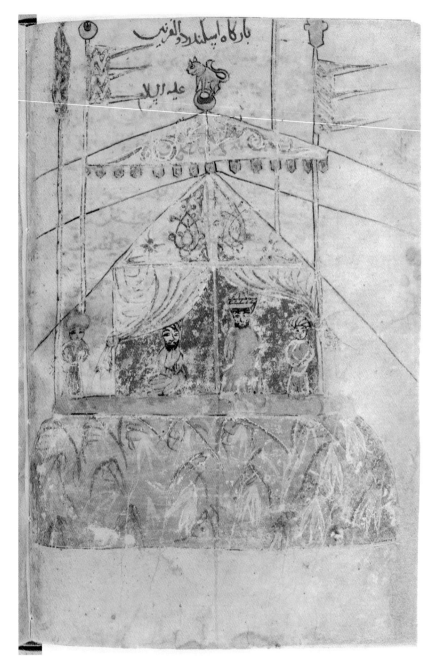

**Figure 11.4** The Court of Alexander the Great (Dhu'l-Qarnayn), *folio 103b from Ms persan 174.* Circa *1272–73, Anatolia. Bibliothèque Nationale de France. Source: © Bibliothèque Nationale de France*

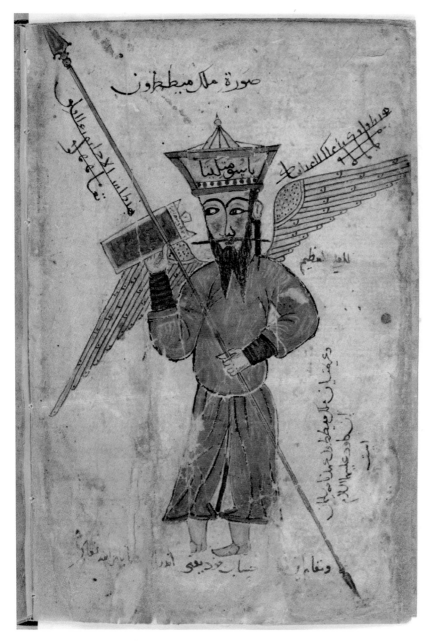

**Figure 11.5** The Angel Metatron, *folio 73b from Ms persan 174.*
Circa *1272–73, Anatolia. Bibliothèque Nationale de France.*
Source: © *Bibliothèque Nationale de France*

from the Jewish Kabbalistic literature as the Recording Angel, features prominently in Nasiri's angelogy, suggesting the Kabbalah's
influence on Islamic occult sciences.[30] These angelic names may
have been transmitted to Nasiri through the work of the famous

magician Ahmad al-Buni, who lived in Egypt in the early thirteenth century and was the author of several well-known magical tracts, in which these Hebrew names feature.[31]

At the same time, the passages dealing with Metatron suggest how the angel and the rituals surrounding him have been adapted to the cultural environment of Islamic Anatolia. The occult knowledge promised by the *Daqa'iq* is intimately bound up with piety. The magician who wishes to invoke Metatron must retreat from the world and devote himself to piety for forty days; when the time comes, he must take a copy of the Qur'an with him, go up a mountain, make a sacrifice of a crane and arrange various foodstuffs like dates and water in fixed positions – even a diagram is provided (Figure 11.6), suggesting that the point of the ritual is to reproduce on earth Metatron's planetary representation.[32] Interestingly, in testimony to Anatolia's multi-cultural environment Nasiri gives the word for crane in Persian, Greek, Turkish and Armenian. Metatron is thus Islamised, but the rituals for invoking him are put in a local Anatolian context.

Nasiri repeatedly emphasises the Islamic credentials of these occult texts. For example, explaining the need for a specialist to perform the important work of magic, he writes:

> It should be known that the science of magical invocation (*'ilm-i mu'azzimī*) is a great task. It is not work for the base or the ignorant. In particular, physicians, materialists, rationalists and philosophers have no faith in this science. Nor do they believe in the Resurrection or the Day of Judgement.[33]

In other words, magic is a task only for the truly pious. Those who reject it are effectively atheists. There are also several allusions to Sufism in the manuscript, such as a brief poem on *'ishqbāzī*, a technical Sufi term for love,[34] while a section of the *Mu'nis al-'Awarif* discusses the importance of renouncing the world, a typical Sufi theme.[35] Indeed, despite the many elements that derive from non-Islamic sources, Nasiri's works are ultimately fundamentally Islamic in character and inspiration.

Written in verse, the *Mu'nis al-'Awarif*, the final work in the manuscript, has a character rather different from the preceding texts and is the only one to be entirely unillustrated. Unlike the other works, the *Mu'nis* makes direct reference to the political circumstances under which it was composed and is less directly concerned with occultism. It is an eclectic collection of poems of different metres and rhyme schemes, mostly by Nasiri himself, although there are also fragments from other authors such as the famous poet Khaqani. After invoking God, the first section deals with the theme of the Day of Judgement and Resurrection. Reflecting on the vanity of this world, the poet urges himself to abandon it for he too is due to die,

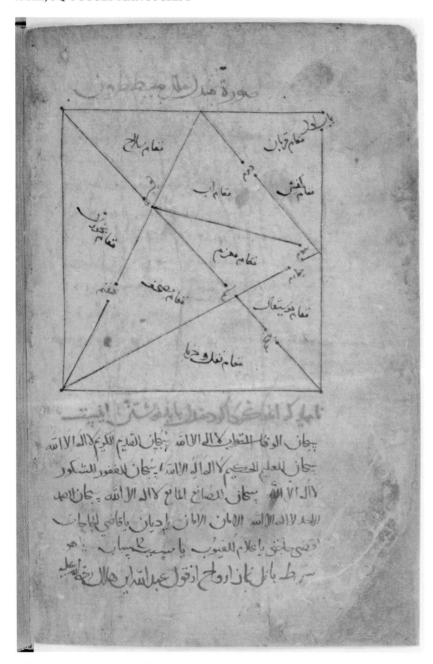

**Figure 11.6** *Diagram of how to invoke Metatron, folio 74b from Ms persan 174. Circa 1272–73, Anatolia. Bibliothèque Nationale de France. Source: © Bibliothèque Nationale de France*

and then embarks on an *ubi sunt* lament: where are the sages of old like Daniel, kings like the ancient Iranian king Kaykhusraw and his wise men, or rulers like the Great Seljuq Sultan Sanjar?[36] The following section discusses the six signs of the end of time on the basis of hadith. The manuscript is somewhat damaged here, but these signs comprise oppressive rulers, the abandoning of asceticism and holy war, seeking positions from the unbelievers, women acting without shame, and lewd behaviour being done openly. A further sign is that unbelievers will seize the whole world, but a man will arise from Rum with a great army and do battle with the Franks. In addition, during these latter days the wolf and the sheep will lie together, one of the numerous unnatural portents that other writers commonly identified as apocalyptic.[37]

This represents a fairly direct allusion to the author's own time and to the Mongol domination of the Middle East. Numerous writers equated the Mongol invasions as a sign of the apocalypse, and the breakdown of morality Nasiri describes is also clearly intended to signify the end of days. Other writers, too, equated the Mongols with the Antichrist whom Islamic tradition envisions emerging towards the end of time, to be vanquished by the *mahdi*, the saviour whom both Sunni and Shi'ite Muslims believe will install a final reign of justice on earth before the end of time. It is at this juncture, however, that Nasiri introduces his most surprising twist, identifying the *mahdi* as none other than his patron, the child sultan Ghiyath al-Din Kaykhusraw III, who is described in two chapters. The first is entitled 'Praise of the Great Sultan, the Pride of the Seljuq Dynasty, Ghiyath al-Dunya wa'l-Din Kaykhusraw ... and the Rule of the Mahdi and its Signs' (fol. 137a). The second is more explicit: 'The Rules of the Mahdi and his being named the King of Time, Ghiyath al-Dunya wa'l-Din, may God lengthen his life' (fol. 137b; Figure 11.7). The text is somewhat damaged on these folios, but enough is clear to confirm the identification of the child king Ghiyath al-Din with the *mahdi* and to situate the apocalyptic vision of the author firmly in the context of Mongol-dominated late Seljuq Anatolia, where the Seljuqs and Mongols are identified with the wolf and sheep of the earlier apocalyptic prophecy.[38]

## Conclusion

For the puppet Seljuq sultanate, surviving on sufferance under Mongol tutelage, Nasiri's manuscript may thus have had a more specific attraction beyond its general role as a manual of occult knowledge presented in attractive illustrated form and accessible language. Magic ultimately aims to accomplish the unfeasible by invoking the supernatural. Can we therefore perhaps see in this collection of texts not simply a justification of the sultanate's present position, but a hope that by learning to invoke supernatural forces,

**Figure 11.7** *The chapter heading introducing Sultan Ghiyath al-Din as the Mahdi, folio 137b from Ms persan 174. Circa 1272–73, Anatolia. Bibliothèque Nationale de France. Source: © Bibliothèque Nationale de France*

some miraculous solution to its situation might be found? In this sense, the Seljuqs' interest in 'the sciences of the ancients' was not merely a question of dabbling in the occult, but represented a crucial political strategy to validate Seljuq claims to rule at a moment of profound, even apocalyptic crisis. Thus, in the works of Nasiri, piety, esoterism, apocalypticism and politics all meet in an enigmatic combination that nonetheless sheds fresh light on the death-throes of Seljuq rule in Anatolia.

## Notes

Acknowledgements: The research leading to these results has received funding from the European Research Council under the European Union's Seventh Framework Programme (FP/2007–2013)/ERC Grant Agreement n. 208476, 'The Islamisation of Anatolia, c. 1100–1500'. I am very grateful to Matthew Melvin-Koushki for discussing the manuscript with me at an early stage of my research; all mistakes, naturally, are mine.

1. Ibn al-Athir 1964, vol. 10, p. 37; see Peacock 2015, p. 186.
2. For recent approaches to religion in the Seljuk world see Safi 2006; Peacock 2015, pp. 246–85; Ansari, Schmidtke and Tor 2016.
3. The main published study of the illustrations is Barrucand 1991, pp. 113–42. However, Barrucand's conclusions have been strongly questioned by art historians in workshops devoted to this manuscript held in St Andrews and Paris in 2017 and 2018. These will be fully published in due course.
4. This situation has only recently begun to change. For some recent studies of occult texts in Islam, see Coulon 2017; Melvin-Koushki 2017, pp. 127–99.
5. Sayılı 2016, pp. 162–68.
6. Orthmann and Schmidl 2017.
7. For some examples of astrological motifs on material culture of the period, see Canby, Beyazit, Rugiadi and Peacock 2016, cat. 7, p. 57, pp. 66–71, 198–209; see also Pancaroğlu 2004, p. 160. For coins see also Spengler and Sayles 1992–96; Leiser 1998, pp. 96–114.
8. Auld 2007, p. 156. I am very grateful to Robert Hillenbrand for this reference.
9. Bar Hebraeus 1932, vol. 1, p. 320.
10. Tiflisi's work on astrology is the *Madkhal fi 'Ilm al-Nujum*, preserved only in a fifteenth-century manuscript made for the library of the Ottoman sultan Mehmed II (MS Istanbul, Nuruosmaniye 3493); the *Kamil al-Ta'bir* is preserved in numerous manuscripts and has been published (Kamal al-Din Abu'l-fadl Hubaysh-i Tiflisi 1388/1968). On the author, see Yazıcı, 'Ḥobayš b. Ebrāhim b. Moḥammad Teflisi'.
11. Melvin-Koushki 2017, pp. 129–33; Coulon 2017, pp. 211–19.
12. Bursa İnebey Yazma Eser Kütüphanesi, MS Hüseyin Çelebi 823, fol. 131a.
13. For manuscripts of the Persian version of the *Kitab al-Thamara* from our period, see for instance MS Istanbul, Süleymaniye Library, Ayasofya 2695, copied in 696 AH; MS Leiden University Library, Or. 96.
14. Shams al-Din Muhammad ibn Amin al-Din Ayyub Dunaysiri 1350/1931.

15. It is likely that the Persian romance *Warqa' wa Gulshah* now preserved in the Topkapı Palace Museum, Istanbul, MS Hazine 841, was also produced for the Seljuq court in Konya in the 1240s, but this cannot be definitely proven through colophons or inscriptions. On the illustrations of MS persan 174 see Barrucand 1991; Caiozzo 2000, pp. 109–40.

16. Five works are identified by Francis Richard in his detailed description of the manuscript in his *Catalogue des manuscrits persans I: Ancien fonds, Bibliothèque nationale, Département des Manuscrits,* pp. 191–95. Richard also offers a conjectural restoration of the order of the original manuscript. However, it must be admitted that it is far from clear at times where a given work begins and ends, and how chapters with no obvious connection to other parts of the manuscript fit in, such as the chapter on magic alphabets (fol. 41b–43b).

17. MS Paris persan 174, fol. 4a.

18. On this topic see Peacock 2013b, pp. 191–222.

19. MS Paris persan 174, fol. 137b.

20. MS Paris persan 174, fol. 129a–b.

21. MS Paris persan 174, fol. 140a.

22. *Tilsim* is the general term for a talisman and is used throughout MS Paris persan 174. A *haykal* is specifically a talisman or votive offering made for a specific planet in order to seek its assistance. More generally, sections of talismanic scrolls were also called *haykal*. For these usages, see Al-Saleh 2014, pp. 24–25, 125, 128–35.

23. For another reference to the author, see fol. 73a, 32a; the reference to *'ulūm-i hādhiq* on this latter page suggests this may be part of the *Daqa'iq al-Hadhiqin*.

24. On *sīmiyā*, see Coulon 2017, pp. 213–14.

25. See Caiozzo 2000, p. 111.

26. MS Istanbul, Süleymaniye Library, Ayasofya 2895, copied by Ibrahim b. Khwajaki b. Abu Bakr al-Qaysarawi.

27. For a study of this aspect, see Caiozzo 2000.

28. MS Paris persan 174, fol. 67b.

29. MS Paris persan 174, fol. 99a.

30. MS Paris persan 174, fol. 72b ff.

31. There are, however, severe problems with the date and attribution of many of Buni's texts; see the discussion in Coulon 2017, pp. 205–29.

32. MS Paris persan 174, fol. 75b.

33. MS Paris persan 174, fol. 77a.

34. MS Paris persan 174, fol. 129a.

35. MS Paris persan 174, fol. 136b.

36. MS Paris persan 174, fol. 135b.

37. See Cook 2002.

38. This passage and the concept of the *mahdi* in medieval Anatolia are discussed in detail in Peacock, 2019.

# CHAPTER TWELVE

# Al-Khāzinī's Astronomy under the Seljuqs: Inferential Observations (*i'tibār*), Calendars and Instruments

*George Saliba*

## Introduction

BY THE TIME the Seljuqs came to prominence, towards the middle of the eleventh century, Islamic science in general and Islamic astronomy in particular had already made remarkable advances. Those advances were to become the foundational building blocks for scientists working under the Seljuqs and for the generations that followed.

In the field of observational astronomy, for example, the first half of the ninth century had already witnessed far-reaching developments that began to give Islamic science its own identity in contradistinction to its role as a continued extension of Hellenistic science. The hallmark of this new identity was to be celebrated by later generations as being precisely a period of targeting the very Hellenistic tradition of which it was an extension and to subject it to a thorough programme of updating.

As far as observational astronomy was concerned, this emergence of a new identity could take place at this particular time simply because ninth-century Islamic scientists could take advantage of the passage of some seven and half centuries that separated them from the original observations recorded by Claudius Ptolemy (d. *circa* 170), the most notable Greek Hellenistic astronomer and the foremost spokesman of Hellenistic astronomy, whom they admired the most.

Almost all basic parameters, whose inadequacy had been revealed by the passage of time, were included in this update. Parameters such as the rate of precession, which is best noted by the slow change in the date of the vernal equinox, which, after several adjustments and the major Gregorian reform of the calendar in the latter half of the sixteenth century, now falls close to 21 March during our current calendar year. Ptolemy had earlier determined this slow precession

motion to have been 1° / 100 years.[1] He reached this result on the basis of comparing his own observations with those of Hipparchus, which had been carried out some 265 years earlier.

Naturally, any small approximation in this result would become exaggerated and more pronounced some 700 years later. Well-known fixed stars such as Regulus, which is relatively easy to observe as it lies very close to the ecliptic, the yearly great circular path that the earth takes around the sun, was determined by Ptolemy to have a longitude close to Leo 2;30° (that is, at 2 degrees and 30 minutes in Leo).[2] When the same star was observed by Battānī in the year 888, it was found to be at 14° of Leo,[3] meaning that it seemed to have moved by about 11;30° instead of the anticipated 7;30° it was supposed to have moved had Ptolemy's value of precession been valid. And by the time of ʿAbd al-Raḥmān al-Ṣūfī, who observed the same Regulus in the year 964/5 – some 830 years after Ptolemy – he found it to have moved by 12;42° from where it was at the time of Ptolemy,[4] instead of moving by only 8;30° if Ptolemy's value of 1° / 100 years could have been trusted. All these observations forced astronomers working during the ninth and tenth centuries to conclude that the rate of precession was to be 1° / 66 years, rather than the 1° / 100 years given by Ptolemy.

Similar discrepancies were noted in regard to the value of the declination of the ecliptic, also expressed by the inclination of the earth's axis, which was determined by Ptolemy to have been 23;51,20°.[5] Ninth-century observations found this value to be more around 23;30°. The list of examples goes on.

The following table gives details of some of the important updates that were adopted in the ninth century – updates that produced values much closer to what is still in use today.

Table 12.1 Details of some of the important Ptolemaic parameters that were updated during the ninth century

| Astronomical Parameter | Values given by Ptolemy *circa* 170 AD | New values at the mid-ninth century *circa* 700 years later |
|---|---|---|
| Rate of precession | 1° / 100 years | 1° / 66 years |
| Solar apogee | Fixed at 5;30° of Gemini | **Found to move together with other planetary apogees or together with precession** |
| Solar eccentricity | 2;29$^{1/2p}$ [6] | **2;6,42 by Thābit**[7] |
| Maximum solar equation | 2;23° | **Between 1;59 and 2;01 according to Ibn Yūnus**[8] |
| Ecliptic declination = inclination of Earth's axis | 23;51,20° | **≈ 23;30° Still valid for modern times** |

## Observational theory

Once the plethora of parameters that needed to be updated was found, the natural question to raise was as follows: How could Ptolemy have been wrong on so many counts? The most innovative answers to this question came in the above-mentioned treatise of Thābit Ben Qurrah (d. 901), entitled 'On the Solar Year'. In that treatise Thābit came to the conclusion that it was Ptolemy's strategy of observation that produced the crude value for the solar eccentricity and its consequent relation to the position of the solar apogee and the solar maximum equation. In lay person's terms, Ptolemy's strategy required that observations of the sun's longitude, as detected from its declination, be made at the equinoxes, which was relatively easy as the changes in the declination of the sun during those times can be detected from day to day. But it also required that observations be made at the exact times of the solstices, when the sun reaches its maximum northerly rising position on the local horizon, during its passage through the summer solstice around 21 June and its diametrically opposite southerly position during the winter solstice around 21 December. During the solstices the sun would seem to rise and set for several days in a row on the same point on the local horizon, or its declination as measured by a mural quadrant would seem to duplicate itself during those days, thus making it very difficult to detect the exact time when the sun crosses the solstice, as can be seen in Figure 12.1.

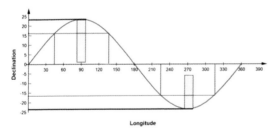

**Figure 12.1** *Declination of the sun, marked on the vertical axis, as the sun moves from the equinoxes at points 0° and 180°, marked along the horizontal axis, where the changes from day to day can be relatively easily detected along the vertical axis. Those changes seem to disappear for a few days at the solstices at 90° and 270°. Observations made in the middle of the season, at points of 45°, 135°, 225° and 315° are as easy to detect as those taken during the time of the equinoxes, thus yielding a more accurate reading of the declination, and thus the solar longitude that is required for the determination of the other parameters. Source: Drawing by the author*

The solution proposed in Thābit's treatise was to change the observational strategy of Ptolemy and instead observe the declination of the sun during the middle of the seasons – thus called the *Fuṣūl* (seasons) method – when the sun crosses the 15th degree of Taurus, the 15th degree of Leo, the 15th degree of Scorpio and the 15th degree of Aquarius, all times much easier to determine with much higher accuracy (Figure 12.1). With that shift in strategy, observers could then determine, all at once, much more correctly the most fundamental parameters for the motion of the sun, upon which the motions of the other planets depend, as well as the solar eccentricity, the position of the solar apogee and the solar equation.

Another area of innovation by ninth-century astronomers was manifested in their abandoning of the chord concept upon which calculations of geometric components of circles in Hellenistic astronomy were based. In the ninth century, astronomers working in the Islamic domain first replaced the chord with rudimentary trigonometric concepts such as the sines, cosines and tangents that they had inherited from the Indian tradition. These trigonometric concepts were further developed in the same period, and new ones were added. These developments can best be observed particularly in the works of someone like Ḥabash al-Ḥāsib (d. 874),[9] where the use of chords was shunned and replaced by a pervasive use of trigonometric functions. By the end of that period, almost all the trigonometric equations and identities that we now know were already in full use. And thus the new calculating techniques almost managed to supplant completely the equivalent techniques involving chord concepts in all the calculations known from Hellenistic astronomy. This acculturation of trigonometry and its promotion as a basic branch of the mathematical sciences, which was based on non-Hellenistic ideas, was a total novelty brought about during the ninth century.

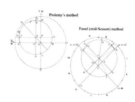

**Figure 12.2**
*Comparison between Ptolemy's and the Fusūl methods.
Source: Drawing by the author*

Those were not all the important results that the ninth century witnessed. Their sheer number, however, and their sheer obvious variation from their Ptolemaic counterparts, as well as the various cultural reasons encountered in the Islamic environment of the ninth century that facilitated the adoption of the new parameters, simply suggested that one could no longer take the inherited Ptolemaic astronomy at face value as the uncontested astronomical system. All, or at least most of those new conditions, changed the attitude of the ninth-century astronomers, from an attitude of accepting the received Hellenistic legacy and building on it – as one would expect from the praise with which Ptolemy was showered by ninth-century astronomers – to an attitude of skepticism and suspicion with regard to those observable values and to a variety of other aspects as well.

One such area that entailed investigating theoretical domains did not look on the face of it as being directly related to observational astronomy. Those theoretical domains included areas of cosmological speculation that were inspired by observational astronomy; once re-oriented, they necessitated posing questions that by themselves produced further observational investigations. In particular, this new attitude of skepticism generated questions and the willingness to re-investigate some basic Ptolemaic statements, especially his statements in the *Planetary Hypothesis*, which touched upon the manner in which the celestial spheres carried out their own motions.

By extension, the motions of those spheres in turn produced the observable motions of the planets that they carried. It was Ptolemy who had stipulated that the motions that were seen in the celestial sphere surrounding the earthly observer – who was located on a fixed earth at the centre of the universe – were the product of particular agents causing those motions in such a way that no one agent could produce two contradictory motions at the same time. For example, in order to account for the daily motion of the whole celestial sphere seemingly completing one full revolution every twenty-four hours, making all of the starry heavens rise in the east and set in the west every day, that motion was supposed to be caused by the natural circular revolution of the starry sphere, the so-called Atlas, that carried all the constellations. They, in turn, kept fixed distances amongst themselves – thus the fixed stars. This starry sphere had to be placed well beyond all the other planetary spheres since in its daily revolution it carried with it all the other planetary spheres that seemed to partake of this daily motion as well.

But once the so-called fixed stars were observed to have their own motion – that of the above-mentioned precession, for which we saw Ptolemy assign the value of $1°/100$ years – and once the ninth-century astronomers determined that motion to be much faster – namely, at the rate of $1°/66$ years – then the natural question was to ask: Which sphere was responsible for this particular second motion of precession? Since Ptolemy stipulated a single motion for every sphere, he had to specify that the sphere responsible for the motion of precession was itself a ninth sphere, placed beyond the eighth sphere of the constellations, but which had to be concentric with it since it did not seem to exhibit the same features of eccentricity that were encountered in the cases of the solar and lunar spheres, as well as the spheres of the other planets, that were all embedded within the Atlas sphere.

On one hand, it was easy to imagine how a solid sphere could easily carry in its regular circular motion another sphere embedded in it – provided the second sphere was so placed that a revolving ring would carry the small sphere of the ring's crown together with its motion, since the ring's crown was at the circumference of the ring and not concentric with it. On the other hand, it was impossible to imagine a sphere 'forcing' another sphere to move along with it, when the second sphere was concentric with it and without assuming the existence of friction, adhesion, or the like between these two spheres. Those additional assumptions were all features of the sublunary world that could not be ascribed to a celestial sphere which was made of the simple element Ether, of which Ptolemy and before him Aristotle had assumed all the celestial spheres were composed.

This glaring cosmological puzzle led one of the patrons of the above-mentioned astronomer Thābit ben Qurrah, a polymath by the name of Muḥammad b. Mūsā b. Shākir (d. 873), to write a treatise

specifically contradicting these Ptolemaic cosmological assertions; he pronounced the impossibility of the existence of a ninth sphere that would be concentric with the eighth sphere and still be made responsible for the precession motion.[10] These kinds of cosmological questions were to become the main concern for generations of astronomers that followed, all the way until the nineteenth century and beyond.

## Astronomy during Seljuq times: al-Khāzinī and *i'tibār*

The achievements of the ninth century detailed so far formed the solid background that brought about the birth of the new Islamic astronomy, together with its distinguishing features that continued to flourish during the following centuries, starting with the Seljuq times. Astronomers of the Seljuq period managed to build further on that foundation and mark new milestones of their own. The most distinguished of those astronomers, to whom this essay devotes the lion's share of discussion, was the polymath astronomer, mathematician, instrument-builder and philosophy of science theorist by the name of Abū al-Fatḥ 'Abd al-Raḥmān al-Khāzinī (fl. 1115–30).[11] Al-Khāzinī, a slave boy of Byzantine origin, was apparently very lucky to have had a benevolent master who made sure that he had the best education of his time, especially an education in the rational sciences.

Khāzinī produced two major scientific works and several other lesser ones that have not all been fully investigated yet. On the subject of astronomy, his *magnum opus* was a handbook that he dedicated to his patron, the Seljuq Sultan Sanjar b. Malikshāh (1086–1157), which he called *al-Zīj al-mu'tabar al-Sanjarī* (The Verified Sanjari Zīj) in honor of his patron. More will be said about this title below. The second major scientific work is his book on hydrostatics, called *Mīzān al-ḥikma* (Balance of Wisdom), which will also be discussed below.

On the subject of observational astronomy, Khāzinī produced two very important treatises that are known so far, both dealing with what can be called philosophy of science, rather than traditional astronomical issues. The first is called *Risāla fī al-ālāt al-'ajība al-raṣdīya* (Treatise on the Miraculous [Observational] Instruments; Figure 12.3) – *Ālāt*, for short – and the second is called

**Figure 12.3** *Title page of Khāzinī's* Risāla fī al-ālāt al-'ajība *(Treatise on the Miraculous [Observational] Instruments). Sipahsalar 681, now in the Madrase-i Ālī Shahīd-i Mutahharī, Tehran*

**Figure 12.4** *Title of* Risāla fī uṣūl al-i'tibār *(A Treatise on the Principles of* I'tibār*). Formerly Sipahsalar no. 10136, now in the Shahīd Mutahharī Library, Tehran*

by more than one title, all dealing with the same philosophical issue concerning observation.

In the introductory section of Khāzinī's *al-Zīj al-mu'tabar al-Sanjarī* now preserved at the Vatican Library, Arabo 761, this second treatise is called *risāla fī uṣūl al-i'tibār* (A Treatise on the Principles of *I'tibār*) – more on the term *i'tibār* below. But in an independent copy of the same treatise, now preserved at the Shahīd Mutahharī Library in Tehran (former Sipahsalar, no. 10136; Figure 12.4), it is called *risāla fī nukat kayfīyat i'tibār mawāḍi' al-sayyāra* (Treatise on Subtleties Regarding the Manner of *I'tibār* of the Wandering Planets' Positions), also simply known as *risālat al-i'tibār* – or *i'tibār*, for short.

Before delving into Khāzinī's intentions in producing these astronomical works, a word should be said about the term *i'tibār* itself, since it obviously touches upon the very concept that is common to Khāzinī's astronomical works. The root from which the term *i'tibār* and its variants are derived (عبر, *'abara* – that is, to cross, to augur, meditate upon, examine, interpret, express, and so on) is itself a very nuanced term upon which no other astronomical work known to us so far has ever focused.

As a term, to be sure, *i'tibār* has a long, variegated history, going all the way back to Qur'anic pronouncements where it means something like deriving a lesson from specific events, or reflecting on some evidence in order to draw a specific inference from it. In the famous commandment of Qur'ān 59:2, the text says '*fa-i'tabirū yā ūlī al-abṣār*' (Take Heed O Ye Who Have Eyes to See); here, the term *i'tabara* is used to mean something along the lines of 'drawing a lesson', drawing inference from what one sees to the new knowledge that one does not see. The term *'ibra*, which is derived from the same Arabic root, is also used very frequently in the Qur'anic text to mean something along the lines of 'a lesson', 'an inference', as in Qur'an 24:44, where the variation of day and night is described as ''*ibratan li-ūlī al-abṣār*' (A Lesson to those Who Have Eyes to See). In all Qur'anic instances the term *i'tabara* or its derivatives seem to reflect the act of drawing an inference from observation, thus abstracting a lesson from the empirical evidence at hand.

The term *i'tabara* in the sense of 'to verify', 'to examine', 'to consider', 'to learn a lesson', and in general 'to derive new knowledge from empirical evidence' was used extensively a century before al-Khāzinī, by the famous polymath physicist, mathematician and astronomer Ibn al-Haytham (*circa* 965–1040), who used it to add the nuance of observation, reasoned consideration, experiment, examination, inference, judgement by analogy,[12] and so on. Thus, between the religious and juridical connotations embedded in the Qur'anic

text and its commentaries, as well as its scientific use by the likes
of Ibn al-Haytham, the term had already become impregnated with a
rich tapestry of meanings by Khāzinī's time.

One of Khāzinī's contemporaries, the famous philosopher Abū al-
Barakāt al-Baghdādī (*circa* 1070–1164) went on to call his own philo-
sophical *magnum opus kitāb al-mu'tabar*, meaning of course that
the judgments expressed in that book were examined closely, tested
by analogy, inferred from other obvious judgments or observations
by personal reflection and discernment, and in general conclusively
verified.[13] Another Andalusian philosopher from the same period,
the famous Averroes (d. 1197), composed a treatise that he called
*faṣl al-maqāl fī taqrīr mā bain al-sharī'a wa-l-ḥikma min al-ittiṣāl*
(The Decisive Treatise on Determining the Connection between
Religious Law and Philosophy). There, he best defined the concept
of *i'tibār* in terms of its relationship to intellectual reasoning in the
following terms:

> Since it has been determined that religious law required the exam-
> ination of the phenomena by reason and deriving inference from
> them (*i'tibāriha*), and since deriving inference (*i'tibār*) is nothing
> more than the derivation of the unknown from the known, and
> its extraction from it, and that is syllogistic reasoning (itself), or
> by means of syllogistic reasoning, then it behooves us to make
> our investigation of the phenomena by means of intellectual
> reasoning.[14]

The philosophical tenor regarding the use of the term *i'tibār*, as
used by contemporaries of Khāzinī, leaves no doubt that this term
was meant as an expression of analogical reasoning that involves a
close consideration of the facts or the phenomena at hand, as well as
making a reasoned judgment concerning their import, thus provok-
ing the production of new knowledge from the close investigation of
the phenomena. As in the often repeated Qur'anic exhortations to
consider the obvious evidence, the succession of day and night, the
site of remains of previous civilisations and the marvels of the starry
heavens are all evidence that should be contemplated and closely
considered in order to reach the conclusion that the world has a
maker and a purpose, an abstract new theological knowledge implied
by the observed phenomena.

In this context it becomes clear why Khāzinī opted to address
the issue of *i'tibār* in his astronomical handbook and to append the
term *mu'tabar* to its title, since the role of observing and theoris-
ing is of paramount importance to this work. In addition, we do
not know of any other astronomical handbook (*zīj*) written within
Islamic civilisation, before or after Khāzinī, that has ever used such
terminology and taken the important step of separating the actual
astronomical results usually included from the theoretical position

of exploring the importance and role of actual observations that led to the astronomical results recorded in that *zīj*.

Thus, in order to highlight that very important philosophical point, Khāzinī decided to open his astronomical handbook with a relatively short treatise specifically exploring the concept of *i'tibār*, which he called *risālat fī-l-i'tibār*. The opening folios of the two extant manuscript copies of that *zīj* so far uncovered in European libraries – Vatican 761 and British Library Or 6669 – have both included copies of such a treatise. Unfortunately, both copies have been desperately shuffled out of order, so much so that the opening treatise on *i'tibār* is hopelessly beyond repair in both manuscripts.[15] But as serendipity would have it, this particular opening treatise has been separated in the manuscript tradition, and a full copy of it is now preserved in Tehran's Sipahsalar library, now called Shahīd Muṭahhirī library, No. 10136. Another slightly incomplete copy is preserved in Istanbul University No. AY 314, pp. 167–95, according to Sezgin who inserted his own repagination into the manuscript and published it together with other treatises in this Istanbul University manuscript.[16]

Needless to say, the independent, complete treatise on *i'tibār* has not yet been published, and thus its import still awaits full investigation. But anyone browsing it cannot fail to notice the importance that Khāzinī attached to the act of closely-considered observations and the distinction he makes between this act of weighing the evidence (*i'tibār*) and observation (*raṣd*) itself. To highlight this distinction, he says in the introduction:

> And I called it (meaning, the treatise) the method of *i'tibār* (weighing of the evidence produced by observations). The difference between it and *raṣd* (observation) is that in observation (*raṣd*) all procedures are invented afresh (*yukhtara'*) and none of them is accepted beforehand, while in *i'tibār* certain observed things are accepted (*musallamāt*), upon which other required things of mean motions are based. And this is the distinction between reasoning from the evidence (*i'tibār*) and observation (*raṣd*).

What Khāzinī wished to say is that in observation the observer determines the parameters afresh (such as motion in longitude, anomaly, latitude and so on) and thus brings forth (*yakhtari'*) new values. However, in *i'tibār* (اعتبار) one accepts parameters (such as mean motions, motion of the apogees and so on) which were determined during a previous observation, and then those parameters are tested by *i'tibār* ('weighing of evidence') to see if they predict the new positions now determined by the new observations. If the predicted positions match with the observations, then those accepted parameters would be considered 'verified' (*mu'tabar*) – hence the title of Khāzinī's book.

Khāzinī's predecessor Bīrūnī had already highlighted the concept of testing values by matching them with observations when in his book *On India* he spoke of the toil astronomers had to go through in order to harness the critical evidence they needed for their theories. There he gave the following example:

> Whoever is diligent, and concerns himself with what he sees of the irregularities regarding the computations of the planets and attempts to correct them, must exert effort to follow the example of Muḥammad b. Isḥāq al-Sarakhsī (second half of the tenth century), when he found in the computation of the planet Saturn a certain slacking. So he persisted in 'weighing the evidence' (*dāwama 'alā al-i'tibār*) until he determined that it was not caused by the equation (of Saturn). He then started adding one revolution (at a time) to Saturn's periods, and would investigate again (*yastaqri'*) until the computation matched his observation (وافق الحساب منها عيانه) which he then recorded in his *Zīj*.[17]

Khāzinī obviously benefited from earlier astronomers such as Bīrūnī, whom he quotes in both of his treatises on the *Miraculous Observational Instruments* and the *Balance of Wisdom*, both to be discussed below. In the introduction to Khāzinī's treatise on *i'tibār*, he showers praise on these predecessors whom he calls 'modern' astronomers (*al-muta'akhkhirūn*) – in this case, meaning astronomers of the Islamic civilisation in contradistinction to the classical Hellenistic ones. At that point, while discussing the reasons that led to renewing observations during Islamic times and in a passage where he draws the distinction between *raṣd* and *i'tibār*, he says: 'What the moderns have uncovered by way of verifying observations (*taḥqīq al-raṣd*), investigating precision of instruments, and dispensing with armillary spheres is best attributed to sheer legitimate magic', as if to say that all those achievements were truly incredible. And yet he says that those moderns recommended repeated re-examination of observations especially in the case of the 'motions of wandering planets, the fixed stars, the apogees, and other such motions that require the disregard of fractions at the time of observations'. But if the positions of the fixed stars were correct, and if the wandering planets were measured with respect to them, then the matter is relegated to observation (*raṣd*) and not to be considered re-evaluation (*i'tibār*). But if there were differences in their positions, then the observer would estimate the values and relegate the matter to considered re-evaluation (*i'tibār*).[18]

In the second treatise, *Risālat fī al-ālāt al-'ajība al-raṣdīya*, Khāzinī expresses his approval of the ability of instruments to produce new knowledge, almost in the same way that analogical reasoning through *i'tibār* was able to produce reasoned unknown theoretical arguments and base them on known observable phenomena. While

discussing the justification for writing the *Ālāt*, he characterises instrument-making as a miraculous craft (ṣinā'a 'ajība) and justifies this characterisation by saying: 'because it leads the investigator to a far-reaching knowledge without any known previous knowledge, and that is the most miraculous of miracles (a'jab al-'ajāib)'.[19] The view of observational instruments as tools for producing new knowledge is philosophically and epistemologically the same as the concept of i'bitār, where new theoretical knowledge was also produced from observable phenomena. No wonder that those instruments were then thought of as miraculous, for without them new knowledge would not have been made available.

Khāzinī's use of earlier sources is freely mentioned in all of his works, as stated above. In this instance, his reference to Bīrūnī appears in this treatise as well. In the third section of this seven-section treatise, Khāzinī refers to an instrument called the instrument of the triangle, a form of a diopter surveying instrument. In the first chapter of that section, he explicitly says: 'this is an instrument that was mentioned briefly in Bīrūnī's *Determination of the Coordinates of Distances Between Cities*', in which Khāzinī promises to detail its construction and use in his own *Ālāt*.[20]

By far the most interesting section of Khāzinī's *Ālāt* treatise is the last one, titled 'Extraction [of distances] without an instrument – meaning with instruments easy to find' – a title that is slightly counterintuitive in a treatise devoted to the description of observational instruments. But from a different perspective, this section can also be read as a confirmation of Khāzinī's belief that the act of observation is more dependent on the ingenuity of the observer in fashioning instruments and techniques by using common sense rather than relying solely on the function of the instruments themselves, no matter how miraculous they can be. In this chapter Khāzinī poses the question: 'If the instruments thus far described were lacking and one wished to know the distance to a visible object by intuition (bi-l-badīha), how would one do that with instruments that are easy to find?' In fact, the very first part (bāb) in this last section is titled 'The manner in which one can determine the distance of objects without an instrument', and the second part of the first chapter 'On the determination of the height of a lighthouse by measuring the shadow'. Khāzinī says in that regard: 'We measure the shadow of the lighthouse, and then set a staff of a known length perpendicular to the ground and measure its shadow. We then multiply the value of the lighthouse's shadow by the length of the staff, and then divide the product by the value of the staff's shadow. The result would then be the height of the lighthouse, with God's assistance'.

An even more interesting chapter in this last section is the one titled 'A subtle (laṭīf) chapter with which we end this book, *On the Ruses* (ḥiyal) *of the Turks*', obviously meaning the ingenious manner with which the Turks (of medieval central Asia) could measure things

with the use of simple techniques. One of these ruses is the tech-
nique of estimating the size of an army without actually counting
it, by estimating the size of a mounted horseman and calculating the
number of such horsemen that could be fitted in a specific terrain.

## On calendars

Another topic of critical astronomical importance was that of cal-
endars and their interrelationships, for the essential utility of the
subject concerns comparing various astronomical observations that
were usually recorded in different calendars. At the opening of his
magnificent *Sanjari Zīj*, Khāzinī introduces the subject of the history
and characteristics of the various calendars known to him. He then
draws tables of conversions relating these calendars and includes eras
and calendars that earlier astronomers had used in order to benefit
from the ability to compare various historical observations and to
calculate numbers of days separating one observation from another.
In the body of this section, he mentions a particular calendar he calls
the Jalālī/Sulṭānī calendar. Of this calendar he says that the Seljuq
Malikshāh (r. 1055–92) had issued an order for its establishment in
the year 471/1075 and required that the new calendar be initiated
just at the time when the sun – really the earth – reached the point
when the centre of the disk of the sun is in line (*muwāzāt*) with the
point of the vernal equinox.[21]

    Historical sources assert that Malikshāh gathered a group of astron-
omers to design the new calendar and that said group of astronomers
included the mathematician, astronomer and renowned poet 'Umar
al-Khayyām himself.[22] However, Taqizadeh asserts that al-Khayyām
must have been a young man when he participated in the initiation
of the calendar, if he did indeed, since he died fifty years after its ini-
tiation.[23] But the matter of young age is by no means unusual since,
as argued by none other than the famous mathematician Godfrey
Harold Hardy (d. 1947), mathematicians tend to demonstrate their
abilities at a relatively young age.[24]

    Much has been written about this initiative to set up a new cal-
endar. The calendar itself is usually called the Jalālī calendar, after
Malikshāh's honorific title Jalāl al-Dawla.[25] Almost all who have
studied this new calendar, which has morphed into the modern cal-
endar still used in Iran by the law that formalised it in 1925, stressed
the fact that this new calendar turned out to be highly precise, even
when compared with the most common and more modern Gregorian
calendar. Suter even recalculated the interpolation schemes of the
Jalālī calendar and found the resulting mean length of the Jalālī
year to yield an error of one day every 3,770 years, in contrast to the
Gregorian calendar which produces an error in the shorter period
of one day every 3,330 years. Thus, Suter concluded that the Jalālī
calendar was more accurate than our own Gregorian calendar. That

judgment has been repeated ever since. Even Heydari-Malayeri's more modern assessment of the Paris Observatory asserted that, because the Persian calendar was 'based on precise astronomical observations' – especially requiring the demanding observation of the vernal equinox – and because it used a very sophisticated intercalation system, it 'made it more accurate than its younger European counterpart, the Gregorian calendar'.[26]

## Khāzinī and the use of trigonometry

In the equally demanding field of mathematical astronomy, we note that Khāzinī freely used trigonometric functions like sines, cosines, tangents and so on (which, as noted above, were developed in the Islamic world during the ninth century) in all of his astronomical works we mentioned so far, instead of using the more complicated classical Hellenistic chord functions and the like. He even went as far as giving an original definition of the basic sine function in the following terms:

> The sine (al-jaib) is a standard (qānūn) to which the values of all arcs are referred. The maximum value of the sine is the radius of the circle, 60 parts. The sine of the complement of an arc is the sine of the remainder of the arc from 90 degrees, that is the sine of the complement of 30 degrees is the sine of 60 degrees.[27]

In the body of the zīj, Khāzinī goes on to compute the tables of these trigonometric functions to three sexagesimal places, with the table of the sine, for example, on fol. 123v of the Vatican copy of the zīj, the cosine on fol. 124r, and so on.

In that regard, one can then assert that Khāzinī continued to incorporate and develop further the field of trigonometry as we now know it and completely abandoned the equivalent but more complex Ptolemaic chords and spherical trigonometric theorems.

## Khāzinī's engineering exploits as related to astronomical observation

Khāzinī's most compelling achievement in the field of engineering and craftsmanship had a direct bearing on astronomical observation is his book *Balance of Wisdom*.[28] The book is designed to solve all sorts of problems usually connected with the department of treasury, such as weighing exact measures of metals, determining the purity of gems and precious stones, the amount of gold and its alloys, especially in coins of the realm, and specific gravities of substances, among other things.

Figure 12.5 shows one image of such a balance, appropriately called the 'balance of wisdom, also known as the comprehensive [one]'.

In this book Khāzinī devotes a section to time-measuring devices such as clocks in the form of clepsydras and sand clocks, which are all very relevant to measuring the passage of time that any astronomical observer would need. In the words of the editor of selections from the Arabic text of Khāzinī's *Balance of Wisdom*, he offers the following description of one of those clocks:

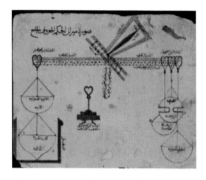

**Figure 12.5** *Folio 230v from Khāzinī's* Balance of Wisdom. *University of Pennsylvania, MS LSJ 386. Source: Courtesy University of Pennsylvania*

The balance-clock consisted of a long lever suspended similarly to the balance-level. To one of its arms was attached a reservoir of water, which, by means of a small hole perforated on the bottom of it, emptied itself in twenty-four hours. This reservoir, being filled with water, was poised by weights attached to the other arm of the lever, and, in proportion as the water flowed from it, the arm bearing it was lifted, the weights on the other arm slid down, and by their distance from the centre of suspension indicated the time which had elapsed.[29]

But that is not all that the book contains. In particular, it also includes a description of useful instruments and experimental results discovered by him and his predecessors. The experimental results Khāzinī had obtained, such as his supplementing of the table of specific gravities, included famous metals, liquids and precious stones. The metals comprised gold, mercury, copper, brass, iron, tin and lead, which were all very important for the industries of the day. Furthermore, the investigation of the specific gravity of gold is closely relevant to the standardisation of the coins of the realm in the department of the treasury to which Khāzinī devoted his book.

In this book, just as in the others, Khāzinī takes the stance of the humble but very knowledgeable person and in general does not attempt to distinguish himself as the sole innovator and discoverer of the techniques and instruments that he describes here and elsewhere. In the case of the *Balance of Wisdom* Khāzinī does not shy away from crediting his predecessors, all well-known scientists such as Thābit b. Qurra (d. 901), Muḥammad b. Zakarīya al-Rāzī (d. 924), Ibn al-Haitham (d. 1040), Bīrūnī – whom he cites as Abū al-Rayḥān (d. 1048) – al-Isfizārī (d. 1110) and his own contemporary Umar al-Khayyam (d. 1131), among others. But, of course, when he finds areas where he could improve upon the works of those distinguished scientists who came before him, as he did with the instrument for determining specific densities invented by Bīrūnī, he goes ahead and details his emendations with the humility of the learned scholar who feels that he constitutes a link in the chain of a tradition of scientists like him.

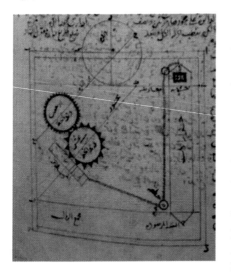

**Figure 12.6** *Image of the self-moving sphere of Khāzinī, fol. 118r from Khāzinī's* Balance of Wisdom. *Bodleian Library, Thurston 3. Source: Photograph by the author, by permission of the Bodleian Library*

Finally, mention should be made of one of the earliest treatises penned by Khāzinī, which was elegantly edited, translated and studied with commentary by Richard Lorch – namely, Khāzinī's treatise on the self-moving sphere that duplicates the motion of the celestial spheres.[30] In essence, the instrument described by Khāzinī is a form of planetarium that can be used for observational purposes as well as entertainment and education. The name of the author (Khāzinī), however, is erroneously spelled as al-Ḥāzimī in the Bodleian manuscript and as al-Khāzimī in the Ẓāhirīya copy, both readings correctly understood by Lorch as scribal variants of Khāzinī's name. The instrument, which is a kind of self-rotating clock, can be set by an observer to mark the time and thus monitor the motion of a phenomenon during that time. Lorch describes in great detail the manner in which such a clock operated. Its use for astronomical observations is undeniable.

An observational astronomer, for example, would like to know the time it takes a specific planet to cross from a particular point on the celestial sphere until it reaches the Meridian of the observer, where most phenomena are observed. Better yet, an observer may wish to determine the duration of a solar or lunar eclipse, an observation that yields many useful astronomical parameters such as the size of lunar or solar disks, among other things. In another sense such an instrument can be looked upon as an automaton that needs relatively little attention to mark the highly desirable required time. Figure 12.6 is an image of such an instrument as it appears in the faintly-preserved Bodleian manuscript Thurston 3, folio 118r.

## Concluding remarks

I hope that this brief essay still manages to illustrate the ingenuity of al-Khāzinī, the brilliant mind who proved with his own works, just barely surveyed here, that he was a formidable scientist of the first order and probably the leading scientist that the Seljuq Sultan Sanjar once employed. His theoretical treatment of the act of observation, which we detailed somewhat for the case of astronomy without really giving it full justice, could be generalised to cover other experimental scientific fields, as he also illustrated with his work on the balance. Knowing his humble beginnings as a slave boy, it is inspiring to learn that, under the care of his first master who exposed him to

the best education of his time, he nevertheless managed to become the distinguished scientist that he was and achieve such theoretical heights as were out of reach for his contemporaries and deservedly admired by his successors.

## Notes

1. See Ptolemy 1984, p. 328.
2. Here and in what follows we use the now conventional semi-colon to separate sexagesimal units from their fractions in much the same way the decimal point functions in the decimal system of numbers. Thus 2;30, means 2 units and a half or 30/60 of the same unit.
3. See al-Battānī 1899, p. 258.
4. See 'Abd al-Raḥmān al-Ṣūfī 1954, p. 184.
5. Ptolemy 1984, p. 72.
6. Ibid. p. 155.
7. See Neugebauer 1962, pp. 264–99.
8. Ibid. p. 276, n. 18.
9. See Debarnot 1987.
10. See Saliba 1994.
11. An excellent biography of Khāzinī was written by Hall 1981, pp. 335–51.
12. See, among others, Sabra 1971, pp. 133–36; this should be supplemented by the notes of Langermann 2014, pp. 147–76, esp. p. 150 *et passim*.
13. For a detailed study of the philosophical implications of al-Baghdādī's work, see Pavlov 2017.
14. *Wa-idhā taqarrara anna al-shar' qad awjaba al-nazar bi-l-'aql fī al-mawjūdāt wa-i'tibārihā, wa-kāna al-i'tibār laisa shay'an akthara min istinbāṭ al-majhūl min al-ma'lūm, wa-istikhrājihi minhu, wa-hādhā huwa al-qiyās aw bi-l-qiyās, fa-wājibun an naj'ala naẓaranā fī-l-mawjūdāt bi-l-qiyās al-'aqlī.* Nader 1968, p. 28 (my translation).
15. David Pingree devoted a special article highlighting the difficulty involved in editing the *Sanjarī zīj* on account of the fragmentary and disorderly nature of the European manuscript copies. See Pingree 1999, p. 105.
16. See Sezgin 2001.
17. Bīrūnī 1958, p. 352, lines 3–7.
18. *Risālat al-i'tibār*, fol. 1v.
19. Introductory part of the *Sanjarī zīj*, Sipahsalar 682, fol. 1v.
20. The instrument Khāzinī is referring to in Bīrūnī's *Determination of the Coordinates of Positions for the Correction of Distances Between Cities*, as mentioned very briefly and cryptically in the context of determining the height of mountains, is indeed found in Jamil Ali's translation of Bīrūnī's work (Ali 1967, p. 187). For the commentary on that section of the text, see Kennedy 1973, pp. 140–43; see also the Arabic text, Cairo edition, 1962, p. 221.
21. See *al-zīj al-Sanjarī*, British Library copy Or. 6669, fol. 33r, and the Vatican copy Arabo 761, fol. 57v.
22. For the names of the members of that committee and the historical sources that mention them, as well as a detailed discussion of the institution of this calendar, see Taqizadeh 1940, esp. pp. 110–17.
23. Ibid.
24. Hardy 1967, pp. 70–71.

25. See, for example, Suter, 'Djalālī', pp. 397–400; and most recently the study of Abdollahy, 'Calendars: Jalālī'.
26. See Heydari-Malayeri 2004 and Akrami 2011.
27. *Al-Zīj al-Sanjarī*, vat. Copy Arabo 761, fol. 33r.
28. The available editions of this work include the one that was produced by the Osmania Press in Hyderabad (India) in 1359/1940, with the title *Kitāb Mīzān al-Hikma*.
29. de Khanikoff 1858–60, esp. p. 105.
30. Lorch 1980, pp. 287–329.

# PART SIX
# OBJECTS AND MATERIAL
# CULTURE

# CHAPTER THIRTEEN

# Casting Shadows

*Margaret S. Graves*

WHERE DOES FORM end and ornament begin? What is the difference between a functional object to which motifs have been applied like a skin (Figure 13.1), and a functional object made in the shape of something else, such as an incense burner in the form of a lion (Figure 13.2)?[1] In the traditional terms of art history the dish in Figure 13.1 is a carrier of ornament and a straightforward example of the so-called 'applied', 'decorative', or 'minor' arts – the last of these names giving a very clear sense of that category's position within the established European hierarchy of artistic worth. The incense

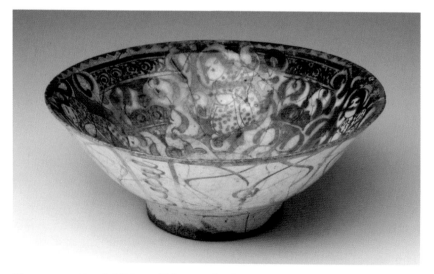

**Figure 13.1** *Bowl. Mid-twelfth to early thirteenth century, Iran. Glazed fritware with lustre overglaze decoration. D. 20.2 cm. Museum für Islamische Kunst, Berlin, no. I.2222. Source: Johannes Kramer, © Museum für Islamische Kunst der Staatlichen Museen zu Berlin – Preußischer Kulturbesitz*

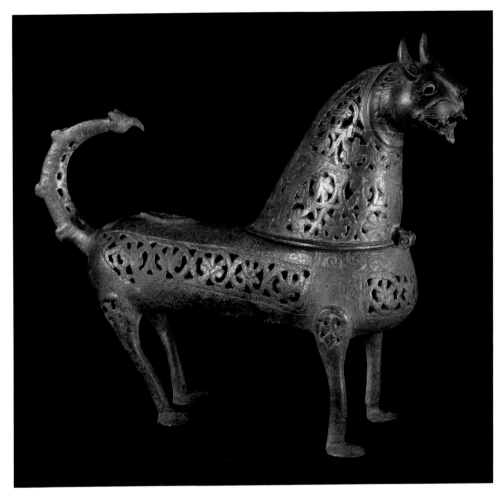

**Figure 13.2** *Incense burner. Eleventh or twelfth century, Khurasan. Cast, engraved, and pierced copper alloy. H. 24.5 cm. The David Collection, Copenhagen, no. 48/1981. Source: Pernille Klemp,* © *The David Collection*

burner is harder to fit into existing art historical taxonomies but would probably fall somewhere under the rubric of 'mimesis'.[2] Such pieces are sometimes bundled into the applied arts but at other times are treated in scholarly and commercial literature as if they were examples of sculpture – an awkward reclassification that has tended to obscure both the prodigious programmes of ornament that articulate such objects and their primary functions as incense burners, pouring vessels and so forth.[3]

Finally, what might we call the things that fall between the artificial poles of 'ornament' and 'form', objects on which forms emerge from plastic surfaces like those of a candlestick base in the Victoria and Albert Museum (Figure 13.3)?[4]

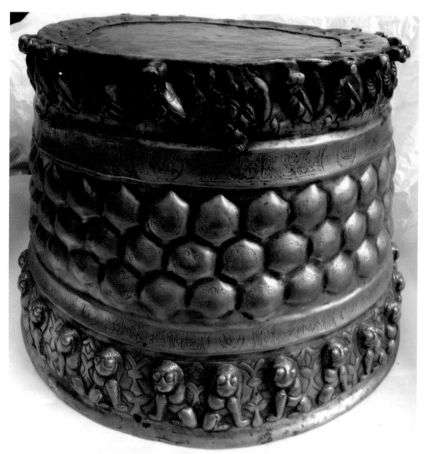

**Figure 13.3** *Candlestick base. Late twelfth or early thirteenth century, Khurasan. Chased, beaten and engraved brass with silver and copper inlay. H. 21.8 cm. Victoria and Albert Museum, London, no. 247-1902. Source: Courtesy of Victoria and Albert Museum*

The portable artworks of pre-Mongol Iran and Central Asia have long been celebrated for their superabundance of figural imagery, but perhaps even more remarkable are the qualities that bring about their striking 'lack of fit' with traditional art historical taxonomies: an innovative plasticity that transcends functionality, a remarkable level of engagement between media, and a consistently lively and intelligent inflection of form through surface ornamentation.[5] All these qualities defy the prefabricated art historical brackets of 'applied arts' and 'sculpture'. To do justice to a milieu in which so many of the finest works of art were also objects of use, we must dig deeper and consider what such objects might have meant in their own time and on their own terms.

Written evidence from the medieval period on such topics is slim. Nevertheless, a prescription found in the *Iḥyāʾ ʿulūm al-dīn* (Revival

of the Religious Sciences) of Ghazali (d. 1111) provides a rare and valuable record from the pen of an important medieval observer. In Ghazali's view there is an important distinction to be made between two- and three-dimensional models of representation within the art of the functional object. According to him, the orthodox Islamic legal position requiring the avoidance of figural depiction is not relevant for images (al-ṣuwar) applied to textile furnishings and vessels. However, it should be upheld, he asserts, for objects of use made in the forms of other (living) things:

> (. . .) images on cushions and spread carpets (al-ṣuwaru allatī ʿalā al-namāriqi wa-l-zarābīyi al-mafrūshah) are not forbidden, and on dishes and bowls (al-aṭbāq wa-l-qiṣāʾ), (but) not vessels taking the shape of images (al-ʾawānī al-muttakhadha ʿalā shakl al-ṣuwar). The tops of incense burners (ruʾus al- majāmir) are sometimes in the shape of a bird (ʿalā shakl ṭayr), this is unlawful.[6]

This statement represents one of those rare, happy moments of direct reference in the medieval textual corpus to material practices, in this case bird finials on incense burners and vessels 'taking the shape of images', also translatable as 'taking the shape of figures'. Such practices are abundantly evident in the surviving material remains from the pre-Mongol Iranian realms that Ghazali occupied for most of his life, but that barely seem to register in the rest of the textual record. I will come back to the material implications of Ghazali's statement shortly, after setting the quote into context.

Ghazali's concerns in this part of the Iḥyāʾ lie with the ordinance and maintenance of orthodox behavior in daily life, and his statements certainly fit right into a well-known debate about the status of image-making in Islam.[7] While much scholarship, medieval and modern, has focused on the juridical function of such edicts, Ghazali's comments and those of other jurists operate within a discourse that also has important material and economic dimensions. Earlier, in the section of the text on objectionable practices in the marketplace, Ghazali ordained against the sale of model animals (askhāl al-ḥayawānāt al-muṣawwara) such as are made for children during festivals, thus directly linking his initial discussion of manufactured figural representation with localised commercial and social practices.[8] These practices may have been widespread – an eleventh-century qadi and imam of the Cordoba mosque reportedly spoke out against the production of festive animal figurines in Islamic Spain, around the same time that Ghazali was writing – but the specificity of the statement suggests Ghazali is referring to popular practices he himself has witnessed and which he anticipates his readers will also recognise.[9]

Ghazali's judgment on 'vessels taking the shape of images' comes a few short passages later in the text, in the section concerned with objectionable practices in hospitality. The scene has shifted, accord-

ingly, from the open gaiety of the festive marketplace to the closed
privacy of the domestic interior, into which the *muḥtasib* (market-
place inspector) is not permitted to penetrate under normal circum-
stances.[10] In this realm of the private household Ghazali thrashes
out the finer points of material images, primarily, one can assume,
for the clarification of the individual who wishes to lead a correct
Muslim life, rather than the regulation of public behaviour. He leads
with an injunction against the hanging of textiles that have images
on them (*'āsdālu al-sutūri wa 'alihā al-ṣuwar*), which motivates his
ensuing clarification concerning the acceptability of figured textiles
when spread on the floor or made into cushions.[11] Uppermost in
Ghazali's mind is undoubtedly the Prophetic precedent of the figured
fabric hangings of Muhammad's wife Aisha, rendered acceptable – in
some versions of the tradition – by being turned into cushions to be
sat upon.[12]

Indeed, that particular tradition of the Prophet is the keystone
for virtually all discussions in the medieval literature concerning
the applied image and the limits of its acceptability.[13] For example,
certain of Ghazali's instructions on figuration are echoed quite
directly in the fourteenth-century Egyptian *hisba* manual of Ibn al-
Ukhuwwa, one of the earliest surviving examples of a detailed and
full-blown guidebook for regulation of the Islamic marketplace.[14] Ibn
al-Ukhuwwa states in his rules for the marketplace inspector that it is
permissible to sell cloths and dishes (*al-thiyab wa-l-atbāq*) on which
there are pictures of animals (*allti 'alīha ṣuwaru al-ḥayawānāt*), and
he makes reference to Aisha to underscore the canonical nature of
his exemplars. However, he also notes that it is not permissible to
sell animal figurines made from clay (*al-ṣuwaru al-maṣnū'ati min
al-ṭīni kal-ḥayawānāt*) such as are traded at festivals for children to
play with – the same objectionable practice cited by Ghazali.[15]

While Ibn al-Ukhuwwa's statements are interesting in their own
right, they stand, in one regard at least, in significant contrast to
those found in the *Ihyā'*. Ibn al-Ukhuwwa, writing a long time after
Ghazali, uses very clear-cut examples with established *fiqh* prec-
edents to demonstrate to his reader an absolute contrast between
two- and three-dimensional representation: images of animals
applied to textiles versus clay animal figurines. Ghazali, on the other
hand, having similarly taken care of both the model animals and the
cloth paradigm, seeks to create a third prescription that will encom-
pass material falling in between those two clear poles – presumably
because he saw such things in the world around him.

Ghazali's somewhat unwieldy formulation *ittikhadha 'alā shakl
al-ṣuwar*, 'taking the shape of images', emphasises the wide field of
likeness encompassed by the term *ṣūra* and its semantic possibilities.
Although most commonly used now in reference to two-dimensional
images, it can refer to both two- and three-dimensional forms of
resemblance and visual reference, making it equivalent at times,

context permitting, to 'image', 'form', or 'figure'. In this instance
the three-dimensionality of the materials in question is made clear
by the modifying *shakl* ('shape, form'), which also amplifies the
concept of 'likeness' contained in *ṣūra*.[16] The Qur'anic applications
of *ṣūra* emphasise its generative aspect, via God the Fashioner (*al-
Muṣawwir*), and the medieval juristic literature on the subject is
primarily concerned with the presence or absence of likeness to
an animate being, as well as the individual context of representa-
tions.[17] On the latter point, it can be seen that Ghazali, like many
other early and medieval theologians who concerned themselves
with image-making in Islam, draws a critical distinction between
the applied, two-dimensional image and the forms of likeness that
'cast a shadow'.[18] His censure is reserved for the functional object
that has been intentionally shaped to take the three-dimensional
form of an animate being. He thus adds a precise engagement with
the material practices of his own time to an established facet of the
'image' debate – the power of the third dimension.

The point of particular interest here is Ghazali's application of this
distinction to functional objects: by singling out vessels or utensils
(*'awānī*) thus transformed, his statement recognises both the trans-
formative capabilities of the plastic arts and the creative potential of
utilitarian objects, as attested in the material he saw around him. The
Persianate cultural area of Ghazali's time had a historical affinity for
modelled animal forms that may well have held, for a pious observer
like Ghazali, a suspicious whiff of Zoroastrianism.[19] Certainly some
legacies of pre-Islamic zoomorphic objects can be traced in the lit-
erature: in medieval Persian the word *takūk*, found in the eleventh-
century lexicography of Asadī Ṭūsī, denotes drinking vessels in the
form of bulls and recalls the tradition of the pre-Islamic rhyton. Later
sources extend the definition of this term to include vessels in the
form of other types of animal.[20] An illustrated manuscript now in
the British Library (Or. 3299) of Shadiyabadi's *Miftāḥ al-fuzalā* (Key
of the Learned), produced *circa* 1490 in Mandu and the subject of a
forthcoming study by Vivek Gupta, even includes a depiction of two
vessels in the form of geese to illustrate the *takūk*.[21]

However, prior to about 1300 a more general term for objects of
use in the form of living things seems to be lacking, in spite of the
sizeable corpus of zoomorphic vessels of various kinds that survive
today from the pre-Mongol Iranian world. The best-known of these
are various ceramic pouring vessels in the form of bovine creatures
(Figure 13.4), or more rarely lions or camels, and cast copper-alloy
cat- or bird-shaped incense burners (Figure 13.2). Zoomorphic
vessels also survive from elsewhere in the Islamic world but there
seems to have been a particularly pronounced predilection for such
things in pre-Mongol Iran.[22] Ghazali was left to get across to his
readers as best he could an entire category of creativity that he
knew they would recognise, the 'vessel that takes the shape of an

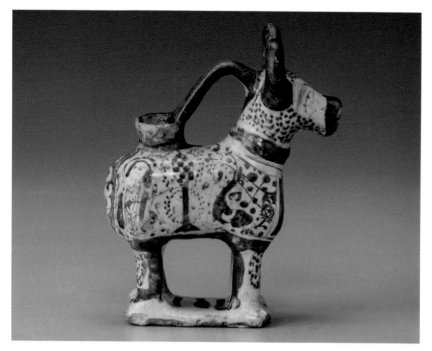

**Figure 13.4** *Aquamanile. Late twelfth or early thirteenth century, Iran. Glazed fritware with lustre overglaze decoration. H. 14.6 cm. Eskenazi Museum of Art, Indiana University, no. 60.58. Source: Kevin Montague, © Eskenazi Museum of Art*

image', even if there was not a single word by which he could name it.

Among the surviving materials there are a number of other things from pre-Mongol Iran, besides the zoomorphic burners and pouring vessels, which could also fit under the rubric of 'vessels taking the shape of images'. For the sake of coherence this short study will take a cue from Ghazali and use for its primary examples bird forms executed in metal, although there are of course many other forms, as well as parallel developments in ceramics, which could also be explored.

Ghazali's citation of bird finials indicates that he is looking not only to objects that are totalising in their assumption of an animal form, but also to those that incorporate modeled animal forms within larger schemata. It also proves beyond doubt that he was familiar with the products of his time: bird finials can indeed be found on many surviving incense burners from eleventh- and twelfth-century Khurasan. A handled metalwork burner with bird finial, excavated at Bishapur in Iran, was speculatively dated by Mehmet Aga-Oglu to the first half of the eleventh century or earlier; this might be the sort of object Ghazali had in mind (Figure 13.5).[23] Cast bird finials are also a frequent feature of incense burners of the handled type from the Late Antique and early Islamic eastern Mediterranean and

Figure 13.5 *Incense burner. First half of eleventh century (?), Bishapur, Iran. Source: R. Ghirshman, 'Les fouilles de Châpour (Iran), deuxième campaign 1936/7', Revue des arts asiatiques 12 (1938): 12–19, plate IX, fig. 5*

Egypt, suggesting that the association between birds and incense burners might have travelled across and around western Asia.[24] This is hardly surprising, given the very portable nature of the material, but establishing the vectors of transmission with real confidence would require much more precise information about findspots and dating than is likely to be forthcoming for the great majority of the objects.

Alternatively, cast bird-shaped finials are a very frequent feature of the 'hooded' type of incense burner that seems to be particular to Khurasan – so much so, in fact, that they are practically a defining feature of that particular type. Ghazali could equally have been thinking of these when he conscripted the avian finial as an example of the impermissible 'shape of images' (Figure 13.6).[25] Their presence among pre-Mongol Khurasanian metalwares does not stop with incense burners, however; they also appear as finials on other types of lidded vessel, and in the thumb-rest position on handled, spouted metalwork ewers and lamps (although non-animate forms, especially spherical and 'pomegranate' type projections, are much more common for the latter).[26] A number of cast copper-alloy birds, probably either destined for or detached from vessels of various kinds, were found in the excavations at Nishapur, and in spite of their small scale and lack of speciation they are certainly immediately identifiable as birds.[27]

By existing independently of any 'carrier' objects, this last group demonstrates the potential for autonomy inherent in the bird finial,

which presumably motivated Ghazali's resistance to such things: unlike a two-dimensional, painted image, which has to be painted *onto* something, the finials do not cease to exist when shorn of their 'supporting' vessels, but instead come to function as independent three-dimensional representations – that is, 'images' – of birds. By citing the particular example of bird finials on incense burners in this discussion, Ghazali enters them into an ascending scale of material autonomy within the representational practices encountered on objects of use. This scale presumably reaches a peak in the incense burners fully in the form of birds, such as falcons or fowl, attributed to pre-Mongol Iran.[28]

The discrete material autonomy of the birds produced by casting copper alloy can be contrasted with those generated through other metalworking techniques that were also highly developed in the pre-Mongol Iranian world: repoussé, chasing and beating to create high-relief surfaces. Brass, a copper-zinc alloy, was commonly worked in sheet form in medieval Iran and its plasticity lends itself to work in repoussé, where forms are beaten through

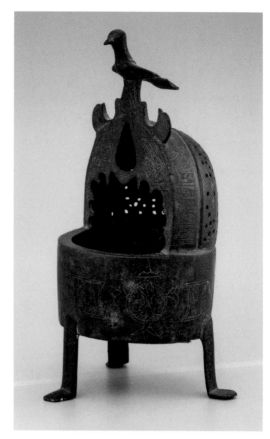

**Figure 13.6** *Incense burner. Eleventh or twelfth century, Khurasan. Cast copper alloy with engraved decoration. H. 25.7 cm. Museum für Islamische Kunst, Berlin, no. I.1291. Source: Christian Krug, © Museum für Islamische Kunst der Staatlichen Museen zu Berlin – Preußischer Kulturbesitz*

from the reverse side.[29] Often used in conjunction with other decorative metalworking techniques, such as chasing, engraving and inlay, repoussé could, in the hands of an expert, exploit the mutability of brass to produce objects that are not only visually and haptically innovative, but where organic life seems to be in the process of emerging from inorganic metal before one's very eyes. The candlestick shown in Figure 13.3 is a good example of this: from sheet brass emerge the protean forms of stylised lions at the base and birds at the shoulder. These birds, their heads and necks projecting fully while their lower bodies and feet remain in low relief, strain at the edges of sculptural three-dimensionality (Figure 13.7).[30] Recent technical analysis of a repoussé brass ewer with silver inlay in the British Museum, adorned with a similar frieze of projecting birds around the

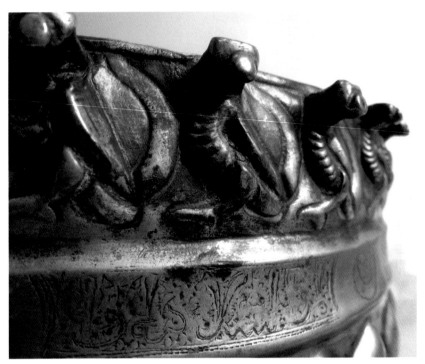

**Figure 13.7** *Detail of a candlestick base. Late twelfth or early thirteenth century, Khurasan. Chased, beaten and engraved brass with silver and copper inlay. H. 21.8 cm. Victoria and Albert Museum, London, no. 247-1902. Source: Courtesy of Victoria and Albert Museum*

collar, reveals that the birds were beaten outwards from the inside of the vessel and are continuous with the sheet metal of the body rather than being moulded separately and subsequently attached, as was once believed.[31]

Some craftsmen pushed the plasticity of the metal surface to its very limits. The fat, duck-like birds on a sprinkler in the Victoria and Albert Museum are quite astonishing examples of metal manipulation, almost fully in the round as they turn their heads back to look at the viewer (Figure 13.8). Created using an L-shaped tool, the birds have not been made separately and joined onto the body of the sprinkler but instead, like the birds on the brass candlestick, were formed by pushing the metal surface outward from inside the vessel's body.[32] A very similar set of ducks adorn the shoulder of a spectacular repoussé candlestick made from a single sheet of brass and now in the Louvre.[33] Where some of the birds have broken off the V&A sprinkler, or have been partly damaged, the stress of the material under deformation becomes fully visible. The birds are also rather disconnected from the object's programme of engraved and inlaid decoration, lending the piece a somewhat experimental air.[34] One wonders whether Ghazali would also have regarded all of these

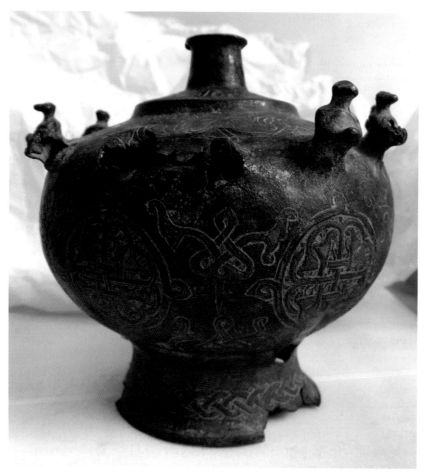

**Figure 13.8** *Rosewater sprinkler. Twelfth century, Iran. Chased, beaten and engraved brass. H. 10.9 cm. Victoria and Albert Museum, London, no M.15-1971. Source: Courtesy of Victoria and Albert Museum*

high-relief creatures as impermissible: those on the candlestick do not quite enter the autonomous realm of the cast birds that are fully in the round, instead remaining dependent on the candlestick as the 'substrate' from which they are materialising. Those on the sprinkler, however, come as close to an independent existence from their carrier object as it is possible to imagine in a continuous metal surface.

The productive tension between surface and form that is such a pronounced and important characteristic of pre-Mongol metalwares is not limited to the protean plasticity of repoussé brass. A group of diminutive copper-alloy flasks in the form of roosting birds (possibly larks or even falcons, depending on the shape of the now-lost heads) exemplify another facet of this phenomenon via the inlaid surface, with its particular suitability for the simultaneous production of

**Figure 13.9** *Flask. Twelfth century, Khurasan. Cast copper alloy with silver inlay. L. 14 cm. Victoria and Albert Museum, London, no. M.54:2-1971. Source: Courtesy of Victoria and Albert Museum*

'illustrative' decoration and articulation of form. They would certainly correspond to Ghazali's 'vessels taking the shape of images'. Most of the published examples of these bird flasks are inlaid with silver, although one formerly in the Rawza Museum, Afghanistan, appears to have incised decoration only.[35]

Inlaid examples are held in the Victoria and Albert Museum (Figure 13.9), the Museum für Islamische Kunst and The Metropolitan Museum of Art; two more were formerly in the Fogg Art Museum and the Harari Collection.[36] A further inlaid object of related form, signed *'amal Shādhī al-naqqāsh* ('the decorator') *al-Harawī* appeared on the Kabul art market, reportedly from Herat.[37] The hollow body of each of these avian flasks is cast in one piece, in the form of a slender bird with its narrow wings folded at exaggerated angles across its back and its tail slightly spread; for the sakes of elegance and practicality alike the bird rests directly upon its underside, without feet. The examples in London and Berlin are each complete with a stopper that forms the bird's head, attached to a tapered spatula for accessing the substance once contained in the interior. The head of the Berlin flask is clearly not original to the body, and this is likely also true of the London one.[38] All the other examples are now headless, but this hardly impedes even a casual observer from recognising that they are in the form of roosting birds.

This is because the bird flasks construct resemblance not only through closely observed, if subsequently stylised, three-dimensional form, but also through a complementary articulation of the surface into units that can be mobilised towards both mimesis and other visual orders simultaneously.[39] The Victoria and Albert Museum's flask is a case in point. The surface of the object harmonises panels of inlay that connote plumage in the places where plumage is most directly suggestive of 'bird' to the beholder – wings and tail, as in the imbricated repeating patterns on the upper wings and lower body,

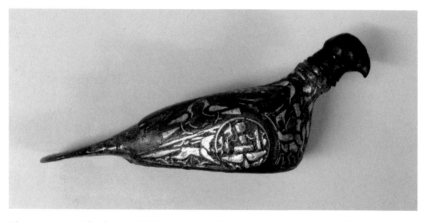

**Figure 13.10** *Flask. Twelfth century, Khurasan. Cast copper alloy with silver inlay. L. 14 cm. Victoria and Albert Museum, London, no. M.54:2-1971. Source: Courtesy of Victoria and Albert Museum*

and the striations of the lower wings and tail (Figure 13.9) – with designs drawn from the broader repertoire of Khurasan inlaid metalwork and inventively fitted into the sometimes awkward spaces that lie around those areas. Across the bird's breast a pair of mounted riders face each other, raising banners and watched by animal heads; in roundels underneath each wing a seated figure symbolising the pseudo-planet Jawzahr grasps the two poles of the double dragon-headed throne (Figure 13.10); running animals and pairs of birds adapt themselves to fill wedge-shaped fillets and bands.[40] Parts of the silver inlay may well be modern replacements, but even allowing for distortions the result is a highly diversified and yet impressively integrated marriage of what art history normally categorises as two different creative impulses: the ornamented surface and the mimetic form.

In all these objects, the division between 'ornament', commonly understood as a secondary application of designs to a pre-existing surface, and 'mimesis', with its implication of a referential function that transcends substrate, is not just blurred but sometimes entirely obscured. While some medieval jurists arrived at a dichotomous split between applied images and three-dimensional representation that can be quite closely paralleled with art history's own taxonomies, one senses in the *ḥisba* literature that many other medieval authors recognised the image as a moving target, requiring each instance of image-production to be considered in conjunction with its precise material and social circumstances of use before it could be deemed permissible or impermissible.[41] Accordingly, the great scholar Ghazali gamely tried to delineate something that lay between the figurine and the applied image, something that was particularly characteristic of pre-Mongol Persianate art. The region was evidently the site of a particular burst of interest in what we – following

Ghazali – can call vessels taking the shape of images. Ghazali's statement bears witness to the presence of zoomorphic vessels and modelled animal forms on manufactured objects in pre-Mongol Iran, as well as providing yet another window onto a complex debate about the status of images in medieval Islam. Most importantly, however, it recognizes the extraordinary capacity of artists in that world for signification through plastic artistry, generating a medieval Islamic art of the object that entirely transcends the modem cleavage of ornament from form.

## Notes

1. Some aspects of the argument presented here are expanded along different lines in my recent book; see Graves 2018, pp. 59–83. I thank the editors and Barry Flood for their comments on an earlier draft of this essay, and Moya Carey for generously sharing her images and expertise on pieces in the Victoria and Albert Museum.
2. While it is given here in the standard English-usage Aristotelian sense, 'mimesis' has important alternative trajectories in the medieval Arabic-speaking world; see Vílchez 2017, pp. 268–310.
3. On 'sculpture' as a category see Troelenberg 2014, pp. 159–74. For a recent analysis of a monumental lion-shaped incense burner in the Metropolitan Museum of Art that makes careful consideration of its epigraphic programme – not only its content but also its placement and appearance – see Blair 2017, pp. 36–40.
4. This candlestick, converted at some point in its life into a bucket, is part of a small group of closely related repoussé candlesticks with inlaid decoration. For others, see the list given in the entry for 'Candlestick with Repoussé Designs' in Graves 2011.
5. Two studies in particular have defined pre-Mongol Iranian art as a historical phenomenon within Anglophone scholarship: Grabar 1968 and Ettinghausen 1970. The latter was written partly in response to the former. More recently, Pancaroğlu's work has expanded the intellectual dimensions of pre-Mongol portable artworks in relation to the human image; see particularly Pancaroğlu 2000 and 2016.
6. Al-Ghazālī 1957, p. 335. A slightly different translation is given in 'al-Ghazali on *Hisba*', appendix to al-Shayzarī 1999, p. 180. I thank Mahmoud Hassan for his assistance with my transliterations from the Arabic.
7. On the larger discourse concerning images in Islam see Flood 2002 and forthcoming; Natif 2011.
8. Al-Ghazālī 1957 vol. 2, p. 333. We cannot know the exact nature of the model animals Ghazali had in mind, but it is likely that such material would be produced quite simply in clay, unglazed and possibly sun-dried rather than fired. See Graves 2008, pp. 246–47.
9. Quoted in a fifteenth-century treatise by Qāsim al-Uqbānī al-Tilimsānī; this text cited in Viguera et al. 2001, p. 181. See discussion and further sources in Gibson 2010, pp. 53–56.
10. On the privacy of the domestic sphere and its defense from penetration by the *muḥtasib* see Alshech 2004.
11. Al-Ghazālī 1957, vol. 2, p. 334.
12. The variants of this hadith are laid out in Elias 2012, pp. 9–10, 13.

13. Ghabin 2009, pp. 210–11.
14. Cook 2000, pp. 450–59; Ghabin 2009, pp. 158–60.
15. Ibn al-Ukhuwwa 1938, p. 56. He also adds the distinction that images of trees are to be tolerated (ṣuwaru al-āshjāri yatasāmaḥu bihā), echoing a hadith of Saḥīḥ al-Bukhārī (the latter quoted in Elias 2012, p. 11).
16. See the discussion of these terms in Boullata 2000.
17. Wensinck and Fahd, 'Ṣūra'; Ghabin 2009, p. 210.
18. The thirteenth-century Shāfi'ī jurist al-Nawawī (d. 1277) ascribed to earlier scholars a belief – which he in turn refuted – that only those forms of likeness that 'cast a shadow' were prohibited. In contrast to Ghazali and others, it was al-Nawawī's view that two-dimensional images of animate beings – whether applied to textiles, coins, walls, or any other surface – were as objectionable as three-dimensional representations of those forms. The only exception he admits is images that have been applied to textiles that will be stepped or sat upon – once more, the precedent of Aisha's cushion is palpable. Wensinck and Fahd, 'Ṣūra'; Ghabin 2009, pp. 210–11.
19. Gibson 2010, p. 52–55.
20. Melikian-Chirvani 1982b, pp. 275–76; Melikian-Chirvani 1991, p. 102–3; Gupta forthcoming, chapter three. I thank Vivek Gupta for sharing his unpublished research with me.
21. Gupta forthcoming, chapter three, figure 2.42.
22. On the ceramic vessels, see the wealth of material in Gibson 2008 and 2010. On the incense burners see Baer 1983a, pp. 57–60.
23. Ghirshman 1983, pp. 12–19; Aga-Oglu 1945, pp. 30–31. Comparison with the decoration on some of the high-tin bronzes of early Islamic Iran might suggest an earlier date than the eleventh century: see examples in Melikian-Chirvani 1974, pp. 124–26, 136–47; Allan, 'Bronze II. In Islamic Iran'.
24. A famous example is illustrated in Bénazeth 1992, pp. 106–7.
25. See discussion of the example in Melikian-Chirvani 1982a, pp. 42–43. Other examples can be found in Pope and Ackermann 1964, p. 1299 A–D; Fehérvári 1976, plate 31a and 31b; Baer 1983a, pp. 50–55; Loukonine and Ivanov 2003, p. 108.
26. Pope and Ackermann 1964, p. 1283 B, 1312 A and C; Rice 1958, plate VII; Fehérvári 1976, plate 3c (ewer), plate 14c (ewer), plate 31c and 31d (oil lamps); Allan 1982, p. 108 (oil lamp), p. 166 (lid); Baer 1983a, p. 25, 159; al-Khamis 1994, vol. 3, plate 25, fig. 6, fig. 39; Laviola 2016, cat. no. 19, 283. A remarkable repoussé silver vessel in the State Hermitage Museum, attributed to tenth- or eleventh-century Khurasan, has a three-dimensional bird on the handle very similar to those seen on twelfth-century inlaid ware; see Piotrovsky and Rogers 2004, p. 82. See also a tenth- or eleventh-century oil lamp with a bird mounted over the wick nozzle, found in Algeciras and probably made locally; Viguera 2001, p. 194.
27. Allan 1982, pp. 53, 96–97; see also the bird-topped pins on pp. 70–71. A small group of famous early Islamic ewers with cast spouts in the form of crowing cockerels, hawks and other birds represent another bronze encounter between bird and vessel, but these have a sometimes startling degree of animation and speciation that makes them quite distinct from the predominantly static little round-breasted birds that have alighted on the Khurasan materials; see Sarre 1934, pp. 10–15; Fehérvári 1976, pp. 27–28, 33, and plate 1; Baer 1983a, p. 84–88. A remarkable

rooster adorns the top of a hooded-type burner in the Boston Museum of Fine Arts, but for the most part the little birds on these incense burners are quite undifferentiated; see Aga-Oglu 1950, p. 8–10; Baer 1983a, pp. 52–53 and 55.

28. A well-known falcon-shaped incense burner was acquired by the Louvre in 1897 (OA 4044), a similar example was acquired much more recently by the Museum of Islamic Art, Doha (MW.282.2006), and the Metropolitan Museum holds a further example (1987.355.2). See Beyazit 2016a, p. 105. Incense burners in the shape of fowl are more numerous; see Baer 1983a, pp. 57–58. An interesting incense burner in the shape of a fowl is held in the Kabul museum (9-2-79; published in Laviola 2016, cat. no. 413); the piece is noteworthy for its almost monumental size, being perhaps more than half a metre high (Valentina Laviola, personal communication, 7 June 2018).

29. On the difficulty of establishing whether medieval metalworks are 'true' bronze, brass or some other copper alloy, and the slippage of medieval Arabic and Persian terms for copper alloys, see Aga-Oglu 1944, pp. 218–23; Allan 1976, pp. 124–26, 155–65; Weinryb 2016, pp. 4–5.

30. For others in the group, see note 4. A related candlestick, now in the al-Sabah Collection in Kuwait, includes in the faceted middle section of the object the repeated repoussé image of a lion bringing down a bull (illustrated in Canby, Beyazit, Rugiadi and Peacock 2016, p. 228).

31. Bülow, Phippard, La Niece et al. forthcoming.

32. The piece has been examined by Moya Carey (personal communication on 21 June and 22 October 2018) and Annabelle Collinet (personal communication on 30 October 2018), who both confirm that it was made using hammering and repoussé (that is, the ducks were not made separately).

33. Collinet 2015.

34. Melikian-Chirvani 1982a, pp. 120–21.

35. Laviola 2016, cat. no. 492, Rawza Museum 1978 (N. 149).

36. V&A no. M:54:2–1971, published in Melikian-Chirvani 1982a, p. 122. Museum für Islamische Kunst no. I.1500. Metropolitan Museum of Art no. 24.47.6. The piece formerly on loan to the Fogg Art Museum was published in Baer 1983a, pp. 65–66, and is apparently identical with that lent anonymously for exhibition and published in Grabar 1959, no. 44. It was returned from the Harvard collections to the anonymous lender in 1998 (personal communication with Mary McWilliams, July 2018). The piece formerly in the Harari Collection is illustrated in Pope and Ackermann 1964, vol. 13, plate 1312 B. It is now presumably in the Museum of Islamic Art in Cairo, together with other parts of the Harari collection of metalwork.

37. Melikian-Chirvani 1979, p. 224 and fig. 5; Laviola 2017, pp. 93–94.

38. Allan 1976, vol. 1, p. 346.

39. Melikian-Chirvani 1982a, p. 122, notes that this division of the surface into structural units is a regional tradition.

40. On the imagery of Jawzahr see Hartner 1973/74, pp. 121–23.

41. Ghabin 2009, p. 210.

CHAPTER FOURTEEN

# What's in a Name? Signature, Maker's Mark or Keeping Count: On Craft Practice at Rayy

*Renata Holod*

THE SITE OF RAYY, located to the immediate south of present-day Tehran, was the site of excavations led by Erich Schmidt in the late 1930s. New study of materials from the crafts' areas has noted a number of objects with writing or marks on them. These, found mainly on ceramics, may convey good wishes. They may follow the habit of the decorator *(naqqash)* as evidenced at the well-known ceramic workshops of twelfth- through seventeenth-century Kashan. Or, they may serve yet another function: namely, the signing off on a filled kiln. Together with moulds for ceramics, leather and metal, bone implements for textile making, and tools for drawing, these names and marks provide evidence for a complex material and visual culture of crafts quarters in the ninth- through early-thirteenth-century urban space. They also contribute to a reconstruction of the traditions and habits of production. This study places the discussed items within the context of studying artisanal (and artistic) practice of the early and middle Islamic periods.

## A short introduction to the archaeology of Rayy

In a short note published in 1935 after the end of the first season of excavations on the site, Erich Schmidt mentions the scale of the site of Rayy, some 14 square miles. This scale and the fact that he was undertaking or planning to undertake other archaeological projects in Iran – namely, at Tepe Hissar (near present-day Damghan) and at Persepolis (in Fars, near present-day Shiraz) – meant that his excavations at Rayy uncovered only a very small percentage of the archaeological remains of this site.[1] In parallel came the programme of aerial surveys undertaken from 1930 to 1939.[2] What finds were retrieved from the official excavations at Rayy were divided among the following institutions according to the then customary division, or 'partage', of archaeological finds: the Muze Iran Bastan, Tehran, retained half

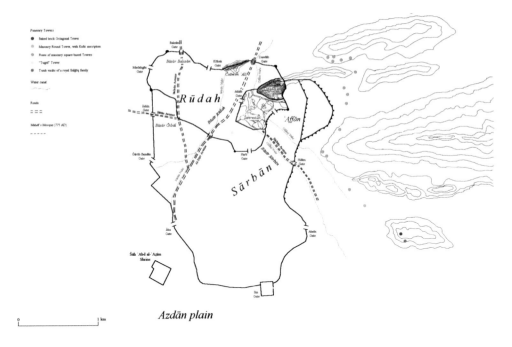

**Figure 14.1** *Citadel, early city and walled extensions of Rayy, with locations of Middle Islamic period mausolea indicated in green. Source: After Rocco Rante*

the finds and the unique pieces; the two main funding institutions on the American side, the University of Pennsylvania Museum of Archaeology and Anthropology (UPMAA) or Penn Museum, and the Museum of Fine Arts, Boston (BMFA), received the largest portion of the division, with the latter taking mainly displayable items, while most of the fragmentary materials were accessioned by the former. Additionally, the Philadelphia Museum of Art (PMA), the Oriental Institute at the University of Chicago (OI) and the Museum of Natural History, New York City (MNH), now hold sample collections from the site and its immediate region. In the first instance, these came to the PMA by way of exchange with the UPMAA, or through earlier purchases on the antiquities market. In the second case, the OI participated in the later seasons of Schimdt's Iranian expeditions. This institution became his base after his first wife, the Philadelphian Mary-Ellen Warden, died and he moved to Chicago. In the third case, the MNH received selected excavated materials as a bequest in 1951 from one of the main supporters of the Rayy Expedition, Gertrude Hickman Thompson. For the purposes of this study, primarily materials from the UPMAA will be considered, although some unique items from the other collections will also be mentioned as necessary.[3]

Archaeological interest in the site of Rayy (Figure 14.1) began in the first half of the nineteenth century, with preliminary studies and map-making expeditions conducted by Robert Ker Porter (1821–22)

and later by architect Pascal Coste (1840). Although Ker Porter's initial plans of the city were imprecise, both Porter's and Coste's plans would represent the most thorough investigations of the site for several decades. At the turn of the nineteenth to the twentieth century and the immediately following decades, the site was continually looted as the Tehran antiquities market fed collector and museum demand in Iran, Europe and the USA. Thus, legitimately and methodically excavated collections from the site of Rayy are all the more valuable to scholars because of the care with which these were recorded in terms of stratigraphy and find loci of the individual trenches, as well as the location and depth of rubbish pits. Later investigations at the site in the twentieth century were not as extensive as the early excavations had been and could be best described as sondages or very specific architectural investigations.[4]

Schmidt's excavations at Rayy during seasons 1934–36 were carried out at the following loci: on the citadel (locus RCi); in the walled city proper (Persian *shahristan* or Arabic *madinah*) and its extensions (loci RB, RH, RG, RTA, RTB, RTC), in the so-called Garden of Abu'l Fath Zadeh, as well as on the slopes of the adjoining hills where two extensive cemeteries with graves and commemorative structures/mausolea were located. For example, the commemorative structure called Naqqareh Khaneh yielded textiles as well as stuccoes. Excavated also were several loci along the northern boundary of the walled city at a locus named Cheshmeh 'Ali (RCh). While this latter area is currently best known as a prehistoric (Neolithic through Iron Age) site, it appears to have been reutilised during the historic periods, as a place for both kilns and other workshops, as well as for some habitation.[5]

At the same time in the late 1930s, Schmidt's Rayy archaeological expedition also worked at the extra-urban location known as Chal Tarkhan, an early Islamic estate site consisting of a fortified farmhouse, a separate reception hall, and what appears to have been a subsidiary hall or religious complex (Figure 14.2). The main aspects of the primary reception hall and its decorative stucco programme in particular were later published by Deborah Thompson.[6] Like the great urban site itself, this rural site on the Rayy Plain was also constantly looted prior to Schmidt's excavations and again afterwards.[7]

The present chapter, part of a larger study on the Rayy sites and Rayy materials now in progress, will discuss the problem of

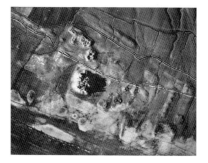

**Figure 14.2** *Aerial view of Chal Tarkhan, a country estate in the area of Rayy, 1935–36. Source: from Erich Schmidt*

identifying signatures or other marks on a variety of materials found at the excavations of the urban site of Rayy itself.[8] Furthermore, these marks will be evaluated in terms of the already published discussions of the epigraphic record in Arabic and Persian on a variety of objects

## Ceramics

### Moulds and moulded wares

Moulds were part of the design and production of unglazed (and glazed) wares. While no masters for moulds appear to have been retrieved from Rayy (nor are they found in Schmidt's meticulous excavation records, or in the studied collections), a master for a mould excavated at Nishapur and now at The Metropolitan Museum of Art (48.101.9) gives us a good idea of the procedure for producing such wares. Because moulds were obviously part of the production process,[9] there is a very good chance that the moulded wares discussed below were actually produced at the Rayy pottery works, and not imported (even though at times moulds did travel).

Noted among the Rayy finds at the UPMAA is a fragmentary mould with what appears to be a maker's mark/signature (Figures 14.3a and b, shown here flipped left to right for better legibility). Located within a small hexagonal figure on the upper register or shoulder of what would have been a large closed vessel, an inscription in four or five lines begins with the word *'amal* (work) and with one other partly legible word: . . . *Semnāni*(?) . . .

Among the excavated moulded wares, examples show the reuse of a mould with the name of the maker of the master on it. On closed shapes, only the shoulder or upper part was decorated. Interesting as well is the fact that two styles of epigraphy appear with the same name: Bu'l-'Amīd (that is, Abu al-'Amīd). In addition to the usual good wishes to the owner, the name of the maker of the master to the mould is introduced by the noun *'amal* (work) and ends with a round mark of concentric circles (Figure 14.4).

Another example of moulded ware with a name is on a sherd numbered RH 6574 where in a smaller ogival medallion the maker of the mould is also introduced with *'amal* (work) and named Maḥmūd ibn Muḥammad (Figure 14.5a).[10]

A.  Inscriptions on the bottom of the base, all vessels with clay bodies and varied colour glazes, many of which do not have find locations marked on them individually. The first two on the list below differ in the style of their writing and would appear to have come from what Schmidt designated as the Islamic I period – that is, the ninth or tenth century.
    1.  *'amal* [RCi 4020]
    2.  *sana'* [no number][11]

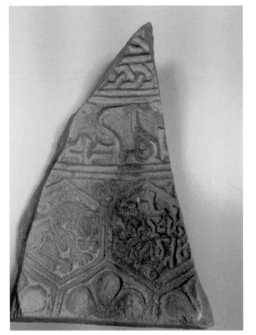 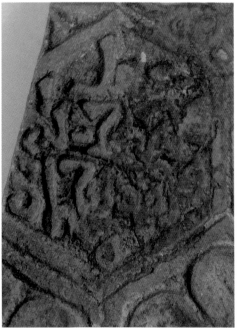

**Figure 14.3a** *Mould for the shoulder of a large closed vessel. University of Pennsylvania Museum of Archaeology and Anthropology [no find number recorded on sherd]. Source: Courtesy of the University of Pennsylvania Museum of Archaeology and Anthropology*

**Figure 14.3b** *Detail of mould for the shoulder of a large closed vessel, shown here flipped left to right for legibility, with the inscription in the hexagonal panel reading 'amal . . . semnāni (?) . . . (work of . . . Semnani). University of Pennsylvania Museum of Archaeology and Anthropology [no find number recorded on sherd]. Source: Courtesy of University of Pennsylvania Museum of Archaeology and Anthropology*

    3. *fana* [no number]
    4. *sarurj*(?) [no number] (Figure 14.5b)
    5. *'Alī* . . . [RH6333]
    6. *maṭbakh* [no number]
    7. *ṭālib* [no number]
    8. *fāsi* [no number]
B. Pseudo-inscriptions on glazed open vessels with clay bodies, all on the interior bottom:
    1. [RB1026.4]: A pseudo-inscription is found on the interior of a large open form (Figure 14.6).
C. Sphero-conical vessels
    1. [RF3186] *'Alī*
    2. [RCh1191]: In addition to the good wishes, there are also inscriptions scratched into the roundels.

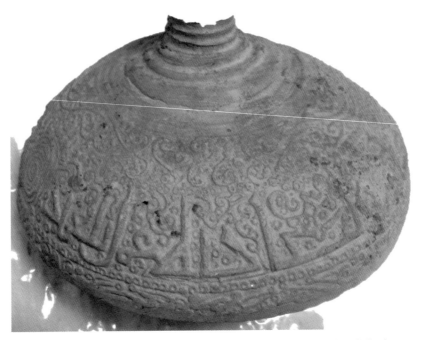

**Figure 14.4** *Sherd of unglazed moulded ware, inscribed . . . li-ṣaḥibi /
ʿamal-i Buʾl-ʿamid (. . . to its owner/work of Būʾl-Amīd [Abu ʾl-Amīd]).
University of Pennsylvania Museum of Archaeology and Anthropology,
37-11-167/ RH 6038. Source: Courtesy of the University of Pennsylvania
Museum of Archaeology and Anthropology*

D.  Imported wares
   1.  [RG 7983]: 'Basra' ware bowl with inscription datable to the
       ninth century CE. A bowl of finely milled yellow clay was
       covered with an opacified tin glaze. While its form imitates
       Chinese import porcelain, the fact that it was decorated with
       an inscription in cobalt glaze places this vessel among the
       numerous wares produced in Basra.[12] Its inscription reads:
       *'baraka li- ṣāḥibihi'* (blessings to its owner); *'min ʿamal abu
       al- naṣr'* (from the work of Abuʾl-Nasr). This type of formula
       is typical for artisanal practice.
   2.  Lustrewares from Kashan: Several sherds as well as almost
       complete vessels were retrieved from Rayy loci and dated by
       the excavators as Islamic II period. Many do have fragmen-
       tary inscriptions, but these appear to be poetic verses.[13] None
       examined thus far appear to have the names of the decorators
       inscribed on them.
E.  Glazed wares likely produced at Rayy
   1.  A series of stonepaste bowls with white glaze and cobalt
       blue stripes may reflect customs of producing dishes in sets
       (Figure 14.7a). Significantly for this study, the inscriptions on
       three of these are located on the exterior of the vessel below

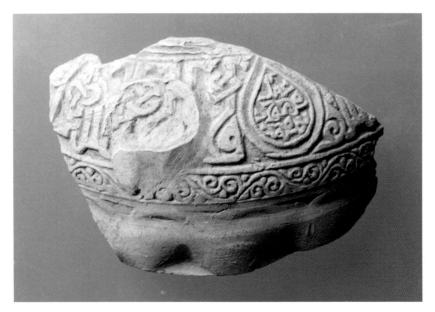

**Figure 14.5a** *Unglazed moulded ware, partial shoulder of a closed form, with the name of the maker given in ogival form as* 'amal-i Maḥmūd ibn Muḥammad *(work of Maḥmūd son of Muḥammad). Formerly in the University of Pennsylvania Museum of Archaeology and Anthropology, RH-6574. Current collection unknown. Source: Archival Photograph courtesy of the University of Pennsylvania Museum of Archaeology and Anthropology*

**Figure 14.5b** *Exterior base of bowl with clay body and turquoise glaze, inscribed in ink as* sarūj(?). *University of Pennsylvania Museum of Archaeology and Anthropology, 37-11-1041/RH 5245. Source: Courtesy of the University of Pennsylvania Museum of Archaeology and Anthropology*

**Figure 14.6** *Pseudo-inscription on the interior bottom of a glazed open vessel with clay body. University of Pennsylvania Museum of Archaeology and Anthropology, RB1026.4. Source: Courtesy of the University of Pennsylvania Museum of Archaeology and Anthropology*

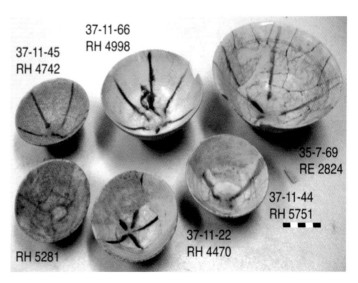

**Figure 14.7a** *A series of stonepaste bowls with white glaze and cobalt blue stripes. Likely produced at Rayy. University of Pennsylvania Museum of Archaeology and Anthropology, RB1026.4. Source: Courtesy of the University of Pennsylvania Museum of Archaeology and Anthropology*

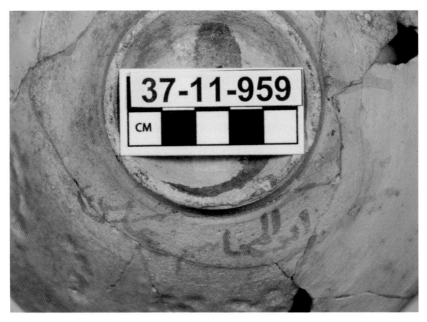

**Figure 14.7b** *White glazed stonepaste bowl with blue streaks and an inscription written in ink on the lower exterior wall, below the glaze line and upside down to interior, reading* Abū 'l-Mujāsim(?) 'Alī. *University of Pennsylvania Museum of Archaeology and Anthropology, 37-11-959/ RH 5038. Source: Courtesy of the University of Pennsylvania Museum of Archaeology and Anthropology*

the glaze line and upside down in relation to the interior of the vessel.

a. [RH 5038]: On the lower exterior wall, below the glaze line, an inscription reads *Abū 'l-Mujāsim 'Alī* (Figure 14.7b).

b. [RH 4747]: On the lower exterior wall, below the glaze line, an inscription reads *Abū 'l-Mujāsim*.

c. [RH 37-11-66]: On the lower exterior wall, below the glaze line, an inscription reads *'Alī* (Figure 14.8).

2. A sherd on which no find spot was marked came from a very large bowl with a clay body and was covered with deep turquoise glaze. It bears a partial inscription on the exterior below the glaze line. Similar to the three examples described above, an inscription on it was written below

**Figure 14.8** *White glazed stonepaste bowl with blue streaks and inscription on the lower exterior wall, below the glaze line and upside down, reading* 'Alī. *University of Pennsylvania Museum of Archaeology and Anthropology, 37-11-66. Source: Courtesy of the University of Pennsylvania Museum of Archaeology and Anthropology*

the glaze line and upside down in relation to the interior of the vessel. It reads . . . *bārayi* (Figure 14.9).

For all these examples, I am proposing that the location of the inscription, upside down in relation to the interior of the vessel could be interpreted as part of the process of production, possibly a signing off on the last piece to fill a kiln by the manager(s) of the pottery works. Given that we know very little about the organisation and the economic (and social) life of such specialised communities, these sign-offs can be taken as an important record of pottery works' management and process.

F. A non-alphabetic mark on a stonepaste body
    1. No number: On the side of a stonepaste vessel in a location similar to the sign-off on a kiln batch discussed above is a graphic mark, probably also to be interpreted in a similar fashion to the examples presented above.
    2. [RG 7863/37-11-109]: This straight-sided stonepaste vessel was marked on the base with two comma-like marks but otherwise decorated on the exterior with an epigraphic programme of verses in New Persian (Figure 14.10).

**Figure 14.9** *Sherd of a large open vessel with a turquoise-glazed clay body and an inscription written in ink on the exterior, below the glaze line and upside down to the interior, reading . . .* bārayi. *University of Pennsylvania Museum of Archaeology and Anthropology [no find spot indicated on sherd]. Source: Courtesy of the University of Pennsylvania Museum of Archaeology and Anthropology*

## Metal

There exists an inscription on an iron plaque said to come from the entrance niche to the so-called 'Tower of Tughril'. The inscription reads: 'Made (*'amal*) by 'Abd al- Wahhāb al- Qazvīnī b. Fakhrāvar at the end of Rajab of the year 534 (March 1140)'.[14] From the reported context (the object was bought on the Tehran market), it is not clear whether the named maker, 'Abd al- Wahhab al-Qazvīni, created the door or the building itself. What is probable is that his father named Fakhrāvar was a convert to Islam.

## Glass

1. [RH 5050 (37-11-409)]: This small cobalt-coloured vase features mould-blown decoration and an inscription.
2. [37-11-264]: The sealing from a vessel in yellowish glass with inscription reads *'amal Abu Sha . . . al-Ba . . .*

## Other

There are also moulds for items of use or wear with the form cut into slate. In two cases, the signature of the same person was scratched into the reverse surface. In all three cases the inscription is rendered in New Persian rather than in Arabic.

1. [RG 2061]: *'amal-i 'Uthmān b. 'Alī b. 'Uthman Rāzī* (archival image, current collection not identified)
2. [RG 2061a]: *'amal-i 'Uthmān Rāzī* (archival image, current collection not identified; Figure 14.11)
3. [BMFA/RH xxx (rest of number not legible)]: This mould for embossed leatherwork(?) features a complex decorative programme carved into slate. It consists of a vegetal border framing harpies and griffins and a central

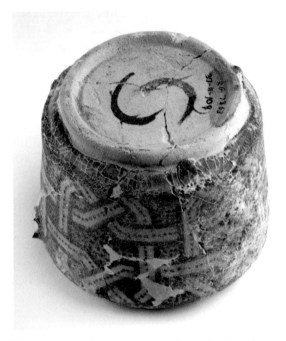

**Figure 14.10** *Stoneware vessel, marked on the base with two comma-like marks. University of Pennsylvania Museum of Archaeology and Anthropology, RG 7863/37-11-109. Source: Courtesy of the University of Pennsylvania Museum of Archaeology and Anthropology*

roundel. The mould is signed with *'amal-i Bandar al-Sharrāj* along the frame of the design (Figure 14.12).[15]

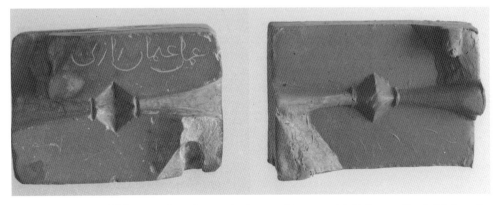

**Figure 14.11** *Mould for metal with inscription reading* 'amal-i 'Uthmān Rāzi. *University of Pennsylvania Museum of Archaeology and Anthropology, RG 2061a. Current collection unknown. Source: Archival photograph courtesy of the University of Pennsylvania Museum of Archaeology and Anthropology*

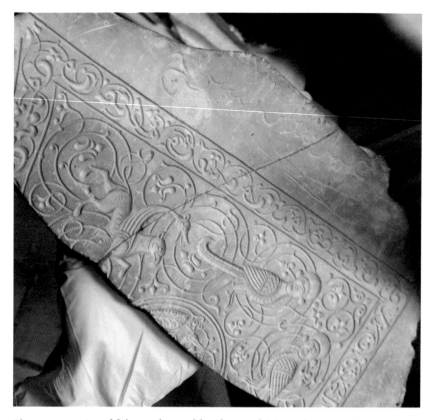

**Figure 14.12** *Mould for embossed leatherwork(?), with a complex decorative programme carved into slate, consisting of a vegetal border framing harpies and griffins and a central roundel, as well as the signature* 'amal-i Bandar al-Sharrāj. *Boston Museum of Fine Arts, RH [rest of number not legible]. Source: Courtesy of the Boston Museum of Fine Arts*

## Notes

1. As discussed in a note in Schmidt 1935. George C. Miles, who was Assistant Director there, published *The Numismatic History of Rayy* (Miles 1938).
2. The aerial surveys were published by Schimdt 1940, while more recently Ayşe Gürsan-Salzmann has positioned these campaigns of photography in a broader setting (Gürsan-Salzmann 2007).
3. The current Rayy materials study project is a follow-up to Rante 2015. This study project has been supported by the Aga Khan Trust for Culture, the Williams Fund of the History of Art Department, University of Pennsylvania, and by the 1984 Foundation.
4. These were published as Adle 1979; Keall 1979; and Adle 1990.
5. The prehistoric site is being studied by Timothy Matney, Hassan Fazeli Nashli and Holly Pittman. For an introduction, see Matney 1995.
6. Thompson 1976.
7. See George Miles' foreword to Thompson 1976, where he mentions the looting. A major portion of these stuccoes is held by the PMA, with

some reliefs deposited at the OI and the UPMAA, and possibly at the Muze Iran Bastan. In fact, the large stucco assemblage now in the PMA collection (29-132-1) would have been looted from this site and come on the very active antiquities market in the late 1920s, before Schmidt's excavations.

8. The UPMAA has just launched a programme for dealing with older excavated (and largely unpublished) materials, called TARA (Toolkit for Archaeological Research and Analysis). All the Rayy materials are being studied and will be made available online at <http://tara.museum.upenn.edu>. I thank Giacomo Benati for his help in navigating the programme and Desiree Annis, Research Assistant for the Rayy Project, for her constant care and support in developing the details.

9. See Canby, Beyazit, Rugiadi and Peacock 2016, pp. 154–65, and p. 324, ns 3 and 6.

10. Image from an archival photograph. Its present location cannot be ascertained.

11. For illustrations of this example and the following ones on this list, see <https://www.penn.museum/collections/object/504489>

12. On attributing this ware to Basra, see Watson 2004, pp. 170–74; Mason 2004, pp. 24–29.

13. On lusterware production and the Kashan workshops, see Watson 1985.

14. George Miles in an appendix to Grabar 1966, pp. 45–46. Bought on the Tehran antiquities market in the 1920–30s by Ernst Herzfeld and inherited by his sister, the plaque was then given by George Miles to the Museum of Art at the University of Michigan [musart_1965_1_167]. It is now installed on a long-term loan at the University of Pennsylvania Museum of Archaeology and Anthropology in the redesigned Middle East galleries.

15. I thank Michael Falcetano for finding this piece in the storage of the BMFA.

# CHAPTER FIFTEEN

# Collaborative Investigations of a Monumental Seljuq Stucco Panel

*Leslee Michelsen and Stefan Masarovic*

THIS CHAPTER PRESENTS an overview of the Museum of Islamic Art Doha (MIA)'s Stucco Research Project organised around and for the monumental Seljuq-era stucco panel now known as SW.160.2011, the known history of the panel before it came into the museum's collection, and the continuing art historical and scientific analyses of the artwork.[1] This is an ongoing project, composed of numerous layers – some historic, some contemporary – not unlike the stucco panel itself (Figure 15.1).

An in-depth condition check and material examination of the panel began in 2012, after its arrival in Doha. The first phase consisted of a detailed visual examination completed by a stratigraphic study of the added materials.[2] Over the past seventy years, the surface of the panel itself has become a rich source of information accumulation.

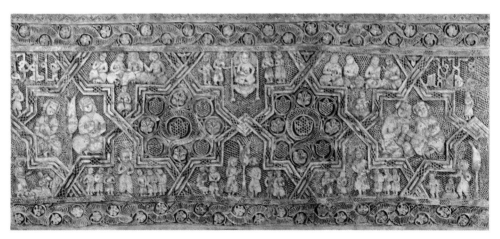

**Figure 15.1** *Stucco panel, before conservation in Doha. Late twelfth century, Iran (Rayy?). Dimensions 353 x 151.5 x 9 cm. Museum of Islamic Art Doha, MIA. SW.160.2010. Source: Photograph by Marc Pelletreau, © Museum of Islamic Art Doha*

When paired with the historic and photographic sources, this material evidence allows us to retrace the likely story of the object in the modern period.

## Historical research on the 'Stora Panel'

Before the MIA panel was renamed SW.160, it was referred to as the 'Stora Panel', indicating the dealers who handled its first recorded sale.[3] The famed brothers Maurice and Rafael Stora, noted art dealers with galleries in Paris and New York, took possession of the panel after its excavation from a site supposedly in or near Rayy, Iran.[4] It is unknown whether this was a commercial or academic excavation, although the authors presume the former due to a lack of any associated notes or publications that mention such an object. The Stora Frères acquired the panel with the mediation or assistance of Arthur Upham Pope, who acted as intermediary between sellers in Iran and dealers and buyers in Europe and North America. He had a hand in the sale of all three of the monumental Seljuq-era stucco panels that are known to exist in the modern period, which include the Philadelphia Museum of Art (PMA) panel and one formerly at the Museum of Fine Arts in Boston, now in a private collection in the USA.[5]

The first mention of the 'Stora Panel' is uncertain and based on information coming from the correspondence of Pope addressed to museum officials and art dealers at the beginning of the twentieth century. It may already have appeared publicly by 1928 when Pope, for the first time to our knowledge, wrote to Fiske Kimball (then Director of the Philadelphia Museum of Art) about an unusual discovery of large stucco panels: 'They have now recovered a whole wall

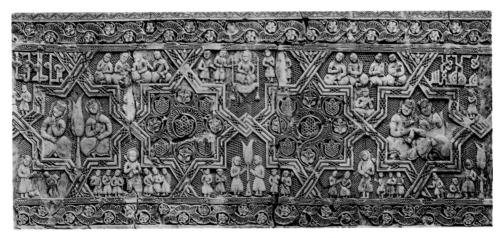

Figure 15.2 *The first known publication of the 'Stora Panel'. Source: Arthur Upham and Phyllis Ackermann,* A Survey of Persian Art from Prehistoric Times to the Present *(London and New York: Oxford University Press, 1938–39), plate 516*

of a room and got it up very nearly intact . . . a wall 12 feet long and 10 feet high [3.65 m × 3.48 m]'.[6]

A clue introducing doubt concerning the origin site of the 'Stora Panel' is the question mark added beside the location indication 'Rayy(?)' that is found below its first known published photograph. The 'Stora Panel' was first published in Pope and Ackerman's *A Survey of Persian Art from Prehistoric Times to the Present* in 1938/39 (Figure 15.2). It was exhibited at the famed *Exhibition of Persian Art* at Burlington House in London in 1931.[7] Pope originally wanted all three monumental Seljuq-era stucco panels to be exhibited together, as detailed in a letter to Leigh Ashton of the Victoria and Albert Museum in London, now held in the Pope Archives at the New York Public Library:

> November 17, 1930
> Dear Ashton,
> . . . As for limiting the exhibits of stucco to one panel, I am in most emphatic disagreement. We can, more advantageously save space by eliminating other exhibits some of which, like the 19th century rugs, are of no historical or aesthetic value and threaten to depress and compromise the quality of the Exhibition . . . These panels will be one of the most important and interesting exhibits in the whole Exhibition. There is not one to be seen in any European Museum and only one, the Boston piece, has been published although the inscription of the Philadelphia piece was the subject of a communication by Professor Martinovitch at the American Oriental Society . . . There are many other reasons for including these pieces which I will not go into now. I know you are uneasy about their authenticity, I think without reason. They have now been studied with extremely critical care by a group of important people, including those best qualified to pass judgment on them. This judgment has been confirmed by an independent study of the material itself and its condition as well as by studies of the epigraphy and ornament. They will be very handsome when installed and will not take up much room. Two are only three by five feet.[8] I know a good many scholars who are looking forward to the chance of seeing them together.
>
> Sincerely yours,
> (AUP)[9]

Pope eventually conceded that only one panel – the 'Stora Panel' – would be sufficient in another letter to Ashton sent two weeks later. In this second letter, Pope alludes to financial difficulties with insurance, although certainly another concern was the growing suspicion of both the Philadelphia and Boston museums about the authenticity of their respective panels:

Hotel Pont Royal
Paris, December 1, 1930

Dear Ashton,
... You will be relieved to know that I have wired Boston and Philadelphia not to send their Ray (*sic*) stucco panels. As long as we are getting the big one from Stora with two or three fine fragments we shall have to let it go at that. Boston and Philadelphia dreaded sending their pieces and the insurance was turning out to be difficult to arrange.

Sincerely,
(AUP)[10]

The 'Stora Panel' remained unsold for some years following its exhibition in Burlington House. In a series of quite entertaining letters from 1934, three years after the exhibition in London, Pope and Maurice Stora discussed the as-yet unsold stucco panel and their efforts to remedy that condition. Pope detailed this in his latest letter of the series, where he noted '. . . and, as I told you, I am again urging your stucco plaque'.[11] Stora responded gratefully to this news in a letter that reveals his anxiety about the panel lingering unsold:

M&R Stora

32 bis blvd Haussman
Paris, le 2(7?) mars 1934

Cher Monsieur Pope,

Nous vous remercions pour votre aimable lettre et pour son contenu, nous serons heureux de reçevoir l'article que vous avez publié dans Ars Islamica sur les panneaux de stuc. Nous avons toujours notre grand panneau – avez vous un client qui pourrait l'acheter ?
Les affaires sont absolument nulles chez nous et nous serions heureux de vendre un peu pour réaliser . . .

. . . amitiés,
M et R Stora[12]

At a currently unknown point – but ostensibly soon after this letter – the 'Stora Panel' was purchased by a private buyer in whose family it remained for three generations, until it was offered for auction in London in 2010 by Christie's, eventually making its way to the MIA.[13]

## Art historical investigations

The conservation and restoration of the panel is key to understanding the iconographic programme. When we began our initial study in 2012, it was clear from an examination of the artwork that there were additions and losses. The surface was mottled with grey and beige overpaint; significant areas of the background tessellation did not match up with their neighbours, indicating patched repairs; and some of the figures looked suspiciously pristine. The scant archival photographs documented some of these changes in its condition (Figures 15.2, 15.3). Our work seeks to build on the very important prior iconographic examinations, while also contributing details to which previous scholars did not have access. Although much of the composition seems to be original, many of the details have been altered or added – details which, of course, inform iconographic analyses.[14]

Notes on the overall decorative figural programme have been made by other scholars, most notably Robert Hillenbrand,[15] who recognised the similarities of the composition with star-and-cross wall tile panels, decorative dados and monumental wall paintings such as those found at Ghaznavid-era Lashkari Bazar (mid-eleventh century) or Qarakhanid-era Samarqand/Afrasiab (late twelfth century). The decorative programme of the panel is a compilation of aspects of the familiar 'princely cycle', detailing feasting, hunting, music-making and the enjoyment of nature in the long tradition of Persianate art and culture.

On the uppermost register of figural decoration, a centrally-positioned enthroned ruler presides, flanked immediately by *amir*s and more distantly by courtiers and musicians. That the royal party occupies the centre is unsurprising, but rather more so for being among the corpus of smaller figures portrayed – although the person of the ruler is substantively larger than his immediate companions. This is echoed in the lowest figural register, where courtly figures – some of whom are clearly *khassakiyya*, while others are as yet unidentified – are depicted in hierarchical proportion. One figure in each grouping – two in the case of the centremost formation – is substantially larger than the others. The vignettes in this register may be scenes of more sober courtly life, as opposed to the merry-making depicted above, but many of the identifying details associated with the figures – the finials of maces, or the details of clothing – have been discovered as having been restored or altered. This complicates our reading and necessitates further research.[16]

Yet, the overall composition is not clearly narrative in focus, except in the most general 'princely cycle' terms, tropes rather than specific stories. The human figures are not incidental to the geometric and vegetal framing in which they are placed, but rather carefully fitted within them and bearing their own internal pattern-

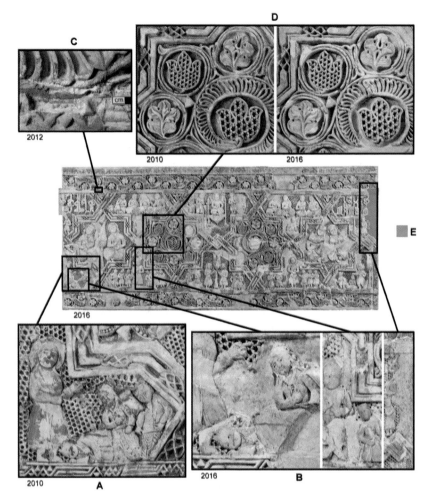

**Figure 15.3** *A: Detail of a restored area upon the panel's arrival in Doha in 2011. B: Three areas with beige plaster remains discovered after removal of added materials. C: Blue overpaint on top of the beige filler. D: Detail of an area before (left) and after (right) conservation. E: Location of areas with beige filler remaining in the 2010s. Source: Photographs by Marc Pelletreau and Stefan Masarovic, © Museum of Islamic Art Doha*

ing, as indicated above. Omitting these 'frames' visually produces a rather delightful pattern of human figures which is as 'ornamental' as the devices more usually agreed to fill such a role. The juxtaposition therefore of not two, but rather three distinct types of ornament in this panel should be considered. As noted by Oya Pancaroglu, 'More than a device to organise and enhance object decoration, the presence of geometry can be interpreted to direct the perception of significance, especially in the ornamental deployment of figural images where narrative intent is absent and the function of iconography is partial'.[17] It is therefore possible that the

artistic programme of the artwork is of tripartite surface decoration: geometric, vegetal and human forms, all functioning as 'repeatable unit[s] of decoration' – a more holistic interpretation than has so far been considered.[18]

## Material study and conservation: modern restoration

Many of the archeological stucco artifacts excavated in Iran in the early decades of the twentieth century were coming from local diggers who sold their finds either to Western museums and collectors via intermediaries such as Arthur Upham Pope,[19] or directly to art dealers trading in Persian antiquities, such as Stora, Kelekian, Rabenou and the like.[20] Pope served as a mediator, transferring initial information related to and about the objects to buyers. Even though he often referred to stucco panels with little detail, a basic description and inaccurate measurements,[21] his correspondence contains revealing and significant information from a technological point of view.

Large stucco panels were exported from Persia in many fragments, as found *in situ*.[22] The 'Stora Panel' was no exception: it was certainly taken in pieces from its findspot – most probably to a workshop in Paris such as that of the M & R Stora dealership – where it was re-assembled using principally a beige, hard cement-like plaster.[23] Areas in-filled with this plaster are clearly visible on the first existing photograph (Figure 15.2), and a few of them are still preserved on the panel. Since they replace larger missing areas and do not cover any original carved surface, they have been kept as an evidence of the first obvious consolidation intervention (Figure 15.3). For structural reasons the back side of the panel must also have been consolidated with a layer of plaster, allowing all of the parts to be held together in a vertical position. Without any backing the panel could not have been displayed as a single piece. The reverse of some of the pieces that have been detached during our conservation treatment contained a few remains of this modern plaster.

On top of the beige plaster, located in the upper left part of the panel, remains of a blue paint layer have been discovered during stratigraphic examination. This is proof that the panel decoration was, at least locally, overpainted or renovated after being assembled, consolidated and filled in (Figure 15.3). This may have happened any time after the first re-assembling. It would not even be surprising if this intervention were part of the first restoration campaign. At the beginning of the twentieth century, when the conservation code of ethics had not yet been clearly defined, dealers freely tested various techniques and materials for 'improving' the condition of their artworks.[24]

On 3 December 1928, Pope described to Kimball the condition of another monumental stucco artefact and explained that the parts

... can be put together so beautifully that the joints will not be conspicuous; they are very easily suppressed. On the originals there evidently was some polychroming ... when they were shipped from Persia, but not a trace survived when they were unpacked in Berlin ... I am wondering whether something could not be done in the way of a fixative to hold in place what colour there is. I am going to make some experiments when I get to Paris.[25]

On SW.160, remains of blue, red and black polychromy are still well preserved today (see below).

In order to retrace the story of the panel after it left M & R Stora, the condition check data from the first existing photograph (Figure 15.2) and the current condition of the object have been recorded as a graphic mapping, and then compared (Figure 15.4). In the 1930s the panel was composed of approximately 100 original parts. Today that number is more than three times higher, and the parts are smaller. This suggests that the panel was broken at least one more time after being re-assembled and photographed for the first time. Such a breakup of the object must have been the result of a strong impact, or a general collapse of the structure supporting the panel, since many originally intact parts are fragmentary today. It is likely that the panel may have broken during shipment, or once in the possession of the new owner.

The panel was not immediately repaired after the incident(s). This explains why many of the parts visible on the earliest known photograph (Figures 15.2, 15.4) are currently missing: approximately 5 to 10 percent of the panel surface was missing in the 1930s, in comparison to 20 to 30 percent in the 2010s. Apparently, fragments were assembled in several restoration campaigns. Mainly plaster of Paris and, in the latest stage, epoxy resin had been used for re-assembling. The treatment of the front side was done in a rather careless manner. Many parts were misaligned, shifted, or rotated, and some were even swapped erroneously. In order to restore a continuity of shapes, lines and decorative patterns, some original parts have been re-carved or drilled; several thick layers of various fillers have been applied on the surface of the re-assembled panel, restoring large missing areas and in some places even covering and modifying the shape of original parts. Waste range of these added materials varies in texture, colour, or technical properties. The most commonly used was a hydrated gypsum powder mixed with an organic binding medium, but we also found various types of white acrylic-based fillers and even a flour-based filler on the lower decorative band.

The variety of overlapping materials gave the object a patchy appearance. To make the panel more homogeneous, past restorers chose to overpaint these areas together with the adjoining original parts. In 2010, at least three to four layers of grey, beige and white overpaint covered approximately 70 percent of the object's surface,

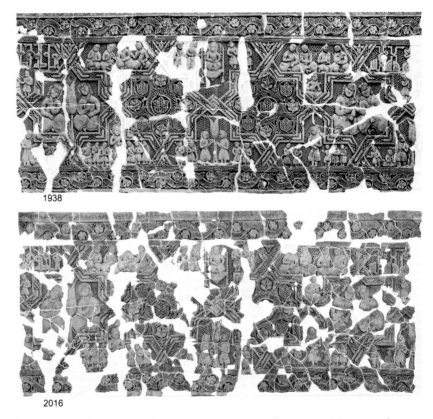

1938

2016

**Figure 15.4** *Comparison between the 1930s and 2010s, with original component parts, the extent of the panel's missing parts and breaks. Source: Photographs by Marc Pelletreau and Stefan Masarovic, © Museum of Islamic Art Doha*

obscuring most of the underlying polychromy. The back side of the panel was entirely covered with a thick layer of epoxy resin reinforced with a metallic structure associated with the outer aluminum frame, which is still present and prevents viewing of the original state of the back.

Considering the evidence of water damage and biological infestation (insect holes, mould and mouse bite marks) on the lower edge of the panel, the object must have been stored for some time in a very humid and dark place.

## Original condition: elemental analyses of pigments and plaster

The aim of the second phase of the condition-check was to obtain information about the original condition of the object. We decided to carry out elemental analyses; our main concern was the composition of the original plaster and the pigments. The existing polychromy is composed of three main colours; it highlights most of the recesses

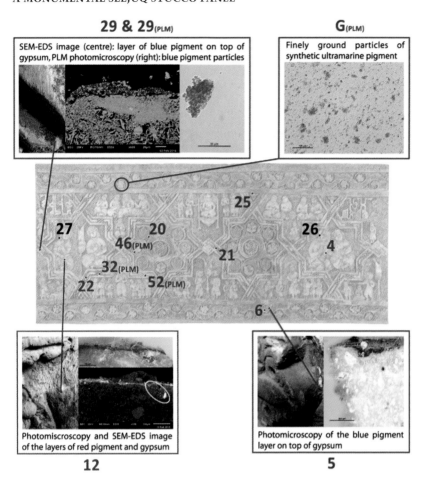

Figure 15.5 *Location of analysed samples and results of pigment identification. Source: Photographs by Mariana Pinto and Stefan Masarovic, © Museum of Islamic Art Doha*

in the floral and geometric decoration (red and blue) and garnishes the larger figures in both lateral star scenes. The figures' clothing was painted with patterns combining red and blue pigments, while pupils and hair were painted black.

Between 2013 and 2016 eleven discrete samples were taken from locations with a high probability of containing the entire stratigraphy of layers (Figure 15.5).[26] The samples were embedded in epoxy resin in order to allow a cross-section analysis of each layer separately.[27]

A scanning electron microscope with attached energy dispersive X-ray spectrometer (SEM-EDS) was used for the identification of the inorganic components. To complete the results of the elemental analyses and particularly to narrow down the identification of the blue pigment, small amounts of blue and red pigments from five

locations were mounted as slides,[28] then observed in transmitted, plane polarised and crossed polarised light (PLM, short for polarised light microscopy).

The composition of the original stucco plaster layer is consistent along all the analysed samples (4, 5, 6, 12, 22, 26 and 27). Two main elements, calcium and sulphur, were found in the atomic ratio, confirming the composition of gypsum (CaSo4), as well as many smaller inclusions identified mainly as sand grains or gypsum lumps.

Two types of red pigment have been found: red lead in the decorative areas (6, 21 and 22), and iron-based pigment particles with traces of lead-based pigment on the figures' clothing (4 and 12). It is unclear if both pigments are part of the original polychromy, as the lead-based particles may also have been introduced with later overpainting.

The SEM-EDS analyses of the blue pigment particles of four samples (5, 20, 25, and 29) indicate the presence of sodium, silica and sulphur, suggesting that the blue is either natural or synthetic ultramarine. Observations of four other blue pigment samples with PLM (G, 29, 46 and 52, of which only 29 comes from the same location as one of the cross-section samples) support the data from the elemental analyses; however, the narrow grain size distribution of the pigment suggests that it is a synthetic form of ultramarine.

The most significant analytic result is thus the discovery of ultramarine blue pigment, and the identification of synthetic ultramarine from four sampled locations. Synthetic ultramarine (produced since the nineteenth century) and natural ultramarine pigment made of lapis lazuli stone (used since the sixth century)[29] are both composed of the same chemical elements. They cannot be distinguished by cross-section analysis when juxtaposed in layers. Therefore, if the presence of natural ultramarine is not definitively excluded, there is a possibility that remnants of the original polychromy were enhanced with modern layers of paint following the medieval decorative scheme.

Nevertheless, on an object that has lost its original context and undergone heavy modern interventions, it is impossible at this stage to draw clear conclusions simply based on the basic pigment-identification, or elemental composition of the stucco plaster. This outcome is consistent with the findings of material observations and analyses carried out four years ago at The Metropolitan Museum of Art on the pigments from a collection of life-sized stucco figures, supposedly coming from the same location of Rayy, which led also to the conclusion that the blue pigment used was a synthetic ultramarine.[30] On the other hand, analyses of three samples from the upper epigraphic band of the PMA monumental stucco panel, performed two years later in the same laboratory, revealed the presence of lapis lazuli.[31] So far, neither of these results allows us to confirm or refute the dating, or to narrow down the provenance of the studied objects, as pigments

can be applied on stucco even in later periods. Therefore, in order to add to the information that may allow us to retrace the origin of the support material, further material examination and detailed analyses of the original stucco plaster – as well as its trace elements and inclusions – are necessary. The Met team has started such a systematic research on a larger collection of eleventh- to thirteenth-century gypsum plaster decorations from several museum collections, including the previously mentioned life-sized stucco figures and the PMA stucco panel.[32] Together with their study of the early Islamic pigments on sixteen painted stucco fragments excavated at Nishapur in the 1930s and 1940s,[33] they continue to build up a corpus of precious analytical data that allows comparisons among the objects recovered from controlled excavations and those with missing information about their original context. We hope that the results of the examination of SW.160 will also contribute to this set of data.[34]

## Conservation treatment and interpretation

In order to display the panel, conservation treatment was needed. Based on the details of the above-mentioned findings, the primary aim of the treatment was to both reveal and stabilise the original surface of the original motifs and their colouration, as well as to prepare the panel for display in a museum setting. Several layers of later-added materials had to be removed cautiously and progressively. By autumn 2016 all the remaining polychromy and original parts had been exposed and visually re-integrated, and the newly-mounted panel was installed on permanent display in the Museum of Islamic Art Doha (Figures 15.3, 15.6, 15.7).

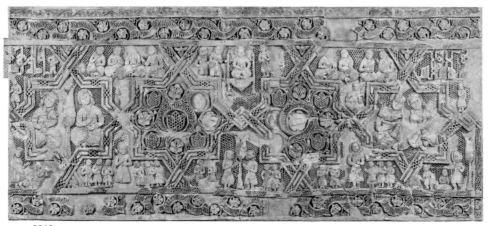

2016

**Figure 15.6** *Stucco panel, after conservation in Doha. Museum of Islamic Art Doha, MIA.SW.160.2010. Source: Photograph by Marc Pelletreau, © Museum of Islamic Art Doha*

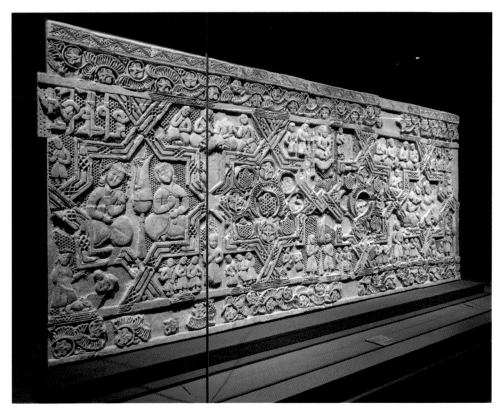

**Figure 15.7** *Stucco panel, on display in 2018. Museum of Islamic Art Doha, MIA. SW.160.2010. Source: Photograph by Marc Pelletreau, © Museum of Islamic Art Doha*

To our knowledge, SW.160 is the only one of the three extant monumental stucco panels known from the Seljuq era to be on permanent public display.[35] Our careful documentation of the entire life of the project – before, during and after conservation – provides and supports accurate documentation of the scientific analyses and art historical research findings revealed by the investigations.[36] These data will help to inform future conservation treatments and the monitoring of any changes in the object's physical condition and will be of use not only to MIA conservators and curators, but also to the wider academic community, the institution and its visitors.[37]

We hope that our study might contribute to the small but growing corpus on medieval stucco within the arts of the Islamic lands. Crucially, we also hope to contribute to cross-disciplinary studies in which the structure, composition and making of an artwork are key investigations alongside – and complementary to – art historical and iconographic research, not separate from them.

## Notes

Acknowledgments: It was a special pleasure to speak about this monumental stucco panel at the symposium *Court and Cosmos: The Great Age of the Seljuqs* at the Metropolitan Museum of Art in June 2016. Dr Martina Rugiadi and Dr Sheila Canby were able to examine the panel with us in Doha during research visits, and one of the other two monumental Seljuq-era stucco panels (from the Philadelphia Museum of Art) was on display in the eponymous exhibition and published in the catalogue. We thank Sheila, Martina, and Dr Deniz Beyazit for their invitation to present and to publish this work.

1.  In this chapter, 'SW.160' will be used to indicate the panel from its acquisition in Doha; the name 'Stora Panel' will be used to discuss its contexts pre-2010.
2.  The MIA Stucco Research Project had the initial goal to clean and conserve the panel so that it would be suitable for public display. The first conversation between curator and conservator, in 2012 – in which it quickly became clear that an intensive programme of removal of the previous restorations and fills would be both essential and time-consuming – led to us looking for external support. In 2015 we wrote a successful grant application to The Bank of America/Merrill Lynch Art Conservation Fund to assist our research project. We thank them for their support.
3.  We do not yet have any evidence concerning its sale within or from Iran.
4.  A hand-drawn sketch of the excavation spot of the PMA panel, purportedly by Arthur Upham Pope, was in its object file (now seemingly lost, although viewed by one of the authors in 2003). It suggests that Pope was aware, at least anecdotally, of the findspots of at least one of the three monumental stucco panels of the Seljuq period listed below in the text.
5.  The three panels are: SW.160, Museum of Islamic Art Doha, from Rayy[?], Iran, late twelfth century (Seljuq), accessioned 2011, 1.51 m × 3.53 m; the 'Boston panel', private collection, USA (from Sava, Iran), thirteenth century (Seljuq), accessioned by the Museum of Fine Arts Boston in May 1930; de-accessioned in April 1939, 1.16 m × 1.78 m; and the PMA panel, Philadelphia Museum of Art, from Rayy, Iran, thirteenth century (Seljuq), accessioned 1930, 172 m × 3.23 m. In addition to the works cited in this chapter by scholar (and long-time supporter of our project) Dr Judith Lerner, Dr Yael Rice has worked on the PMA stucco panel and the rich archive of very entertaining letters written between Arthur Upham Pope and Fiske Kimball, then Director of the PMA. Dr Rice, Dr Lerner and Dr Melanie Gibson all very generously shared their own research on one or more of the three stucco panels with us at various stages of the MIA project, for which we thank them.
6.  A letter from Pope to Kimball providing several descriptions of this wall was first published in Gluck and Silver 1996, pp. 155–56. While this statement was almost certainly in relation to Sasanian stucco work that he was also handling, this remains one of the earliest recorded discussions by Pope in regard to excavated stucco and his associations with it.
7.  Pope and Ackerman 1964, plate 516.
8.  It is often problematic to effectively identify the stucco walls in Pope's letters and cables, as he refers to the panels with little detail, basic

descriptions, and – most of the time – inaccurate or approximate meas-
urements (3ft × 5ft = 92 cm × 152 cm). SW.160: 4ft 11in × 11ft 3in =
151.5cm × 343cm. 'Boston panel': 3ft 9in × 5ft 8in = 116cm × 178cm.
PMA panel: 5ft 7in × 10ft 7in = 172cm × 323cm.

9. Pope Archive, New York Public Library: International Exhibition of
Persian Art, London 1930–1931 Box 2:L.

10. Ibid.

11. Arthur Upham Pope to Stora, from Oxford, 18 October 1934 [NYPL 3:
Personal Correspondence 1934 Si-Sz].

12. Pope Archives, New York Public Library: Box 3, Personal Correspondence
1934 Si-Sz.

13. We are continuing work in the Stora archives in Paris to research the
decades between these two sales, in the hope that it might enlighten
not only the biography of the panel, but also the physical treatments
undertaken in between.

14. This chapter documents the first phase of the research project; forth-
coming publications may investigate the narrative scenes in more
depth, as well as present the materials science analyses of this panel
and comparanda from the other two monumental Seljuq stucco panels.

15. Hillenbrand 2010.

16. While the more central and larger vignettes closely correspond to famil-
iar tropes in monumental wall paintings and stucco panels, as well as
portable arts such as metalwork and ceramics, the vignettes of the lower
register contain several rather unusual and puzzling scenes which may
have a different character. Our research on these scenes is ongoing, and
informed – as well as stymied – by the conservation and materials science
investigations which have significantly altered some of the later restora-
tions and infills of these sections. As much of the historic restoration
work concerned or involved these vignettes, it seemed prudent to await
the completion of the full conservation of the panel before undertaking
these examinations. We are grateful to Eva Baer for discussing these lower-
register vignettes with us during the *Court and Cosmos* symposium.

17. Pancaroğlu 2016, p. 193. This thought-provoking article has greatly
informed our continuing work on the iconography of the stucco panel.

18. Ibid. p. 196. In many ways the conservation work that 'halted' our
iconographic research provided time for reflection on the overall decora-
tive programme as a whole and the figural units which contribute to
that effect.

19. Allen 2016, pp. 128 and 137.

20. Ibid. pp.144–60. Of course there exists a rich bibliography on the special
personal and professional connections between Pope and the Rabenou
family; see, for instance, Lerner 2016, pp. 183–86, and Overton 2016,
pp. 360–62.

21. Even the first published measurements (1938/39) of the 'Stora Panel'
are not accurate (117cm × 180cm – 3ft 6in × 5ft 11in against 151.5cm ×
343cm in 2016 – 4ft 11in × 11ft 3in).

22. Lerner 2016, pp. 182–84.

23. Indeed, an important corollary to this article is the contextualisation
of the art and antiquities market of the period which brings so much to
bear on the excavation, transport, conservation, restoration and display
of this artwork. While not the thrust of the current article, the authors
are aware of the need to address this in a more comprehensive manner.
In the meantime, we point readers to works such as Komaroff 2000.

24. Artisans affiliated with the Rabenou workshop in Paris were known for skillful restorations in the 1920s and 1930s; see Overton 2016, p. 365.
25. Lerner 2016, p. 184.
26. Since the black pigment is most likely carbon-based and cannot be analysed with SEM-EDS, we do not detail the result for samples 26 and 27.
27. Our analyses were carried out in collaboration with the materials science laboratories at UCL-Qatar by Mariana Pinto under the supervision of Dr Myrto Georgakopoulou, with support from Phillip Connolly. We are grateful for their support. See Pinto 2016.
28. The pigments have been dispersed in Cargillle Melmount mounting media with RI 1.539 and 1.662.
29. Plesters 1983, pp. 37, 39, and 55–56.
30. Heidemann, de Laperouse, and Parry 2014, pp. 35–71.
31. The examination of the morphology of gypsum crystals has confirmed an initial supposition that the upper epigraphic band and the figural scene of the PMA panel may not have been produced at the same time and that they did not belong together originally. Canby, Beyazit, Rugiadi and Peacock 2016, pp. 75–77, 314.
32. Caro et al. 2016.
33. Holakooei et al. 2016.
34. However, it is necessary to complete our research with further analyses of the composition of original gypsum plaster and its inclusions (bulk chemistry analysis, morphological examination of gypsum crystals, mineralogy of various inclusions and so on) as well as more detailed examination of pigments (their impurities and trace elements) on a larger set of stucco objects from the MIA collection, such as the polychrome head purportedly from Rayy (SW.74). Among non-MIA objects, ideally, the 'Boston' panel should also be included in such an examination.
35. Now that the PMA panel has been exhibited at the Met, we hope that it will continue to be on public display in Philadelphia. The third panel, usually known as the MFA panel, has been in a private American collection since its deaccession from the Boston Museum of Fine Arts in 1939. We are grateful to the owner for allowing us to check its condition.
36. As materials science and multimedia initiatives are critical aspects of our research, they will provide exciting avenues of exploration and interaction for the MIA audiences. This greatly informed our shaping of the research project. From the inception of the work, we viewed and structured the project as a collaborative endeavour, with a variety of outputs – not merely academic articles or a monograph, for example, but also enhanced didactic materials and interactive multimedia for the very diverse groups of learners who visit the MIA galleries. We measure the success of this stucco project, therefore, as being closely tied to its public exhibition at the MIA and associated educational activities which will detail its construction and restoration processes to the public.
37. Upcoming work includes full 3-D digitisation of the panel and partial replicas for hands-on interaction and a more multisensory approach to engaging MIA's visitors with its collections. Screen-based in-gallery interpretation employing the object's 3-D data will also extend and enhance engagement in multiple ways. The complexities of the

conservation process can be revealed step by step, demonstrating the results and revelations of scientific analyses and treatments. Touch screens will enable visitors to control and manipulate the object, enlarging, rotating and stripping back layer-by-layer to gain a better understanding of how it was made and restored. Colour can also be added digitally, to interpret what the panel may have looked like originally. The figurative nature of the iconography of the panel lends itself well to programme activities that employ and inspire storytelling or animation. These innovative forms of interpretation can be used in – and also beyond – the museum, as outreach in schools, or for international audiences as digital collections resources. We are grateful to Marc Pelletreau, Head of Multimedia at the Museum of Islamic Art Doha, who has been a long-term collaborator on this project.

CHAPTER SIXTEEN

# The Florence *Shāhnāma* between History and Science

*Alessandro Sidoti and Mario Vitalone*
(with an appendix on analyses carried out by Antonio Sgamellotti)

THE NATIONAL CENTRAL Library of Florence holds the earliest known copy of the *Shāhnāma* (Book of Kings; Figure 16.1), the national epic poem of the Persian-speaking world and work of the poet who came to be known as Abu'l-Qasim Firdowsi Tusi ('from/ of Tus', the city in Khorasan, today in northeast Iran, where he originated).[1] The manuscript was identified in 1978 by Angelo M. Piemontese during his research for a comprehensive catalogue of Persian manuscripts in Italian libraries. Until then, it was incorrectly classified as an anonymous Arabic commentary of the Qur'an.[2]

The volume is in large format (48 × 32 cm) and made of 265 sheets.[3] The writing style of the main text in Persian is *naskhi*, while the more than 700 cartouches written in Arabic are in Kufic script. It cannot be ruled out that it was because of these cartouches that the manuscript was erroneously thought to be a commentary of the Qur'an.

The manuscript is missing the initial sheet. It contains only the first volume of the *Shāhnāma*, 22,000 verses out of the approximate total of 50,000 verses. However, its importance for the reconstruction of the text is unquestionable, especially considering its date, clearly expressed at the end of the manuscript: 30 Muharram 614 (9 May 1217). This date makes the manuscript the oldest known copy of the *Shāhnāma*, as summarised in Table 16.1:

Table 16.1 Dates of the earliest surviving manuscript copies of the *Shāhnāma*

| | |
|---|---|
| End of composition of *Shāhnāma* | 1009(?) |
| National Library Florence | 1217 |
| Saint-Joseph University, Beirut | 1250–1350(?), without colophon |
| British Library, London | 1276 |
| Topkapı Palace Library, Istanbul | 1330 |
| National Library St Petersberg | 1333 |
| National Library Cairo | 1341 |

**Figure 16.1** *Colophon of the* Shāhnāma. *614/1217. Dimensions 48 x 32 cm. National Library of Florence, Italy, Magl. III.24. Source: Courtesy of the National Library of Florence*

The manuscript records the date, but not the place of copying nor the signature of the copyist (Figure 16.1). Thus, pinpointing the place of production is not easy. Surely the manuscript had – at a time very close to its copying – a Turkish reader, probably based in

**Figure 16.2** *Note of the provenance from Girolamo Vecchietti accompanying the* Shāhnāma. *614/1217. Dimensions 48 x 32 cm. National Library of Florence, Italy, Magl. III.24. Source: Courtesy of the National Library of Florence*

Anatolia, who studied and collated the text with another manuscript in his possession and added numerous glosses to the first fifty sheets. The manuscript then arrived in Egypt and from there was brought to Italy in 1591 or 1594. There is no doubt about who brought the manuscript to Italy: on the rear-guard sheet we find a note stating 'n: 76. Portato da Girol: Vecchietti di Cairo' (brought by Girolamo Vecchietti from Cairo; Figure 16.2).

Girolamo Vecchietti, born in Cosenza of a Florentine family, alone and together with his brother Giambattista, undertook several missions to Egypt with the aim to find, among other things, manuscripts for the activities of the Medici Stamperia Orientale (Eastern Press). This was a company founded in 1584 by Cardinal Ferdinando de' Medici on proposal of the Orientalist scholar Giovan Battista Raimondi,[4] with the main purpose of printing texts in Arabic to be used for the promotion of Catholicism among Muslims and the refutation of the Eastern Christian rites.[5] The Stamperia Orientale had the merit of contributing, through the manuscripts accumulated for its activities, to the formation of one of the first large collections of Islamic manuscripts in Europe. Some of these flowed into the collection of Antonio Magliabechi, from which originated the current National Central Library of Florence.

## Conditions of the manuscript and conservation interventions

The operational phase of the intervention was preceded by the evaluation of conservation needs. Reiterating the requirement for diagnostic analysis to be carried out, specific parts of the volume were analysed before submitting them to the intervention, in order to identify techniques and suitable materials. In 2004 it was deemed necessary to dismantle the binding and to store the text-block and the binding separately, as the condition of the leaves

Figure 16.3 *The binding before the dismantling of the* Shāhnāma *in 2004.
614/1217. Dimensions 48 x 32 cm. National Library of Florence, Italy,
Magl. III.24. Source: Courtesy of the National Library of Florence*

made it impossible to turn the pages sewn at the spine without
losing fragments.

The eighteenth-century binding, typical of the Magliabechiana
collection,[6] was composed of two boards in paperboard, uncovered,
and a leather spine that covered approximately one third of the
boards themselves (Figure 16.3). It had five bands in cord and a paper
manuscript label on the spine. The front board has a paste-down
with a handwritten note in pencil; the rear board instead has a guard
leaf and a paste-down, on which is positioned a paper label with the
shelfmark of the volume.

In relation to the binding's condition, the spine was greatly
damaged, with large gaps corresponding to the first, fifth and sixth
compartment, and the hinges were completely torn. The leather was
substantially depleted, with surface abrasions and signs of a biologi-
cal attack. On the back of the spine, at the second, third and fourth
compartment, were the remains of the spine lining in parchment.
The paper label on the spine appeared incomplete and presented the
degrading effects of iron gall ink. Of the five bands, the first, fourth
and fifth were only adhering to one of the two boards. Portions of the
thread at the head chain stitch were still present.

The text block was stored in a clamshell-type container made
of cardboard and canvas, with the 265 large format leaves (48 ×
32cm) divided into 27 quires, each contained in a paper folder. An
end-leaf was attached to the first quire, evidently attributable to the
eighteenth-century western binding. Three types of graphic work
have been recognised: the main text in Farsi, the glosses in Turkish,

**Figure 16.4** *Degradation due to hydrolysis, before conservation (fol. 3r) of the* Shāhnāma. *614/1217. Dimensions 48 x 32 cm. National Library of Florence, Italy, Magl. III.24. Source: Courtesy of the National Library of Florence*

and cartouches in Arabic (containing good-luck formulas) in at least two different hands.

The general condition of the leaves was considered substantially acceptable (the damage being mainly located near the cartouches only), but the presence of certain types of damage (chemical, physical and mechanical) reaffirmed the conservation action required, especially as some areas were in real danger of losing fragments. In particular, these included the deterioration of the paper (up to perforation) due to hydrolysis catalysed by the acidic components of the inks and colours of the cartouches (Figure 16.4); the presence of heavy guards and mending to the crease of bifolia (Figures 16.5a, b), due to an excessive rigidity in the opening phase; and the presence of previous repairs (paper and parchment, linings), both historical and modern, which in some cases were unsuitable from a mechanical point of view or covered parts of the text.

The specific treatment chosen was a minimally invasive intervention on the dismantled binding.[7] This was stored in a clamshell-type rigid container, in acid-free cardboard and canvas, lined internally with acid-free paper; a polyethylene foam cushion, covered with acid-free paper, was added to simulate the thickness of the text block and maintaining the cover in its 'original' position.

With regard to the paper, it was first considered necessary to document with digital photography in JPEG format the condition of all of the leaves of the volume before treatment, with a diagnostic sampling

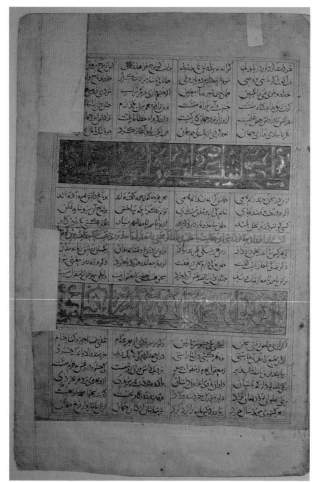

**Figure 16.5a, b** *Heavy and rigid guards covering the text and removal of stiffening guards (fol. 5r and fol. 41v)*

of all significant elements detected (inks, stains, old repairs, abrasion and other types of damage).[8]

Then the intervention on the leaves was divided into two distinct phases: the first consisted of those operations that could be carried out without waiting for the results of diagnostic tests; and a second stage was dedicated to interventions on the cartouches, after acquiring the results of the diagnostic tasks. Water-based treatments were avoided, as raising the water content of the object could have accelerated copper-based degradation, and copper ions could have spread into untreated areas.

Specifically, the operations of the first phase were:

- dry cleaning the leaves with a brush with soft bristles, controlled microvacuuming and staedtler mars plastic rubber powder;
- verification of the stability of the graphic media by means of localised tests;

- consolidation of graphic media which presented problems of stability, with high substitution methylcellulose of BDH Chemicals Ltd to 3% solution in ethanol – methanol in 80:20 ratio, applied with a brush;
- removal of adhesive residues with a methylcellulose[9] poultice to 6% with interposition of Japanese paper;
- alcoholic deacidification of the paper support in the areas affected by acid hydrolysis with calcium propionate in ethyl alcohol and WEI T'o, as well as results from the preliminary tests;
- consolidation with methylcellulose to 4% of the guards' junction of bifolia, consisting of two leaves joined along the paper fold;
- removal of guards from the crease and previous repairs that covered parts of text or that caused tension and stiffening of the original paper support, with compresses of methylcellulose to 6% with interposition of Japanese paper;
- assembly of the previous repairs removed on acid-free sheets (leaves of the same size), in the position in which they were actually placed, with indication of the origin of the paper;
- mending of tears present outside of the writing area with Japanese tissue Vang 50200 and 56100 and methylcellulose at 4%;
- mending of lacunae in areas not affected by oxidation and in any case without any text or decorations, with adequate thickness Japanese paper, toned with Winsor & Newton watercolours, and methylcellulose to 4%;
- detachment of the paper guard paper stuck to the first quire, and its relocation within the binding.

Subsequently steps were taken to carry out diagnostic analyses in the Department of Inorganic Chemistry of the University of Perugia under the supervision of Antonio Sgamellotti (see Appendix). The main objective of the non-invasive investigations was, as mentioned, to identify the components of inks and binders employed in the realisation of the cartouches, in order to decide on the most appropriate intervention techniques, in particular by preventing the migration of those elements responsible for the heavy degradation of the paper substrate. Beyond this, however, once the results of the analysis were obtained, we proceeded with the final steps, working on the cartouches:

- removal of the previous interventions of restoration in paper or tissue present on the cartouches, with a methylcellulose poultice to 6% with interposition of Japanese paper (Figures 16.6a, b);
- lining oxidised zones in correspondence with the direction of the 'cartouches' with Japanese tissue Vang 56100 and Klucel G in ethyl alcohol; it was lined on the verso in the case of cartouches arranged in the same position on the recto as on the verso of the same paper (Figures 16.7a, b, c);

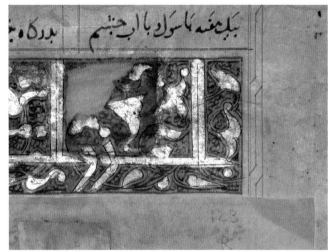

**Figure 16.6a, b** *Detachment of an 'old' restoration paper placed on a cartouche, before and after (fol. 123r)*

**Figure 16.7a, b, c** *Part of a cartouche before, during and after the lining (fol. 94v)*

- detachment of the original paper fragments stuck on contiguous paper with compresses of methylcellulose to 6% with interposition of Japanese paper and repositioning, where possible, of the same in their original place with methylcellulose to 4%;
- compensation of the areas affected by superficial abrasion with suitable thick Japanese paper or Japanese tissue Vang 50400 and methylcellulose to 4%;
- mending of lacunae present on the 'cartouches' with Japanese paper of adequate thickness, toning with Winsor & Newton watercolours, and methylcellulose to 4% (Figures 16.8a, b);
- flattening of the papers, interleaved with filter papers, under crystal plates.

The restoration of the paper support in correspondence with operations on the cartouches has been the subject of photographic documentation even during the intervention, collecting images with the digital UV light microscope and checking that the intervention did not cause the UV fluorescent copper-based ink to bleed into the surrounding area (Figures 16.9a, b). Upon completion of the activities

Figure 16.8a, b *Mending of lacunae, before and after (fol. 152r).*

Figure 16.9a, b *UV images of fol. 94v*

on the leaves, we proceeded with the reorganisation of the papers according to the original order (before dismantling) and with flattening under weight. Then we moved on to digital photography of each paper.

The final phase of the work concerned the ultimate conservative construction, specifically:

- making of four flap folders in acid-free cardboard, for the conservation of each quire (Figure 16.10);
- production of three rigid containers, clamshell-type, in acid-free cardboard and canvas, lined internally with acid-free paper, the first

**Figure 16.10** *Quires before being inserted into folders*

for the conservation of folders containing the quires; the second for the conservation of the leaves on which the 'old' removed repairs were repositioned; the third for the detached binding;
• making of a polycarbonate container,[10] fitted with three compartments for the conservation of boxes containing the binding, the leaves and 'old' removed repairs (Figure 16.11). This was equipped

**Figure 16.11** *Polycarbonate container*

with a front opening flap, four hinges, with safety closure and six support legs. As the manuscript is very susceptible to water content fluctuations, in order to monitor the interior 'microclimate' with effective temperature and humidity measurements, the enclosure was provided with a housing for inserting a data logger for environmental monitoring.[11]

## Appendix: non-invasive diagnostic analysis

(Carried out by the Inorganic Chemistry Laboratory, University of Perugia, under the supervision of Antonio Sgamellotti)

Non-invasive analyses of elementary type (XRF) and molecular (FT-MIR reflectance and fluorescence and UV-Vis) were conducted on three bifolia. These were named respectively *mf1* (I bifolio V quire, leaves 39–48), *mf2* (IV bifolio of IV quire, leaves 33–34), and *mf3* (I bifolio the quire XXII, leaves 209–218). Each side of the bifolium was called a, b, c and d.

XRF analysis shows a substantial uniformity of the materials used; for each bifolium there is the presence of calcium (Ca) on paper, of mercury (Hg) – to indicate the use of cinnabar – in the red lines that divide the columns of the written part, as in the demarcation lines of the cartouches and in interior decoration of some of them. In the blue lines there is use of indigo and lapis lazuli; in particular in the cartouches, where it appears as a double blue frame, the use of indigo was detected for the outer frame and of lapis lazuli in the innermost frame (mf2_a–d; Figures 16.12–15). The indigo is also present in those cartouches with a single blue frame (mf3_a–d; Figures 16.16–19) and

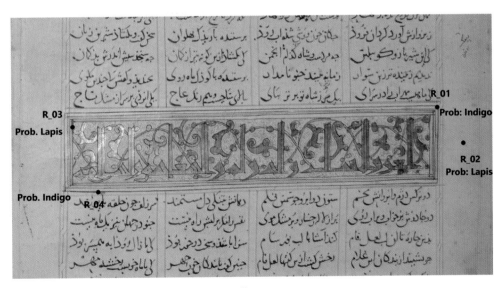

**Figure 16.12** *Fol. 34v, XRF and UV-VIS reflectance*

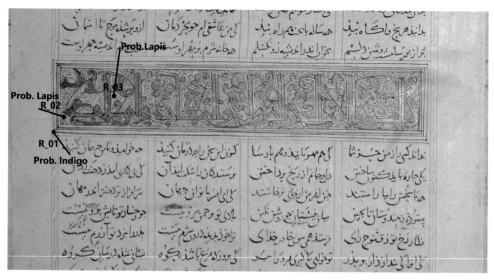

**Figure 16.13** *Fol. 34r, XRF and UV-VIS reflectance*

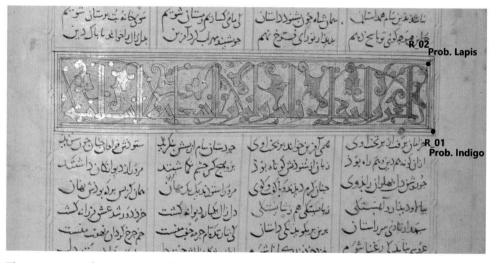

**Figure 16.14** *Fol. 33v, XRF and UV-VIS reflectance*

lapis lazuli inside the cartouches as a decorative background (mf2_b;
Figure 16.13).

Within some cartouches (mf1_c, mf2_d, mf3_b-d; respectively;
Figures 16.20, 16.15, 16.17) there is an ochre patina covering some
decorations – originally probably green – where there was found
copper (Cu), probably at the origin of the element-developed degrada-
tion in those areas and visible especially in the corresponding back
of the cartouche.

The golden areas are made exclusively of gold (Au), even where
they appear degraded or having iridescent reflections (Figures

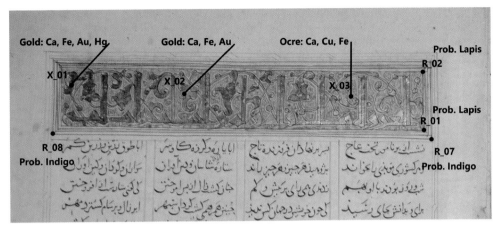

Figure 16.15 *Fol. 33r, XRF and UV-VIS reflectance*

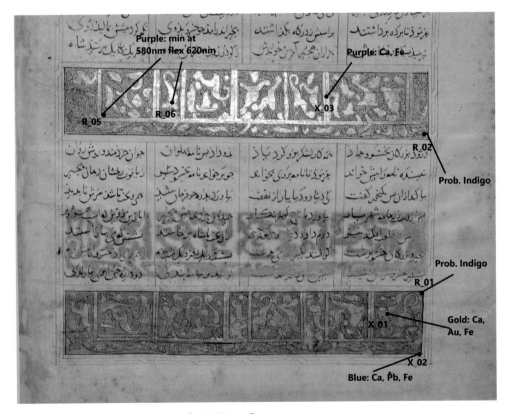

Figure 16.16 *Fol. 218v, XRF and UV-Vis reflectance*

16.21–24); in certain areas there are visible traces of mercury (Hg) underneath, maybe the sign of cinnabar used as a bole or some sort of preparation.

In correspondence with the lapis and red lines on the pages – and

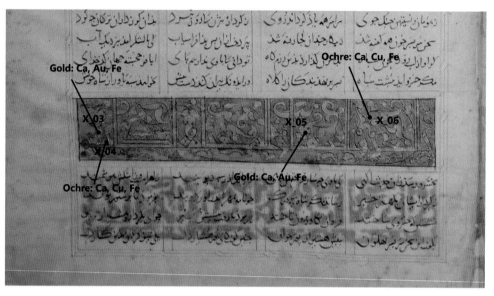

**Figure 16.17** *Fol. 218r, XRF and UV-Vis reflectance*

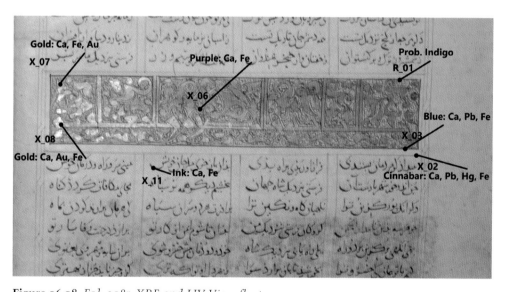

**Figure 16.18** *Fol. 218r, XRF and UV-Vis reflectance*

only in the presence of these lines for their entire extension – was detected the presence of lead (Pb) as a sort of preparation before they were traced.

The presence of indigo and lapis lazuli was also confirmed by the analysis of UV-Vis reflectance, as well as from Raman spectrometry measures, carried out in the same areas.

The XRF analysis on the black ink showed the presence of iron (Fe) as the only distinguishing feature, even where the hue of writing

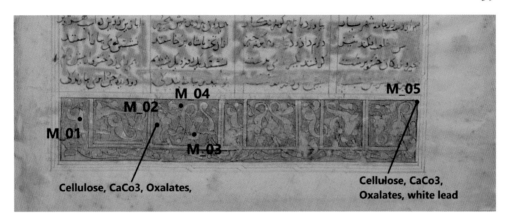

Figure 16.19  *Fol. 209r, FT-MIR*

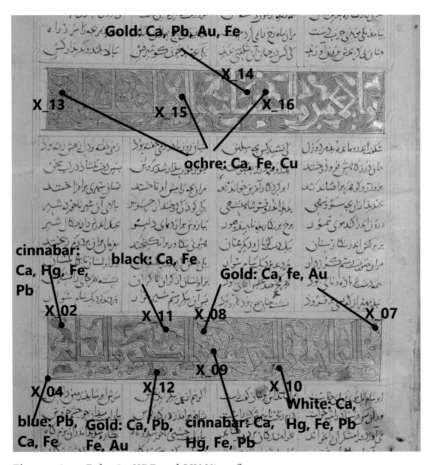

Figure 16.20  *Fol. 48r, XRF and UV-Vis reflectance*

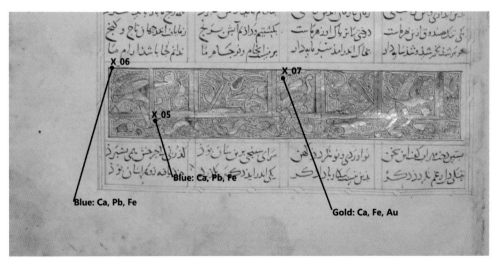

Figure 16.21 *Fol. 39r, XRF analyses*

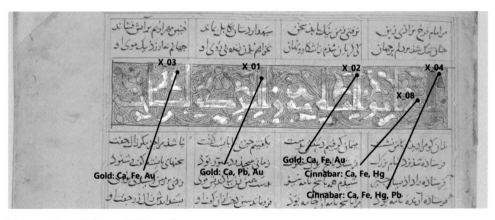

Figure 16.22 *Fol. 39r, XRF analyses*

appeared different from black, thus meaning that the ink is most probable an iron gall ink.

## Non-invasive surveys conducted in the mid-infrared region (FT-MIR)

A spectroscopic analysis in the mid-infrared reflectance (FT-MIR) was conducted, in a non-invasive manner, on one side of each bifolium (mf1_b-c, and mf2_a mf3_a); only for the bifolium called mf1 two sides were examined (b and c). In general, in all the acquired spectra are noticed the signals of cellulose and calcium carbonate, probably used as a charge substance in the production process of the paper support itself.

Regarding the identification of the nature of the pigments, the use

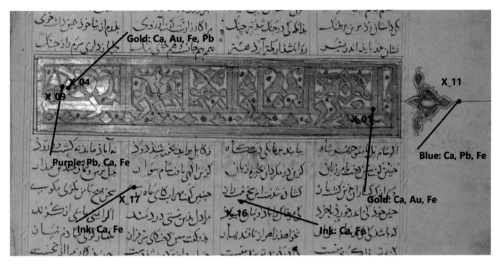

Figure 16.23 *Fol. 39v, XRF analyses*

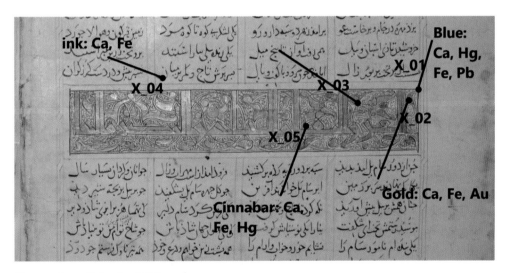

Figure 16.24 *Fol. 48v, XRF analyses*

of this technique has allowed us to detect the presence of white lead, also confirmed by XRF analysis (identification of lead), in the thin blue lines that delineate the cartouches mf1_b, mf1_c and mf3_a, while in the bifolium mf2_a, along the same lines, lapis lazuli has been identified.

The presence of oxalate, however, has emerged mostly on a few points in the proximity of the ink and the two cartouches (mf1_c background, mf3_a; Figures 16.24, 16.16). In particular in the cartouche in mf1_c, where XRF analysis has detected copper in addition to oxalates, there have also been seen signals referable to a probable protein component. This identification has emerged with greater

clarity in a single point, along one of the decorating blue lines in the cartouche of mf1 (mf1_b; Figure 16.23). In other areas there are many signals resulting from a complex component of paper making. Oxalates are common organic degradation by-products and considered a sort of 'marker' of an occurrence of oxidative deterioration.

In addition, in some points of the darker paper mf1_c (Figure 16.20) it does not exclude the presence of carboxylates (band at about 1540 cm-1). Finally, in the spectra acquired in the vicinity of two areas of integration (mf3_a; Figure 16.16) – relating to a previous restoration – signals of cellulose, probably related to the use of Japanese paper, have been detected, as well as an intense signal at about 1748 cm-1 suggesting the presence of an organic component, whose specific nature, however, is difficult to define.

## Conclusions

The manuscript needed conservation, as it was not possible to handle it without the risk of losing fragments. Even though the degraded areas were very localised, specifically in and near the cartouches, the presence of various repairs added throughout the history of the manuscript made the task of stabilising the object very difficult. As the first attempt of dismantling the binding and housing the quires in single acid-free envelopes was not sufficient for storing the object under safe conditions, a longer and more invasive conservation project was carried out, also including the study of the composition of some of the bifolia and the treatment of all the leaves of the text block.

Subsequently it was decided that the manuscript, even though now much safer to handle, was still very fragile and that rebinding it in a new binding (both western and near eastern styles were considered and finally discarded) would have caused too much stress on the very weak areas of the cartouches. Thus, the object was stored in a conservation-grade enclosure that would also provide a detailed description of the microclimate within which the object would be conserved.

Even though the manuscript may be subject to further degradation, especially due to copper, this conservation project enabled a big step forward in the study and safe transmission of this extremely important treasure of the library collection.

## Notes

Acknowledgments: The authors wish to thank The Metropolitan Museum of Art for its contribution to the conservation project, Studio Paolo Crisostomi srl for the cooperation on the restoration and conservation treatments, and Antonio Sgamellotti of the Inorganic Chemistry Department of the University of Perugia.

1. The *Shāhnāma* is divided into sections, recounting the exploits of a particular king or incidents that occurred during his reign, from the first, Kayumars, to the last, Yazdagird, defeated by the Arab conquerors.
2. On the spine is a label reading 'III.XXIV Arab. in Muham. Alkor. Commen. Anom'. On the front endleaf a label reads 'Anon. Commentarius in Muhammadis Alkoranum'. See Piemontese 1980.
3. The manuscript, with shelf mark Magl. III.24, has been fully digitised before recent restoration work. It is available online at <http://teca.bn cf.firenze.sbn.it/ImageViewer/servlet/ImageViewer?idr=BNC F000 414 7894#>
4. See Casari 2016.
5. On the activities of Tipografia Medicea an interesting exhibition was held from 16 October 2012 to 22 June 2013 at the Medicea Laurenziana Library in Florence. See the catalogue, Fani and Farina 2012.
6. The Magliabechiana collection owes its name and its origins to the scholar and bibliophile Antonio Magliabechi, also the librarian of the Medici family, who on his death bed on 26 May 1714 declared his willingness to leave his possessions to the poor of the city of Florence in order to form 'a public library for the universal benefit of the city'. His possessions consisted mainly of an exceptional book collection of about 30,000 volumes.
7. The conservation of the detached binding involved the following: no treatment of the leather of the spine; localised alcohol-based deacidification with WEI T'o (methoxy magnesium methyl carbonate) of the paper label on the spine, without filling in the lacunae; consolidation of the bands in their original position with flax yarn passages; consolidation of the lacerations on the spine present in leather with Japanese paper of suitable thickness and methylcellulose to 4%; placing of the spine in a folder of acid-free cardboard with flaps and closure strips; repositioning of parts of pastedowns raised in correspondence of the hinges with methylcellulose to 4%, taking care to document photographically the portions of the opposite boards which thus have been covered.
8. For this purpose, the conservators used a 12.1-megapixel digital SLR camera; a 1.3 megapixel digital portable microscope with LED light source, capable of magnifications up to 200x, connected to a PC via a USB connection, able to capture video and images through a management software; and a second digital microscope, with characteristics similar to the first, but with an ultraviolet light source.
9. Metylcellulose used throughout the project was Tylose Mh 300 p.
10. The container has been made with 5 mm polycarbonate sheets, sufficient to withstand the weight of the clamshell, in the assembly were not employed cyanoacrylates.
11. Ebro data logger series EBI 20 TH-1, able to record the values of temperature between – 30 °C and + 60 °C with a margin of error of 0.5 °C, and relative humidity between 0% and 100% with a margin of error of 3%. The data logger is equipped with a software that allows to programme the detection and recording of activities, establishing the temporal cadence of the same record, the eventual duration of the monitoring and eventual reference interval with the minimum and maximum values of the two parameters (one can download through a USB connection the recorded data, which can be viewed in Excel format).

# Glossary

**AMIR:** Literally, 'commander'; sometimes a provincial governor or military leader. Toward the end of the Abbasid period, *amir*s appointed by the caliph became more independent, with some establishing their own dynasties and usurping control from the caliph.

**'AṢABIYYA:** 'Spirit of kinship'. The *'aṣaba* are male relations in the male line in the family or tribe.

**BASMALA:** Refers to the sentence 'in the name of God'; recited before all but one sura of the Qur'an.

**CARAVANSERAI:** Lodgings constructed on caravan routes at regular intervals, for use mainly by travellers, merchants and pilgrims.

**DĀR AL-'IMĀRA:** Administrative centre and residence of the ruler.

**DHIMMĪ:** Non-Muslims living in an Islamic state.

**FAQĪH:** An expert in *fiqh*, the specialised knowledge of law.

**FIRĀSAT:** Physiognomy.

**FITNA:** Civil disorder, unrest.

**FUQAHĀ':** Pl. of **Faqīh**

**FUTUWWA:** Urban associations of young men with chivalric aspirations, who at times brought order to lawless communities. Some of these groups had Sufi connections.

**HADITH:** The traditions of what the Prophet Muhammad said or did, transmitted by his companions; used in Islamic jurisprudence (*fiqh*) to resolve legal, religious, and social issues not addressed in the Qur'an.

**HAZAR BAF:** Persian term, meaning, literally 'thousand weavings'. In architecture it is a brickwork decoration in relief, which creates a play of light and shadow.

**HISBA:** Activities of state-appointed individuals who enforce the law of Islam (the shariʿa) in both public and private spheres.

**IWAN:** A vaulted hall walled on three sides, with the fourth side opening directly to the exterior, a courtyard, or to a covered space.

**JALĀLĪ CALENDAR:** A true solar calendar that was introduced in Iran under Malik Shah (r. 465–85/1072–92). Variants of the Jalālī calendar are still in use in Iran and Afghanistan.

**KĀTIB:** Scribe or secretary in government administration.

**KHASSAKIYA:** Elite of the corps of guards who served as personal bodyguards of a ruler.

**LAQABI:** Decorative technique of applying coloured glaze over a moulded motif on stone-paste vessels.

**MADHHAB:** School of religious law.

**NASAB:** Genealogy or spiritual lineage.

**NISBA:** A component of an Arabic name that reflects an individual's or his ancestors' connection to a profession, person, group, or place.

**TAʿAṢṢUB:** Religious factionalism.

**ULEMA:** A body of Muslim scholars recognised as having specialist knowledge of Islamic law and theology.

**WAQF:** Charitable religious endowment.

**WAQFĪYA:** Legal document stipulating the properties, revenues and expenditures of a charitable religious endowment (*waqf*).

# Bibliography

ʿAbd al-Raḥmān al-Ṣūfī (1954), *Ṣuwar al-kawākib al-thamāniya wa-l-arbaʿīn*, Hyderabad: Osmania.

Abdollahy, Reza, 'Calendars: Jalālī', *Encyclopaedia Iranica*.

Abu Shama (1998), *Kitab al-rawdatayn fi akhbar al-dawlatayn al-nuriyya wʾal-salahiyya*, ed. M. H. Ahmad, Cairo: Maṭbaʿat Dār al-Kutub al-Miṣrīyah.

Acun, Hakkı (ed.) (2007), *Anadolu Selçuklu Dönemi Kervansarayları*, Ankara: T.C. Kültür ve Turizm Bakanlığı Yayınları.

Adle, Chahryar (1979), 'Construction funéraires à Rey circa Xe–XIIe Siècle', in *Akten des VII. Internationalen Kongresses für Iranische Kunst und Archäologie, München, 7.-10. September 1976*, Berlin: D. Reimer, pp. 511–36.

Adle, Chahryar (1990), 'Notes sur les première et seconde campagnes archéologiques à Rey: Automne-hiver 1354–55/1976–77', in F. Perrot (ed.), *Contribution à l'histoire de l'Iran, Mélanges offerts à Jean Perrot*, Paris: Recherche sur les civilisations, pp. 295–307.

Adle, Chahryar (2015), 'Trois mosquées du début de l'ère islamique au Grand Khorassan: Bastam, Noh-Gonbadan/Haji-Piyadah de Balkh et Zuzan d'après des investigations archéologiques', in Rocco Rante (ed.), *Greater Khurasan*, Berlin: de Gruyter, pp. 89–114.

Aga-Oglu, Mehmet (1944), 'A Brief Note on Islamic Terminology for Bronze and Brass', *Journal of the American Oriental Society*, 64: 4.

Aga-Oglu, Mehmet (1945), 'About a Type of Islamic Incense Burner', *The Art Bulletin*, 27: 28–45.

Aga-Oglu, Mehmet (1950), 'An Iranian Incense Burner', *Bulletin of the Museum of Fine Arts*, 48: 271.

Akrami, Musa (2011), 'The Development of Iranian Calendar: Historical and Astronomical Foundations', published online at https://arxiv.org/abs/1111.4926 (accessed 20 June 2018).

Aksaraylı, Kerimüddin Mahmud (1944), *Müsameret ül-ahbâr: Moğollar Zamanında Türkiye Selçukluları Tarihi*, ed. Osman Turan, Ankara: Türk Tarih Kurumu.

Âkubovskij, A. Û. (1947), 'Dve nadpisi na severnom mavzolee 1152 g. v Uzgende', *Èpigrafika Vostoka*, 1: 27–32.

Al-Aflākī al-ʿĀrifī, Şams al-Dīn Aḥmad (1959–61), *Manākib al-ʿĀrifīn (Metin)*, ed. Tahsin Yazıcı, 2 vols, Ankara: Türk Tarih Kurumu.

Al-Antaki, Yahya b. Saʻid (1990), *Tarikh al-Antaki al-maʻruf bi-silat tarikh Utikha*, ed. A. U. Tadmuri, Tripoli: Jarus Baras.

Al-Battani, Muhammad (1899), *Al-Battānī sive Albatenii, Opus Astronomicum*, n. XL, parte III, ed. Carlo Alphonso Nallino, Rome: Pubblicazioni del Reale Osservatorio di Drera in Milano.

Al-Bundari (1889), *Zubdat al-nuṣra wa-nukhbat al-ʻuṣra*, in Martijn Theodoor Houtsma (ed.), *Recueil de textes relatifs à l'histoire des Seldjoucides*, Leiden: E. J. Brill.

Al-Ghazālī (1957), *Ihyāʼ ʻulūm al-Dīn*, ed. Badawī Ṭabāna, Cairo: Dār Ihyāʼal-Kutub al-ʻArabiyya.

Al-Ghazālī, Abū Ḥamīd Muḥammad b. Muḥammad b. Aḥmad (1915), *Makātib-i Fārsī-yi Ghazālī*, ed. ʻAbbās Iqbāl, Tehran: Kitābfurūh-i Ibn Sīnā.

Al-Ḥusaynī, Ṣadr al-Dīn b.ʻAlī (1984), *Akhbār al-dawla al-Saljūqiyya*, ed. Muḥammad Iqbāl, Beirut: Dār al-Afāq al-Jadīda.

Al-Husayni, Ṣadr al-Dīn b.ʻAlī (2014), *The History of the Seljuq State: A Translation with Commentary of the Akhbar al-dawla al-saljuqiyya*, trans. Clifford Edmund Bosworth, London: Routledge.

Al-Khamis, Ulrike (1994), *Early Islamic Bronze and Brass Ewers From the 7th to the Mid-13th Century*, doctoral dissertation, University of Edinburgh.

Al-Khaṭīb al-Baghdādī, Abū Bakr Aḥmad b.ʻAlī (n.d.), *Taʼrīkh Baghdād*, 14 vols, Beirut: Dār al-Kutub al-ʻIlmiyya.

Al-Muqaddasī, Shams al-Dīn Abū ʻAbdallāh Muḥammad b. Aḥmad (1906), *Aḥsān al-taqāsīm fī maʻarifat al-aqālīm*, ed. M. J. De Goeje, Leiden: Brill.

Al-Rāvandī, Muḥammad b. ʻAlī b. Sulaymān (1365/1945f.), *Rāḥat al-ṣudūr wa-āyāt al-surūr dar tārīkh āl Saljūq*, ed. M. Iqbāl, Tehran: Amīr Kabīr.

Al-Qazvīnī al-Rāzī, Naṣīr al-Dīn Abūʼl-Rashīd ʻAbd al-Jalīl (1358/1980), *Naqḍ: maʻrūf bih baʻḍ mathālib al-nawāṣib fī naqḍ ʻBaʻḍ fadāʼih al-ravāfiḍ*, ed. Jalāl al-Dīn Muḥaddith, Tehran: Intishārāt-i Anjuman-i Āthār-i Millī.

Al-Saleh, Yasmine F. (2014), *Licit Magic: The Touch and Sight of Islamic Talismanic Scrolls*, doctoral dissertation, Harvard University.

Al-Shayzarī (1999), *The Book of the Islamic Market Inspector: Nihāyat al-rutba fī ṭalab al-ḥisba (The Utmost Authority in the Pursuit of Ḥisba) by ʻAbd al-Raḥmān b. Naṣr al-Shayzarī*, trans. and ed. R. P. Buckley, Oxford: Oxford University Press, pp. 139–90.

Al-Ṣarīfīnī, al-Ḥāfiẓ Taqī al-Dīn Abū Isḥāq Ibrāhīm Muḥammad (1414/1993), *al-Muntakhab min Kitāb al-siyāq li-taʼrīkh Nīsābūr*, ed. Khālid Ḥaydar, Beirut: Dār al-Fikr.

Algar, Hamid, 'Iran IX. Religions in Iran 2. Islam in Iran', *Encyclopaedia Iranica*.

Allan, James, 'Bronze II. In Islamic Iran', *Encyclopaedia Iranica*.

Allan, James (1976), *The Metalworking Industry in Iran in the Early Islamic Period*, doctoral dissertation, University of Oxford.

Allan, J. W. (1978), 'From Tabriz to Siirt: A Relocation of a 13th Century Metalworking School', *Iran*, 16: 182-83.

Allan, James (1982), *Nishapur: Metalwork of the Early Islamic Period*, New York: The Metropolitan Museum of Art.

Allan, James (2011), 'Silver Vessel', in Robert Hillenbrand (ed.), *The Sarikhani Collection: An Introduction*, London: Paul Holberton, pp. 53–54.

Allegranzi, Viola (2014), 'Royal Architecture Portrayed in Bayhaqī's *Tārīḫ-i Masʻūdī* and Archaeological Evidence from Ghazni (Afghanistan, 10th-12th c.)', *Annali dell'Istituto Orientale di Napoli*, 74: 95–120.

Allegranzi, Viola (2015), 'The Use of Persian in Monumental Epigraphy from Ghazni (Eleven-Twelfth Centuries)', *Eurasian Studies*, 13: 23–41.

Allegranzi, Viola (2016), 'Voyage à travers les écritures monumentales de Transoxiane (Xe–XIIe siècles)', *IFEAC Working Paper*, 10, published online at <https://f.hypotheses.org/wpcontent/blogs.dir/1268/files/2016/06/WP 10-Viola-Allegranzi.pdf> (accessed 1 July 2017).

Allegranzi, Viola (2017), *Les inscriptions persanes de Ghazni, Afghanistan: Nouvelles sources pour l'étude de l'histoire culturelle et de la tradition épigraphique ghaznavides (Ve–VIe/XIe–XIIe siècles)*, doctoral dissertation, Université Sorbonne Nouvelle – Paris III.

Allegranzi, Viola (2018), 'Les inscriptions persanes du tombeau d'Abū Ja'far Moḥammad, Ghazni (Afghanistan), début du VIe/XIIe siècle: La poésie comme lieu de mémoire et d'histoire', *Studia Iranica*, 47 pp. 89–118.

Allegranzi, Viola (2019), *Aux sources de la poésie ghaznavide. Les inscriptions persanes de Ghazni (Afghanistan, XIe–XIIe siècles)*, 2 vols, Paris: Presses Sorbonne Nouvelle.

Allen, Lindsay (2016), '"The Greatest Enterprise": Arthur Upham Pope, Persepolis and Achaemenid Antiquities', in Kadoi 2016, pp. 127–68.

Ali, Jamil (1967), *The Determination of the Coordinates of Positions for the Correction of Distances between Cities*, Beirut: American University of Beirut Press.

Alshech, Eli (2004), '"Do Not Enter Houses Other Than Your Own": The Evolution of the Notion of a Private Domestic Sphere in Early Sunni Islamic Thought', *Islamic Law and Society*, 11: 291–332.

Anisi, Alireza (2007), *Early Islamic Architecture in Iran, 637–1059*, doctoral dissertation, University of Edinburgh.

Ansari, Hassan (2016), 'Sunnism in Rayy during the Seljūq Period: Sources and Observations', *Der Islam*, 93: 460–71.

Ansari, Hassan, Sabine Schmidtke and D. G. Tor (eds) (2016), 'The Religious and Intellectual History of Rayy from 900 Through the Seljūq Period', special issue of *Der Islam*, 93.

Apanovich, Olga (2007), 'К вопросу о должности кундастабла у Сельджукидов Рума в XIII в.: кундастабл руми и Михаил Палеолог', *Vizantiiskii Vremennik* 66: 171–92.

Apanovich, Olga (2009), 'Наемные и вассальные христианские контингенты на службе у анатолийских сельджуков', in Sergei Karpov (ed.), Причерноморье в Средние века, vol. 7, Saint Petersburg: Aleteia, pp. 72–117.

Asutay-Effenberger, Neslihan (2012), 'Byzantinische (griechische) Künstler und ihre Auftraggeber im seldschukischen Anatolien', in A. Speer and Ph. Steinkrüger (eds), *Knotenpunkt Byzanz: Wissensformen und kulturelle Wechselbeziehungen*, Berlin: Walter de Gruyter, pp. 799–818.

'Athamina, Khalil (1992), 'The "Ulamā" in the Opposition: The "Stick and the Carrot" Policy in Early Islam', *Islamic Quarterly*, 36: 153–78.

Aubin, Jean (1995), *Emirs mongols et vizirs persans dans les remous de l'acculturation*, Paris: Association pour l'avancement des études iraniennes.

Auld, Sylvia (2007), 'Another Look at the Waq-Waq: Arabesques and Talking Heads', in Jean-Louis Bacqué-Grammont, Michele Bernardini, and Luca Berardi (eds), *L'arbre anthropogène du Waqwaq, les femmes-fruits et les îles des femmes: Recherches sur un mythe à large diffusion dans le temps et l'espace*, Naples: Università degli studi di Napoli 'L'Orientale'/Institut Français d'Études Anatoliennes Georges Dumézil.

Babadjanov, B. and K. Rahimov (eds) (2011), *Üzbekiston obidalaridagi*

*durdona bitiklar* (Masterpieces of Uzbekistan's Architectural Epigraphy), Tashkent: Fund Forum.

Babaie, Sussan (2015), 'Chasing after the *Muhandis:* Visual Articulations of the Architect and Architectural Historiography', in Kishvar Rizvi (ed.), *Affect, Emotion, and Subjectivity in Early Modern Muslim Empires: New Studies in Ottoman, Safavid and Mughal Art and Culture*, Leiden: Brill, pp. 21–44.

Baer, Eva (1965), *Sphinxes and Harpies in Medieval Islamic Art: An Iconographic Study*, Jerusalem: The Israel Oriental Society.

Baer, Eva (1983a), *Metalwork in Medieval Islamic Art*, Albany, NY: SUNY Press.

Baer, Eva (1983b), 'The Ruler in Cosmic Setting: A Note on Medieval Islamic Iconography', in Daneshvari 1983, pp. 13–20.

Bahrami, Mehdi (1936), 'Le problème des ateliers d'étoiles de faïence lustrée', *Revue des Arts Asiatiques*, 10: 180–91.

Bahrami, Mehdi (1937), *Recherches sur les carreaux de revêtement lustré dans la céramique persane du XIIIe au XVe siècles (étoiles et croix)*, Paris: Les Presses modernes.

Bahrami, Mehdi (1949), *Gurgan Faïences*, Cairo: Scribe Egyptien.

Bakırer, Ömür and Scott Redford (2017), 'The Kubadabad Plate: Islamic Gilded and Enameled Glass in Context', *Journal of Glass Studies*, 59: 171–91.

Balivet, Michel and Homa Lessan Pezechki (2017), 'Byzance, Iran, Turquie: Opposition politique et échanges lexicaux: Une approche historico-linguistique', in *Études turco-iraniennes: Anatolie-Iran du Moyen-Ages à l'époque moderne*, Istanbul: Isis, pp. 29–43.

Bar, Hebraeus (1932), *Chronography*, trans. Ernest A. Wallis Budge, London: Oxford University Press.

Barrucand, Marianne (1991), 'The Miniatures of the *Daqa'iq al-Haqa'iq* (Bibliothèque Nationale Pers. 174): A Testimony to the Cultural Diversity of Medieval Anatolia', *Islamic Art*, 4: 113–42.

Bartol'd, Vasilij V. (1968), *Turkestan Down to the Mongol Invasion*, trans. T. Minorsky, ed. C. E. Bosworth, London: Luzac (3rd edition).

Baş, Ali (2010), 'Öresun (Tepesi Delik) Han'ında Temizlik ve Restorasyon Çalışmaları', in K. Pektaş (ed.), *XIII. Ortaçağ ve Türk Dönemi Kazıları ve Sanat Tarihi Araştırmaları Sempozyumu 14–16 Ekim 2009*, Istanbul: Pamukkale Üniversitesi, pp. 69–84.

Başan, Aziz (2010), *The Great Seljuks: A History*, Abingdon: Routledge.

Bayhaqī, Abū'l-Faḍl Muḥammad b. Ḥusayn Kātib (n.d.), *Tārīkh-i Bayhaqī*, ed. Saʿīd Nafīsī, Tehran: Kitābkhāna-yi Sanāʾī.

Bayram, Sadi and Ahmet Hamdi Karabacak (1981), 'Sahib Ata Fahrü'd-Din Ali'nin Konya, İmaret ve Sivas Gökmedrese Vakfiyeleri', *Vakıflar Dergisi*, 13: 21–69.

Bénazeth, Dominique (1992), *L'art du métal au début de l'ère chrétienne*, Paris: Editions de la Réunion des musées nationaux.

Beyazit, Deniz (2016a), 'Incense Burner in the Form of a Bird of Prey', in *Court and Cosmos: The Great Age of the Seljuqs*, New York: The Metropolitan Museum of Art.

Beyazit, Deniz (2016b), *Le décor architectural artuqide en pierre de Mardin placé dans son contexte regional: contribution à l'histoire du décor géométrique et végétal du Proche-Orient des XIIe–XVe siècles*, Oxford: Archeopress.

Biran, Michal (2004), 'Il-Khanids', *Encyclopædia Iranica*.

Bīrūnī (1958), *Kitāb mā lil-hind min maqūla maqbūlatun fī al-ʾaql aw mardhūla*, Hyderabad: Osmanīya.

Bivar, A. D. H. (1986), 'Naghar and Īryab: Two Little-Known Islamic Sites of the North-West Frontier of Afghanistan and Pakistan', *Iran*, 24: 131–38.

Bivar, A. D. H (1987), 'A Presumed Ghaznavid Royal Seal', in B. M. Alfieri and U. Scerrato (eds), *Studi in onore di Ugo Monneret de Villard (1881–1954), II: Il mondo islamico* (*Rivista degli Studi Orientali*, 59), Rome: Bardi Editore, pp. 17–22.

Blair, Sheila (1992), *The Monumental Inscriptions from Early Islamic Iran and Transoxiana: Studies in Islamic Art and Architecture* (*Supplements to Muqarnas*, 5) Leiden: Brill.

Blair, Sheila S. (1994), 'An Inscription from Barūjird: New Data on Domed Pavilions in Saljūq Mosques', in Hillenbrand 1994a, pp. 4–11.

Blair, Sheila (1998), *Islamic Inscriptions*, Edinburgh: Edinburgh University Press.

Blair, Sheila (2007), *Islamic Calligraphy*, Edinburgh: Edinburgh University Press.

Blair, Sheila (2014), *Text and Image in Medieval Persian Art*, Edinburgh: Edinburgh University Press.

Blair, Sheila (2015), 'Place, Space, and Style: Craftsmen's Signatures in Medieval Islamic Art', in Eastmond 2015a, pp. 230–48.

Blair, Sheila (2017), 'Writing as a Signifier in Islam', in Sheila Blair and Jonathan Bloom (eds), *By the Pen and What They Write: Writing in Islamic Art and Culture*, New Haven and London: Yale University Press, pp. 15–49.

Blair, Sheila (forthcoming), 'Signatures as Evidence for Artistic Production in the Islamic Lands', in Matteo Burioni and Ulrich Pfisterer (eds), *Kunstgeschichte der Vier Erdteile / Art History of the Four Continents*, Munich: Wissenschaftliche Buchgesellschaft.

Blair, Sheila and Jonathan Bloom (1999–2000), 'Signatures on Works of Islamic Art and Architecture', *Damaszener Mitteilungen*, 11 [=*Gedenkschrift für Michael Meinecke (1941–1995)*]: 49–66.

Blessing, Patricia (2013), 'Allegiance, Praise, and Space: Monumental Inscriptions in Thirteenth-century Anatolia as Architectural Guides', in Gharipour and Schick 2013, pp. 431–46.

Blessing, Patricia (2014), *Rebuilding Anatolia after the Mongol Conquest: Islamic Architecture in the Lands of Rūm, 1240–1330* (*Birmingham Byzantine and Ottoman Studies*, 17), Farnham and Burlington, VT: Ashgate Publishers.

Blessing, Patricia (2015), 'Buildings of Commemoration in Medieval Anatolia: The Funerary Complexes of Ṣāḥib ʿAṭā Fakhr al-Dīn Alī and Māhperī Khātūn', *al-Masāq: Journal of the Medieval Mediterranean* 27: 245–46.

Blessing, Patricia and Rachel Goshgarian (eds) (2017), *Architecture and Landscape in Medieval Anatolia, 1100–1500*, Edinburgh: Edinburgh University Press.

Bloom, Jonathan (1993), 'The Qubbat al-Khaḍrāʾ and the Iconography of Height in Early Islamic Architecture', *Ars Orientalis*, 23: 135–39.

Bloom, Jonathan (2012), 'The Expression of Power in the Art and Architecture of Early Islamic Iran', in Edmund Herzig and Sarah Stewart (eds), *Early Islamic Iran* (*The Idea of Iran*, 5), London and New York: I. B. Tauris, pp. 102–19.

Bombaci, Alessio (1966), *The Kūfic Inscription in Persian Verses in the Court of the Royal Palace of Mas'ūd III at Ghazni (Reports and memoirs, Istituto Italiano per il Medio ed Estremo Oriente, Centro studi e scavi archeologici, 5)*, Rome: IsMEO.

Bosworth, Clifford Edmund (1963), *The Ghaznavids: Their Empire in Afghanistan and Eastern Iran, 994–1040*, Edinburgh: Edinburgh University Press.

Bosworth, Clifford Edmund (1968), 'The Political and Dynastic History of the Iranian World (A.D. 100–1217)', in William B. Fisher (ed.), *The Cambridge History of Iran*, Cambridge: Cambridge University Press, vol. 5, pp. 1–202.

Bosworth, Clifford Edmund (1973), *The Ghaznavids: Their Empire in Afghanistan and Eastern Iran, 994–1040*, Beirut: Librairie du Liban, 2nd edition.

Bosworth, Clifford Edmund (1977), *The Later Ghaznavids, Splendour and Decay: The Dynasty in Afghanistan and Northern India 1040–1186*, Edinburgh and New York: Edinburgh University Press.

Bosworth, Clifford Edmund (2001), 'Notes on Some Turkish Names in Abu 'l-Faḍl Bayhaqī's Tārīkh-i Mas'ūdī', *Oriens*, 36: 299–313.

Boullata, Kamal (2000), 'Visual Thinking and the Arab Semantic Memory', in Kamal Abdel-Malek and Wael Hallaq (eds), *Tradition, Modernity, and Postmodernity in Arabic Literature: Essays in Honor of Professor Issa J. Boullata*, Leiden: Brill, pp. 284–303.

Bozdoğan, Sibel and Gülru Necipoğlu (2007), 'Entangled Discourses: Scrutinizing Orientalist and Nationalist Legacies in the Architectural Historiography of the "Lands of Rum"', *Muqarnas*, 24: 1–6.

Bozer, Rüstem (2007), 'Eğirdir Han', in Hakkı Acun (ed.), *Anadolu Selçuklu Dönemi Kervansarayları*, Ankara: T. C. Kültür ve Turizm Bakanlığı Yayınları, pp. 237–53.

Brambilla, Marco (n.d.), *Sultaniyya.org*, published online at <http://sultani yya.org> (accessed 4 October 2018).

Brandenburg, Dietrich and Kurt Brüsehoff (1980), *Die Seldschuken: Baukunst des Islam in Persien und Turkmenien*, Graz: Akademische Druck- und Verlagsanstalt.

Brend, Barbara (1975), 'The Patronage of Faḫr al-Din 'Ali ibn al-Husain and the Work of Kaluk ibn 'Abd Allah in the Development of the Decoration of Portals in Thirteenth-Century Anatolia', *Kunst des Orients*, 11: 160–86.

Bulliet, Richard W. (1972), *The Patricians of Nishapur: A Study in Medieval Islamic Social History*, Cambridge, MA: Harvard University Press.

Bülow, Anna, Julianne Phippard, Susan La Niece and Daniel O'Flynn (forthcoming), 'The Role of Conservation and Scientific Research', in *The Making of the Albukhary Foundation Gallery of the Islamic World*, London: British Museum.

Bundārī al-Fatḥ b. 'Alī b. Muḥammad (1889), *Zubdat al-nuṣra wa-nukhbat al-'uṣra*, ed. M. Th. Houtsma, Leiden: Brill.

Çağman, Filiz (2005), 'Glimpses into the Fourteenth-Century World of Central Asia: The Paintings of Muhammad Siyah Qalam', in Roxburgh 2005, pp. 148–56.

Cahen, Claude (1962), 'The Historiography of the Seljuqid Period', in B. Lewis and P. M. Holt (eds), *Historians of the Middle East*, London: Oxford University Press, pp. 59–78.

Cahen, Claude (1988), *La Turquie pré-ottomane*, Istanbul: L'Institut français d'Études anatoliennes d'Istanbul.

Cahen, Claude (2001), *The Formation of Turkey: The Seljukid Sultanate of Rūm, Eleventh to Fourteenth Century*, trans. P. M. Holt, Harlow: Longman.

Caiozzo, Anna (2000), 'Rituels théophaniques et pratiques magiques: Les anges planetaires dans le manuscript persan 174 de Paris', *Studia Iranica*, 29: 109–40.

Canepa, Matthew (2015), 'Inscriptions, Royal Spaces and Iranian Identity: Epigraphic Practices in Persia and the Ancient Iranian World', in Eastmond 2015a, pp. 10–35.

Campanini, Massimo (2011), 'In Defence of Sunnism: al-Ghazālī and the Seljuqs', in Lange and Mecit 2011, pp. 228–39.

Canby, Sheila, Deniz Beyazit, Martina Rugiadi and A. C. S. Peacock (2016), *Court and Cosmos: The Great Age of the Seljuqs*, New York: The Metropolitan Museum of Art.

Carboni, Stefano (1997), *Following the Stars: Images of the Zodiac in Islamic Art*, New York: The Metropolitan Museum of Art.

Carboni, Stefano (2001), *Glass from the Islamic Lands: The al-Sabah Collection*, London: Thames and Hudson.

Caro, Frederico et al. (2016), 'Materials and Production Technologies of 11th–13th Century Iranian Gypsum Plaster Decoration', *41st International Symposium on Archaeometry*, 15–21 May 2016, Kalamata, Greece.

Casari, Mario (2016), 'Raimondi, Giovanni Battista', in *Dizionario Biografico degli Italiani*, Roma: Istituto della Enciclopedia Italiana, vol. LXXXVI, pp. 221–24.

Chavannes, Edouard (1900), *Documents sur les Tou-Kiue (Turcs) occiden-taux*, Paris: J.-M. Tremblay.

Clark, Bruce (2006), *Twice a Stranger: The Mass Expulsions That Forged Modern Greece and Turkey*, Cambridge, MA: Harvard University Press.

Collinet, Annabelle (2015), 'Un chef-d'oeuvre du monde iranien médiéval: Le chandelier aux canards', *Musée du Louvre at dailymotion*, published online at <https://www.dailymotion.com/video/x58hkf7> (accessed 20 October 2018).

Combe, Etienne, Jean Sauvaget, and Gaston Wiet (eds) (1931–96), *Répertoire chronologique d'épigraphie arabe*, 18 vols, Cairo: Imprimerie de l'Institut Français d'Archéologie Orientale.

Cook, David (2002), *Studies in Muslim Apocalyptic*, Princeton: Darwin Press.

Cook, Michael (2000), *Commanding Right and Forbidding Wrong in Islamic Thought*, Cambridge: Cambridge University Press.

Coulon, Jean-Charles (2017), *La magie en terre d'islam au Moyen Age*, Paris: Editions du comité des travaux historiques et scientifiques.

Crane, Howard Grant (1993), 'Notes on Saljūq Architectural Patronage in 13th Century Anatolia', *Journal of the Economic and Social History of the Orient*, 36: 1–57.

Creswell, Keppel Archibald (1969), *Early Islamic Architecture*, 3 vols, Oxford: Oxford University.

Creswell, Keppel Archibald (1973), *A Bibliography of the Architecture, Arts and Crafts of Islam*, Cairo: American University at Cairo Press.

Creswell, Keppel Archibald (1989), *A Short Account of Early Muslim*

*Architecture, revised and supplemented by J. W. Allan*, Aldershot: Scolar Press.

Crone, Patricia (2004), *God's Rule: Government and Islam, Six Centuries of Medieval Islamic Political Thought*, New York: Columbia University Press.

Cuneo, Paolo (1988), *Architettura armena dal quarto al diciannovesimo secolo*, Rome: De Luca.

Daneshvari, Abbas (ed.) (1981), *Essays in Islamic Art and Architecture in Honor of Katharina Otto-Dorn*, Malibu: Undena.

Daneshvari, Abbas (1986), *Animal Symbolism in Warqa wa Gulshah (Oxford Studies in Islamic Art*, 2), Oxford: Oxford University Press.

*Database of Medieval Anatolian Texts and Manuscripts in Arabic, Persian and Turkish*, Project Coordinator A. C. S. Peacock, published online at <https://www.islam-anatolia.ac.uk> (accessed 17 October 2019).

Daywaji, Sa'id (1957), 'Madaris al-Mawsil fi'l-'ahd al-atabiki', *Sumer*, 13: 73–95.

Daywaji, Sa'id (1968), 'Mashhad al-Imam Yahya bin al-Qasim', *Sumer*, 24: 171–82.

Daywaji, Sa'id (1982), *Tarikh al-Mawsil*, Mosul: Al-Majma' al-'Ilmi al-'Iraqi.

Dehkhodâ, Alîakbar, *Loghatnâme*, published online at <https://vajje.com> (accessed 17 October 2019).

de Khanikoff, Nicolas (1858–60), 'Book of the Balance of Wisdom, an Arabic Work on the Water Balance', *Journal of the American Oriental Society*, 6: 1–128.

de Khanikoff, Nicolas (1862), 'Les inscriptions musulmanes du Caucase', *Journal Asiatique 5ème série*, 20: 57–155.

Debarnot, Marie-Thérèse (1987), 'The Zīj of Ḥabash al-Ḥāsib: A Survey of MS Istanbul Yeni Cami 784/2', *Annals of the New York Academy of Sciences*, 500: 35–69.

Delilbaşı, Melek (1993), 'Greek as a Diplomatic Language in the Turkish Chancery', in N. G. Moschonas (ed.), *Η επικοινωνία στο Βυζάντιο: πρακτικά του Β Διεθνούς Συμποσίου, 4–6 Οκτωβρίου 1990*, Athena: K.B.E./E.I.E., pp. 145–53.

Denike, B. P. (1939), *Arkhitekturni Ornament Srednei Azii*, Moscow and Leningrad: Vses: Akad architekt.

Dhahabī, Shams al-Dīn Muḥammad b. Aḥmad b. 'Uthmān (1994), *Ta'rīkh al-Islam*, ed. 'Umar Tadmurī, Beirut: Dār al-Kitāb al-'Arabī.

Dhahabī, Shams al-Dīn Muḥammad b. Aḥmad b. 'Uthmān (1998), *Siyar a'lām al-nubalā'*, ed. Shu'ayb al-Arna'ūt, Beirut: Mu'assasat al-Risāla.

Diez, Ernst (1918), *Churasanische Baudenkmäler (Arbeiten des Kunsthistorischen Instituts der K. K. Universität Wien [Lehrkanzel Strzygowski]*, 7), Berlin: Reimer.

Dodd, Erica Cruikshank and Shereen Khairallah (eds) (1981), *The Image of the Word: A Study of Quranic Verses in Islamic Architecture*, 2 vols, Beirut: American University of Beirut.

Doğan, Nermin Şaman (2008), *Isparta'da Selçuklu ve Beylikler Dönemi Mimarisi*, Isparta: T. C. Isparta İl Kültür ve Turizm Müdürlüğü, pp. 63–79.

Dold-Samplonius, Yvonne (1992), 'Practical Arabic Mathematics: Measuring the Muqarnas by al-Kāshī', *Centaurus*, 35: 193–242.

Durand-Guédy, David (2010), *Iranian Elites and Turkish Rulers: A History of Iṣfahān in the Saljūq Period*, London and New York: Routledge.

Durand-Guédy, David (ed.) (2013), *Turko-Mongol Rulers, Cities and City Life*, Leiden and Boston: Brill.

Eastmond, Antony (ed.) (2001), *Eastern Approaches to Byzantium*, Aldershot: Ashgate.

Eastmond, Antony (2010), 'Gender and Patronage between Christianity and Islam in the Thirteenth Century', in Engin Akyürek, Nevra Necipoğlu and Ayla Ödekan (eds), *First International Sevgi Gönül Byzantine Studies Symposium*, Istanbul: Vehbi Koç Vakfı, pp. 78–88.

Eastmond, Antony (ed.) (2015a), *Viewing Inscriptions in the Late Antique and Medieval World*, Cambridge: Cambridge University Press.

Eastmond, Antony (2015b), 'Introduction: Viewing Inscriptions', in Eastmond 2015a, pp. 3–9.

Eastmond, Antony (2015c) 'Textual Icons: Viewing Inscriptions in Medieval Georgia', in Eastmond 2015a, pp. 76–98.

Elias, Jamal (2012), *Aisha's Cushion: Religious Art, Perception, and Practice in Islam*, Cambridge, MA: Harvard University Press.

Elisséeff, Nikita (1952–54), 'La titulature de Nūr ad-Dīn d'après ses inscriptions', *Bulletin des Etudes Orientales*, 14: 155–96.

Elisséeff, Nikita (1967), *Nur ad-Din, un grand prince musulman de Syrie au temps des Croisades (511–569 H./1118–1174)*, 3 vols, Damascus: Institut Français de Damas.

Ephrat, Daphna (2000), *A Learned Society in a Period of Transition: The Sunni 'Ulamā' of Eleventh-Century Baghdad*, Albany: State University of New York Press.

Erdmann, Kurt (1943), *Die Kunst Irans zur Zeit der Sasaniden*, Berlin: Kupferberg.

Erdmann, Kurt (1961), *Das anatolische Karavansaray des 13. Jahrhunderts*, vol. 1, Berlin: Verlag Gebr. Mann.

Erdmann, Kurt (1977), *The History of the Early Turkish Carpet*, trans. Robert Pinner, London: Oguz Press.

Erdmann, Kurt and Hanna Erdmann (1976), *Das anatolische Karavansaray des 13. Jahrhunderts*, vols 2 and 3, Berlin: Verlag Gebr. Mann.

Erzi, Adnan S. (1963), *Selçukiler Devrine âid İnşâ Eserleri*, Ankara: Türk Tarih Kurumu.

Esfanjary, Eisa (2017), *Persian Historic Urban Landscapes: Interpreting and Managing Maibud Over 6000 Years*, Edinburgh: Edinburgh University Press.

Ettinghausen, Richard (1939), 'Dated Persian Faience', in Pope and Ackerman 1939, vol. 2, pp. 1667–96.

Ettinghausen, Richard (1943), 'The Bobrinski "Kettle": Patron and Style of an Islamic Bronze', *Gazette des Beaux-Arts 6 sér.*, 24: 193–208.

Ettinghausen, Richard (1957), 'The "Wade Cup" in the Cleveland Museum of Art, Its Origin and Decorations', *Ars Orientalis*, 2: 327–66.

Ettinghausen, Richard (1959), 'Further Comments on the Wade Cup', *Ars Orientalis*, 3: 197–200.

Ettinghausen, Richard (1970), 'The Flowering of Saljuk Art', *Metropolitan Museum Journal*, 3: 111–31.

Ettinghausen, Richard (1974), 'Arabic Epigraphy: Communication or Symbolic Affirmation', in Dickran K. Kouymjian (ed.), *Near Eastern Numismatics, Iconography, Epigraphy, and History: Studies in Honor of George C. Miles*, Beirut: American University of Beirut, pp. 297–317.

Fani, Sara and Margherita Farina (eds) (2012), *Le Vie delle Lettere: La Tipografia Medicea tra Roma e l'Oriente*, Firenze: Mandragora.

Fehérvári, Géza (1974), 'Some Problems of Seljuq Art', in W. Watson (ed.),

*The Art of Iran and Anatolia from the 11th to the 13th Century* A.D.: *A Colloquy Held 25–28 June 1973* (*Colloquies on Art & Archaeology in Asia*, 4), London: Percival David Foundation of Chinese Art, School of Oriental and African Studies, pp. 1–12.

Fehérvári, Géza (1976), *Islamic Metalwork of the Eighth to Fifteenth Century in the Keir Collection*, London: Faber and Faber.

Field, Henry and Eugene Prostov (1942), 'Excavations in Uzbekistan, 1937–1939', *Ars Islamica*, 9: 143–50.

Fiey, Jean Maurice (1959), *Mossoul chrétienne: Essai sur l'histoire, l'archéologie et l'état actuel des monuments chrétiens de la ville de Mossoul*, Beirut: Maronite Press.

Finster, Barbara (1994), *Frühe iranische Moscheen: Vom Beginn des Islam bis zur Zeit salǧūqischer Herrschaft* (*Archäologische Mitteilungen aus Iran, Ergänzungsband*, 19), Berlin: Reimer.

Finster, Barbara (2007), 'Notes on the Ornamentation of the Domes in Iranian Sacred Buildings', in Annette Hagedorn and Avinoam Shalem (eds), *Facts and Artefacts: Art in the Islamic World, Festschrift for Jens Kröger on his 65th Birthday*, Leiden: Brill, pp. 419–27.

Flood, Finbarr Barry (2002), 'Between Cult and Culture: Bamiyan, Islamic Iconoclasm, and the Museum', *The Art Bulletin*, 84: 641–59.

Flood, Finbarr Barry (2009), *Objects of Translation: Material Culture and 'Hindu-Muslim' Encounter*, Princeton: Princeton University Press.

Flood, Finbarr Barry (2015), 'Idea and Idiom: Knowledge and Praxis in South Asian and Islamic Architecture', *Ars Orientalis*, 45: 148–62.

Flood, Finbarr Barry (forthcoming), *Image and Islam: Polemics, Theology, and Modernity*, London: Reaktion Books.

Flury, Sylvie (1925), 'Le décor épigraphique des monuments de Ghazna', *Syria*, 6: 61–90.

Foletti, Ivan and Erik Thunø (eds) (2016), *The Medieval South Caucasus*: *Artistic Cultures of Albania, Armenia, and Georgia, Convivium: Exchanges and Interactions in the Arts of Medieval Europe, Byzantium, and the Mediterranean*, Brno: Seminarium Kondakovianum.

Fourniau, Vincent (ed.) (2001), *Études karakhanides* (*Cahiers d'Asie centrale*, 9), Aix-en-Provence: Éd. ÉDISUD.

Frenkel, Yehoshua (2015), *The Turkic Peoples in Medieval Arabic Writings*, Abingdon and New York: Routledge.

Gabriel, Albert (1935), 'Le Masdjid-i Djum'a d'Iṣfahān', *Ars Islamica*, 2: 7–44.

Galdieri, Eugenio (1972–84), *Iṣfahān: Masǧid-i Ǧum'a*, 3 vols, Roma: ISMEO.

Galdieri, Eugenio (2002), 'Une correction de ḳibla dans la mosquée du Vendredi à Ispahan', in: Philip Huyse and Maria Szuppe (eds): *Iran: Questions et connaissances. Actes du IVe Congrès Européen des Études Iraniennes, Paris, 6–10 septembre 1999, 2. Périodes médiévale et moderne* (Cahiers de Studia Iranica 26), Leuven: Peeters, pp. 485–89.

Georgacas, Demetrius (1971), *The Names for the Asia Minor Peninsula and a Register of Surviving Anatolian Pre-Turkish Placenames*, Heidelberg: Carl Winter Universitätsverlag.

Georganteli, Eurydice (2012), 'Transposed Images: Currencies and Legitimacy in the Late Medieval Eastern Mediterranean', in J. Harris, C. Holmes and E. Russell (eds), *Byzantines, Latins, and Turks in the Eastern Mediterranean World after 1150*, Oxford: Oxford University Press, pp. 141–79.

Genito, Bruno and Fariba Saeiedi Anaraki (eds) (2011), *ADAMJI Project: From the Excavation (1972–1978) to the Archive (2003–2010) in the Masjed-e Jom'e, Isfahan*, Tehran: Italian Embassy, ICHHTO/Rome: IsIAO.

Ghabin, Ahmad (2009), *Ḥisba: Arts and Craft in Islam*, Wiesbaden: Harrassowitz.

Gharipour, Mohammad and İrvin Cemil Schick (eds) (2013), *Calligraphy and Architecture in the Muslim World*, Edinburgh: Edinburgh University Press.

Ghaznavī, Khwāja Sadīd al-Dīn Muḥammad (1345/1926f), *Maqamāt-i Zhanda Pīl*, ed. Ḥeshmat Allāh Mu'ayyad Sanandajī, Tehran: Tarjuma va Nashr-i Kitāb.

Ghirshman, Roman (1938), 'Les fouilles de Châpour (Iran), deuxième campaign 1936/7', *Revue des arts asiatiques*, 12: 12–19.

Ghirshman, Roman (1961), *Sept mille ans d'art en Iran*, Paris: Musée du Petit Palais.

Ghouchani, Abdullah (1986), *Inscriptions on Nishabur Pottery*, intro. M. Y. Kiani, trans. M. Charlesworth, Tehran: Reza Abbasi Museum.

Gibson, Melanie (2008), 'The Enigmatic Figure: Ceramic Sculpture from Iran and Syria, c. 1150–1250', *Transactions of the Oriental Ceramic Society*, 73: 39–50.

Gibson, Melanie (2010), *Takūk and Timthāl: A Study of Glazed Ceramic Sculpture from Iran and Syria, Circa 1150–1250*, 2 vols, doctoral dissertation, University of London.

Gierlichs, Joachim (1995), *Mittelalterliche Tierreliefs in Anatolien und Nordmesopotamien: Untersuchungen zur figürlichen Baudekoration der Seldschuken, Artuqiden und ihrer Nachfolger bis ins 15. Jahrhundert*, Tübingen, Ernst Wasmuth.

Giese-Vögeli, Francine (2007), *Das islamische Rippengewölbe: Ursprung, Form, Verbreitung*, Berlin: Mann.

Giunta, Roberta (2001), 'The Tomb of Muḥammad al-Harawī (447/1055) at Ġaznī (Afghanistan) and Some New Observations on the Tomb of Maḥmūd the Ġaznavid', *East and West*, 51: 109–26.

Giunta, Roberta (2003), *Les inscriptions funéraires de Ġaznī (IVe–IXe/Xe–XVe siècles)*, Naples: Università degli studi di Napoli 'L'Orientale', IsIAO, Fondation Max van Berchem.

Giunta, Roberta (2005a), 'Testimonianze epigrafiche dei regnanti ghaznavidi a Ġaznī', in M. Bernardini and N. Tornesello (eds), *Scritti in onore di Giovanni M. D'Erme (Series Minor 68)*, Napoli: Università degli Studie di Napoli 'l'Orientale', vol. 1, pp. 525–55.

Giunta, Roberta (2005b), 'Islamic Ghazni: An IsIAO Archaeological Project in Afghanistan, A Preliminary Report (July 2004–June 2005)', *East and West*, 55: 473–84.

Giunta, Roberta (2010), 'New Epigraphic Data from the Excavations of the Ghaznavid Palace of Mas'ūd III at Ghazni (Afghanistan)', in P. Callieri and L. Colliva (eds), *South Asian Archaeology: Proceedings of the 19th Meeting of the European Association of South Asian Archaeology in Ravenna, Italy, July 2007*, vol. II, *Historic Period (BAR International Series, 2133)*, Oxford: BAR, pp. 123–31.

Giunta, Roberta (2015), 'The Corpus of Seljuk Inscriptions in the Great Mosque of Isfahan: A Project for a Web Database', in B. Genito (ed.), *Digital Archaeology from the Iranian Plateau (1962–1977): Collected Papers on the Occasion of the 10th Anniversary of the Demise of Umberto Scerrato*

(*Series Minor* 80), Naples: Università degli studi di Napoli 'L'Orientale', pp. 115–42 .

Giunta, Roberta (2017), 'Tombeaux et inscriptions funéraires de Ghazni (Afghanistan): Quelques documents inédits du XIe–XIIIe siècle', *Vicino Oriente*, 21: 127–45.

Giunta, Roberta (2018), 'The Saljuq Inscriptions of the Great Mosque, Isfahan', in B. Genito (ed.), *Four Lectures on the IsMEO Activities in the Masjed-e Jom'e of Isfahan* (*Conferenze ISMEO*, 2), Rome: IsMEO, pp. 7–36.

Giunta, Roberta and Cécile Bresc (2004), 'Listes de la titulature des Ghaznavides et des Ghurides à travers les documents numismatiques et épigraphiques', *Eurasian Studies*, 3: 161–243.

Glassen, Erika (1981), *Der mittlere Weg: Studien zur Religionspolitik und Religiosität der späteren Abbasiden-Zeit* (*Freiburger Islamstudien*, 8), Wiesbaden: Steiner.

Gluck, Jay and Noel Silver (1996), *Surveyors of Persian Art: A Documentary Biography of Arthur Upham Pope and Phyllis Ackerman*, Ashiya, Japan: SoPa.

Godard, André (1949a), 'Khorāsān', *Āthār-é Īrān*, 4: 7–150.

Godard, André (1949b), 'Voutes iraniennes', *Āthār-é Īrān*, 4: 180–360.

Godard, André (1936a), 'Les anciennes mosquées de l'Iran', *Āthār-é Īrān*, 1: 187–210.

Godard, André (1936b), 'Ardistān et Zawārè', *Āthār-é Īrān*, 1: 285–309.

Godard, André (1936c), 'Notes complémentaires sur les tombeaux de Marāgha', *Āthār-é Īrān*, 1: 125–60.

Godard, André (1951), 'L'origine de la madrasa, de la mosquée et du caravan-sérail à quatre iwans', *Ars Islamica*, 15/16: 1-9.

Golden, Peter (1972), 'The Migrations of the Oguz', *Archivim Ottomanicum*, 4: 45–84.

Golden, Peter (1982), 'Imperial Ideology and the Sources of Political Unity Amongst the Pre-Čingisid Nomads of Western Eurasia', reprinted in Peter Golden, *Nomads and Their Neighbours in the Russian Steppe*, Farnham: Ashgate, pp. 37–76.

Golden, Peter (2002), 'War and Warfare in the Pre-Cingisid Western Steppes of Eurasia', in Nicola do Cosmo (ed.), *Warfare in Inner Asian History*, Boston and Cologne: Brill, pp. 105–72.

Grabar, Oleg (1959), *Persian Art Before and After the Mongol Conquest*, Ann Arbor: University of Michigan Museum of Art.

Grabar, Oleg (1963), 'The Islamic Dome: Some Considerations', *Journal of the Society of Architectural Historians*, 22: 191–98.

Grabar, Oleg (1968), 'The Visual Arts, 1050–1350', in J. A. Boyle (ed.), *The Cambridge History of Iran, Volume V: The Saljuq and Mongol Periods*, Cambridge: Cambridge University Press, pp. 626–58.

Grabar, Oleg (1990), *The Great Mosque of Isfahan*, New York and London: New York University Press.

Graves, Margaret (2008), 'Ceramic House Models from Medieval Persia: Domestic Architecture and Concealed Activities', *Iran*, 46: 227–51.

Graves, Margaret (2011), 'Candlestick with Repoussé Designs', in Margaret S. Graves and Benoit Junod (eds), *Treasures of the Aga Khan Collection: Architecture in Islamic Arts*, Geneva: Aga Khan Trust for Culture, pp. 82–83.

Graves, Margaret (2012), *Islamic Art and Architecture and Material Culture: New Perspectives* (*Oxford BAR International Series*, 2436), Oxford: Archaeopress.

Graves, Margaret (2018a), *Arts of Allusion: Object, Ornament, and Architecture in Medieval Islam*, New York: Oxford University Press.

Graves, Margaret (2018b), 'Say Something Nice: Supplications on Medieval Objects and Why They Matter', in Sabine Schmidtke (ed.), *Studying the Near and Middle East at the Institute for Advanced Study, Princeton, 1935–2018*, Piscataway, NY: Gorgias Press, pp. 322–30.

Gray, Basil (1994), 'Saljuq Art: Problems of Identity, Patronage and Taste', in Hillenbrand 1994a, pp. 1–3.

Grenet, Frantz (2004), 'Maracanda/Samarkand, une métropole pré-mongole: Sources écrites et archéologie', *Annales: Histoire, Sciences Sociales*, 5 (59e année): 1043–67.

Grohmann, Adolf (1957), 'The Origin and the Early Development of Floriated Kufic', *Ars Orientalis*, 2: 183–213.

Guidetti, Mattia (2017), 'The Islamicness of Some Decorative Patterns in the Church of Tigran Honents in Ani', in Blessing and Goshgarian 2017, pp. 155–87.

Guest, Grace D. and Richard Ettinghausen (1961), 'The Iconography of a Kashan Luster Plate', *Ars Orientalis*, 4: 25–65.

Gündoğdu, Hamza (1998), 'Köprüköy Hanı', *(Atatürk Üniversitesi) Güzel Sanatlar Enstitüsü Dergisi*, 4: 79–90.

Gündoğdu, Hamza (2007), 'Iğdır/Şerafeddin Ejder Kervansaray', in Hakkı Acun (ed.), *Anadolu Selçuklu Dönemi Kervansarayları*, Ankara: Kültür ve Turizm Bakanlığı.

Gupta, Vivek (forthcoming), *Wonder Reoriented: Manuscripts and Experience in Islamicate Societies of South Asia (ca. 1450–1600)*, doctoral dissertation, University of London.

Gürsan-Salzmann, Ayşe (2007), *Exploring Iran: The Photography of Erich F. Schmidt, 1930–1940*, Philadelphia: University of Pennsylvania Museum of Archaeology and Anthropology.

Ḥāǧǧī Qāsimī, Kambīz (ed.) (1383/2004a), *Masāǧid. Ganǧnāma: Farhang-i āṯār-i miʿmārī-i islāmī-i Īrān*, 6 (Congregational Mosques. Ganjnameh: Cyclopaedia of Iranian Islamic Architecture, 6), Tehran: Dānišgāh-i Šahīd Bihištī.

Ḥāǧǧī Qāsimī, Kambīz (ed.) (1383/2004b), *Masāǧid-i ǧāmiʿ. Ganǧnāma: Farhang-i āṯār-i miʿmārī-i islāmī-i Īrān*, 7-8 (Congregational Mosques. Ganjnameh: Cyclopaedia of Iranian Islamic Architecture, 7-8), 2 vols, Tehran: Dānišgāh-i Šahīd Bihištī.

Ḥāǧǧī Qāsimī, Kambīz (ed.) (1389/2010), *Imāmzādahā va-maqābir. Ganǧnāma: Farhang-i āṯār-i miʿmārī-i islāmī-i Īrān*, 11–13 (Emamzadehs and Mausoleums. Ganjnameh: Cyclopaedia of Iranian Islamic Architecture, 11–13), 3 vols, Tehran: Dānišgāh-i Šahīd Bihištī.

Hall, Robert (1981), 'Al Khāzini', in Charles C. Gillispie et al. (eds), *Dictionary of Scientific Biography*, New York: Scribner, vol. 7, pp. 335–51.

Hallaq, Wael (1984), 'Caliphs, Jurists and the Seljūqs in the Political Thought of Juwaynī', *The Muslim World*, 74: 26–41.

Halm, Heinz (1971), 'Der Wesir Al-Kunduri und die Fitna von Nīšāpūr', *Die Welt des Orients*, 6: 205–33.

Halm, Heinz (1974), *Die Ausbreitung der šafiʿitischen Rechtsschule von den Anfängen bis zum 8./14. Jahrhundert*, Wiesbaden: Dr. Ludwig Reichert Verlag.

Halm, Heinz (1975), 'Die Anfänge der Madrasa', *Zeitschrift der Deutschen Morgenländischen Gesellschaft*, Supplement 3/1, XIX: *Deutscher Orientalistentag*, pp. 438–48.

Halm, Heinz (2014), *Shi'ism*, Edinburgh: Edinburgh University Press.

Hanne, Eric J. (2007), *Putting the Caliph in his Place: Power, Authority, and the Late Abbasid Caliphate*, Madison, NJ: Fairleigh Dickinson University Press.

Hardy, Godfrey Harold (1967), *A Mathematician's Apology*, with foreword by C. P. Stone, Cambridge, Cambridge University Press.

Harut'yunyan, Varazdat M. (1960), *Mijnadaryan Hayastani k'aravanatnern u kamurjnerě: Karavansarai i mosty srednevekovoij Armenii*, Erevan: Haypethrat.

Ḥātim, Ġulām'alī (1389/2010), *Mi'mārī-i islāmī-i Īrān dar daura-i salǧūqi-yān*, Tehran: Ǧihād-i Dānišgāhī.

Hartmann, Angelika (1975), *An-Nasir li-Din Allah (1189–1225): Politik, Religion, Kultur in der späten 'Abbasidenzeit*, Berlin: de Gruyter.

Hartner, Willy (1973/74), 'The Vaso Vescovali in the British Museum: A Study on Islamic Astrological Iconography', *Kunst des Orients*, 9: 99–130.

Heidemann, Stefan, Jean-François de Laperouse and Vicki Parry (2014), 'The Large Audience: Life-Sized Stucco Figures of Royal Princes from the Seljuq Period', *Muqarnas* 31: 35–71.

Herrmann, Georgina (1977), *The Iranian Revival*, Oxford: Elsevier Phaidon.

Herzfeld, Ernst (1921), 'Khorasan', *Der Islam*, 11: 107–74.

Herzig, Edmund and Sarah Stewart (eds) (2015), *The Age of the Seljuks* (*The Idea of Iran*, 6), London and New York: I. B. Tauris.

Heydari-Malayeri, H. (2004), 'A Concise Review of the Iranian Calendar', *Laboratoire d'Etudes du Rayonnement et de la Matière en Astrophysique et Atmosphères*, published online at <https://arxiv.org/abs/astro-ph/0409620v1> (accessed 20 June 2018).

Hillenbrand, Carole (1988), 'Islamic Orthodoxy or Realpolitik? Al-Ghazālī's Views on Government', *Iran*, 26: 81–94.

Hillenbrand, Carole (2001), 'Some Reflections on Seljuq Historiography', in Eastmond 2001, pp. 73–98.

Hillenbrand, Carole (2005), 'Rāvandī, the Seljuk Court at Konya and the Persianisation of Anatolian Cities', *Mésogeios*, 25–26: 157–69.

Hillenbrand, Carole (2007), *Turkish Myth and Muslim Symbol: The Battle of Manzikert*, Edinburgh: Edinburgh University Press.

Hillenbrand, Carole (2011), 'Aspects of the Court of the Great Seljuqs' in Lange and Mecit 2011, pp. 22–38.

Hillenbrand, Carole (2015), 'The Life and Times of 'Amīd al-Mulk al-Kundurī', in Peacock and Tor 2015, pp. 161–73.

Hillenbrand, Robert, 'Saldjukids. VI. Art and architecture. 1. In Persia', *EI2*.

Hillenbrand, Robert (1972), 'Saljūq Monuments in Iran: I', *Oriental Art*, 18: 64–77.

Hillenbrand, Robert (1974), 'The Development of Saljuq Mausolea in Iran', in William Watson (ed.), *The Art of Iran and Anatolia from the 11th to the 13th Century A.D.* (*Colloquies on Art & Archaeology in Asia*, 4), London: University of London, pp. 40–59.

Hillenbrand, Robert (1975), 'Salǧūq Monuments in Iran: III. The Domed Masǧid-i Ǧāmi' at Suǧās', *Kunst des Orients*, 10: 49–79.

Hillenbrand, Robert (1976), 'Saljuq Dome Chambers in North-West Iran', *Iran*, 14: 93–102.

Hillenbrand, Robert (ed.) (1994a), *The Art of the Seljuqs in Iran and Anatolia: Proceedings of a Symposium Held in Edinburgh in 1982*, Costa Mesa, CA: Mazda Publishers.

Hillenbrand, Robert (1994b), *Islamic Architecture: Form, Function and Meaning*, New York: Columbia University Press.

Hillenbrand, Robert (2006), 'The Islamic Re-Working of the Sasanian Heritage: Two Case Studies', in P. Baker and B. Brend (eds), *Sifting Sands, Reading Signs: Studies in Honour of Géza Fehérvári*, London: Furnace, pp. 1–14.

Hillenbrand, Robert (2010), 'A Seljuk Figural Stucco Wall Panel', *Art of the Islamic and Indian Worlds* (Sale 7871), London: Christie's, pp. 96–98.

Hillenbrand, Robert (2017), 'The Frontispiece Problem in the Early 13th-Century Kitab al-Aghani', in Lorenz Korn and Martina Müller-Wiener (eds), *Central Periphery? Art, Culture and History of the Medieval Jazira*, Wiesbaden: Reichert, pp. 199–227.

Hoffman, Eva R. and Scott Redford (2017), 'Transculturation in the Eastern Mediterranean', in Finbarr Barry Flood and Gülru Necipoğlu (eds), *A Companion to Islamic Art and Architecture*, Hoboken, NJ: John Wiley, vol. 1, pp. 405–30.

Holakooei, Parviz, Jean-François de Laperouse, Martina Rugiadi and Federico Caro (2016), 'Early Islamic Pigments at Nishapur, North-Eastern Iran: Studies of the Painted Fragments Preserved at The Metropolitan Museum of Art', *Archeological and Anthropological Sciences*, 10: 175–95.

Holod, Renata (2012), 'Event and Memory: The Freer Gallery's Siege Scene Plate', *Ars Orientalis*, 42: 194–219.

Holtzman, Livnat (2016), 'The Miḥna of Ibn ʿAqīl (d. 513/1119) and the Fitnat Ibn al-Qushayrī (d. 514/1120)', in Sabine Schmidtke (ed.), *The Oxford Handbook of Islamic Theology*, Oxford: Oxford University Press, pp. 660–78.

Iakobson, Anatolij Leopol'dovich (1950), *Ocherk istorii zodchestva Armenii V–XVII vekov*, Moscow: Gosudarstvennoe Izdatelstvo Arkhitektury i Gradostroitel'stva.

Ibn Abd al-Zahir, Abd al-Aziz al-Khuwaytir (ed.) (1976), *al-Rawd al-Zahir fi Sirat al-Malik al-Zahir*, Riyadh: al-Khuwaytir.

Ibn Abī Yaʿlā al-Ḥanbalī, Abū'l-Ḥusayn Muḥammad b. Muḥammad b. al-Ḥusayn (1997), *Ṭabaqāt al-Ḥanābila*, Beirut: Dār al-Kutub al-ʿIlmiyya.

Ibn al-Athir (1965–67), *al-Kamil fi'l-ta'rikh*, ed. C. Tornberg, Beirut: Dar Sadir.

Ibn al-Athīr, ʿIzz al-Dīn Abū'l-Ḥasan ʿAlī (1979), *al-Kāmil fi'l-ta'rīkh*, 13 vols, ed. C. Tornberg, Beirut: Dār Ṣādir.

Ibn al-Jawzī, Abū'l-Faraj ʿAbd al-Raḥmān b. ʿAlī (1992), *al-Muntaẓam fī ta'rīkh al-umam wa'l-mulūk*, ed. M. ʿA. ʿAṭā, 18 vols, Beirut: Dār al-Kutub al-ʿIlmiyya.

Ibn al-Jawzi (1359/1940), *Al-Muntazam*, vol. 8, ed. F. Krenkow, Hyderabad: Daʾirat al-Maʿarif al-ʿUthmaniya.

Ibn al-Ukhuwwa (1938), *The Maʿālim al-Qurba fī Aḥkām al-Ḥisba of Ḍiyāʾ al-Dīn Muḥammad Ibn Muḥammad al-Quraishī al-Shāfiʿī, known as Ibn al-Ukhuwwa*, ed. Reuben Levy, London: Luzac.

Ibn Bibi (1390/2012), *Al-Avāmir al-ʿAlaʾiyya fī al-umur al-ʿAlāʾiyya*, ed. Zhāla Mutahiddīn, Tehrān: Pazhūhishgāh-i ʿulūm-i insānī wa muṭaliʿāt-i farhangī.

Ibn Fadlan (1966), *Ibn Fadlan's Reisebericht*, ed. Zegi Validi Togan, Leipzig: Kraus (1st edition 1939).

Ibn Fadlan (1959), *Risalat Ibn Fadlan*, ed. Sami Dahhan, Damascus: Majmaʿ al-Lughah al-ʿArabiyya.

Ibn Hassul (1940), *Kitab tafdil al-atrak ʿala saʾir al-ajnad*, ed. A. al-Azzawi, *Belleten* 4: 26–51.

Ibn Hassul (2015), 'The Superiority of the Turks over Other Regiments', in Yehoshua Frenkel (trans.), *The Turkic Peoples in Medieval Arabic Writings*, New York: Routledge.

Ibn Khallikan (1843–71), *Kitab Wafayat al-A'yan: Ibn Khallikan's Biographical Dictionary*, trans. Baron MacGuckin de Slane, 4 vols, Paris: Printed for the Oriental Translation Fund of Great Britain and Ireland.

Ibn Kathīr, Abū'l-Fidā' Ismā'īl b.'Umar (n.d.), *al-Bidāya wa'l-nihāya*, 16 vols, Aleppo: Dār al-Rashīd.

Ibn Munavvar = Muḥammad b. Munavvar b. Abī Sa'd b. Abī Ṭāhir b. Abī Sa'īd Mayhanī (1381/1961), *Asrār al-tawḥīd fī maqāmāt al-Shaykh Abī Sa'īd*, ed. M. R. Shafī'ī Kadkanī, Tehran: Intishārāt-i Āgāh.

İnalcık, Halil, 'Harir. ii The Ottoman Empire', *EI2*.

Jackson, Cailah (2017), 'An Illuminated Manuscript of Early Fourteenth-Century Konya? Anīs al-Qulūb (ms Ayasofya 2984, Süleymaniye Kütüphanesi, Istanbul)', *Journal of Islamic Manuscripts*, 8: 85–122.

Jacobsthal, Eduard (1899), *Mittelalterliche Backsteinbauten zu Nachtschewân im Araxesthale*, Berlin: Greve.

Jalali, Nadira (ed.) (1377/1999), *Tarix-e al-e Saljuq dar Anatoli compiled by Unknown Author*, Tehran: Daftar-i nashr-i mīrāth-i maktūb.

Jāmī, 'Abd al-Raḥmān (1858), *Nafaḥāt al-Uns min Ḥaḍarāt al-Quds*, ed. William Nassau Lees, Calcutta: Maṭba'a-yī Līssī.

Kabir, Mafizullah (1964), *The Buwayhid Dynasty of Baghdad, 334/946–447/1055*, Calcutta: The Iran Society.

Kadoi, Yuka (ed.) (2016), *Arthur Upham Pope and A New Survey of Persian Art*, Leiden: Brill.

Kafadar, Cemal (2007), 'Introduction: A Rome of One's Own: Reflections on Cultural Geography and Identity in the Lands of Rum', *Muqarnas*, 24: 7–25.

Kahle, Paul (1953), 'Chinese Porcelain in the Lands of Islam', *Journal of the Pakistan Historical Society*, 1: 218–33

Kâhya, Yegân et al. (2001), 'Sivas Gökmedrese Üzerine Yeni bir Değerlendirme', in Osman Eravşar and Haşim Karpuz (eds), *I. Uluslararası Selçuklu Kültür ve Medeniyeti Kongresi: Bildiriler*, Konya: Selçuklu Araştırmaları Merkezi.

Kalter, Johannes (1987), *Linden-Museum Stuttgart (Abteilungsführer Islamischer Orient)*, Stuttgart: Linden-Museum.

Kamal al-Din Abu'l-fadl Hubaysh-i Tiflisi (1388/1968), *Kamil al-Ta'bir-i Tiflisi*, ed. Sayyid Husayn Radawi Buqra'i, Tehran: Nashr-i Nay.

Karame, Alya (2017), *Qur'ans from the Eastern Islamic World between the 4th/10th and 6th/12th Centuries*, doctoral dissertation, University of Edinburgh.

Karev, Yury (2005), 'Qarakhanid Wall Paintings in the Citadel of Samarqand: First Report and Preliminary Observations', *Muqarnas*, 22: 46–84.

Karev, Yury (2013), 'From Tents to City. The Royal Court of the Western Qarakhanids between Bukhara and Samarqand', in Durand-Guédy 2013, pp. 99–147.

Kay, H. C. (1897), 'A Seljukite Inscription at Damascus', *Journal of the Royal Asiatic Society*: 335–45.

Keall, Edward J. (1979), 'Topography and Architecture of Medieval Rayy', in *Akten des VII. Internationalen Kongresses für Iranische Kunst und Archäologie, München, 7.–10. September 1976*, Berlin: D. Reimer, pp. 537–45.

Kennedy, Edward S. (1973), *A Commentary Upon Bīrūnī's Kitāb Taḥdīd al-Amākin*, Beirut: American University of Beirut Press.

Khaleghi-Motlagh, Djalal (1998–2008), *The Shahnameh (The Book of Kings), and Notes on the Shahnameh*, New York: Persian Heritage Foundation.

Khazanov, Anatoly M. (1994), *Nomads and the Outside World*, Madison: The University of Wisconsin Press, 2nd edition.

Khāzinī (1940), *Balance of Wisdom: Kitāb Mīzān al-Hikma*, Hyderabad: Osmania Press.

Khmelnitskiy, Sergei G. (1992), *Mezhdu arabami i tjurkami: Ranneislamskaja architektura Srednej Azii (Architektura Srednej Azii IX–X vv.)*, Berlin: Continent.

Khmelnitskiy, Sergei G. (1996–97), *Mezhdu samanidami i mongolami: Arkhitektura Srednei Azii XI – nachala XIII vv.*, 2 vols, Berlin: Continent.

Khwānda, Mīr Ghiyāth al-Din b. Humām al-Dīn (1938), *Dastūr al-vuzarā'*, ed. Sā'īd Nafīsī, Tehran: Iqbāl.

Kirmānī, Nāṣir al-Dīn Munshī (1959), *Nasā'im al-ashār min laṭā'im al-akhbār dar tārīkh-i vuzarā*, ed. Mīr Jalāl al-Dīn Ḥusaynī Armavī, Tehran: Dāneshgāh-i Tehrān.

Klausner, Carla (1973), *The Seljuk Vezirate: A Study of Civil Administration, 1055–1194*, Cambridge, MA: Harvard University Press.

Kočnev, B. (2001), 'La chronologie et la généalogie des Karakhanides du point de vue de la numismatique', in Fourniau 2001, pp. 49–75.

Komaroff, Linda (2000), 'Exhibiting the Middle East: Collections and Perceptions of Islamic Art', *Ars Orientalis*, 30: 1–8.

Korn, Lorenz, 'Saljuqs vi. Art and Architecture', *Encyclopaedia Iranica*.

Korn, Lorenz (2004), *Ayyubidische Architektur in Ägypten und Syrien: Bautätigkeit im Kontext von Politik und Gesellschaft, 564–658/1169–1260*, Heidelberg: Heidelberger Orientverlag.

Korn, Lorenz (2007), 'Saljuq Dome Chambers in Iran: A Multi-Faceted Problem of Islamic Art', *Archäologische Mitteilungen aus Iran und Turan*, 39: 235–60.

Korn, Lorenz (2010), 'Der Masǧid-i Gunbad in Sangān-i Pā'īn (Ḥurāsān/Iran): Architektur, Baudekor und Inschriften', *Beiträge zur Islamischen Kunst und Archäologie*, 2: 81–103.

Korn, Lorenz (2012), 'Architecture and Ornament in the Great Mosque of Golpayegan (Iran)', *Beiträge zur Islamischen Kunst und Archäologie*, 3: 212–36.

Korn, Lorenz (2018), 'Between Architectural Design and Religious Politics: Aspects of Iranian Mosques of the Saljuq Period', in Pierfrancesco Callieri and Adriano Valerio Rossi (eds), *Civiltà dell'Iran. Passato – Presente – Futuro. Atti del Convegno Internazionale Roma, 22–23 febbraio 2013 (Il novissimo Ramusio, 6)*, Rome: Roma Scienze e lettere, pp. 153–69.

Korn, Lorenz (forthcoming), 'Masǧid-i ǧāmi'-i Burūǧird. Nukātī dar bāb-i ṭarrāḥī va-sāḫt-i bināhā-i daura-i salǧūqī', *Asar*.

Korn, Lorenz, Christian Fuchs, Anja Heidenreich, Philipp Schramm, Zatollah Nikzad and Zarrintaj Sheibani (2015 [2018]), 'The Great Mosque of Golpayegan: Report on the First Campaign, 1385/2007', *Archäologische Mitteilungen aus Iran und Turan*, 47: 197–251.

Korobeinikov, Dmitri (2003), 'Orthodox Communities in Eastern Anatolia in the Thirteenth to Fourteenth Centuries. Part 1: The Two Patriarchates: Constantinople and Antioch', *Al-Masaq*, 15: 197–214.

Korobeinikov, Dmitri (2005a), 'Orthodox Communities in Eastern Anatolia in the Thirteenth to Fourteenth Centuries. Part 2: The Time of Troubles', *Al-Masaq*, 17: 1–29.

Korobeinikov, Dmitri (2005b), 'Михаил VIII Палеолог в Румском султанате. Часть I', *Vizantiiskii Vremennik*, 64: 77–98.

Korobeinikov, Dmitri (2009), 'A Greek Orthodox Armenian in the Seljukid Service: The Colophon of Basil of Melitina', in Rustam Shukurov (ed.), *Mare et litora: Essays Presented to Sergei Karpov for his 60th Birthday*, Moscow: Indrik, p. 709–24.

Korobeinikov, Dmitri (2011), 'Михаил VIII Палеолог в Румском султанате: свидетельства поздних источников', *Vizantiiskie Ocherki* [n. vol.]: 116–38.

Korobeinikov, Dmitri (2014), *Byzantium and the Turks in the Thirteenth Century*, Oxford: Oxford University Press.

Korobeinikov, Dmitri (2016), 'Семья Вардахла на византийской и сельджукской службе', *Vizantiiskie Ocherki* [n. vol]: 87–101.

Kotzabassi, Sofia (2004), Βυζαντινά χειρόγραφα από τα μοναστήρια της Μικράς Ασίας, Athens: Ekdoseis Ephesos.

Kračkovskaâ, V. A. (1949), 'Èvolûciâ kufičeskogo pis'ma v srednej azii', *Epigrafika Vostoka*, 3: p. 3–27.

Kreyenbroek, Philip and Khalil Jindy Rashow (2005), *God and Sheikh Adi are Perfect*, Wiesbaden: Harrassowitz Verlag.

Kuçur, Sadi (2009), 'Selçuklu Şehir Tarihi Açısından Sivas Gök Medrese (Sahibiye Medresesi) Vakfiyesi', in Adem Esen, Haşim Karpuz and Osman Eravşar (ed.), *Anadolu Selçuklu Şehirleri ve Uygarlığı Sempozyumu Bildirileri*, Konya: Selçuklu Belediyesi, pp. 337–49.

Kühnel, Ernst (1956), 'Die Kunst Persiens unter den Buyiden', *Zeitschrift der Deutschen Morgenländischen Gesellschaft*, 106: 78–92.

Lane, Arthur (1947), *Early Islamic Pottery*, London: Faber and Faber.

Lane, Edward William (1863–93), *An Arabic-English Lexicon*, 8 vols, London: Williams and Norgate.

Langermann, Tzvi (2014), 'From My Notebooks on *Tajriba* / (*nissayon*) "experience": Texts in Hebrew, Judeo-Arabic, and Arabic', *Aleph*, 14: 147–76.

Laviola, Valentina (2016), *Metalli Islamici dai territori Iranici Orientali (IX–XIII sec.): La documentazione della Missione Archeologica Italiana in Afghanistan*, doctoral dissertation, Università Ca' Foscari Venezia.

Laviola, Valentina (2017), 'Artisan's Signatures from Pre-Mongol Iranian Metalwork: An Epigraphic and Paleographic Analysis', *Eurasian Studies*, 15: 80–124.

Le Strange, Guy (1905), *Lands of the Eastern Caliphate: Mesopotamia, Persia, and Central Asia, from the Moslem Conquest to the Time of Timur*, Cambridge: Cambridge University Press.

Le Strange, Guy (1924), *Baghdad During the Abbasid Caliphate*, Oxford: Oxford University Press.

Leiser, Gary (1998), 'Observations on the "Lion and Sun" Coinage of Kai-Khusraw', *Mesogeios*, 2: 96–114.

Leiser, Gary (2017), *Prostitution in the Eastern Mediterranean World*, London: I. B. Tauris.

Leisten, Thomas (1998), *Architektur für Tote: Bestattung in architektonischem Kontext in den Kernländern der islamischen Welt zwischen 3./9. und 6./12. Jahrhundert (Materialien zur iranischen Archäologie, 4)*, Berlin: Reimer.

Lekka, Anastasia (2007), 'Legislative Provisions of the Ottoman/Turkish Governments Regarding Minorities and Their Properties', *Mediterranean Quarterly*, 18: 135–54.

Lerner, Judith (2016), 'Arthur Upham Pope and the Sasanians', in Kadoi 2016, pp. 169–230.

Leroy, Jules (1964), *Les manuscrits syriaques à peintures conservés dans les bibliothèques d'Europe et d'Orient: Contribution à l'étude de l'iconographie des églises de langue syriaque*, Paris: P. Geuthner.

Lorch, Richard (1980), 'Al-Khāzinī's Treatise on the "Sphere that Rotates by itself"', *Journal for the History of Arabic Science*, 4: 287–329.

Loukonine, Vladimir and Anatoli Ivanov (2003), *Persian Art: Lost Treasures*, London: Sirocco.

Madelung, Wilfred (1969), 'The Assumption of the Title Shāhānshāh by the Buyids and the Reign of the Daylam', *Journal of Near East Studies*, 28: 84–108, 169–83.

Madelung, Wilfred (1985), 'The Spread of Māturīdism and the Turks', reprinted in *Religious Schools and Sects in Medieval Islam*, London: Variorum Reprints, pp. 109–68.

Madelung, Wilfred (1988), *Religious Trends in Early Islamic Iran*, Albany, NY: The Persian Heritage Foundation, pp. 26–38.

Madelung, Wilfred (2002), 'The Westward Migration of Hanafi Scholars from Central Asia in the 11th to 13th Centuries', *Ankara Üniversitesi İlahiyat Fakültesi Dergisi*, 43: 41–55; reprinted in Sabine Schmidtke (ed.) (2002), *Studies in Medieval Muslim Thought and History*, London: Variorum Reprints, pp. 41–55.

Makdisi, George (1961), 'Muslim Institutions of Learning in Eleventh-Century Baghdad', *Bulletin of the School of Oriental and African Studies* 24: 1–56.

Makdisi, George (1963), *Ibn 'Aqīl et la resurgence de l'Islam traditionaliste au XIe siècle*, Damascus: Institut Français de Damas.

Makdisi, George (1973), 'The Sunni Revival', in D. S. Richards (ed.), *Islamic Civilisation, 950–1150*, Oxford: Cassirer, pp. 155–68.

Makharadze, Neli and Nodar Lomouri (eds) (2010), *Byzantium in the Georgian Sources*, Tbilisi: Institute of Oriental Studies.

Mamedov, Mukhammed (2004), *Soltan Sanjaryñ Kümmeti – Mavzolej Sultana Sandžara – Mausoleum of Sultan Sanjar*, Istanbul: Altan Matbaa.

Manandian, Hakob A. (1965), *The Trade and Cities of Armenia in Relation to Ancient World Trade*, trans. Nina Garsoian, Lisbon: Livraria Bertrand.

Marr, Nikolai Iavkovlevitch (1893–94), 'Novye materialy po armianskoi epigrafike', *Zapiski vostochago otdelenia imperatorskago russkago arkheologicheskago obshchestba* 8: 82–83.

Mason, Robert B. (2004), *Shine Like the Sun: Lustre-Painted and Associated Pottery from the Medieval Middle East*, Costa Mesa, CA: Mazda.

Mason, Robert B. and M. S. Tite (1994), 'Beginnings of Islamic Stonepaste Technology', *Archaeometry*, 36: 77–91.

Masson, M. E. (1971), 'Fragmenty nadpisi karahanidskogo mavzoleâ v gorodiŝa Afrasiab', *Èpigrafika Vostoka*, 20: 77–84.

Masson Smith, John (1978), 'Turanian Nomadism and Iranian Politics', *Iranian Studies*, 11: 57–81.

Massullo, Martina (forthcoming), 'Mausolées et lieux de *ziyāra* à Ghazni (Afghanistan) du Xe au XXe siècle' [map drawn in collaboration with M. M. Lamberti and H. Renel], in *Atlas du monde musulman médiéval (Xe–XVIe siècles)*, Paris: CNRS Orient & Méditérannée, Islam médiéval.

Matney, Timothy (1995), 'Re-Excavating Cheshmeh Ali', *Expedition*, 37: 26–38.

Mayer, Leo A. (1956), *Islamic Architects and Their Works*, Geneva: A. Kundig.

Mayer, Leo A. (1958), *Islamic Woodcarvers and Their Works*, Geneva: A. Kundig.

Mayer, Leo A. (1959), *Islamic Metalworkers and Their Works*, Geneva: A. Kundig.

McClary, R. P. (2017), *Rum Seljuq Architecture, 1170–1220: The Patronage of Sultans*, Edinburgh: Edinburgh University Press.

McCormick, Michael (2001), *Origins of the European Economy: Communications and Commerce, AD 300–900*, Cambridge: Cambridge University Press.

Meinecke, Michael, 'Kubadabad', *EI2*.

Meinecke, Michael (1976), *Fayencedekorationen seldschukischer Sakralbauten in Kleinasien*, Tübingen: Wasmuth.

Meisami, Julie Scott (1999), *Persian Historiography to the End of the Twelfth Century*, Edinburgh: Edinburg University Press.

Melchert, Christopher, 'Education iv. The Medieval *Madrasa*', *Encyclopaedia Iranica*.

Melchert, Christopher (1997), *The Formation of the Sunni Schools of Law*, Leiden: Brill.

Melikian-Chirvani, Assadullah Souren (1970), 'Le Roman de Varqe et Golšâh', *Arts Asiatiques*, 22: 1–262.

Melikian-Chirvani, Assadullah Souren (1974), 'The White Bronzes of Islamic Iran', *Metropolitan Museum Journal*, 9: 123–51.

Melikian-Chirvani, Assadullah Souren (1979), 'Les bronzes du Khorāssān – VII', *Studia Iranica*, 8: 187–205.

Melikian-Chirvani, Assadullah Souren (1982a), *Islamic Metalwork from the Iranian World: 8th–18th Centuries*, London: Her Majesty's Stationery Office.

Melikian-Chirvani, Assadullah Souren (1982b), 'Le rhyton selon les sources Persanes', *Studia Iranica*, 2: 263–92.

Melikian-Chirvani, Assadullah Souren (1991), 'Les taureaux à vin et les cornes à boire de l'Iran islamique', in Paul Bernard and Frantz Grenet (eds), *Histoire et cultes de l'Asie central préislamique*, Paris: Éditions du centre nationale de la recherche scientifique, pp. 101–25.

Melville, Charles (2006), 'The Early Persian Historiography of Anatolia', in Judith Pfeiffer and Sholeh A. Quinn (eds), *History and Historiography of Post-Mongol Central Asia and the Middle East: Studies in Honor of John E. Woods*, Wiesbaden: Harrassowitz, pp. 135–66.

Melvin-Koushki, Matthew (2017), 'Powers of One: The Mathematicization of the Occult Sciences in the High Persianate Tradition', *Intellectual History of the Islamicate World*, 5: 127–99.

Ménage, Victor Louis (1979), 'The Islamization of Anatolia', in N. Levtzion (ed.), *Conversion to Islam*, New York and London: Holmes & Meier, pp. 52–67.

Métivier, Sophie (2009), 'Les Maurozômai, Byzance et le sultanat de Rūm: Note sur le sceau de Jean Comnène Maurozômès', *Revue des études byzantines*, 67: 197–207.

Métivier, Sophie (2012), 'Byzantium in Question in 13th-Century Seljuk Anatolia', in Guillaume Saint-Guillain and Dionysios Stathakopoulos (eds), *Liquid and Multiple: Individuals and Identities in the Thirteenth-Century Aegean*, Paris: ACHCByz, pp. 235–58.

Michael the Syrian (1899–1914), *Chronique de Michel le Syrien*, ed. and trans. Jean-Baptiste Chabot, Paris: Leroux.

Michell, George and Richard Eaton (1992), *Firuzabad: Palace City of the Deccan* (*Oxford Studies in Islamic Art*, 8), Oxford: Oxford University Press.

Mīrkhwānd, Muhammad b. Burhān al-Dīn Khwāndshāh (1339/1920f.), *Tārīkh rawdat al-ṣafā*. Tehran: Kitābkhāna-yi Khayyām.

Miles, George C. (1938), *The Numismatic History of Rayy*, New York: American Numismatic Society.

Miles, George C. (1965), 'Inscriptions on the Minarets of Saveh, Iran', *Studies in Islamic Art and Architecture in Honour of Professor K. A. C. Creswell*, Cairo: American University at Cairo Press, pp. 163–78.

Miles, George C. (1966), 'Appendix', in Oleg Grabar, 'The Islamic Commemorative Structures', *Ars Orientalis*, 6: 45–46.

Mottahedeh, Roy (2001), *Loyalty and Leadership in an Early Islamic Society*, London: I. B. Tauris, 2nd edition.

Mulder, Stephennie (2014), *The Shrines of the 'Alids in Medieval Syria: Sunnis, Shi'is and the Architecture of Coexistence*, Edinburgh: Edinburgh University Press.

Nader, Albert (1968), *Kitāb faṣl al-maqāl wa-taqrīr mā bain al-sharī'a wa-l-ḥikma min ittiṣāl*, Beirut: Dār al-Mashriq.

Nastič, Vladimir N. (2000), 'A New Glance to the Attribution of Shâh Fâzil (Ferghana)', in Wijdan Ali and James D. Deemer (eds), *Islamic Art Resources in Central Asia and Eastern and Central Europe: Proceedings of the Fifth International Seminar for Islamic Art and Architecture*, Mafraq: Āl al-Bayt University, pp. 45–49.

Nastič, Vladimir N. and B. D. Kočnev (1988), 'Katributsii mavzoleâ Shah-Fazil', *Èpigrafika Vostoka*, 24: 68–77.

Nastič, Vladimir N. and B. D Kočnev (1995), 'Katribucii ûžjnogo uzgenskogo mavzoleâ (èpigrafičeskie i numizmatičeskie dannye)', *Vostočnoe istoričeskoe istočnikovedenie i special'nye istoričeskie discipliny*, 4: 177–98.

Natif, Mika (2011), 'The Painter's Breath and Concepts of Idol Anxiety in Islamic Art', in Josh Ellenbogen and Aaron Tugendhaft (eds), *Idol Anxiety*, Stanford, CA: Stanford University Press, pp. 41–55.

Navā'ī, Kāmbīz and Kāmbīz, Ḥāǧǧī Qāsimī (1390/2011), *Ḫišt va-ḫayāl: Šarḥ-i mi'amārī-i islāmī-i Īrān*, Tehran: Surūš.

Nemceva, Nina Borisouna (2009), *Rabat-i Malik, XI–načalo XVIII vv. (Arkheologičeskie Issledovaniâ)* (*Working Paper*, 33), Tashkent: IFEAC.

Neugebauer, Otto (1962), 'Thābit Ben Qurrah "On the Solar Year" and "On the Motion of the Eighth Sphere"', *Proceedings of the American Philosophical Society*, 106: 264–99.

Nīshāpūrī, Ẓāhir al-Dīn (2004), *Saljūqnāma*, ed. A. H. Morton, Chippenham: E. J. W. Gibb Memorial Trust.

Nīshāpūrī, Ẓāhir al-Dīn, Kenneth A. Luther and C. E. Bosworth (2001), *The History of the Seljuq Turks: From the Jāmi' Al-Tawārīkh: An Ilkhanid Adaption of the Saljūq-Nāma of Ẓahir Al-Dīn Nīshāpūrī*, Abingdon: Routledge.

Niẓām al-Mulk, Abū 'Alī Ḥasan al-Ṭūsī (1378/1958f), *Siyar al-mulūk*, ed. Hubert Darke, Tehran: Intishārāt-i 'Ilmī va Farhang.

Nizam al-Mulk (1960), *Siyasatnama: The Book of Government or Rules for Kings*, trans. Hubert Darke, London: Routledge and Kegan Paul.

Niẓāmī Ganjawī (1380/1960), *Sharafnāma*, ed. Barāt Zanjānī, Tehran: Intishārāt-i Dānishgāh-i Tihrān.

Ögel, Semra (1966), *Anadolu Selçukluları'nın Taş Tezyinatı*, Ankara: Türk Tarih Kurumu.

Ögel, Semra (1972), *Der Kuppelraum in der türkischen Architektur*, Istanbul: Nederlands Historisch-Archeologisch Instituut in het Nabije Oosten.

O'Kane, Bernard (2009), *The Appearance of Persian on Islamic Art*, New York: Persian Heritage Foundation.

Oikonomidès, Nikos (1983), 'Les Danishmendides, entre Byzance, Bagdad et le sultanat d'Iconium', *Revue Numismatique, 6e série*, 25: 191–92.

Oikonomidès, Nikos (1999), 'L'«unilinguisme» officiel de Constantinople byzantine (VIIe–XIIe s.)', *Symmeikta*, 13: 9–22.

Öney, Gonül (1994), 'Pottery from the Samosata Excavations, 1978–81', in Hillenbrand 1994a, pp. 286–94.

Önge, Mustafa (2007), 'Caravanserais as Symbols of Power in Seljuk Anatolia', in Jonathan Osmond and Ausma Cimdina (eds), *Power and Culture: Identity, Ideology, Representation*, Pisa: Pisa University Press, pp. 49–67.

Orthmann, Eva and Petra G. Schmidl (eds) (2017), *Science in the City of Fortune: The* Dustūr al-Munajjimīn *and its World*, Berlin: Ebverlag.

Otto-Dorn, K. (1978–79), 'Figural Stone Reliefs on Seljuk Sacred Architecture in Anatolia', *Kunst des Orients*, 12: 103–49.

Overlaet, Bruno (1993), *Splendeur des Sassanides: L'empire Perses entre Rome et la Chine (224–642)*, Bruxelles: Musées Royaux d'Art et d'Histoire.

Overton, Keelan (2016), 'Filming, Photographing, and Purveying in "the New Iran": The Legacy of Stephen F. Nyman c 1935–1942', in Kadoi 2016, pp. 327–72, 360–62.

Pachymérès, Georges (1984–2000), *Relations Historiques*, ed. Albert Failler, 5 vols, Paris: Belles Lettres.

Pancaroğlu, Oya (2000), *'A World Unto Himself': The Rise of a New Human Image in the Late Seljuk Period (1150–1250)*, doctoral dissertation, Harvard University.

Pancaroglu, Oya (2004), 'The Itinerant Dragon Slayer: Forging Paths of Image and Identity in Medieval Anatolia', *Gesta*, 43: 151–64.

Pancaroğlu, Oya (2016), 'Ornament, Form, and Vision in Ceramics from Medieval Iran: Reflections of the Human Image', in Gülru Necipoğlu and Alina Payne (eds), *Histories of Ornament: From Global to Local*, Princeton: Princeton University Press, pp. 192–203.

Parani, Maria G. (2003), *Reconstructing the Reality of Images: Byzantine Material Culture and Religious Iconography (11th–15th Centuries)*, Leiden: Brill.

Patton, Douglas (1992), *Badr al-Din Lu'lu': Atabeg of Mosul, 1211–1259* (*Occasional Papers Series*, 3), Seattle: Middle East Center of the Jackson School of International Studies, University of Washington.

Paul, Jürgen (2005), 'The Seljuq Conquest(s) of Nishapur: A Reappraisal', *Iranian Studies*, 38: 575–85.

Pavlov, Moshe (2017), *Abū al-Barakāt al-Baghdādī's Scientific Philosophy: The Kitāb al-Mu'tabar*, London, Routledge.

Peacock, A. C. S. (2010), *Early Seljūq History: A New Interpretation*, London and New York: Routledge.

Peacock, A. C. S. (2013a), 'Sufis and the Seljuk Court in Mongol Anatolia: Politics and Patronage in the Works of Jalal al-Din Rumi and Sultan Walad', in Peacock and Yildiz 2013, pp. 206–26.

Peacock, A. C. S. (2013b), 'Court and Nomadic Life in Saljuq Anatolia', in Durand-Guédy 2013, pp. 191–222.

Peacock, A. C. S. (2015), *The Great Seljuk Empire*, Edinburgh: Edinburgh University Press.

Peacock, A. C. S. (2016), 'Advice for the Sultans of Rum: The "Mirrors for Princes" of Early-Thirteenth-Century Anatolia', in Bill Hickman and Gary Leiser (eds), *Turkish Language, Literature, and History: Travelers' Tales, Sultans, and Scholars Since the Eighth Century*, London and New York: Routledge, pp. 266–307.

Peacock, A. C. S. (2017), 'Islamisation in Medieval Anatolia', in A. C. S. Peacock (ed.), *Islamisation: Comparative Perspectives from History*, Edinburgh: Edinburgh University Press, 134–55.

Peacock, A. C. S. (2019), *Islam, Literature and Society in Mongol Anatolia*, Cambridge: Cambridge University Press.

Peacock, A. C. S., Bruno de Nicola and Sara Nur Yıldız (eds) (2015), *Islam and Christianity in Medieval Anatolia*, Farnham: Ashgate.

Peacock, A. C. S. and D. G. Tor (2015), 'Preface', in A. C. S. Peacock and D. G. Tor (eds), *Medieval Central Asia and the Persianate World: Iranian Tradition and Islamic Civilisation*, London: I. B. Tauris, pp. xix–xxvi.

Peacock, A. C. S. and Sara Nur Yıldız (eds) (2013), *The Seljuks of Anatolia: Court and Society in the Medieval Middle East*, London and New York: I. B. Tauris.

Peacock, A. C. S. and Sara Nur Yıldız (eds) (2016), *Literature and Intellectual Life in 14th–15th Century Anatolia*, Würzburg: Ergon Verlag.

Pellat, Charles (1969), *The Life and Works of Jahiz*, trans. D. M. Hawke, Berkeley and Los Angeles: University of California Press.

Perry, J. R. (2006), 'Turkic-Iranian Contacts, i. Linguistic Contacts', *Encyclopædia Iranica*.

Pickett, Douglas (1997), *Early Persian Tilework: The Medieval Flowering of Kashi*, Madison, NJ: Fairleigh Dickinson University Press.

Piemontese, Angelo M. (1980), 'Nuova luce su Firdawsi: uno Šāhnāma datato 614 h./1217 a Firenze', *Annali dell'Istituto Universitario Orientale di Napoli*, 40: 1–38, 189–242 .

Piemontese, Angelo M. (1989), *Catalogo dei manoscritti persiani conservati nelle biblioteche d'Italia*, Roma: Istituto Poligrafico dello Stato.

Piltz, Elisabeth (1994), *Le costume officiel des dignitaires byzantins à l'époque Paléologue*, Uppsala: S. Academie Upsaliensis.

Pingree, David (1999), 'Preliminary Assessment of the Problems of Editing al-Zīj al-Sanjarī', in Yusuf Ibish (ed.), *Editing Islamic Manuscripts on Science: Proceedings of the Fourth Conference of al-Furqan Islamic Heritage Foundation 29th-30th November 1997*, London: Al-Furqān Islamic Heritage Foundation.

Pinto, Mariana (2016), 'Examination of a Stucco Panel from the Museum of Islamic Art (object SW.160): A Technical Report Presenting the Result from the Paint Samples Analyses', unpublished paper, submitted to the conservation laboratories of the Museum of Islamic Art Doha, University College London – Qatar, Doha, Qatar.

Pirniyā, Muḥammad Karīm (1370/1992), 'Gunbad dar mi'mārī-i Īrān', *Asar*, 20: 5–139.

Piotrovsky, M. B. and J. M. Rogers (2004), *Heaven on Earth: Art from Islamic Lands*, Munich, Berlin, London and New York: Prestel.

Plesters, J. (1989) 'Ultramarine Blue, Natural and Artificial', in. A. Roy (ed.), *Artists' Pigments*, London: Washington and Archetype Publications, vol. 2, pp. 37–65.

Pope, Arthur Upham and Phyllis Ackerman (eds) (1938–39), *A Survey of Persian Art from Prehistoric Times to the Present*, 6 vols, Oxford: Oxford University Press.

Pope, Arthur Upham and Phyllis Ackermann (1964), *A Survey of Persian Art from Prehistoric Times to the Present*, 12 vols, London and New York: Oxford University Press, 2nd edition (2nd impression 1967).

Porter, Yves (2004), 'Potters, Painters and Patrons: Documentary Inscriptions and Iconography in Pre-Mongol Iranian Ceramics', *Transactions of the Oriental Ceramic Society*, 69: 25–35.

Preiser-Kapeller, Johannes (2008), *Das Episkopat im späten Byzanz: Ein Verzeichnis der Metropoliten und Bischöfe des Patriarchats von Konstantinopel in der Zeit von 1204 bis 1453*, Saarbrücken: Verlag Dr. Müller.

Preiser-Kapeller, J. (2015), 'Liquid Frontiers: A Relational Analysis of Maritime Asia Minor as a Religious Contact Zone in the Thirteenth-Fifteenth Centuries', in Peacock, de Nicola and Yıldız 2015, pp. 117–45.

Pritsak, Omeljan (1954), 'Die Karachaniden', *Der Islam*, 31: 17–68.

Pseudo-Kodinos (1966), *Traité des offices*, intro., ed. and trans. J. Verpeaux, Paris: Éditions du Centre National de la Recherche Scientifique.

Pseudo-Kodinos (2013), *Pseudo-Kodinos and the Constantinopolitan Court: Offices and Ceremonies*, ed. Ruth Macrides, Joseph Munitiz, and Dimiter Angelov, Farnham: Ashgate.

Pseudo-Nishapuri [Qashani] (1332/1953), *Saljuqnama*, ed. I. Afshar, Tehran: Golāle-ye Khāvar.

Ptolemy (1984), *Ptolemy's Almagest*, trans. Gerald J. Toomer, London: Duckworth.

Pulleyblank, Edwin G. (2000), 'The Hsiung-nu', in Hans Robert Roemer (ed.), *History of the Turkic Peoples in the Pre-Islamic period*, Berlin: K. Schwarz, pp. 52–75.

Qazvīnī, Yahyā b. 'Abd al-Latīf (1944), *Kitāb lubb al-tawārīkh*, Tehran: Bunyād va Gūyā.

Rahman, Abdur (1998), 'The Zalamkot Bilingual Inscription', *East and West*, 48: 469–73.

Rante, Rocco (2007), 'Topography of Rayy During the Early Islamic Period', *Iran*, 45: 161–80.

Rante, Rocco (2008), 'The Iranian City of Rayy: Urban Model and Military Architecture', *Iran*, 46: 189–211.

Rante, Rocco (2015), *Rayy, from its Origins to the Mongol Invasion: An Archeological and Historiographical Study*, Leiden: Brill.

Rante, Rocco and Carmen di Pasquale (2016), 'The Urbanisation of Rayy in the Seljuk Period', *Der Islam*, 93: 413–32.

Rashid al-Din (1960), *Cami' al-tavarih (Metin), II. Cild, 5. Cuz, Selçuklar Tarihi*, ed. A. Ateş, Ankara: TTK.

Rashid al-Din (2001), *The History of the Seljuq Turks from the Jami' al-Tawarikh: An Ilkhanid Adaptation of the Saljuq-nama of Zahir al-Din Nishapuri*, trans. K. A. Luther, London: Routledge.

Rashīd al-Dīn Fadlallāh (1983), *Jāmi' al-Tawārīkh*, 2 vols, ed. Ahmad Ātesh, Tehran: Dunyā-yi Kitāb.

Rashid al-Din Fadl-allah Tabib (1957), *Jāmi' al-Tavārīkh*, ed. and trans. into Russian A. K. Arends, 3 vols, Baku: Izdatel'stvo Akademii Nauk Azerbaidzhanskoi SSR.

Rashid al-Din Fadl-allah Tabib (1998), *Jami u't-Tawarikh: Compendium of Chronicles—A History of the Mongols*, trans. Wheeler M. Thackston, 3

vols, Cambridge, MA: Harvard University Department of Near Eastern Languages and Civilizations.

Rawandi, Muḥammad A. A. (1921), *Rahat al-sudur wa ayat al-surur*, ed. M. Iqbal, London: Luzac.

Reşîdüddîn, Fazlullah (1999), *Camiu't-tevârîh*, trans. Ahmed Ateş, vol. 2, part 5, Ankara: TTK.

Rāzī, Najm al-Dīn (1352/1974), *Marmūzāt-i Asadī dar Mazmūrāt-i Dā'ūdī*, ed. Muhammad Riḍā Shāfi'ī Kadkanī, Tehran: McGill University Institute of Islamic Studies, Tehran Branch.

Redford, Scott (1990), 'How Islamic Is It? The Innsbruck Plate and Its Setting', *Muqarnas*, 7: 119–35.

Redford, Scott (1994), 'Thirteenth Century Rum Seljuq Palaces and Palace Imagery', *Ars Orientalis*, 23: 215–32.

Redford, Scott (2009), 'The Inscription of the Kırkgöz Hanı and the Problem of Textual Transmission in Seljuk Anatolia', *Adalya*, 12: 347–59.

Redford, Scott (2014), *Legends of Authority: The 1215 Seljuk Inscriptions of Sinop Citadel*, Istanbul: Koç University Press.

Redford, Scott (2015a), 'The Rape of Anatolia', in Peacock, de Nicola and Yıldız 2015, pp. 107–16.

Redford, Scott (2015b), 'Intercession and Succession, Enlightenment and Reflection: The Inscriptional Program of the Karatay Madrasa, Konya', in Eastmond 2015a, pp. 148–69.

Redford, Scott (2016a), 'Caravanserais and Commerce', in Paul Magdalino and Nevra Necipoğlu (eds), *Trade in Byzantium: Papers from the 3rd International Sevgi Gönül Byzantine Studies Symposium*, Istanbul: Vehbi Koç Foundation, pp. 297–311.

Redford, Scott (2016b), 'Reading Inscriptions on Seljuk Caravanserais', in M. Guidetti and S. Mondini (eds), *«A mari usque ad mare»: Cultura visuale e materiale dall'Adriatico all'India*, Venice: Edizioni Ca'Foscari, pp. 221–34.

Redford, Scott (2018), 'Rum Seljuk Emir Mübarizeddin Ertokuş and his Madrasa: Reading Identity through Architectural Patronage', Koray Durak and Ivana Jevtić (eds), *Identity and the Other in Byzantium. Papers from the 4rd International Sevgi Gönül Byzantine Studies Symposium*, Istanbul: Vehbi Koç Foundation, pp. 225–43.

Redford, Scott, 'One Man, Two Caravanserais', in Ali Uzay Peker (ed.), *Ömür Bakırer'e Armağan/Festschrift for Ömür Bakırer*, Ankara: Middle East Technical University Faculty of Architecture Press.

Redford, Scott and M. J. Blackman (1997), 'Luster and Fritware Production and Distribution in Medieval Syria', *Journal of Field Archaeology*, 24: 233–47.

Redford, Scott and Gary Leiser (2008), *Victory Inscribed: The Seljuk Fetiḥnāme on the Citadel walls of Antalya, Turkey*, Antalya: Kıraç Research Institute on Mediterranean Civilizations.

Rice, D. S. (1955), *The Wade Cup in the Cleveland Museum of Art*, Paris: Paris Société Nouvelle des Éditions du Chêne.

Rice, D. S. (1958), 'Studies in Islamic Metalwork, VI', *Bulletin of the School of Oriental and African Studies*, 21: 225–53.

Richard, Francis (1989), *Catalogue des manuscrits persans I: Ancien fonds, Bibliothèque nationale, Département des Manuscrits*, Paris: Bibliothèque nationale.

Riyāḥī, Muḥammad Amīn (1369/1991), *Zabān wa Adab-i Fārsī dar Qalamraw-i 'Uthmānī*, Tehran: Shirkat-i Intishārātī-yi Pāzhang.

Rogers, J. Michael (1971), *Patronage in Seljuk Anatolia, 1200–1300*, doctoral dissertation, University of Oxford.

Rogers, J. M. (1995), 'Saldjukids. VI. Art and Architecture. 2. In Anatolia', *EI2*.

Roux, Jean-Paul (1982), *Études d'Iconographie Islamique : Quelques Objets Numineux des Turcs et des Mongols*, Paris: Association pour le développement des études turques; Leuven : Peeters.

Roux, Jean-Paul (1983), 'Le problème des influences turques sur les arts de l'islam', *Turcica*, 15: 59–103.

Roux, Jean-Paul (1984), *La religion des Turcs et des Mongols*, Paris: Payot.

Roxburgh, David J. (ed.) (2005), *Turks: A Journey of a Thousand Years, 600–1600*, London: Royal Academy of Arts.

Rūdakī Samarqandī, Abū 'Abd-Allāh (1387/2009), *Dīwān-i Rūdakī*, ed. Qādir-i Rustam, Tehran: Mu'assisa-i farhangī-yi ECO.

Rugiadi, Martina (2010), 'The Ghaznavid Marble Decoration: An Overview', published online at <http://web.mit.edu/akpia/www/articlerugiadi.pdf> (accessed 1 November 2018).

Sabra, Abdelhamid (1971), 'The Astronomical Origin of Ibn al-Haytham's Concept of Experiment', in *Actes du XIIe congrès international d'histoire des sciences, Paris 1968*, Paris: A. Blanchard, pp. 133–36.

Safi, Omid (2006), *The Politics of Knowledge in Premodern Islam: Negotiating Ideology and Religious Inquiry*, Chapel Hill: University of North Carolina Press.

Saint-Laurent, B. (1989), 'The Identification of a Magnificent Koran Manuscript', in F. Déroche (ed.), *Les Manuscrits du Moyen-Orient: Essais de Codicology et Paléographie*, Istanbul and Paris: Institut Francais d'Etudes Anatoliennes d'Istanbul et Bibliotheque Nationale, pp. 115–24.

Saltini, G. (1860), 'Notizia di trenta codici manoscritti di Giovan Battista Raimondi, che si conservano nella biblioteca Magliabechiana di Firenze', *Giornale Storico degli Archivi Toscani*, 4: 297–308.

Salman, 'Isa and Najat Totonchi (1975), *Texts in the Iraq Museum, vol. 8: Arabic Texts*, Baghdad: Directorate General of Antiquities.

Saliba, George (1994), 'Early Arabic Critique of Ptolemaic Cosmology: A Ninth-Century Text on the Motion of the Celestial Spheres', *Journal for the History of Astronomy*, 25: 115–41.

Ṣāliḥī Kāḫakī, Aḥmad (1391/2012), 'Ta'ammulī dar katībahā va-nuqūš-i masǧid-i ǧami'-i Zavāra', *Nāma-i Bāstān-Šināsī*, 97: 97–120.

Sarre, Friedrich (1934), 'Die Bronzenkanne des Kalifen Marwan II in Arabischen Museum in Kairo', *Ars Islamica* 1: 10–16.

Sarre, Friedrich (1936), *Der Kiosk von Konia*, Berlin: Verlag für Kunstwissenschaft.

Sarre, Friedrich and Ernst Herzfeld (1911), *Archaologische Reise im Euphrat-und Tigris-Gebiet*, 4 vols, Berlin: Verlag von Dietrich Reimer.

Sayan, Yüksel (1999), *Türkmenistan'daki Mimari Eserler (XI.–XVI. yüzyıl)* (*Kültür Bakanlığı Yayınları Sanat Eserleri Dizisi*, 248), Ankara: Ankara Kültür Bakanlığı Yayınları.

Sayılı, Aydın (2016), *The Observatory in Islam and Its Place in the General History of the Observatory*, Ankara: Atatürk Kültür Merkezi, 2nd edition.

Scerrato, Umberto (1994), 'Sura XXIII 1–6 in a Saljuq Inscription in the Great Mosque at Isfahan', *East and West*, 44: 249–57.

Schmidt, Erich (1935), 'Excavations at Rayy', *Ars Islamica* 2: 139–41.

Schmidt, Erich (1940), *Flights over the Ancient Cities of Iran*, Chicago: Oriental Institute.

Schmitz, B. (1994), 'A Fragmentary *Mina'i* Bowl with Scenes from the *Shahnama*', in Hillenbrand 1994a, pp. 156–64.

Schnyder, R. (1994), 'In Search of the Substance of Light', in Hillenbrand 1994a, pp. 165–69.

Schroeder, Eric (1964–67), 'The Seljuq Period', in Pope and Ackerman 1964, vol. 3, pp. 981–1045.

Serjeant, R. B. (1972), *Islamic Textiles: Material for a History to the Mongol Conquest*, Beirut: Librairie du Liban.

Sezgin, Fuat et al. (2001), *Manuscript of Arabic Mathematical and Astronomical Treatises* (Frankfurt Institute for the History of Arabic Islamic Science, Series C, Facsimile Editions, 66, reproduced from Manuscript A. Y. 314, Istanbul University), Frankfurt: Strauss Offsetdruck.

Shams al-Din Muhammad ibn Amin al-Din Ayyub Dunaysiri (1350/1931), *Nawadir al-Tabadur li-Tuhfat al-Bahadur*, ed. Muhammad Taqi Danish-Pazhuh and Iraj Afshar, Tehran: Pazhuhishgah-i 'Ulum-i Insani wa Mutala'at-i Farhangi.

Shkirtladze, Zaza (ed.) (2018), *Ani at the Crossroads*, Tbilisi: Ivane Javakhishvili Tbilisi State University Press.

Shokoohy, M. (1994), 'Sasanian Royal Emblems and Their Reemergence in the Fourteenth-Century Deccan', *Muqarnas*, 11: 65–78.

Shokoohy, Mehrdad (n.d.), *Corpus Inscriptionum Iranicarum*, London: Published on behalf of the Corpus Inscriptionum Iranicarum School of Oriental and African Studies.

Shukurov, Rustam (1995), 'AIMA: The Blood of the Grand Komnenoi', *Byzantine and Modern Greek Studies*, 19: 161–81.

Shukurov, Rustam (2001), 'Turkmen and Byzantine Self-Identity: Some Reflections on the Logic of the Title-Making in Twelfth- and Thirteenth-Century Anatolia', in Eastmond 2001, pp. 255–72.

Shukurov, Rustam (2004), 'Christian Elements in the Identity of the Anatolian Turkmens (12th–13th Centuries)', in *Cristianità d'Occidente e cristianità d'Oriente (secoli VI–XI)*, Spoleto: Fondazione Centro italiano di studi sull'alto Medioevo, pp. 707–64.

Shukurov, Rustam (2013a), 'Churches in the Citadels of Ispir and Bayburt: An Evidence of "Harem Christianity"?' in G. Vespignani (ed.), *Polidoro: Studi offerti ad Antonio Carile*, vol. 2, Spoleto: Fondazione Centro italiano di studi sull'alto Medioevo, pp. 713–23.

Shukurov, Rustam (2013b), 'Harem Christianity: The Byzantine Identity of Seljuk Princes', in Peacock and Yıldız 2013, pp. 115–50.

Shukurov, Rustam (2016), *The Byzantine Turks, 1204–1461*, Leiden: Brill.

Sibt b. al-Jawzi (1951), *Mir'at al-zaman*, Hyderabad: Dairatu'l-Maarifil-Osmania.

Sinor, Denis (1985), 'Some Components of the Civilization of the Turks', in G. Jarring and S. Rosén (eds), *Altaistic Studies*, Stockholm: Almqvist and Wiksell International, pp. 145–59.

Sinor, Denis (1990), 'The Founding of the First Türk Kaghanate', in Denis Sinor (ed.), *The Cambridge History of Early Inner Asia*, Cambridge: Cambridge University Press, pp. 285–316.

Šīrāzī, Bāqir Āyatullāhzāda (1359/1980), 'Masǧid-i Ǧāmi'-i Ardistān', *Asar*, 1: 6–51.

Siroux, Maxime (1947), 'La mosquée Djum'a de Bouroujird', *Bulletin de l'Institut Français d'Archéologie Orientale du Caire*, 46: 239–58.

Siroux, Maxime (1956), 'La mosquée Djoumeh de Marand', *Arts Asiatiques*, 3: 89–97.

Smith, Myron B. (1936), 'The Manars of Isfahan', *Athar-é Iran*, 1: 313–58.

Smith, Myron B. (1937), 'Material for a Corpus of Early Iranian Islamic Architecture: II. Manār and Masdjid, Barsīān (Iṣfahān)', *Ars Islamica*, 4: 7–40.

Smith, Myron B. (1939), 'Material for a Corpus of Early Iranian Islamic Architecture: III. Two Dated Seljuk Monuments at Sīn (Iṣfahān)', *Ars Islamica*, 6: 1–10.

Smith, Myron B. (1947), *The Vault in Persian Architecture: A Provisional Classification, with Notes on Construction*, doctoral dissertation, Johns Hopkins University.

Snelders, Bas (2010), *Identity and Christian-Muslim Interaction: Syrian Orthodox from the Mosul Area*, Leiden: Orientalia Lovaniensia Analeteca.

Soudan, Frédérique and Ludwig Kalus (2017), *Thesaurus d'épigraphie islamique*, Geneva: Fondation Max van Berchem, published online at <http://www.epigraphie-islamique.org> (accessed 17 October 2019).

Sourdel-Thomine, Janine (1953), 'Deux minarets d'époque seljoukide en Afghanistan', *Syria*, 30: 108–36.

Sourdel-Thomine, Janine (1970), 'La mosquée et la madrasa: Types monumentaux caractéristiques de l'art islamique médiéval', *Cahiers de Civilisation Médiévale*, 13: 97–115.

Sourdel-Thomine, Janine (1974), 'Inscriptions seljoukides et salles à coupoles de Qazwin en Iran', *Revue des Études Islamiques*, 42: 3–43.

Sourdel-Thomine, Janine (1978), *Lashkari Bazar: Une résidence royale ghaznévide et ghoride*, 1B: *Le décor non figuratif et les inscriptions* (*Mémoires de la Délégation Archéologique Française en Afghanistan*, 18), Paris: de Boccard.

Sourdel-Thomine, Janine (1981), 'A propos du cénotaphe de Mahmud à Ghazna (Afghanistan)', in Daneshvari 1981, pp. 127–35.

Spengler, William F. H. C. and Wayne G. Sayles (1992–96), *Turkoman Figural Bronze Coins and Their Iconography*, Lodi, WI: Clio's Cabinet.

Spuler, Bertold, 'Djuwaynī, Shams al-Dīn Muḥammad b. Muḥammad', *EI2*.

Steppan, Thomas (ed.) (1995), *Die Artuqiden-Schale im Tiroler Landesmuseum Ferdinandeum Innsbruck: Mittelalterliche Emailkunst zwischen Orient und Occident*, Innsbruck and Munich: Edition Maris.

Stern, S. M. (1971), 'Yaʿqub the Coppersmith and Persian National Sentiment', in C. E. Bosworth (ed.), *Iran and Islam in Memory of the Late Vladimir Minorsky*, Edinburgh: Edinburgh University Press, pp. 535–55.

Stock, Gabriele (1989), 'Das Samanidenmausoleum in Bukhara', *Archäologische Mitteilungen aus Iran*, 22: 253–90.

Stock, Gabriele (1990), 'Das Samanidenmausoleum in Bukhara', *Archäologische Mitteilungen aus Iran*, 23: 231–60.

Stock, Gabriele (1991), 'Das Samanidenmausoleum in Bukhara', *Archäologische Mitteilungen aus Iran*, 24: 223–46.

Stronach, David and T. Cuyler Young Jr. (1966), 'Three Octagonal Seljuq Tomb Towers from Iran', *Iran*, 4: 1–20.

Strzygowski, J. (1918), *Die Baukunst der Armenier und Europa: Ergebnisse einer vom Kunsthistorischen Institutes der Universität Wien 1913 durchgeführten Forschungsreise I–II*, Vienna: Schroll.

Suter, H., 'Djalālī', *EI1*.

Tabbaa, Yasser (1982), *The Architectural Patronage of Nur al-Din, 1146–1174*, doctoral dissertation, New York University.

Tabbaa, Yasser (1994), 'The Transformation of Arabic Writing, Part 2: The Public Text', *Ars Orientalis*, 24: 117–47.

Tabbaa, Yasser (1997), *Constructions of Power and Piety in Medieval Aleppo*, University Park: The Pennsylvania State University Press.

Tabbaa, Yasser (2000), 'Dayfa Khatun, Regent Queen and Architectural Patron', in D. F. Ruggles (ed.), *Women, Patronage, and Self-Representation in Islamic Societies*, Albany, NY: State University of New York Press, pp. 17–34.

Tabbaa, Yasser (2002), 'The Mosque of Nur al-Din in Mosul, 1170–72', *Annales Islamologique*, 36: 339–60.

Taqizadeh, S. H. (1940), 'Various Eras and Calendars Used in the Countries of Islam', *Bulletin of the School of Oriental Studies*, 9: 107–32.

TARA (Toolkit for Archaeological Research and Analysis), published online at <http://tara.museum.upenn.edu> (accessed 17 October 2019).

Tariq, J. (1982), *Studies in Mediaeval Iraqi Architecture*, Baghdad: Ministry of Culture and Information.

Temir, Ahmet (1989), *Kırşehir Emiri Caca Oğlu Nur el-Din'in 1272 Tarihli Arapça-Moğolca Vakfiyesi*, Ankara: Türk Tarih Kurumu (1st edition 1959).

Tetik, Ahmet (2005), *Arşiv Belgeleriyle Ermeni Faaliyetleri: 1914–18*, vol. 1, Ankara: Genelkurmay Basım Evi.

*The Thesaurus Linguae Graecae*, published online at <http://www.tlg.uci.edu> (accessed 17 October 2019).

Thompson, Deborah (1976), *Stucco from Chal Tarkhan-Eshqabad near Rayy*, Warminster: Aris and Phillips.

Tite, M. S. (2011), 'Technology of Glazed Islamic Ceramics Using Data Collected by the Late Alexander Kaczmarczyk', *Archaeometry*, 53: 329–39.

Tietze, Andreas and Gilbert Lazard (1967), 'Persian Loanwords in Anatolian Turkish', *Oriens*, 20: 125–68.

Tor, D. G. (2007), *Violent Order: Religious Warfare, Chivalry, and the ʿAyyār Phenomenon in the Medieval Islamic World*, Würzburg: Ergon Verlag.

Tor, D. G. (2009), 'A Tale of Two Murders: Power Relations Between Caliph and Sultan in the Twelfth Century', *Zeitschrift der Deutschen Morgenländischen Gesellschaft*, 159: 279–97.

Tor, D. G. (2011), '"Sovereign and Pious": The Religious Life of the Great Seljuq Sultans', in Lange and Mecit 2011, pp. 39–62.

Tor, D. G. (2015), 'The Importance of Khurāsān and Transoxiana in the Classical Islamic World', in Peacock and Tor 2015, pp. 1–12.

Tor, D. G. (2016), 'Rayy and the Religious History of the Seljuq Period', *Der Islam*, 93: 377–405.

Tor, D. G. (2017), 'The Political Revival of the ʿAbbāsid Caliphate: Al-Muqtafī and the Seljuqs', *Journal of the American Oriental Society*, 137: 301–14.

Treptow, Tanya, with the collaboration of Donald S. Whitcomb (2007), *Daily Life Ornamented: the Medieval Persian City of Rayy*, Chicago: Oriental Institute of the University of Chicago.

Troelenberg, Eva-Maria (2014), 'On a Pedestal? On the Problem of the Sculptural as a Category for Perception of Islamic Objects', in Gabriele Genge and Angela Stercken (eds), *Art History and Fetishism Abroad: Global Shiftings in Media and Methods*, Bielefeld: transcript, pp. 159–74.

Tuncer, Orhan Cezmi (1985), 'Mimar Kölük ve Kalûyân', *Vakıflar Dergisi* 19: 109–18.

Turan, Osman (1947), 'Şemseddin Altun Aba, Vakfiyesi ve Hayatı', *Belleten*, 11: 197–233.

Turan, Osman (1948), 'Celaleddin Karatay, Vakıfları ve Vakfiyeleri', *Belleten*, 12: 17–138.

Turan, Osman (1955), 'The Ideal of World Domination among the Medieval Turks', *Studia Islamica*, 4: 77–90.

Turan, Osman (1958), *Türkiye Selçukluları Hakkında Resmi Vesikalar*, Ankara: Türk Tarih Kurumu.

Turan, Osman (1980), *Selçuklar Târihi ve Türk-İslâm Medeniyeti*, Istanbul: Ötüken Neşriyat.

Umnâkov, I. I. (1927), 'Rabat-i Malik', in [n. ed.], *Sbornik v čest' V. V. Bartol'da*, Dushanbe: Izdanie Obŝestva dlâ izučeniâ Tadžikistana, pp. 179–92.

Ünal, Rahmi Hüseyin (1969–70), 'Iğdır Yakınlarında bir Selçuklu Kervansarayı ve Doğubeyazıt-Batum Kervan Yolu Hakkında Notlar', *Sanat Tarihi Yıllığı*, 3: 7–15.

Ünal, Rahmi Hüseyin (1982), *L'étude du portail dans l'architecture pré-ottomane*, Izmir: Ege Üniversitesi Edebiyat Fakültesi Yayınları.

Uyar, Tolga (2015), 'Thirteenth Century "Byzantine" Art in Cappadocia and the Question of Greek Painters at the Seljuk Court', in Peacock, de Nicola and Yıldız 2015, pp. 215–31.

van Berchem, Max and Josef Strzygowski (1910), *Amida*, Heidelberg: Carl Winter's Universitätsbuchhandlung.

Vásáry, I. (2015), 'Two Patterns of Acculturation to Islam: The Qarakhanids versus the Ghaznavids and Seljuqs', in Herzig and Stewart 2015, pp. 9–28.

Viguera María Jesús et al. (2001), *El Splendor de los Omeyas cordobeses: La civilización musulmana de Europa Occidental*, 2 vols, Granada: Fundación El Legado Andalusí.

Vílchez, José Miguel Puerta (2017), *Aesthetics in Arabic Thought: From Pre-Islamic Arabia Through al-Andalus*, trans. Consuelo López-Morillas, Leiden: Brill.

Volov, L. (1966), 'Plaited Kufic on Samanid Epigraphic Pottery', *Ars Orientalis*, 6: 107–33.

Vryonis, Speros (1971), *The Decline of Medieval Hellenism in Asia Minor and the Process of Islamization from the Eleventh through the Fifteenth Century*, Berkeley, Los Angeles and London: University of California Press.

Warland, Rainer (2014), 'Byzantinische Wandmalerei des 13. Jahrhunderts in Kappadokien: Visuelle Zeugnisse einer Koexistenz von Byzantinern und Seldschuken', in Neslihan Asutay-Effenberger and Falko Daim (eds), *Der Doppeladler: Byzanz und die Seldschuken in Anatolien vom 11. bis 13. Jahrhundert*, Mainz: Römisch-Germanisches Zentralmuseum, pp. 53–68.

Watson, Oliver (1985), *Persian Lustre Ware*, London: Faber and Faber.

Watson, Oliver (2004), *Ceramics from Islamic Lands*, London: Thames and Hudson.

Weinryb, Ittai (2016), *The Bronze Object in the Middle Ages*, New York: Cambridge University Press.

Wiet, Gaston (1940), 'Inscriptions coufiques de Perse', in G. Maspero (ed.), *Mélanges Maspero III. Orient Islamique*, Cairo: Impr. de l'Institut Français d'archéologie orientale, pp. 127–36.

Wilber, Donald Newton (1955), *The Architecture of Islamic Iran: The Il-Khanid Period*, Princeton, NJ: Princeton University Press.

Wilber, Donald (1973), 'Le Masǧid-i Ǧami' de Qazwin', *Revue des Études Islamiques*, 41: 199–229.

William of Rubruck (2010), *The Mission of Friar William of Rubruck: His Journey to the Court of the Great Khan Möngke, 1253–1255*, ed. Peter Jackson, Farnham: Ashgate.

Wensinck, A. J. and T. Fahd, 'Šūra', *EI2*.

Wolper, Ethel Sara (1999), 'Portal Patterns in Seljuk and Beylik Anatolia', in Çiğdem Kafescioğlu and Lucienne Thys-Şenocak (eds), *Aptullah Kuran için Yazılar*, Istanbul: Yapı Kredi Yayınları, pp. 65–80.

Wolpert, Ethel Sara (2003), *Cities and Saints: Sufism and the Transformation of Urban Space in Medieval Anatolia*, University Park, PA: Pennsylvania State University Press.

Wordsworth, Paul (2016), 'Sustaining Travel: The Economy of Medieval Stopping-Places Across the Karakum Desert, Turkmenistan', in Stephen McPhillips and Paul Wordsworth (eds), *Landscapes of the Islamic World: Archaeology, History and Ethnography*, Philadelphia: University of Pennsylvania Press, pp. 219–36.

Yalman, Suzan (2011), *Building the Sultanate of Rum: Religion, Urbanism and Mysticism in the Architectural Patronage of ʿAla al-Din Kayqubad (r. 1220–1237)*, doctoral dissertation, Harvard University.

Yalman, Suzan (2012), 'ʿAla al-Din Kayqubad Illuminated: A Rum Seljuq Sultan as Cosmic Ruler', *Muqarnas*, 29: 151–86.

Yalman, Suzan (2017), 'The "Dual Identity" of Mahperi Khatun: Piety, Patronage and Marriage across Frontiers in Seljuk Anatolia', in Blessing and Goshgarian 2017, pp. 224–52.

Yavuz, Ayşıl Tükel (1996), 'Anadolu Selçuklu Dönemi Hanları ve Posta-Menzil-Derbent Teşkilatları', in Zeynep Ahunbay, Deniz Mazlum and Kutgün Eyüpgiller (eds), *Prof. Doğan Kuban'a Armağan*, Istanbul: Eren, pp. 25–38.

Yavuz, Ayşıl Tükel (1997), 'The Concepts that Shape Anatolian Seljuk Caravanserais', *Muqarnas*, 14: 80–95.

Yavuz, Ayşıl Tükel (2006), 'Kervansaraylar', in Ali Uzay Peker and Kenan Bilici (eds) *Anadolu Selçukluları ve Beylikler Dönemi Uygarlığı (Mimarlık ve Sanat)*, Ankara: Kültür ve Turizm Bakanlığı, pp. 435–45.

Yavuz, Ayşıl Tükel (2011), 'The Baths of Anatolian Seljuk Caravansarais', in Nina Ergin (ed.), *Bathing Culture of Anatolian Civilizations: Architecture, History, and Imagination*, Leuven: Peeters, pp. 77–141.

Yazıcı, Tahsin, 'Ḥobayš b. Ebrāhim b. Moḥammad Teflisi', *Encyclopaedia Iranica*.

Yazıcı, Tahsin (2010), 'Persian Authors of Asia Minor', *Encyclopeadia Iranica*.

Yıldız, Sara Nur (2006), 'Mongol Rule in Thirteenth-Century Seljuk Anatolia: The Politics of Conquest and History Writing', doctoral dissertation, University of Chicago.

Yıldız, Sara Nur (2011), 'Manuel Komnenos Mavrozomes and his Descendants at the Seljuk Court: The Formation of a Christian Seljuk-Komnenian Elite', in Stefan Leder (ed.), *Crossroads between Latin Europe and the Near East: Corollaries of the Frankish Presence in the Eastern Mediterranean (12th–14th centuries)*, Würzburg: Ergon Verlag, pp. 55–77.

Yinanç, Refet (1984), 'Kayseri ve Sivas Darüşşifaları'nın Vakıfları', *Belleten*, 48: 299–307.

Zeymal, Y. V. (1996), 'Stucco and Plasterwork, §III, 5, (i)(a): Western Central Asia: 8th–12th Centuries', in J. S. Turner (ed.), *The Dictionary of Art*, New York: Grove, vol. 29, cols 821a–823b.

Zhordania, Erekle (2019), изантийский Понт и Грузия. Вопросы исторической географии и этнотопонимики юго-восточного Причерноморья в XIII–XV веках, St Petersburg: Алетейя.

# Index